Depth Effects

The publisher and the University of California Press
Foundation gratefully acknowledge the generous support
of the Eric Papenfuse and Catherine Lawrence
Endowment Fund in Film and Media Studies.

Depth Effects

Dimensionality from Camera to Computation

BROOKE BELISLE

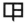

University of California Press

University of California Press
Oakland, California

© 2024 by Brooke Belisle

Library of Congress Cataloging-in-Publication Data

Names: Belisle, Brooke, 1977– author.
Title: Depth effects : dimensionality from camera to computation /
 Brooke Belisle.
Description: Oakland, California : University of California Press, [2024] |
 Includes bibliographical references and index.
Identifiers: LCCN 2023016776 | ISBN 9780520393851 (hardback) |
 ISBN 9780520393868 (paperback) | ISBN 9780520393875 (ebook)
Subjects: LCSH: Mass media—Aesthetics. | Technology—Aesthetics. |
 Computational photography.
Classification: LCC P93.4 .B36 2024 | DDC 302.2301—dc23/eng/20230807
LC record available at https://lccn.loc.gov/2023016776

Manufactured in the United States of America

33 32 31 30 29 28 27 26 25 24
10 9 8 7 6 5 4 3 2 1

Contents

	Introduction: Dimensional Aesthetics	1
	Entrelacs I. Depth	9
1.	The Sidedness of Things: Object Recognition and Computer Vision	15
	Entrelacs II. How a Cube Coheres	59
2.	Surfacing Subjectivity: Portrait Mode and Computational Photography	65
	Entrelacs III. Unfinished Incarnation	109
3.	Visible World: Photographic Maps and Computational Photogrammetry	115
	Entrelacs IV. Other Landscapes	165
	Acknowledgments	171
	Notes	175
	Bibliography	205
	Index	219

Introduction

Dimensional Aesthetics

Dimensions seem like measurable things, even the very measurability of things. But the most common way dimensions are given—height × width × depth—already suggests something stranger. The × symbols that read as "by, by, by" are not additive but transformative, a crisscrossing and compounding. Dimensions are not stable properties of space but, instead, its factors: they produce and multiply. Dimensionality names the relational structure of spatiality, its opening up and holding together, a self-differing or spacing that makes up and takes up space.

Dimensional aesthetics asks how the relational structure of spatiality is mediated and made sensible. It engages aesthetics not merely as a question of art, or "how things look," but also in the broader meaning of sense experience: aesthetics concerns material ways of "making sense." Dimensional aesthetics asks how spatiality is represented in images, and also how images and embodied vision are themselves spatial and spatializing. It asks how spatial relationships that may seem objective or immanent—front and back, surface and depth, foreground and background, here and there—structure formations of power and formulate modes of alterity.

Images can never contain the space of the world they picture; but they produce depth effects that convey, to a viewer, dimensional relationships that are not strictly "in" the image. Art history has examined the depth effects of three-point perspective in drawing and painting. Film and media scholars have traced depth effects from stereoscopic photography through 3D cinema and digital virtual reality (VR). But contemporary techniques of computational imaging complicate how these accounts have understood dimensionality in terms of optical verisimilitude or visceral illusion. The dimensional aesthetics of computational imaging unsettles long-standing norms of visual mediation and the critical frameworks developed around them.

2 / *Introduction*

Computational imaging incorporates photography and lens-based imaging; it often involves imagery that has been optically recorded by cameras or sensors. It also relies on digitization—the fact that machines engage images as quantitative information. But it leverages photographic and digital qualities of visual representation into automated processes that aggregate, analyze, and extrapolate visual information through artificial intelligence (AI). More than simply reformatting analog imagery as digital data, these computational processes produce forms of visibility that are based on, and emerge from, the relational, patterned, and probabilistic operations of algorithms. These operations are not just mathematical but also explicitly spatialized because they involve how pixel values are mapped to the coordinate grids of picture planes. Computer vision algorithms analyze numerical expressions about pixels in spatialized arrays; artificial intelligence processes take place through spatialized informatic structures, such as the layered neural networks of deep learning; and spatial information extracted from imagery is used to spatialize images in mutable ways—allowing, for example, depth of field and vantage point to be altered. The dimensional coordinations of these algorithmic processes do not fit the spatial terms of embodied visual experience but reshape those terms as computational imaging techniques become pervasive.[1]

This book examines three spatial techniques of contemporary computational imaging: object recognition in computer vision, depth mapping in computational photography, and computational photogrammetry in mobile mapping apps. These techniques involve photographs and are largely interpreted as photographic in that they seem to record and rearticulate the world's actual visibility. But they incorporate algorithmic processes of extrapolation and interpolation that disrupt how photographs have been understood as isomorphic imprints of whatever they depict. This disruption leverages digitization, but it goes beyond how digitization was understood to undermine the material and semiotic link between image and referent—the visual representation and the actual things it represents. Computational imaging techniques do not just recode this relationship through quantitative logics; they move away from privileging it at all.[2] In computational imaging, representational and referential value is reoriented toward different relationships: patterns seen to relate multiple images and to inflect any single image as internally multiple. To understand this shift—what is new about it and why it might matter—one place we can turn to is the history of photography that computational imaging seems to leave behind.

As computational imaging techniques change what could appear to cohere and take place as visible, both in the world and in images, they revi-

talize questions of dimensional aesthetics that shaped the early history of photography, before its twentieth-century norms were stabilized. Before the spatiotemporal terms of a photograph were fixed by modernist notions of indexicality and medium specificity, nineteenth-century photographic practices often invested ways of seeing relational space within an image and strategies for combining or coordinating images into multidimensional views. Panoramic and stereoscopic formats in photography's first decades did not fit the serial and successive coordination of photographs that became the norm of cinema, and so from a twentieth-century perspective seemed tangential to the through line of media aesthetics.[3] Yet these popular forms suggested ways of relating images that resonate with today's computational practices.

Although it is true that "new media" often resurface whatever has become "old" enough to feel new again, I am not arguing that twenty-first-century computation is the continuation or evolution or return-of-the-repressed of nineteenth-century photography. My approach to media archaeology is more aligned with Michel Foucault's sense of historical reordering and Walter Benjamin's concern that the future rests on continually reframing how past and present seem linked.[4] I am inspired, in particular, by the way Benjamin understood his *Arcades Project* as a "stereoscopic and dimensional seeing into the depths of historical shadows."[5] This metaphor aligns the provisional coordination of a stereoscopic view with the dialectical structure, and political stakes, of what he called historical materialism. To look into the temporal depth between "then" and "now" is to see the contingency and the ongoing, present-tense coordination of that relationship. Benjamin saw this effort as urgent, a way to recognize and grasp possible futures that are presently at stake as past violence bends toward what appears as their inevitable foreclosure. The depth effect of a stereoscopic view—its relational triangulation of a dimensionality that appears self-evident—is both an explicit topic in this book and a heuristic for its overall project.

The comparative approach of this book is reflected in its structure. Rather than proceeding from past to present and from old to new media, its three core chapters cut across different time periods, media technologies, and disciplinary categorizations of images. In each chapter, I introduce a technique of computational imaging through an example of mainstream visual culture; I look back to early photographic practices that deploy a similar spatial strategy; and I take up contemporary art that explores what is at stake in today's changing media and its restagings of dimensional aesthetics. These questions build, asking how the objective contours of things, the subjective depths of personhood, and the expansive dimensions of a

4 / *Introduction*

world-in-common are conceived as visible and articulated through visual representation.

The three core chapters of this book do not advance a linear argument as much as articulate related facets of the critical framework that dimensional aesthetics offers. Chapter 1 contextualizes contemporary techniques of computer vision, deep learning, and object recognition in relation to the history of stereoscopic photography. It draws on artworks by Trevor Paglen to show how what seems like the objective shape of things is always related to an embedded point of view. Chapter 2 explores how the computational processes of smartphone photography—especially depth mapping—reinvent, and yet fail to reinvent, photographic aesthetics. It explains how Portrait mode transforms the shallow depth of field it simulates, foregrounding the subject by pushing the world away. The chapter situates this depth effect within the racialized norms of anthropometric and portrait photography, and finds more expansive potentials in recent artworks by Lorna Simpson and LaToya Ruby Frazier. Chapter 3 traces how techniques of computational photogrammetry—used to translate between image space and actual space—developed from embodied, material practices of photographic surveying and stereophotogrammetry. It compares the immersive and augmented reality views of Google Maps with the distanced perspectives of artworks by Andreas Gursky to explore how incompatible vantage points appear reconciled by, and as, the world's own coordination.

These three chapters interrelate and compound, mirroring the computational imaging processes they discuss. Chapter 1 explores how dimensional information is extracted from photographs of objects to train the spatial operations of visual algorithms. Chapter 2 shows how these algorithms then feed back into the spatial operations of contemporary photography. Chapter 3 explains how this interleaving of photographic and computational imaging in photogrammetry now conditions the terms in which spatiality itself is conceived as, and rendered, visible. The sequence of chapters also scales out conceptually to consider how techniques of aesthetic mediation presume and posit the apparent dimensionality of things, people, and the world they add up to. It moves from the challenge of seeing the shape of any one thing when a side of it will always face away; to the challenge of portraying the unpresentable interiority of another person's subjectivity; to the challenge of picturing the whole world, which would necessarily overflow any view.

With the framework of dimensional aesthetics, I show what is at stake in the way depth effects mediate the spatial terms of visibility: the recognition that these terms are provisional, relational, and continually renegotiated.

What appears as the objective shape of things—what holds together, what surfaces, what connects—is contingent on specific ways of rendering dimensional relationships sensible and interpreting them as self-evident. This involves political and ideological operations as much as technical and aesthetic strategies. Depth effects mediate how spatiality seems self-organized—the most basic, relational conditions in which anything could take place and appear.

As dominant aesthetic techniques for mediating dimensionality change, so too do ways that the relational contingencies of dimensionality are conceived and made sensible. As computational imaging inherits and adapts photographic strategies for rendering the world's dimensions fully and objectively visible, this promise of total visibility threatens to carry forward and update a violent, colonial presumption: that everything and—more importantly—how everything interrelates could be made explicit through representation. Imaging advances driven by AI rekindle aspirations entangled with early photography, seeming to promise that everything visible, and all vantage points, could be reconciled and accounted for within a single, overarching systemization. This aligns with capitalist logics of exchangeability and imperialist logics of control by proxy. Current techniques of computational imaging echo with ways that nineteenth-century photography was used in efforts to seize through visual capture and manage through spatial quantification: algorithmic operations used in smartphone cameras and mapping apps inherit and reinvent early photographic techniques that were invented to racially classify bodies of colonized peoples and extract resources from colonized lands.

By drawing connections between the dimensional aesthetics of "new" media in the nineteenth and twenty-first centuries, I am not simply tracing a lineage of ongoing violence. I am asking how we might rethink the relationship between photographic and algorithmic techniques of mediating spatiality, in order to envision alternative through lines and trajectories and to reopen more capacious potentials of dimensional aesthetics. I move across different registers of visual culture—utilitarian and scientific practices, popular and commercial media, and fine art—to consider how different depth effects stage a paradox that can only be restaged without being resolved. Dimensional aesthetics prompts us to encounter relational contingencies that both open and limit our look, weaving us into a visible world that is held in common through, rather than despite, irreducible articulations of difference.

To imagine forms of coordination that would emerge from and through differentiation rather than foreclosing it, I turn to aesthetic mediation to

6 / *Introduction*

explore the relational terms of experience—its dimensional facets and hinges. Dimensional aesthetics responds to a demand to conceive of coordinations that may not be fully visible—a thing "in itself," subjectivity, the whole world—in ways that are not founded on the stability or completeness of an image, and that exceed any externalized logic of spatial representation. Instead of positing fixed forms for coordinations that could only be contingent, aesthetic mediation could articulate and rearticulate the facets and dimensions that allow the same things to appear to cohere and make sense in different ways.

The way I make sense of visual culture follows a long line of media theory and philosophy invested in the phenomenological implications of aesthetic experience.[6] My conception of dimensionality and depth, in particular, draws directly on the work of mid-twentieth-century French philosopher Maurice Merleau-Ponty. For him, depth names a structure of ontological relation, a way that Being self-articulates. It describes a nonoppositional form of difference, in which singular aspects open dimensions of a whole that does not reduce them. Depth, then, is a condition of visibility that co-constitutes seer and seen, disclosing the contingency of how something is visible to someone from somewhere. It is also a condition of spatiality: depth co-constitutes the relative position of everything that exists relative to everything else in a shared world that holds itself together through holding everything apart.

Inspired by Merleau-Ponty's description of dimensionality as jointed or hinged and mutually enveloping, I have chosen to interleave the book's three chapters with shorter, more conceptual interchapters. I call these *entrelacs*, the French word that Merleau-Ponty uses to describe the structure of depth, which is usually translated into English as *interlacing, interweaving,* or *intertwining*. Taken together, these interchapters could be thought of as a single chapter that might have been placed first or last in the book, but which has instead been spaced out and interwoven between the others. This spacing works to surface, at the joints of the book, the phenomenological framework that subtends and relates the arguments in each chapter but is not explicitly argued within them. It discloses how my way of reading Merleau-Ponty has shaped what I say about depth in the rest of the book, but also, I hope, brings forward his thought on its own terms, for other readings. One reason I return repeatedly to his work to interrupt or intervene between the other chapters is to show how his language pushes past mine to unravel distinctions between objects, subjects, and the world that my chapters might seem to maintain. His metaphors and redefinitions—especially his concept of "flesh"—undermine the most

common terms that I felt unable to avoid when talking about the "objects" of object recognition, the "subject" of portraiture, and the "world" shown on a world map.

This book's interwoven structure also reflects my interest in avoiding any explicit adequation between sensuous objects and abstract ideas, historical examples and philosophical problems. In the three central chapters, I trace a history of dimensional aesthetics through specific technologies, artworks, and examples of visual culture. In the interstitial sections where I conceptualize dimensionality, Merleau-Ponty's writing about depth becomes my object: I quote from his texts and engage with his ideas in readings that are as fine-grained—and also perhaps as idiosyncratic—as the archival work and formal analysis of the chapters. These are two sides of the same inquiry, but each offers its own rich details. Artworks and visual media are not illustrations of philosophical concepts, as if this is "what they mean." They speak in historically situated and material ways that cannot be translated beyond their thingliness. Likewise, abstract ideas are not concretized in or by specific things, as if this is "how they matter." Keeping more concrete and abstract approaches separate allows me to engage related aspects of dimensional aesthetics without attempting to fuse them. It admits that my object of inquiry is an idea that could not, itself, be posited as a thing that my inquiry completely constitutes. I hope that structuring the project this way helps leave room for readers and for other work, opening space like the two perspectives of a stereoscopic view to enable and invite the kind of depth effects that this book explores.

ENTRELACS I

Depth

Depth is obvious and yet elusive. It extends behind the front or below the top, hidden by whatever surface you may face. Metaphorically, it describes what recedes or remains withheld, not fully given or within reach. Practically, it measures a volume that could potentially be filled: how much can be stacked up in a box or pushed back into a closet, how far you can plunge down into a pool. In geometry, depth is the third dimension that turns a two-dimensional figure into a three-dimensional object—a square into a cube.

In standard measurements, depth is listed last because it follows from the way height and width are measured: the depth of the table depends on which way you have turned it, which side you have made the front. Height and width are relative to one another in the same plane as your body. Height extends up and down from head to toe as you stand, and width spans what is to your left and to your right. But depth extends away from you. Its other side is behind your back. Depth is the dimension you are "inside" and cannot survey. It is what a flat image can suggest but never contain, the quality of space that surrounds and envelops. Depth is how anything takes up space. It describes what space feels like and seems to be at the level of embodied experience, before measurements are made and dimensions are abstracted. Because of this primordiality, the phenomenological philosopher Maurice Merleau-Ponty argues that depth should be considered the first dimension rather than the last—if it could be considered a dimension at all.[1]

Merleau-Ponty interrogated the phenomenon of depth throughout his career: from his 1945 magnum opus, *Phenomenology of Perception*, to the book left unfinished, *The Visible and the Invisible*, when he died unexpectedly in 1961. His last essay, "Eye and Mind," is devoted to the

10 / *Entrelacs I*

concept of depth. In it, he describes depth as an "enigma" that "insists on being sought [. . .] all through life," not realizing he was writing near the end of his own. He argues that "depth is still new," still a puzzle, even "centuries after the 'solutions' of the Renaissance" to depict depth through three-point perspective and "centuries after Descartes" did away with depth by making it "an unmysterious interval," "interchangeable with breadth."[2]

Cartesian space is totalizing, Merleau-Ponty argues, because it posits space as a preexisting container waiting to be filled, in which all points are mappable in principle relative to one another and relative to the space as a whole. This conception of space "erect[s] it into a positive being, beyond all points of view, all latency and depth, devoid of any real thickness"—a "space without hiding places."[3] For Merleau-Ponty, space is not an empty coordinate grid "in which things are laid out, but, rather, the means by which the position of things becomes possible."[4] Depth describes the relational structuring of this positioning.

Depth names what Merleau-Ponty calls the "reciprocal insertion" of everything that exists relative to everything else in the same world.[5] This reciprocity is not an objective distribution—a tidy ordering in which there is a place for everything and everything is in its place. If "breadth and height are the dimensions according to which [things] are juxtaposed," such that their positions appear as interchangeable with a shift in perspective, then depth is "the dimension according to which things or the elements of things envelop one another" to produce mutually exclusive structures of visibility.[6] Depth's convolutions surface some aspects and withhold others, such that it is impossible not only to see the totality of everything all at once but even to conceive of this total visibility. Depth disallows the "pure positivity of Being" that would erect or be erected in objective, positive spatiality and visibility. It undoes oppositions—between subjects and objects, mind and body, or sense and substance—that both presume and seem to prove the self-evidence of what is.

Depth is not merely a visual effect belonging to perspective, nor is it an objective property belonging to things; it is an ontological structure. Merleau-Ponty calls depth an "'existential'" dimension because it describes the spatialized articulation of existence, a way that presence is spaced— things held together and held apart in co-presence.[7] Depth articulates singularities as relational dimensions of a whole that they constitute through and as their mutual difference rather than as their synthesis. This whole is not prior to or produced as the summation of its multiple aspects; but neither do its parts precede it or derive from it. Depth names a paradox in which a whole takes place by self-spacing mutually exclusive aspects, self-

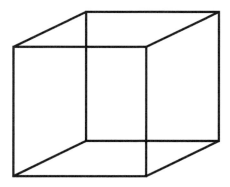

FIGURE 0.1. Illustration of a Necker cube.

differing in ways that are irreducible. This articulation is how the everywhere and always of space and time are constantly given through the infinite differentiation of each here and there, each now and then. Merleau-Ponty argues that the gaps (écarts) of depth's spacing function like joints and hinges, or quilting points (capitonnage).[8] If these gaps could be filled and the joints fused to form a pure positivity of space, then, paradoxically, whatever forms of interdependence constitute coexistence would pull apart.

Due to its paradoxical structure, depth can be figured but never quite grasped. It names a way in which elements that seem "mutually incompossible"—unable to both exist at once—are co-constitutive.[9] One figure Merleau-Ponty uses to describe this paradox is the Necker cube, a line drawing that can be seen to cohere in two different ways. Looking at this drawing, the lines clearly all stay where they are, but the cube they appear to form can shift between two entirely different organizations of six square faces. This experience can feel passive rather than active on the part of the perceiver, as if the drawing pops into one three-dimensional shape and then shifts to "make sense" in a different way, as a different cube. Merleau-Ponty argues that this is not, as it is often called, an optical illusion but, rather, exhibits the paradox that depth names and always involves: the two cubes are mutually exclusive and yet both "there," each latent in the other and "made of" the other.[10] They are not discrete aspects of the same whole to which they both add up; they are each "total parts."[11]

Although depth, as a word and as a concept, names something spatial, it is not essentially spatial for Merleau-Ponty; neither is it simply a metaphor. He finds it not only in the structure of space and the spatial terms of visibility but also in the structure of embodied subjectivity and intersubjectivity,

temporality, and the world as such. For Merleau-Ponty, depth is the way Being takes place.[12] Like the Necker cube, Being can only be made up of everything that "is," all together and at once; yet Being articulates itself through every singular thing and moment and view. For Merleau-Ponty, depth names a spacing of Being: a paradox of self-differing and interrelation through which Being is given as nothing but itself.

Because Merleau-Ponty understands depth as the structure of Being, it inflects every concept in his philosophy.[13] Depth's structure of mutual envelopment is the form of the "chiasm" and "intertwining" that he elaborates in the influential last chapter of *The Visible and the Invisible*, and of what he came to call "flesh." Depth names how the invisible relates to the visible. The "depth of the visible" is what exists as unpresented, in a way he sometimes calls primordial or immemorial. It is the "inner lining" of the visible. He says it is "present as a certain absence" and as the "inner framework" of the visible. It is at the joints and in the gaps that structure what is present and visible, écarts that are capitonnage—inflection points where things hold together across different dimensions and multiple views become possible.

Merleau-Ponty's concept of depth is, in a sense, the "lining" and "inner framework" of his larger philosophical project—an effort to conceptualize difference in a way that would not presume opposition or demand synthesis. His work participated in a shift from the German phenomenological lineage of Hegel, Husserl, and Heidegger toward a French framework entangled with existentialism, poststructuralism, and postcolonialism. Influenced by World War II, this line of phenomenology developed in explicit resistance to fascism; thinkers working in its tradition continue to redress exclusionary models of subjectivity and meaning, presence and progress, community and world that continue to underwrite violence. The paradox of depth, as Merleau-Ponty describes it, rhymes with and influences how other philosophers in this tradition also look toward the dimensional coordination of spatiality to consider forms of relationality in which elements are neither self-standing nor reducible as the same.[14] Instead of describing how a transcendent consciousness self-actualizes to produce the world and the future, this line of thought looks for ways to affirm Being and meaning within the finite, material, and precarious terms in which the world is given each moment.

This line of thought remains urgent in our twenty-first-century moment, as ascendant technologies and ideologies seem to mutually reinforce totalizing logics that cannot account for depth's irreducible relationality. The "mistake" that Merleau-Ponty saw in Descartes and hoped to

redress is not only repeated but also escalated by contemporary norms of computation. Computational imaging is based in the mathematical precepts of Cartesian, coordinate space and its positivist ontology—the "space without hiding places." Current techniques for recording and modeling space extrapolate dimensional relationships into mathematical forms—geometrical expressions and statistical probabilities. They rely on automated, algorithmic operations to fill the gaps that structure visibility and depth, extrapolating a computational model of vision and quantitative model of spatiality. This attempts to undo the relational contingencies of depth, to produce empirical and universal ways of seeing and knowing. As computational imaging has come to dominate the mediation of visual experience, the conception of space it encodes and enacts increasingly structures not only how we see and represent the world but also how we presume it exists as seeable, and how we conceive of visibility as relating seer and seen. Changing aesthetic techniques for mediating dimensionality and making depth visible negotiate ethical questions and ontological paradoxes that do not have technological solutions.

Merleau-Ponty died in 1961, when movies were projected from celluloid and phones were wired into walls. His ideas about depth are not "about" or "applicable to" contemporary forms of computational visual culture in any direct way—not even media formats that promise to capture and simulate three-dimensional depth and embodied immersion. His work is expressly interested, however, in ways that aesthetic experience negotiates the ontological structure of depth. For him, the way a work of art stages the terms of sense experience and signification—offering a specific way for the perceiver to "gear into" its form and make sense of it—proposes a way of engaging the world and interpreting it as sensible. In some artworks, he saw depth effects that mutually opened the work and its perceiver, and that invested what was unpresentable as much as what was presented. This potential of aesthetic form could act in the other direction, or as the other side, of aesthetic techniques that rationalize and evacuate depth.

Aesthetic form cannot explicitly render depth, but it can stage depth effects. Depth effects are "effects" in the sense of being both provisional and self-effacing. Depth is sensible only as what Merleau-Ponty calls "the presentation of a certain absence"—an absence that is determinate of what is presented but is not presented in itself. Depth effects are not specific to visual mediation, or to ways that flat images might convey volume. Merleau-Ponty described how painting, poetry, and music could all produce experiences of depth—in the interrelationships of brush strokes on a canvas, words in a sonnet, or notes in a sonata. In each case, meaning appears

14 / *Entrelacs I*

through and as a relational contouring of the sensible: an irreducible tension of presence and absence, materiality and ideality. Aesthetic depth effects happen when the "joints" that internally differentiate a work and hold it together—allowing it to appear as a particular formation of the sensible, and to make any sense—seem to also constitute a "porosity" or openness to what is constitutively beyond its framework. Depth appears as a latency or alterity that could not be surfaced, only limned through effects that are themselves contingent and unstable.

Merleau-Ponty understood depth as a question the world poses, that demands continual response in the form of further questioning rather than any answer. He believed that artists and authors like Paul Cézanne and Marcel Proust were, like him, interrogating depth throughout their lives, using aesthetic form where he used philosophy's formulations. In the spirit of that shared and ongoing inquiry, this book takes up the question of depth as it is staged across aesthetic and conceptual formations—particularly, visual aesthetics and formulations of the visible. On the one hand, I consider how computational imaging techniques are reorganizing the norms and dominant logics of visual representation in efforts to stabilize and overwrite depth's contingencies. On the other hand, I show how contemporary artists use depth effects to explore dimensional relationships that continue to slip any fixed framework. I explore ways that they reopen or reactivate the dimensional aesthetics of photography, right when computational processes are transforming what counts as a photograph and leaving the optical and indexical definitions of photography behind. These processes aggregate photographic images as a substrate or raw material that can be mined for quantitative data and used to build computational forms of vision. They analyze shapes in photographs in ways that aim to strip away aesthetic inflection to extract the spatial information "beneath" or beyond it. They attempt to add up and rebind all the partial views that photographs seem to have parsed the world into, synthesizing all these flat and singular perspectives into the objective dimensions of a total view. But, because of its constitutive limits, the photographic image may continue to surface depth's paradox.

1. The Sidedness of Things

Object Recognition and Computer Vision

> Give us a few negatives of a thing worth seeing, taken from different points of view, and that is all we want of it. Pull it down or burn it up, if you please.
>
> OLIVER WENDELL HOLMES, "The Stereoscope and the Stereograph," 1859

CHIHUAHUA OR MUFFIN?

Memes mixing up foods and animals started showing up on Twitter in fall 2015. It began with a string of posts by Karen Zack, @teenybiscuit: "duckling or plantain?"; "shrew or kiwi?"; "labradoodle or fried chicken?"; "puppy or bagel?"; "shiba or marshmallow?"; "kitten or ice cream?" The genre was well established by spring of 2016, when "chihuahua or muffin?" went viral, juxtaposing bumpy tops of blueberry muffins with the crooked features of little Chihuahua faces.[1] To get the joke is to discover a silly similarity: the muffin-ness of Chihuahuas and the Chihuahua-ness of blueberry muffins. But it is also to see, for at least a moment, the beady black eyes of a Chihuahua and the blueberries baked into a muffin as similar dark dots, similarly arranged, inside similar beige blobs—to see less like a person comparing dogs and muffins, and more like an algorithm sorting images.

These memes with marshmallow- and muffin-like pets are visual puns, cute games about cuteness, almost literally eye candy. They are also, however, parodies of object recognition, a common task of computer vision. Computer vision is a field of computer science that aims to computationally model and enact human visual functions—such as identifying and labeling objects in images.[2] Beginning with its name, the language of this field—with terms like machine learning, neural networks, object recognition—conflates human and machine in ways that already presume its goal. When a person looks at the "chihuahua or muffin?" meme and tries to answer, they emulate what is already an emulation: a person plays at seeing like a computer that aims to see like a person. Specialists working in this field began to share and discuss the animal-or-food memes as object recognition

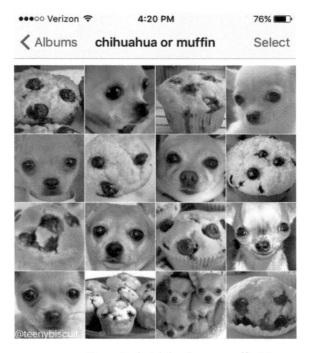

FIGURE 1.1. Karen Zack, "chihuahua or muffin?," posted on Twitter, March 9, 2016. © Karen Zack/ @teenybiscuit.

memes, spoofs that show how algorithms could be confused by similar images of very different things.[3] Object recognition can be broken down into more specific tasks, such as detection and classification; and it can be tailored to particular types of objects, like faces. As a general term, however, it names what counts as seeing for computer vision: identifying shapes of things with patterns of pixels. The joke of "chihuahua or muffin?" suggests how misrecognition could be built into the premise of object recognition, because computer vision's objects are always already images—flat and bounded arrangements of pixels.

Computer vision analyzes digital images—which are, for a computer, series of numbers indicating what kind of pixels would be placed where in the coordinate grid of a digital display. So, to be an object for computer vision means to constitute a pattern of pixels. Object recognition is about identifying and comparing these patterns of pixels, and statistically modeling how they correlate with category labels like "muffin." What human viewers interpret in terms of visual similarity, algorithms assess in terms of

The Sidedness of Things / 17

numerical relationships and mathematical probability. For example, if a computer confuses images of Chihuahuas and blueberry muffins, this might have less to do with any similarity between beady eyes and blueberries than with the fact that a low degree of color variation overall in these images makes them stand statistically apart, to a very similar degree, from more colorful images labeled "salad" or "carousel."

Object recognition was a central focus of computer vision when the animal or food memes appeared: these memes prompted humans to see like computers at a moment when considerable efforts were being made to teach computers how to see like humans. Major advances in computer vision gained momentum beginning around 2012, as developments in artificial intelligence (AI) and machine learning made it increasingly possible to train algorithms in object recognition.[4] A critical factor in this leap was the development of artificial neural networks, algorithmic structures modeled after the interconnected neurons in human brains. These networks use artificial intelligence techniques to extract and pass information through successive processing nodes. In what is often called "deep learning," large sets of sample images can be fed into a neural net that will work to analyze patterns in the images and build predictive classification models for them. Thousands of labeled images of Chihuahuas and muffins, for example, might be fed into a neural net to train object recognition algorithms that can distinguish between these two categories and correctly label Chihuahuas and muffins in new images. Deep learning enables the object recognition that enables computer vision.

Another factor supporting advances in computer vision was the rise of smartphone photography and image-based social media platforms. As the number of photographic images circulating online increased exponentially, it became easier to create larger sets of sample images of everyday things that could be used to train object recognition algorithms. As billions of photographs began to be posted online every day, this flood of images also seemed to require the kinds of automated sorting and searchability that computer vision could enable. The emergence of object recognition memes in 2015 reflected that by then, many people had digitally captured and shared images of their pets and breakfasts and were searching for and recirculating similar images. In creating memes like "chihuahua or muffin?," Karen Zack almost emulated a Google image search by gathering, grouping, and presenting a grid of visually related images. Posting this set of images on a social media platform turned it, in turn, into an image; and posting a series of similar puzzles produced a new, recognizable category of images—the animal-or-food meme—that other people began to produce. "Animal or

18 / *Chapter 1*

food" can now be used as a search term in its own right, to yield a grid of these memes as the result in a Google image search. This feedback loop amplifies the recursive logic of each object recognition meme, opening from the way one person might compare one set of images to the larger, social and platformed logics that interrelate human and machine methods of grouping and parsing images. Computational methods, then, not only emulate human visual practices but also inflect them.

Object recognition memes like "chihuahua or muffin?" make it seem like computer vision and human vision are similar enough to make the same mistakes. With their cuteness and humor, they suggest that this confusion could be fun and funny. They also suggest that it could enrich rather than reduce human ways of seeing, yielding unexpected potentials for how people might perceive and interpret the visible world. How fun, in other words, to discover the muffin-ness of puppies, as if it had always been there waiting to be noticed, until we looked at them this way! The joke comes at the computer's expense because only humans could enjoy the cuteness and get the humor of mixing up tiny dogs and blueberry muffins. It is a joke no computer could grasp even if it was the one to unwittingly make it. These memes are not, then, asking people to see like computers as much as prompting them to see in the way the meme maker did: as a person pretending to see like a computer. This is a playful performance, a way to encounter the gap between human and computer vision, but to experience it as a delightful rather than threatening difference. It is compensatory and reassuring, recasting what could be understood as a technological alienation of human vision as, instead, an aesthetic kind of defamiliarization that produces fresh ways of seeing.

The humor of the object recognition memes deflects much more pernicious confusions and misrecognitions that follow from how computer vision aims to model human seeing. In summer 2015, just months before the first of those memes was posted, software developer Jacky Alciné encountered a category error in the computer vision operations of Google Photos: in some of the personal photographs that he had uploaded to that platform, automatic photo tagging had mislabeled Black people as gorillas.[5] More than a software error, this mislabeling rearticulated a violent history of dehumanization, seeming even to update it through algorithmic means.[6] The object recognition algorithms involved were intended to help people sort and manage their personal photo archives, using the same strategies that Google uses to make a constantly accumulating aggregation of public images searchable online. At the same time, when people upload their personal photographs into the Google Photos platform—and possibly add or

correct suggested labels—such seemingly innocuous acts help extend Google's reach from public into private images, adding to the overall set of sample images available to train Google's computer vision algorithms, and helping Google refine its strategies for object recognition. In the case of Jacky Alciné, the misalignment between the personal photographs of one Black man and the model of computer vision trained to label them challenged the intended universality of computer vision. Google "solved" the problem by simply removing "gorilla" as a category label altogether.

The object recognition and facial recognition algorithms that mislabeled Black people as gorillas in Google Photos had been trained on sample images that overrepresented white people and underrepresented Black people for the category of "person." This problem sparked broad outrage and became emblematic of how systemic biases were being trained into computer vision. Researchers were able to show how computer vision systems tended to overlook the faces of Black people more often than other faces, and more frequently mislabeled them—incorrectly identifying them as male or rating them as angry even when smiling.[7] As critics have explained how bias can be built into algorithmic automations, it has become obvious that no form of computer vision could be neutral or universal.[8]

That understanding has not stopped the increasing penetration of computer vision into everyday life, however. For example, major companies have been using it to screen job candidates.[9] One platform for this, HireVue, has promised faster and better employment decisions by replacing initial face-to-face interviews with AI video analysis: applicants upload video responses to interview questions, and a neural network assesses their voice, posture, and facial expressions in the recording. HireVue's website offers extended assurances that this method is not only unbiased but helps "reduce hiring bias and increase diversity."[10] Rather than relying on the individual perception and personal inclinations of any given interviewer, HireVue claims that it "deploys scientifically validated assessments" to "zero in on the highest quality candidates." This process relies on computer vision algorithms that have been trained on sample videos, which were qualitatively assessed by psychologists. The way HireVue "deploys" psychological assessments relies on several interlocking assumptions. It assumes that a psychologist could discern diagnostic cues from the way people appear in video recordings—which would allow psychologists, then, to attach category labels to videos that could be used as examples in training sets. And it assumes that if these diagnostic cues are manifest in a video, then they can be associated with legible and identifiable properties *of* the video, in ways algorithms could also "see" and learn to label. This ends up

20 / *Chapter 1*

translating ways that psychologists have been trained to interpret embodied behaviors in face-to-face encounters to ways that computer vision algorithms are trained to analyze mathematical patterns between points that are mapped to a person's facial features as the relative positions of those points shifts across a series of video frames. The chain of equivalences and elisions that computer vision is built upon begins, then, before any specific input is fed into a neural net, with a structural proposition: that algorithms would glean the same, if not more and better, information from quantitative patterns in images as people could through embodied, visual experience. Computer vision presumes and fuels the assumption that statistically useful information about whatever images visually represent could be gleaned and extrapolated from geometrical shapes measurable at the surface of these representations. But that idea is older than the AI that enables computer vision.

Services like HireVue carry forward problematic premises and practices that developed alongside the medium of photography. Since the mid-nineteenth century, the flat, bounded spatiality of photographic images has been used in colonialist attempts to translate anything photographable into the quantitative and commensurate terms of geometrical and statistical information. Facial recognition algorithms that detect and label faces according to categories of race, gender, and affect directly follow nineteenth-century techniques for objectifying and measuring bodies at the surface of photographs. For emergent fields of nineteenth-century science and pseudoscience, photography's ability to render the body as image seemed to make all forms of embodied identity and affect objectively visible, and comparable across sets of images.[11] Shapes of facial features, like the length of a forehead, were measured and compared in images to "identify" traits of intelligence or criminality; and facial expressions were photographed and categorized to study emotion and theorize hysteria. Techniques for spatially analyzing bodies in photographs were used to visually "prove" theories of eugenics and scientific racism, and were expanded into default processes of policing and surveillance in the early twentieth century.

Using photographs as proxies to visually analyze what they depict assumes not only that a photographic image imprints the actual shape of whatever it pictures but also that this shape could be interpreted from the two-dimensional form of the image. To accomplish such an interpretation requires treating a photographed body as a geometrical figure, mapping points and triangulating spatial relationships. It abstracts dimensional conditions of embodiment—for example, the sidedness that prevents any body from being fully seen at once—into mathematical expressions about objec-

The Sidedness of Things / 21

tive space, formulations of shape and volume that could interpolate what was not visible in the image from what was. These mathematical expressions can then be compared across images, extrapolating patterns in groups of images. Methods used in computer vision take up ways that photographs have been used since the mid-nineteenth century in ethnographic and anthropometric attempts to classify racial and sociological types—grouped for relational analysis in order to make categorical claims that would justify those very groupings.

Efforts to redress this harmful legacy and to correct the biases of computer vision have most often involved adding more diverse and inclusive data to training sets. Diversifying datasets aims to ensure that the statistical patterns extracted from these sets would not reinscribe historical forms of privilege, prejudice, and exclusion that already shape visual archives. Diversifying datasets can help adjust algorithms to produce more accurate outcomes, tweaking input to get better output. But it leaves intact, and may even reinvest, a kind of misrecognition that takes place before computer vision algorithms correctly or incorrectly recognize the shapes of things they have been trained to see. This more fundamental misrecognition takes place in, first, assuming that photographs serve as material proxies for what they picture. In training computer vision, this assumption moves beyond a familiar belief in photographic indexicality—the idea that the spatialized form of the image imprints the material visibility of what it pictures—by presuming that relationships between images also convey ways things actually relate. As with the "Chihuahua or muffin?" puzzle, recognizability is staged in terms of relationships between images rather than in terms of how an image mediates between a viewer and a particular visible object.

As the visual archive of photography is uploaded and analyzed to train computer vision, concerns about labeling images correctly and creating exhaustive training sets reinvest a faith in photographic representation as a way to shore up trust in computational imaging processes—even as these processes actively challenge that faith. Computer vision is built from photographs, and it develops an analogy between human and machine seeing that photography enabled. But the ways photographs are used to train computer vision unsettles assumptions about photographic representation that had helped authorize that analogy. Object recognition algorithms seem to interpret any photograph as a "view" of what it pictures. But this interpretive process does not invest authority and accuracy in the particular conditions of that photograph's exposure: how it inscribed rays of light, cast at a particular place and time, to imprint the visual form of an actual referent. Instead, object recognition processes extract and extrapolate the visual

22 / *Chapter 1*

expression of an object by relating many discrete images to one another. The conditions of any view are stripped away in order to get at the object "itself" beyond any particularized way of seeing it—and not even to get at this particular object *as* itself, but rather to affirm and refine the category that this object instantiates.

The unique relational structure of image analysis in computer vision corresponds with the architectures of neural nets. It reflects how AI operates and how deep learning identifies and interpolates patterns from the photographs fed into it. The relational structures that subtend computer vision shift emphasis from a singular, isomorphic link between an image and the thing it pictures to instead consider how relationships between images capture dimensions of visibility that exceed the grasp of any one image. This relational logic moves away from how a human viewer could perceptually grasp the visual form of a photographic image in terms of an implicitly embodied "view" to focus, instead, on how the quantitative information of a digital image could be coordinated into mathematical expressions of objective visibility. Computer vision uses photographs—and the model of representation that photography naturalized—as base material for producing a very different construct of vision and representation.

In some ways, the relational processes of deep learning and object recognition mark what is most computational about computer vision, and how it breaks from the norms of photographic mediation. In other ways, however, these relational processes point back to and recenter early photographic practices that also emphasized spatial and dimensional coordinations between multiple images more than the isomorphic imprint that any one image might constitute. These practices were part of a transformative moment in the nineteenth century, when photography was a relatively new medium and its norms had not yet stabilized. For a short time, stereoscopic and serial strategies for relating multiple images were just as prevalent as the single image format that would later be understood—in contrast to cinema—as part of photography's "medium-specificity."[12] Rather than emphasizing the way an object is inscribed in a single photograph, these practices emphasized a relationship held between several images and invested this relationship with a form of referentiality. This referentiality was less pictorial than dimensional, positing that the way images materially and perceptually coordinate—how they appear to cohere—works to rearticulate how the material world they depict is, itself, materially arrayed and perceptually available—how it exists as self-coordinated.

The dimensional aesthetics of early photography were part of a transition in visual culture, as photography became not just dominant, but the

The Sidedness of Things / 23

default imaging technology going forward. As that happened, and the visible world became increasingly mediated by photographic representation, the world's objective visibility began to seem inherently photographic, as if the world took place to be seen in precisely the way that photography was suited to apprehend. As Siegfried Kracauer put it in a 1927 essay, the world itself took on a "photographic face," like a person posing for the camera—in the sense that it seemed to direct itself toward photographic representation, and to arrange its features so as to be "completely reducible to the spatial continuum that yields itself to snapshots."[13]

Juxtaposing the period when photography transformed visual culture with a contemporary period in which computational techniques are displacing lens-based imaging suggests how recent shifts may not leave photography behind as much as return to and rework some of the terms that its conventions had only provisionally stabilized. Today, computer vision incorporates assumptions that early photography helped naturalize, using sets of photographs as proxies for the visible world. But how those photographs are "seen" by algorithms posits that these images encode the visible world in a way that algorithms can extract: as quantifiable relationships of spatialized information. This kind of visibility co-constitutes both its subject and its objects—computer vision and recognizable shapes of things—through abstractions of mathematical dimensionality. The problem with this quantified construction of vision is not just that it outsources seeing to machines—vision has long been machine-mediated. The problem is, rather, how computer vision redefines visibility as a schematic, calculable property of objects rather than an embodied, enworlded contingency whose relational dimensions implicate the viewer.

STEREOSCOPIC DEPTH AND DIMENSIONAL VIEWS

To interpret the three-dimensional shape of things from flat images, computer vision algorithms extrapolate spatial relationships between pixels—an approach to dimensionality that breaks from the terms of both human seeing and photographic representation. Unexpected resources for thinking about this shift can be found, however, in the early history of photography, when new coordinations between embodied vision and machine-mediated imaging were also underway. Algorithmic techniques for training object recognition from sets of photographs draw on and transform nineteenth-century strategies for spatially coordinating discrete photographs into dimensional views.

In the second half of the nineteenth century, the singular photographic image was not necessarily the norm. Panoramic, stereoscopic, and serial

formats all offered ways to coordinate more than one photograph into a spatialized integration. Looking back from the temporal coordination of photographs in cinema, in the twentieth century, or from the potentials of digital media in the twenty-first, those spatial strategies can appear "precinematic" or "postcinematic." By another reckoning, however, these formats do not hinge upon cinema at all but articulate a different range of possibilities for spatial coordination that extends from photographic through digital and now computational imaging.[14]

As computational imaging strategies seem to break from an established, historical through line of lens-based imaging, they propose an alternative trajectory of media aesthetics that recenters what has been seen as tangential. Early strategies for drawing multiple, related images into explicit forms of spatial connection were not only common but also pivotal in photography's development. The way that sets and series of photographs could convey a dimensionality that otherwise seemed to exceed the image helped support analogies—which computer vision now takes up and transforms—between human and technologically mediated seeing, actual space and image space, the visible world and visual representation. Their depth effects were integral in establishing a photographic form of realism that would later seem self-evident.

In photography's first decades, a photograph was not necessarily understood as a "realistic" way to depict something.[15] Photography was immediately celebrated for its capacity to inscribe every minute detail, without relying on a human eye to notice and a human hand to render every visible element. This exhaustive impartiality of mechanical inscription was sometimes seen, however, as a flaw. A photograph could seem to render merely a cacophony of incoherent detail, without regard to relative significance.[16] A painting might seem to convey a more accurate view of what it pictured to the extent that its subjective and aesthetic rendering was felt to better emulate ways that perception organizes visual experience—framing a view from a particular perspective, distilling the essence of a subject despite momentary variations. Ways of interpreting accuracy, objectivity, and verisimilitude shifted in the nineteenth century and in relationship to the rise of photography.

The depth effect of stereoscopic photography helped support the reality effect of photography more generally. This has not been very well appreciated, partially because the depth of stereoscopic images has often been described as an illusion, aligned with the spectacular rather than evidentiary potentials of lens-based media.[17] Stereoscopic photographs can seem, like 3D films, to constitute an exception to and complication of a more standard and central format.

In what is still probably the most influential account of the stereoscope, Jonathan Crary groups it with other optical toys that swerved, temporarily, away from an otherwise monocular epistemology structuring vision and representation at least since the camera obscura.[18] In the arc of historical development that he traces, the dominant form that photography took in the twentieth century—with a singular camera and singular image—constituted a return to that monocular logic. Writing in 1990, Crary already saw the transformative effects of digital media and framed the history he offered of "an earlier reorganization of vision" as part of the "historical background" of questions that were once again coming to the fore.[19] On the one hand, the photographic norms that seemed to stabilize after that early reorganization enabled abstractions that digital imaging, and now computational imaging, escalate. On the other hand, instabilities that those photographic norms seemed to have stabilized are resurfaced as contemporary algorithmic logics reopen dimensional aesthetics of early photographic formats that precede those norms. Early photographic techniques for coordinating images in spatial relationships of depth and dimensional perspective offer a nonlinear genealogy for some of the spatialized, relational practices of deep learning and object recognition in computer vision.

Over the second half of the nineteenth century, stereoscopic photographs were one of the most, if not the most, popular forms of photographic imaging and played a critical role in the rise of photography as a popular mass medium.[20] The inventions of the stereoscope and of photography were announced within months of one another, and stereoscopic pairs of images were almost immediately made using the earliest photographic formats.[21] Stereoscopic images do not have to be photographs, but in the nineteenth century, they almost always were: first produced as daguerreotypes and from glass plate negatives before becoming common as the paper prints called stereographs. When a stereograph is viewed through a stereoscope, only one image is shown to each eye, each image presenting a view from a slightly shifted vantage point meant to correlate with the slight distance between a person's two eyes. Looking through a stereoscope, a person sighted in both eyes will tend to coordinate the perspectival difference between the two images as registering how their situated, binocular perception would grasp the depth and sidedness of something positioned relative to them in a shared space. The photographs are perceptually coordinated in a way that produces a depth effect, as if embodied vision could encounter the depicted scene in its actual dimensionality.

An international boom in stereoscopic photography was set off in 1851, when the stereoscope was featured at the first world's fair and the

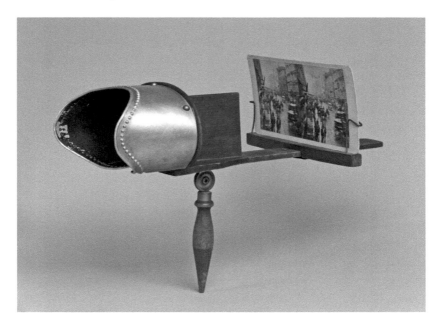

FIGURE 1.2. Stereoscope with stereograph. Twentieth-century example of the model popularized by Oliver Wendell Holmes. Courtesy of Bard Graduate Center: Decorative Arts, Design History, Material Culture; New York. Photographer: Bruce M. White.

invention of collodion enabled mass production of stereographs. Stereographs circulated through colonial routes at a global scale, bringing "foreign" views to European and US viewers and prompting viewers in colonized territories to quite literally embody views that were produced by European and US photographers. By 1854 the London Stereoscopic Company was using the tagline "no home without a stereoscope."

An 1859 essay by Oliver Wendell Holmes, who had created his own design of stereoscope, imagines a "comprehensive and systematic stereographic library" in which images of everything worth seeing could constitute "something like a universal currency."[22] Because this "comprehensive system of exchanges" operated with what Holmes calls the "skin or form" rather than the substance, his proposal suggests a revaluing of the relationship between these, or even "the divorce of form and substance."[23] In a rhetorical flourish, Holmes exhorts: "Give us a few negatives of a thing worth seeing, taken from different points of view, and that is all we want of it. Pull it down or burn it up, if you please."[24] This passage powerfully evokes how the logic of photographic representation helped support capital-

ist and colonialist ways of commodifying the material world within systems of universal equivalence and exchange.[25] What is often overlooked, however, is the fact that this passage is not speaking simply about photographic representation but, in particular, about the *paired* images of a stereoview: Holmes specifies "a few" negatives. Rather than saying the single photograph as an object could stand in for the thing itself, he suggests the *relationship* between different photographs could recapitulate the visibility of the thing itself.

The difference between images is what enables stereoscopic depth, and it also anchors the analogy between eyes and cameras that was used to explain this depth to nineteenth-century spectators. For example, a widely read explanation of the stereoscope, published the year of the Great Exhibition in the *Illustrated London News,* claims that "the two plates in the two cameras stand truly for the two eyes, and receive each just such picture, no more, no less, as each eye receives."[26] Robert J. Silverman has explained how "a network of natural theological presumptions" and "sturdy Victorian scientific principles" supported the idea that "[b]ecause it duplicated the optical circumstances of human binocular vision, the stereoscopic camera functioned like a pair of surrogate eyes and could create truthful pictures of the world"; its "twin lenses" serving as "infallible scribes that could etch reality on their photographic tablets."[27] A stereoview was said to be as good as an actual view, then, because cameras had photographically recorded a scene exactly as it would have presented itself to two eyes. By extension, this perfect inscription seemed to allow the "actual" scene to present itself to the viewer's two eyes, via the stereograph, as it would present itself "in person"—not as a representational image as much as a visual experience that demanded perceptual coordination. The very spacing of images in a stereo pair seemed to reiterate the way the world presents itself to embodied perception—as unfolding in space, visible from multiple angles at once.

Through a stereoscope, the perception of depth performed a visceral analogy. At the level of embodied perceptual experience, the stereoscope's depth effect related eyes with cameras and things with images. It proposed that the dimensionality people perceive in the world could be reiterated by the dimensions of photographic representation. The perception of depth that a stereograph could prompt both drew upon and helped authorize an analogy between human vision and photographic imaging. This idea pertained less to the relationship between any image and its referent than to the way the multisidedness of something, as experienced in embodied vision, could also be experienced through a coordination of multiple, correlated images.

28 / *Chapter 1*

One reason stereographs are often described as precinematic is that they were usually sold and viewed in numbered sets, viewed as series in which one view was explicitly related to the next. Sometimes the conceits of this sequencing did suggest a temporally continuous narrative. More frequently, however, the seriality was also framed within a spatial logic, as tours or views of related places. The spatial relationship between views was often explicitly continuous, as in series that followed railroad lines and stereoscopic panoramas in which the edge of one view was intended to coincide with the edge of the next.[28] In some ways, this kind of spatial continuity across multiple stereographs extrapolated the dimensional fusing of the stereo pair to bridge the gap between different pairs. In other ways, it leaned on the spatial strategy of the panorama, an influential format of nineteenth-century visual culture across several media forms, to suggest that multiple photographs could present a simultaneous view from multiple perspectives.

French artist François Willème invented a panoramic and stereoscopic strategy for rendering a three-dimensional model from a set of photographs.[29] In 1859, the same year Holmes published his ecstatic essay, Willème patented what he called *photosculpture*. This process used a set of photographs, captured simultaneously in one short exposure, to produce a three-dimensional sculpture of the person photographed. In a moment when photographic portraiture was commercializing, popularizing, and automating the traditional process of portrait painting—which I will say more about in chapter 2—photosculpture aimed to leverage the potentials of photography for sculptured portraits as well. It was briefly very popular: Willème made photosculpture portraits of French artists and actors, Austrian nobility, and the king and queen of Spain. Antoine Claudet, a prominent early photographer who had led the popularization of stereoscopic photography in France, purchased rights to Willème's patent and developed his own modified technique. In 1867, a photosculpture studio opened in New York City and claimed to receive thousands of orders within its first few days—including a commissioned portrait of Ulysses S. Grant.[30]

To create a photosculpture, first a subject would pose directly under a plumb bob hung from the ceiling, on a small, circular platform that was carefully marked in twenty-four pie-shaped sections, inside a circular room whose continuous wall was segmented into twenty-four paneled sections. Twenty-four cameras were concealed behind these wall panels, peeking through small openings spaced at every 15 degrees. These cameras would be triggered simultaneously, using a foot pedal and a system of cords to control their shutters, to capture a set of images of the subject from twenty-

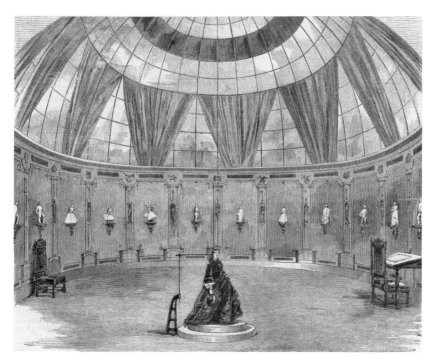

FIGURE 1.3. Illustration of François Willème's photosculpture studio, published in *Le Monde illustre*, December 31, 1864.

four wraparound perspectives. These images would then be made into lantern slides and projected in a sculpting studio, where a clay bust was positioned under a plumb bob, on a rotating circular platform marked with twenty-four sections. Each image was projected onto a screen behind the clay model, aligning the plumb bob in the image with the one in the studio. Beaumont Newhall describes how Willème or one of his assistants would trace the outline of each projected image onto the clay using a pantograph: "As he traced the outline of the projected photograph, the modeling tool bit into the clay [. . . .] The revolving platform holding the clay was turned to correspond to the number of the photograph, and the process was repeated. Once the twenty-four photographs had been traced, the result was a statue, which simply needed to be smoothed off before being cast into a more permanent form."[31] In other words, iterative tracings cut distinct sections into the clay, correlated to each distinct photographic perspective. When the sculptor "simply smoothed" the edges, these differences were materially merged into a unified, three-dimensional object.

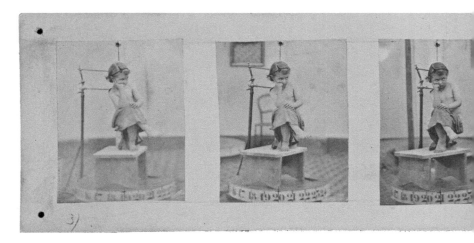

FIGURE 1.4. François Willème, study for photosculpture of a seated child, ca. 1865. Six albumen silver prints, 3.5 × 4.5 cm each. Courtesy of the George Eastman Museum.

Willème's photosculpture process treated dimensionality as a condition of how any person was visible, a way they showed up as the unique contours of their own embodied appearance and cohered as themselves across all the different angles from which they might be viewed or photographed. The wraparound orientation and temporal simultaneity of the twenty-four images he used in his process enacted a spatiotemporal integration centered by the embodied subject themselves. Replaying the twenty-four perspectives, one by one, to bind them back together in the clay form seemed to reactivate or rematerialize the subject's own integrated dimensionality. Willème's method relied on the sculptor's eyes and hands to physically map these outlines from images onto clay and then smooth their disjunctions into a single surface. This process concretized and externalized the kind of perceptual merger that a stereoview had required of its viewer, where the merger of discrete, flat photographs into a coherent, three-dimensional volume remained entirely contingent on the viewer's embodied look.

Photosculpture was fading out of popularity in the 1870s, when Eadweard Muybridge began to create the photographic series he called motion studies. Like Willème, Muybridge arranged a battery of cameras at regular intervals to capture a series of photographs from different points of view. Muybridge is much better known today than Willème because his serial images of bodies in motion were an important step in the develop-

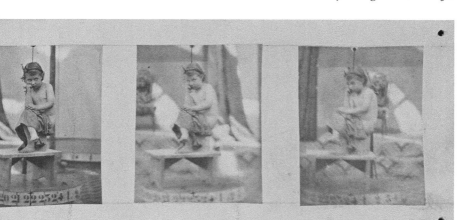

ment of cinema. Much of his photography, however, shared Willème's interest in spatial rather than temporal coordination and followed panoramic and stereoscopic approaches to conveying a dimensional view. He made stereographic series and panoramas, and even stereopanoramas, before he produced the temporal series of his early motion studies—which he used stereocameras to create.[32] In his later work at the University of Pennsylvania, he continued to explore spatial as well as temporal ways of constructing his serial views. At least twenty plates of the later motion studies published in 1887 in *Animal Locomotion* capture only one moment or an "isolated" phase of motion. One shows a man suspended in midair as he performs an acrobatic flip; another shows a woman with her hand raised to spank a child bent over her knee.

For these simultaneous series, Muybridge's subjects were "photographed synchronously" from cameras that were triggered all at once from "various points of view."[33] The reference notes and annotations in Animal Locomotion carefully indicate which series were made this way and explain how the cameras were arranged differently for these than for the more common series showing successive phases of motion over time. Images in these single-moment series were sequenced so that adjacent images were taken by adjacent cameras. If the more common motion studies suggest how slices of time could add up to duration, seeming to anticipate cinema, these other series suggest how slices of space could add up as volume.

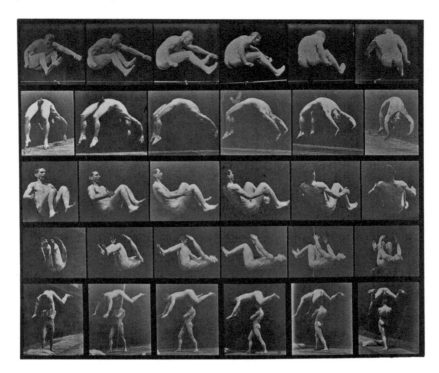

FIGURE 1.5. Plate 522 from Eadweard Muybridge, *Animal Locomotion: An Electro-photographic Investigation of Consecutive Phases of Animal Movements*, vol. 2, *Men (Nude)*, plates printed by the Photogravure Company of New York, 1887. Courtesy of the Boston Public Library via Digital Commonwealth: Massachusetts Collections Online.

To see a series like this, a viewer looks at each image in turn, and seems to perceive the same object from a rotating perspective. The material work that a photosculptor would do to "smooth" the edges between different vantage points thus shifts to a perceptual register, as a viewer coordinates the discrete images into an implicit, dimensional coherence. The viewer sees something that appears to spatially cohere as the same thing, multiple aspects coordinated as a wraparound view. As with stereoscopic photography, this coordination relies on how a viewer would grasp perspectival differences between images as facets of the same thing, triangulated by the spatial integration of their own embodied perception. If the stereograph, however, promised to rearticulate the visual experience of being physically present in the very spot where the view was captured, these series offer something very different. They prompt an embodied

The abstraction that characterized Muybridge's simultaneous series took a further step in the early twentieth century, in the "time and motion studies" of Frank and Lillian Gilbreth.[34] Their research into "scientific management" used visual methods inspired by Muybridge's motion studies, but also drew on stereoscopic photography, and followed Willème in making sculptures to transpose the two-dimensional space of photographs into three-dimensional form.[35] The Gilbreths used multiple exposure and long-exposure photographs to document the motions of people performing physical tasks of industrialized labor—such as sewing, drilling, or hammering. Small lights were affixed to the workers' hands, so that the lit paths traced by their gestures would show up as visible lines in the resulting photographs, which they called "cyclegraphs."[36] The Gilbreths explain:

> Upon observing our very first cyclegraph records, we found that we had attained our desire, and that the accurate path taken by the motion stood before us in two dimensions. By taking the photographic record stereoscopically, we were able to see this path in three dimensions, and to obtain what we have called the stereocyclegraph. This showed us the path of the motion in all three dimensions; that is, length, breadth, and depth.[37]

Frustrated by the provisional nature of the stereoscopic image, however—the fact that its dimensions only appeared to a single viewer while looking through a stereoscope—they aimed to make the path traced by the gesture even more concrete by sculpting wire "motion models."

To facilitate their motion models, the Gilbreths placed gridded screens "of known dimensions" around the worker who would be photographed—noting that "the worker may be enclosed in a three, four, five, or six-sided box" of these "cross-sectioned" screens.[38] Framing the gesture from multiple perspectives in a stereograph, these grids allowed the shape of the lit path to be quantifiably located and mapped to a physical model. A stereocyclegraph presented a three-dimensional view, but only from the single viewing position where the camera had been placed. A physical wire model, however, "makes it possible to see this path from all angles."[39] The Gilbreths proposed that a worker could use the wire models to learn not just "through his eye" but "with his fingers," tracing the motion path in order to "accustom his muscles to the activity that they are expected to perform."[40]

The Gilbreths' efforts were intended to quantify, compare, and optimize worker's movements, to increase efficiency and therefore productivity. Like the stereoscopic views that would have been collected in Holmes's proposed

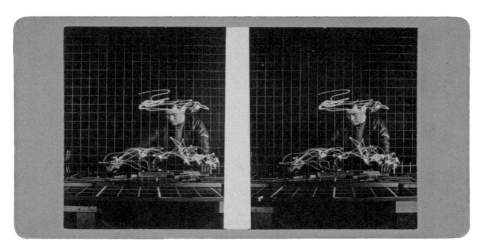

FIGURE 1.6. Frank B. Gilbreth, *Efficient Work Operation*, ca. 1919. Stereograph with two gelatin silver prints; *left*, 3 3/16 × 2 7/16 in.; *right*, 3 3/16 × 2 9/16 in.; *mount*, 3 5/16 × 7 in. Courtesy of the George Eastman Museum.

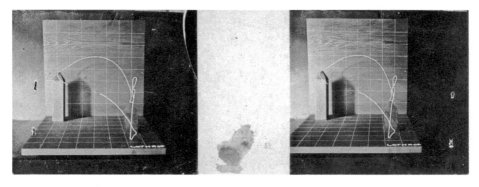

FIGURE 1.7. Gilbreth motion model, ca. 1915. Stereograph, two gelatin silver prints on paper card, 4.25 × 1.5 in. overall. From image verso: "Wire model of foreman on drill press. This shows 'positioning' in the midst of 'transporting.'" Courtesy of the Kheel Center for Labor-Management Documentation and Archives, Cornell University.

library, and like the dimensional perspectives that Muybridge produced, they aimed to capture and rearticulate the actual, visible dimensions of what they pictured. But their stereocyclegraphs and wire motion models successively produce and materialize a new object that was not visible prior to this process. Their method concretizes the shape of a movement as a thing in itself, by rendering it first as something photographable and then

as something quantifiable in a photographic image. They began to compare and classify the shapes they modeled this way, producing a taxonomy of gestures: grasp, position, release, et cetera. They called these movement units *therbligs,* an anagram of their name, and proposed that each could be optimized for efficiency. They created motion models of the optimal versions of these gestures, concretizing a motion that had not actually been performed by any one person but, instead, represented a shape that had been composited from the most efficient motions of all the workers performing that type of gesture. In other words, movements made by specific bodies were abstracted into lines traced in images; quantified, compared, and combined as geometrical shapes; sculpted into concrete, three-dimensional forms; and, presumably, reembodied by workers who would learn from the model and perform according to its shape.

Tendencies toward the quantification of space were already present in nineteenth-century photography: stereographs were used in geological surveys to capture dimensions of geological formations, and Muybridge's motion studies were often photographed against lined or gridded backgrounds. But the Gilbreths' work marks a period of transition in which techniques used to quantify the spatial relationships in photographs began to move from explicit, material interventions—such as an actual, gridded screen—to serving as a general framework for imaging per se. As the twentieth century progressed, digital and computational technologies facilitated this shift, changing how photographs could be translated into numerical information and, by extension, how the visible shapes of things could be expressed in terms of abstract, mathematical dimensionalities.

MODEL METHODS AND THE WORLD OF OBJECTS

In the second half of the twentieth century, the problem of capturing and rearticulating the visible shape of things began to be recast as object recognition and approached through emerging techniques in computer science. Instead of rearticulating any embodied, perceptual form of dimensional coordination, computational approaches began to privilege an abstract, geometrical spatiality—a model of space—that could bridge the two-dimensional, coordinate plane of an image and the three-dimensional spatiality of whatever that image pictured. Instead of aiming to capture and render a dimensional view for an embodied perceiver, these strategies aimed to capture and render the shape of things relative to an objective spatiality that did not require one.[41]

Many of the basic principles of contemporary computer vision were outlined in the 1960s by Woodrow Wilson Bledsoe, in research into facial

36 / *Chapter 1*

recognition that was funded through a front company for the US Central Intelligence Agency. Bledsoe's papers are largely unpublished and undigitized, housed in almost fifty linear feet of boxed material at a research center in Austin, Texas, where he long served as a faculty member at the University of Texas. Despite the difficulty of accessing his written work, Bledsoe's research—especially a technique he called the "model method"—is routinely cited by twenty-first-century researchers as foundational for the field of computer vision.

Although his intentions were very different, Bledsoe's early efforts in facial recognition resonate with Willème's interest in translating between two- and three-dimensional representations of faces. Like Willème, Bledsoe aimed to extrapolate dimensional information about the unique shape of a person's face from flat photographs showing them from different perspectives. His goal was to create a "recognition machine" that could "accumulate information from pictures of known individuals and 'learn' to recognize these individuals" such that it might identify them in "new pictures."[42] While this project focused on faces, it also developed, more generally, what he called "the ability of recognizing pictures by machines."[43] Bledsoe postulated that a recognition machine could reenact the "steps in recognition" that might take place when a person looks at a photograph: "from a vague awareness that 'this is a human head,' through the determination that 'it is a partial profile of a male,' to the recognition that 'it is John Smith' with a hat on."[44] This account posits an equivalence between human and machine seeing that would continue to underwrite the development of computer vision, and makes clear how photographs stood in for the things they pictured even at this early stage. It also naturalizes a hierarchical interpretation of features as the work of recognition that a machine might reenact. The "steps in recognition" move from distinguishing a human (human head, in profile), to a gender (male), to a specific person (John), to what is not "the person" (a hat) but might be associated with them (and especially with a gendered and personal identification—a man's hat, the hat John always wears). This way of understanding how a person recognizes another person—using a photograph as proxy—begins to imagine how "recognition" could be codified as a categorical parsing of features and things presumed to be objectively visible and explicit in pictures.

Pages of Bledsoe's work are devoted to explaining painstaking processes for optically scanning photographs and abstracting them into mathematical information. One of Bledsoe's techniques drew on the history of stereoscopic photography and involved interpolating "the three dimensional structure of a face" from a pair of photographs made from different per-

The Sidedness of Things / 37

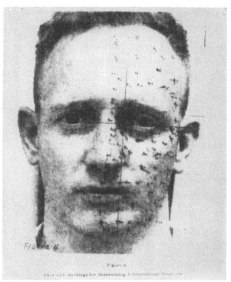
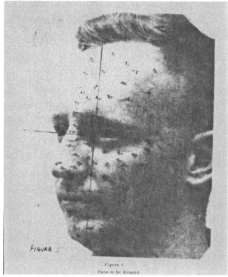

FIGURE 1.8. Figure 4, figure 5, and table 1 from Woodrow W. Bledsoe's "Facial Recognition Project Report," submitted to the King-Hurley Research Group, Washington, DC, 1964. The Woodrow "Woody" W. Bledsoe Papers, 1949–1996, Briscoe Center for American History, the University of Texas at Austin.

spectives.[45] In a paper from March 1964, he explains how points in two related photographs might be compared—using either physical marks made on the face before being photographed or fixed features visible in each photograph like "the corner of the left eye"—to triangulate spatial relationships between those points.[46] From this, a "rotation equation" could

38 / *Chapter 1*

be deduced and used to create "a mathematical reconstruction of the face in its rotated position."[47] Bledsoe suggests that "a specially designed stereoscopic camera" could be helpful for this work, and that "a human machine operator" could then "look at the pictures through a stereoscope to estimate the facial type."[48] He goes on to speculate that "if we could obtain a good three-dimensional representation of the face this representation itself could be used as input"—an idea that formed the basis of a second technique he developed over the following months.[49]

In a paper dated August 1964, Bledsoe describes what he calls "the model method of facial recognition." In this approach, the "position and shape" of features in a photographed face would be compared to the position and shape of those features in the "three-dimensional model" of a " 'standard' head."[50] The dimensions of the standard head were determined by averaging physical measurements taken from seven people. Bledsoe claims that though this model could "either be a real physical model or one which is simulated in the computer," the "state of the art of varying physical models" at that time made it more "practical" to modulate a mathematical model.[51] This model of the standard head provided a "two-dimensional map," a projection of three-dimensional information onto a coordinate plane, that could be compared to spatial relationships of facial features in a flat photograph.[52] The model would be adjusted to reflect mathematical relationships between key points of facial features in the photograph, customized to better match the specific face in the image. Throughout, Bledsoe emphasizes how this method is based on the "best guess" and on an attempt to match probable relationships between features in the image and the model rather than an attempt to plot and model every point on the surface of the face.[53] He describes how the "model is changed from the most general and most likely to the specific in such a way that the changes made are the most probable way" to account for the deviations between what was predicted by the model and what is found in the image.[54]

Several problems motivated Bledsoe's attention to relationships between images—and between images and model—rather than the relationship between any one image and its referent. It was a "major difficulty," for example, that one person could "present to the camera" any number of "poses."[55] Added to this were additional conditions of photographic mediation that he termed the "photography parameters" of each image: the way that variables such as lighting and scale and perspective would inflect the same face's appearance in different photographs.[56] The problem for facial recognition was less about validating the referential link between a photograph and the person it pictured—like someone comparing a traveler to his

passport to say, "yes, that is really him"—than about verifying that the person pictured in one photograph was the same person pictured in a different photograph. Rather than focusing on how perfectly any particular photograph could represent its subject, he hoped to identify some common articulation of that subject found across all possible photographic representations of them—and as compared to the representation of a "standard" subject also derived from multiple people rather than belonging to any one. In other words, what constituted a subject's "identity" was the consistent deviation found across their images from the facial geometry established as the norm.

Bledsoe's research follows strategies of spatial coordination found in early nineteenth-century photography in that it invests in what spatial relationships between images could communicate rather than in what might be isomorphically imprinted in the exposure of a single photograph. It marks a significant step, however, from how those early photographic formats prompted an embodied viewer to coordinate their multiplicity into the dimensions of a materially coherent object or of a perceptually coherent view.

Like Willème's photosculpture, Bledsoe's research aims to translate between the three-dimensional shape of a human body and the two-dimensional spatiality of its photographic representation. Bledsoe's "model method" extracts and combines spatial relationships from photographs to produce a three-dimensional model. But, rather than manually combining multiple silhouettes into a sculpture, Bledsoe's process correlates mathematical expressions of how specific positions relate across images from different perspectives. This method treats dimensionality as a quantifiable relationship between numerically expressed points in space. It centers the abstraction of mathematical dimensionality rather than dimensions of embodied visibility that condition how both actual faces and photographed faces appear. Dimensionality is anchored in the "model" that could correlate the visceral contours of an actual face and the optical, flat plane of a photographic image.

Bledsoe's research laid much of the groundwork for research into computer vision that would rapidly develop, in the following decades, as computer processing power increased and digital imaging practices streamlined the process of algorithmically analyzing images. Before the deep learning processes of twenty-first century AI, machine learning processes for object recognition were painstakingly built, like Bledsoe's "recognition machine," from sets of photographs. One of the most influential training sets in the development of computer vision is the COIL-100 dataset. Developed at Columbia University in 1996, it reiterates techniques used by Willème and

40 / Chapter 1

FIGURE 1.9. Objects photographed for Columbia University's Computer Vision Laboratory, COIL-100 project, 1996.

Muybridge as it also incorporates the quantitative abstractions used by Bledsoe.[57] This dataset contains seventy-two thousand images of one hundred discrete objects. Each object was placed on a motorized platform and photographed every 5 degrees of rotation, to produce seventy-two different views. A page on Columbia's website documenting the project shows a sort of class photo in which all the objects stand together for a group portrait. It is a bizarre assortment: a bell pepper and a tomato, two different packs of cigarettes, toy cars and small plastic boats, three different mugs and several cans of soda, a bottle of Elmer's glue and two tins of cat food, a pack of gum and a bottle of Rolaids, a box of Tylenol and a stick of Old Spice deodorant. Except for a bright yellow can spuriously labeled "nuclear waste," it seems as if the researchers involved simply gathered small things scattered across

The Sidedness of Things / 41

FIGURE 1.10. Documentation of the process used to create the COIL-100 images, as published in the 1996 technical report by S. A. Nene, S. K. Nayar, and H. Murase. The original caption reads: "Figure 4: The objects were placed at the center of a motorized turntable. The turntable was rotated through 360 degrees. An image was acquired with a fixed color camera at every 5 degrees of rotation."

their lives at home and work—pulled things from desk drawers and borrowed things from kitchens and children's rooms. There would be no "standard" model to which these many different shapes could be compared. Instead, the dataset is used to test how well object recognition programs can account for the three-dimensionality of things in general, identifying the same object across many perspectival variations. The interrelationship of multiple views becomes part of the definition of the object. This construction incorporates the variability of vantage points as if perspective were a feature of the object rather than a condition of how it is photographed or seen. It works to obviate conditions of perspective and mediation—along with their implications.

Sets of photographs used for object recognition are meant to teach machines not only how to recognize particular things but also how the very structure of visibility functions, how a thing is defined as "seeable" in a way that is abstracted from any specific instance. The way these datasets encode the dimensionality of what they picture, however, cannot help but encode specific ways of seeing marked by particular values. For example, consider the stereoscopic images of the NORB dataset, created in 2004. NORB was used to develop computer vision systems that could "recognize generic objects purely from their shape, independently of pose, illumination, and surrounding clutter."[58] It "contains images of 50 toys belonging to 5 generic categories: four-legged animals, human figures, airplanes, trucks, and cars."[59] These were photographed in different combinations, with different lighting conditions, and from different elevations and angles. Unlike the wraparound views captured in the COIL-100 dataset, which control for regular shifts in perspective, the NORB set intentionally varies what Bledsoe would have called the "photography parameters" to draw out variations in how two-dimensional photographs could render three-dimensional objects. This aim is complicated by how it used stereoscopic pairs of images.[60]

42 / Chapter 1

FIGURE 1.11. Objects photographed for the NORB dataset and test images. Top image shows the twenty-five objects used for training and the twenty-five objects used for testing. There are five object categories: animals, human figures, airplanes, trucks, and cars. Courtesy of Yann LeCun, NORB: Generic Object Recognition in Images, Courant Institute/Computational and Biological Learning Lab, New York University.

As with the COIL-100 set, this training set was created by placing objects on a rotating, circular platform; but rather than capturing head-on, single frames from a stable position, a stereoscopic camera was repositioned above the objects at different angles and heights. The miniature scale of the toys and grayscale tones give the images the appearance of aerial surveillance images. The culturally specific nature of the toys seems anything but generic. The "humans" are from plastic toy sets of "army men" or "cowboys and Indians." The "animals" are not the everyday sort—like dogs or birds—but a lion, an elephant, and dinosaurs. Bizarre combinations and

The Sidedness of Things / 43

mismatched scales of people, animals, and vehicles suggest outlandish encounters and traffic jams. The toy soldiers, carrying weapons and posing in action, cast every situation as a potential conflict.

Despite the unreality—even absurdity—of these images, the kind of object recognition they train and test has real-world implications for remote sensing and aerial surveillance. The choice of objects and their arrangements communicates assumptions about what computer vision needs to see; the stereoscopic and aerial presentation trains the ways of seeing that computer vision can be used to enact. The goal of this training is to reliably identify objects despite changes of perspective and context; the end result is yet another process that factors out the material specificity of any point of view, incorporating contingent conditions of visibility into algorithmic definitions of the object. Within these definitions, the kinds of contingencies that inhere in point of view are difficult to register. Some of these problems show up in test photographs that have been labeled by the object recognition algorithms trained using the NORB set. For example, in one test image that shows a soldier kneeling next to a child, the man has been identified and labeled as "human" but the child goes unrecognized—perhaps too small or weaponless to show up as a person.

Object recognition has become more powerful as larger and larger sets of images have been used to train it. ImageNet, a dataset begun in 2007, now includes more than 14 million photographs classified into more than twenty-one thousand category labels.[61] Fei-Fei Li, one of ImageNet's creators, explained in an interview that "toy" datasets—like Coil-100 and NORB—were no longer adequate given the "explosion" of images circulating online.[62] This explosion seemed to both demand and enable more powerful forms of object recognition. To build such a large dataset, ImageNet researchers scraped images from photo sharing sites on the internet and used Amazon's Mechanical Turk platform to hire low-wage workers to label them. At one point, workers were reportedly labeling images at a rate of 250 per minute. Li claimed ImageNet's goal was to "map out the entire world of objects."[63]

The idea that a massive dataset of labeled photographs could be this comprehensive recalls Oliver Wendell Holmes's idea that a stereographic library could visually capture everything worth seeing. That this aspiration shifted form, from a library to a map, reflects that the world was already so thoroughly photographed by the early twenty-first century that the problem was no longer to create that archive but to manage it—not to capture all the world within a system of representation as much as to map the internal structure and interrelated elements of that system. This shift also

corresponds with changing ideas about what such a visual archive captures or conveys. Holmes's library was meant to collect "views" so that anyone could access, by way of stereographs, the perceptual experience of whatever those stereographs represented. Holmes describes these stereographs as having a material kind of value: as bank notes "engraved" by the sun that would "pay in solid substance" to the viewer.[64] This conflation of visual representation and monetary currency corresponds with ways global capitalism was working to posit all the world within a universal framework of exchange value.[65] On the other hand, this kind of visual currency was still anchored in particular, perceptual experience as a kind of gold standard. ImageNet's goal to map the entire world of objects went off this standard. Instead of hoping to archive everything worth seeing in the form of visual experiences, ImageNet aims to diagram how visible things exist as such relative to one another—producing a statistical model of object relations.

The rise of ImageNet changed how the world could be conceived and constituted as visible via a structure of visual representation, and how relationships between images could be used to glean information about the "world of objects" those images were thought to depict. As an unprecedentedly large dataset of labeled images, it enabled computational techniques that both relied on and could more efficiently operate on such large datasets. It was instrumental for developing AI-based methods of deep learning that use convoluted neural networks (CNNs) to identify patterns of information that are not known in advance, may be legible only to computational algorithms, and emerge through the process of algorithmic analysis. These methods of deep learning are not limited to purposes of image analysis, but they evolved through efforts to solve the problem of object recognition and therefore transformed that problem. This transformation was apparent in results from 2010 to 2017 in the ImageNet Large Scale Visual Recognition Challenge (ILSVRC). Starting in 2012, the accuracy of entries into this object recognition competition dramatically rose: what had been an almost static error rate of about 25 percent steadily dropped to half that, then by half again. This jump in accuracy was enabled by neural nets using forms of deep learning.

Object recognition based in deep learning relies on large sets of images because it identifies, predicts, and compares patterns in a probabilistic way rather than by correlating related perspectives or through one-to-one matches between known and unknown examples. Instead of grasping the shape of something by gleaning how different aspects of the same object cohere across different perspectives, this method extrapolates the shape of something categorically, from many different images of similar things. The

The Sidedness of Things / 45

CNNs used for deep learning identify patterns, called features, that can be extracted as series of numbers called feature vectors. Different layers of the network extract different features, and connected layers extract relationships between features. All of this operates mathematically, interpreting the numerical expression of a digital image.

For example, one layer of a CNN might identify lines by finding continuous pixels of the same color; but what a viewer sees as color and shape, algorithms interpret as a numerical RBG value (ratio of red, blue, and green) and as a geometrical equation about points in a coordinate plane. Another layer in the neural net might then compare all the lines found in the "line" layer to assess if any of these connect to form corners. Then another layer might compare all the corners identified to assess whether any connect boundaries of the same shapes, and so on. As an image moves through the layers of a neural network, a set of numbers moves through mathematical forms of analysis that identify patterns in those numbers, which are expressed in new sets of numbers, which are then passed to the next level, which will attempt to identify patterns among the patterns, and so on. The depth in deep learning refers to the relationship between these layers.

The layers in deep learning are often imagined in terms of spatial depth, like geological strata—and some diagrams of neural networks encourage this. But the depth of deep learning is a much more abstract expression of mathematical dimensionality, a compounding of relational complexity. A dimension is added each time one feature vector (a linear series of numbers) is related to another to produce a new feature vector. This process follows a logic of Cartesian space, in which two numbers could be used to describe the position of a point, and then multiple points could be related in lines within planes, and then multiple planes could be related. These relationships quickly compound, however, beyond a three-dimensional space people can understand to express high-dimensional, abstract relationships that are impossible to visualize. DeepFace, one deep learning model for facial recognition, convolutes image features into a 4,096-dimensional feature vector. The "depth" of deep learning takes the kind of dimensional relationships that condition how the shape of something appears both for embodied vision and in visual imaging, and translates these relationships into a different kind of mathematical dimensionality that describes how discrete, numerical expressions can be correlated and compounded.

As deep learning has enabled more powerful forms of object recognition, computer vision systems have become more useful, and increasingly ubiquitous. As of the early 2020s, computer vision systems that analyze shapes and

46 / Chapter 1

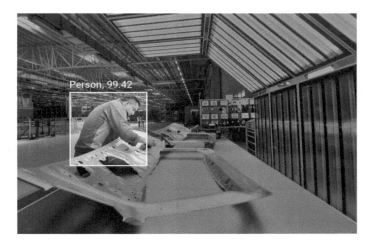

FIGURE 1.12. Image illustrating how computer vision can detect defects and assess "ergonomics" in manufacturing, published by the computer vision company Visio in online promotional materials. Courtesy of Gaudenz Boesch, Founder, Visio.ai.

identify objects in images are used in an astonishing range of applications. They are used in mobile phone cameras to automate focus and lighting and optimize photographs—as I will discuss in the next chapter. They are used in classrooms to track attendance and catch students who fall asleep.[66] They can be used by farms to predict when crops will need to be harvested, analyzing images of blooming and fruiting plants. They are used with medical imagery to diagnose and monitor health conditions. They are used with traffic cameras, not only to automate citations but also to analyze pedestrian paths and parking patterns for city planning, and even to assess whether drivers are tired or distracted using facial recognition. They are used with surveillance cameras in stores to interpret customer behavior and plan staffing, stocking, and display strategies. They are used in manufacturing to detect defects, monitor worker compliance with regulations, and, in the tradition of the Gilbreths, to "objectively quantify and assess" efficiency and productivity.[67]

The widespread use of computer vision has made it easy to forget that its techniques of object recognition can still only produce what Bledsoe called "best guesses." This guesswork becomes more difficult to challenge, however, when it is largely black-boxed in processes that are opaque even to their designers. The fact that these processes are difficult to explicate and critique has seemed to support rather than block their spread, casting opacity as a kind of profundity. Deep learning can make it seem as if computers

are extracting truths about the visible world that are objectively present and captured in images in ways that algorithms can see even if people cannot. The idea that computer vision could see and make visible for us what would otherwise exceed our vision follows the same logic of the Gilbreths' motion models. They used photography as a form of machine seeing to capture and construct movement itself as a thing that could be concretized, compared, and optimized.[68] The ideal movement materialized by the model was not actualized as movement, however, until workers were made to emulate its shape and incorporate it as the movement of their own bodies. In the case of AI and computer vision, an algorithmic reshaping of visibility could not be incorporated or assimilated back into the register of embodied experience—even if it comes to assert itself as the default framework, like the Gilbreths' grids, structuring visibility as such.

RESITUATING SEEING

The artist Trevor Paglen has explored the computational transformation of visibility in ongoing work since about 2016.[69] That year he published an essay offering the term "invisible images" to describe how image data, expressed as numerical information, is legible to a computer in ways that are not visible for a viewer.[70] He explains that, with massive datasets like ImageNet, "AI systems have appropriated human visual culture and transformed it into a massive, flexible training set" for computer vision. This has enabled "the automation of vision on an enormous scale," in ways that shift its dominant structure from the register of human perception to that of machine legibility. In order to understand what he calls the machine visual culture that has already absorbed and displaced human visual culture, Paglen urges that we "need to learn how to see a parallel universe composed of activations, keypoints, eigenfaces, feature transforms, classifiers, training sets, and the like."[71] Invoking specific operations of computer vision, Paglen suggests that people must find a way to grasp the structuring terms of its "invisibility," or the way it restructures vision. His art practice since that essay has been driven by this need, exploring how algorithmic processes that are constitutively impossible to see might nevertheless be given form and made sense of through the register of aesthetic experience.

In 2019 Paglen collaborated with AI researcher Kate Crawford to launch two related projects that surfaced some of what is structurally invisible in the construction of computer vision.[72] An essay published online, "Excavating AI: The Politics of Images in Machine Learning Training Sets," and an art exhibition, *Training Humans*, both offered a critical archaeology

of the image training sets. *Training Humans* presented training imagery from the history of facial recognition research, including Bledsoe's. Its most popular installation, *ImageNet Roulette*, was based on ImageNet and was also available to view online. *ImageNet Roulette* was a simple web interface prompting users to upload a photograph of themselves and see how a computer vision system trained on ImageNet's "person" classifications might label them. As the name implied, this felt like a game of chance and a risky gamble because it yielded confusing and often offensive labels. People posted their results on social media, sharing how they had been "recognized" as, for example, a creep, an orphan, an occultist.[73]

The viral spread of *ImageNet Roulette*, combined with increasing awareness about racial biases in AI, prompted ImageNet to issue an "update" in 2020, removing some examples of the classification "person." ImageNet posted a page on its website to explain that it had "filtered" out instances of this classification that could "cause problematic behaviors of the model."[74] This action seemed both to take responsibility and to avoid it, ascribing agency to a model that misbehaved while also suggesting that the problem was with faulty data rather than with the model itself. It echoed Google's response to the problem of Google Photos' labeling Black people gorillas by removing the category of "gorilla." Once again, both problems and solutions were limited to the level of outputs and inputs, without addressing the structure of these systems or their broader implementations. Crawford and Paglen's essay "Excavating AI" takes issue with these superficial efforts, arguing that "[t]here is no easy technical 'fix' by shifting demographics, deleting offensive terms, or seeking equal representation by skin tone" because there is no "'neutral,' 'natural,' or 'apolitical' vantage point that training data can be built upon."[75]

Paglen's work has helped emphasize the situated nature of any vantage point and any construction of seeing by materializing the relational structures of algorithmic processes in ways that make viewers consider the situated conditions and limits of their own perspective. For example, the same year *ImageNet Roulette* appeared online, Paglen installed another ImageNet-based artwork at the Curve exhibition space in the Barbican. He wallpapered its curved walkway with about thirty-five thousand photographs pulled from ImageNet's dataset, with verbal labels floating over the array to suggest categorical groupings. Walking along the wall, viewers found themselves playing a kind of matching game between images and labels, as if enacting the task of object recognition these images are used to train. "Apple" was easy, the word appearing surrounded by images of apples. Other categories, however, became more complicated, like "alcoholic,"

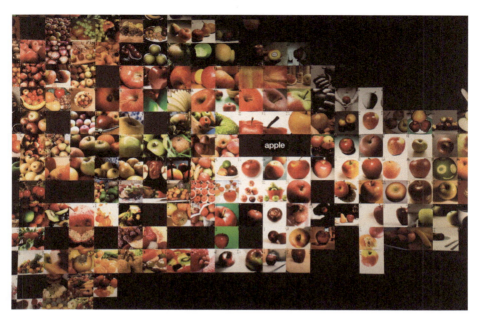

FIGURE 1.13. Trevor Paglen, *From "Apple" to "Anomaly,"* 2020. Installation view at the Curve, Barbican, September 26, 2019–February 19, 2020. © Max Colson, 2019. Courtesy of the artist and the Barbican Centre.

"entrepreneur," and "convict."[76] Looking at images clustered nearer to and farther from different labels, viewers could not help but "see" or try to see what commonalities governed these associations—to identify the features of "convict"-ness that related images (and the people they pictured) most proximate to that label. By suggesting such subjective identifications, this work, like *ImageNet Roulette*, articulated political and cultural dimensions of what could otherwise seem like technological processes and problems of object recognition. Unlike the online interface of *ImageNet Roulette*, however, *From "Apple" to "Anomaly"* made use of an expansive, material space. The curved shape of the exhibition prompted visitors to physically move in order to see an extended array that could not be grasped in any single overview. The extended structure of the installation generated a kind of sidedness from its very continuity, asking viewers to make sense of an unbroken interrelation of many discrete images that they could not see all at once. By demanding that visitors navigate the expansive space of the Curve, the installation recast the quantitative kinds of spatial analysis that object recognition algorithms use to relate images in terms of an embodied effort to spatially interpret images and see them as spatially related.

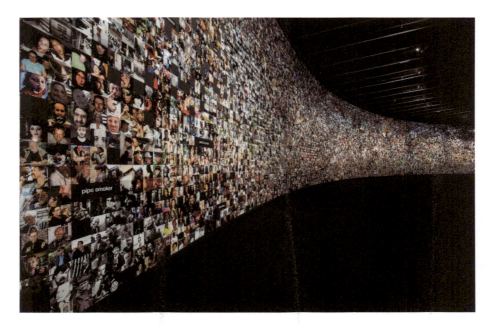

FIGURE 1.14. Trevor Paglen, *From "Apple" to "Anomaly,"* 2020. Installation view at the Curve, Barbican, September 26, 2019–February 19, 2020. © Max Colson, 2019. Courtesy of the artist and the Barbican Centre.

Paglen used a similar strategy for a sculpture in his 2020 exhibition *Bloom*. A giant head in the center of the show was created using the specific measurements Bledsoe had used to approximate the "standard head." Bledsoe used his standard head as a mathematical model, a set of geometrical expressions about the expected average. This model offered a baseline for interpreting how the voluminous shape of any particular head could be extracted from the mathematical relationships of points mapped to its features in photographs. Paglen's sculpture reverses this process by concretizing the mathematical model as a specific, actual head. Cast in white, without a body, and looming much larger than any real head, the sculpture visually demonstrates both the abstraction and the particularity of any "standard." In this case, the white, male colleagues whom Bledsoe measured for his research combine in what looks as vague and as familiar as a common sales mannequin—and is just as exclusionary in its assumption and assertion of an unmarked norm.

As he revisits critical elements in the history of computer vision, Paglen offers object lessons about object recognition. By finding material expressions for computational processes, his work pushes back against the forms of dematerialization and abstraction involved in extracting dimensionality

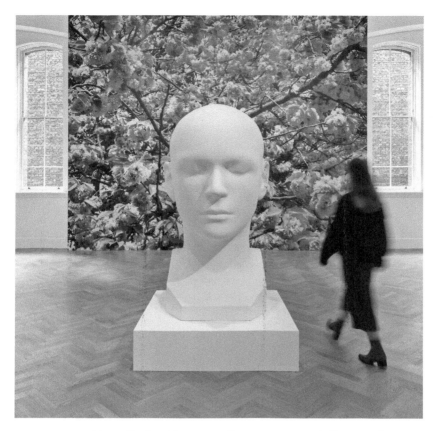

FIGURE 1.15. Trevor Paglen, *Bloom*, installation view, Pace Gallery, London, 2020. Photo by Damian Griffiths. © Trevor Paglen. Courtesy of the artist and Pace Gallery.

from photographs. This tactic can only be oblique, offering experiences that could act as metaphors or analogies for the numerical, algorithmic processes they address. But it can surface structural logics of these processes and communicate, in the very mode of a mistranslation, their incommensurability with the terms of embodied, human vision that they seem to route around and reconstruct. The aesthetic experiences Paglen creates open possibilities for viewers to coordinate perspectives that materially involve and position them relative to that coordination.

The title of Paglen's 2019 exhibition with Crawford, *Training Humans*, suggests that art about and made from computer vision training sets could be used to catch people up with these systems, teaching them to see in the

FIGURE 1.16. Trevor Paglen, *Behold These Glorious Times!* (still), 2017. Single-channel color video projection, stereo, 10 min. Original score: Holly Herndon. © Trevor Paglen. Courtesy of the artist, Altman Siegel, San Francisco, and Pace Gallery.

ways we have taught computers to. The work that comes closest to this aim is a video installation, *Behold These Glorious Times!*, which debuted in Paglen's 2017 show *A Study of Invisible Images*. More than any other piece in this show and in Paglen's work on AI up to that point, this ten-minute video offers a crash course in how sets of images are used to train computer vision. It is made up entirely of found images from such sets, which Paglen sequenced as a screen-based, moving image projected about six feet square on the surface of the white wall where I saw it at Metro Pictures gallery in New York. Its original score was composed with the musician Holly Herndon, using sounds from auditory training sets that are used to teach machines how to recognize human speech.[77]

Behold almost seems to depict a computer's point of view as its vision is being trained—as it is fed sets of images and attempts to relate them. It

The Sidedness of Things / 53

presents the viewer with a visual experience they cannot perceptually synthesize: images changing too quickly to follow and relating in too many different ways to make sense of. The way a viewer struggles to see patterns that outrun recognition suggests that the video is training them, offering a contemporary, computational update to the perceptual training for technological modernity that cinema was once thought to offer its spectators.[78]

Behold seems to build from more straightforward tasks of object classification toward more nuanced problems of categorizing affect and human experience. It begins by offering what feels like another explication of ImageNet, this time taking advantage of the temporality of the moving image to explore relationships that *From "Apple" to "Anomaly"* structured in extended space. First, a small square blinks into view at the center of a black screen, rapidly moving through a series of similar images. The musical score syncopates with the changing image, staccato pulses of sounds that seem somewhere between digital beeps and choral vocalizations. The images switch too fast to follow but share a similar shape: big hats, sombreros? After a few more seconds, another small, square image blinks into view to the left of the first. It shuffles through variations of its own—animals, gray, in water, hippos? Seven seconds in, another new square image pops up to the right of the center. As it becomes clear that each tile is flashing through a set of related images, it becomes easier to guess the theme of each but more difficult to see how they could all relate: sombreros, hippos, birds—oh my? Soon more squares are added to complete the row, then more begin to arrive, faster and spaced more irregularly in a mosaic of image tiles. Guitars, typewriters, jack-o'-lanterns, cars. It is not possible to track each new tile and guess its theme as too many appear too quickly in unpredictable places. Finally, a nine-by-eleven grid of square image tiles spans the full projection from edge to edge. As each tile flits through its own visual theme, patterns of colors emerge and relate as if each tile is a pixel of a larger, moving image whose sense is being scrambled.

All of this unfolds over less than one minute. Almost as soon as this grid appears complete, it disappears, and images scaled to fill the entire projected square begin to flit by, as if one tile from the first grid is being shown in close-up, presenting related instances within a single object category. Themes start to replace one another within only a few seconds, and new categories move away from the "snapshot" objects of the video's first section. Inky fingerprints, luggage X-rays, numbers of house addresses, and license plates connote surveillance, security, the tracking of identity and location. What had felt at first like some frenetic vacation slideshow— and a pattern-matching memory game—begins to feel like a more instrumental, invasive, and potentially coercive structure of seeing.

54 / *Chapter 1*

If the first section of *Behold* engages the classification and recognition of specific objects, the second engages the extraction of three-dimensional shape. It dramatically shifts in style and pace. Instead of a quick succession of related images, a single object is shown rotating. First these are one-dimensional: a sandwich, then a salad, then a bagel spin like Frisbees in the center of a black screen, with jagged pixel edges marking them as flat cutouts. Then, in imagery similar to the COIL-100 set, a black-gloved hand places one toy object after another on a rotating platform. A goose, then a duck, then an owl take a full twirl. The image then refracts into a grid of smaller tiles, each showing the same rotating object. It continues to refract into smaller tiles, then shifts from what look like positive to negative images, the object depicted becoming increasingly pixelated and unrecognizable. This sequence suggests a visual exposition of the processual analysis that happens in deep learning, as convoluted neural nets break down images into features. It shows how what counts as the identifiable shape of something becomes increasingly illegible for a human viewer as it becomes increasingly specified as recognizable for computer vision. As toy figures become etiolated, ghostly shapes, their characteristic contours give way to sparse coordinations of pixels, suggesting how what counts as dimensionality for a human viewer is lost in the way that computer vision specifies it. For computer vision algorithms, depth exists only as a numerical abstraction, an expression of relationships between points that can only ever be in the single plane of an image, iterated across multiple images.

The next sections of the video move from objects to people, beginning with photographs of facial expressions: smiling, frowning, surprise. Photographs of people performing different emotions shift in time with vocalizations in the score, making the faces appear like puppets or instruments being played. This suggestion becomes more overt as the images move from facial expressions to hand gestures: pinching, swiping. In an internet-era update of the Gilbreths' industrial research, the gestures being modeled are primarily associated with navigating digital interfaces. Gesturing in the air, in anticipation of being seen by a computer, these people seem to perform a one-sided pantomime with imaginary images. As hand gestures begin to give way to more full-body motions, actions begin to look frantic: one person after another pushing, pulling, jumping. Images of social interactions like hugging and smiling begin to take on an affect that overflows their role as categorial examples. Imagery from what appear to be home movies is mixed in with scenes from Hollywood films, prompting personal associations and rehearsing cultural clichés, while also suggesting that these are already intermingled. Watching

The Sidedness of Things / 55

FIGURE 1.17. Trevor Paglen, *Behold These Glorious Times!* (still), 2017. Single-channel color video projection, stereo, 10 min. Original score: Holly Herndon. © Trevor Paglen. Courtesy of the artist, Altman Siegel, San Francisco, and Pace Gallery.

rapidly changing contexts, attempting to synthesize all these instances within a category, feels more fraught than the game of pattern recognition that began with hats and hippos. Is this what "happiness" looks like? Is all happiness alike, any smile a variation of some "standard" smile—whether the cake-smeared glee a parent captures on baby's birthday or the high-wattage grin of a movie star in a love scene? What does it mean to use visual culture as a general archive for extracting how happiness is visible, codifying what counts as joy? In *Behold*'s final moments, the image refracts into a grid and etiolates as it has in earlier scenes, this time breaking down further and further until there are only white pixels fluttering on a black background. The score slows down and fades out as the image unravels into information, a binary pattern that only a computer might understand.

56 / *Chapter 1*

The aesthetics of Paglen's video invoke familiar, avant-garde traditions of montage and structuralist cinema—as if attempting to galvanize new sensibilities with strange juxtapositions, retrain apperception through machinic rhythms, or lay bare the structural devices of deep learning algorithms. But the visual and temporal grammars of cinema can only mistranslate the convolutions of neural nets and algorithmic operations of training computer vision. There is no way to see what or how computer vision sees because it is numerical rather than visual. So, *Behold* is not making "invisible images" visible or allowing human viewers to see like computers. Instead, it uses the spatial and temporal relationships of the moving image to explore the relational logics of computer vision. The gap that opens in the incommensurability of these two frameworks is affectively bridged by the viewer who attempts to make sense of what they are seeing. Using cinematic form to invoke computational logics entirely untranslatable and irreducible to it, Paglen begins to suggest how visual experience gives rise to meaning at the level of visual experience itself, through forms of relationality that cannot be reduced to calculations.

SIDEDNESS

To render not just any "thing worth seeing" but the "entire world of objects" as a comprehensive system of visual representation would require a systematization that rearticulates whatever interrelationships coordinate all those things as an "entire world." But a visible world cannot be rendered as an explicit set of object relations, concretely articulated in numerical terms. This would eradicate the possibility of *seeing* the world from within, as part of it. Programmatically extracting the shapes of things from different images that disclose different aspects composites a model of unsituated, perspectiveless visibility that could only interpret images relative to one another, within a system of image relations. It makes no space for the dimensional relationships that produce and hold open a visible world as not only visible, but as a world—a voluminous co-presence in which seer and seen are mutually articulated.

Anything visible is always visible from a particular vantage point; the apparently objective dimensions of a thing are shaped by the contingencies of a particular perspective. The shape that appears to belong to a thing, as its material self-coordination as that thing, is always inflected by the dimensions of a given point of view that mutually situates seer and seen. This is what computer vision aims to strip away and transcend. As computer vision aims to see past "photography parameters" and more correctly label and

categorize objects in images, it attempts to reduce and redefine visibility as an objective and quantifiable quality of things. The stakes of this project are not just mistakes of misrecognition but an inability to account for the situatedness of visibility, a contingency and relationality that involve the seer in the seen.

Even the best-intentioned efforts to make computer vision more inclusive tend to unwittingly bolster its authorizing assumption that adding up all possible, particular views would overcome the limits of their particularity and yield a complete view. But the fact that any view is situated is not a flaw of embodied vision that technical vision can overcome. Instead, it is a structural property of visibility. It is an expression of an ontological dimensionality, an articulation of sidedness and self-differentiation that allows the world to produce itself without either preexisting itself or becoming something else. This is one reason a smile could express something otherwise inexpressible, a happiness that is shared through its expression but is not entirely interchangeable and universal as a categorical norm.

Dimensionality prevents space from being an empty grid of mathematically mapped coordinates, in which everything that materially exists takes place as explicitly visible. Instead, space opens as and through a relational spacing and spatialization of everything taking place and appearing visible relative to everything else. The interdependent dimensionality of the world's depth allows for and requires gaps and blind spots, aspects that are occluded and face away. Like the disjunction between the two images of a stereograph, it is this spacing that allows the contingent, material coordination of any view. It is a sidedness to things that belongs not just to things but to seeing, and that leaves room for other views.

ENTRELACS II

How a Cube Coheres

When the incomplete manuscript of *The Visible and the Invisible* was published in 1964, it included 115 pages of working notes suggesting how the author had intended to continue. Buried in this back matter is a note that Maurice Merleau-Ponty titled "Depth":

DEPTH

November, 1959

Depth and "back" (and "behind")——It is pre-eminently the dimension of the hidden——(every dimension is of the hidden)——There must be depth since there is a point whence I see—since the world surrounds me——

Depth is the means the things have to remain distinct, to remain things, while not being what I look at at present. It is pre-eminently the dimension of the simultaneous. Without it, there would not be a world or Being, there would only be a mobile zone of distinctness which could not be brought here without quitting all the rest—and a "synthesis" of these "views." Whereas, by virtue of depth, they coexist in degrees of proximity, they slip into one another and integrate themselves. It is hence because of depth that the things have a flesh: that is, oppose to my inspection obstacles, a resistance which is precisely their reality, their "openness," their *totum simul.* The look does not overcome depth, it goes round it.

[. . . Depth] arises at the moment when it was going to be impossible to have a distinct vision of 2 points at the same time. Then, the two images that are out of phase and not superposable "take" suddenly as profiles *of* the same thing in depth——This is not an *act* or an intentionality (which would go to an *in itself* and would give only juxtaposed in itselfs)——It is in general, and by virtue of a field property, that this identification of two incompossible views is made, and because depth is open to me, because I have this dimension so as to move my look in it, *this openness*——[1]

59

60 / *Entrelacs II*

Already a fragment, this note is further disjointed by doubled dashes, suggesting connections not fully made, ideas not entirely spelled out. On the one hand, this openness offers gaps through which I hope to enter, and leaves room for an elaboration that I hope to pursue. I will loop back to this note repeatedly as I weave my own argument about sidedness through Merleau-Ponty's understanding of depth. On the other hand, this passage is not incomplete or in need of supplement, and exceeds what I may draw from it. As is typical in Merleau-Ponty's writing, the style does not just suit the concept but is also the mode of the idea's expression: depth is a refusal of synthesis, completion, or closure.

Synthesis names how discrete elements combine as something else, such that they no longer remain as discrete elements. Dimensionality can seem to require or instantiate a form of synthesis, and philosophers have often thought about this using the heuristic of a cube.[2] A cube is nothing but the holding together of all its six faces, all at once (*totum simul*); it names the specific volume created by the way these cohere as facets of a single shape. For an embodied perceiver, however, a cube can never be seen all at once; there will always be a hidden face or a side that "faces away." It would seem, then, that a perceiver has to combine multiple, partial "views" in order to grasp the "synthesis" of the cube as a whole.

Depth describes the displacement of the cube's unseen side. As "the dimension of the hidden" and "of the simultaneous," it articulates what exists as co-present with the perceiver but escapes the here and now of what is present to their look. Depth stops up perception's reach, "oppose[s] to my inspection obstacles, a resistance"—it is the thickness behind or beyond the side I see that spaces apart and differentiates an "other" side. The paradox of the cube is that "the cube itself, with six equal faces, is only for an unsituated gaze"; but I cannot unsituate my gaze. I look at the cube from somewhere, and "the world surrounds me" in the same way that it extends to include the "back" of the cube.[3]

The cube's depth takes place within a depth that also positions me. The mere fact that "there is a point whence I see"—that I am within the depth of the world—prevents me from seeing all sides of things at once. But, Merleau-Ponty argues, this is not actually a problem. The problem would, instead, arise if we could overcome the limits depth poses. "If the thing itself were attained," he cautions, "stretched out before us without any mystery," it "would cease to exist as a thing at the very moment that we believed we possessed it. What makes up the 'reality' of the thing is precisely what steals it from our possession."[4] Depth offers an obstacle to my "inspection," but the thickness and "flesh" of things "constitutes a resist-

How a Cube Coheres / 61

ance which is precisely their reality." To get at the thing in its entirety, in other words, would be to turn it into an idea.

Visual representation reiterates the paradox of the cube's sidedness rather than solving it. The flatness of a picture can seem to pluck the object that it pictures out from the world's depth, presenting it from an unsituated look. Even a photograph of a cube, however, shows the side that was facing the camera. To capture all sides would require a series of photographs, rotating around the object or rotating it in front of the camera. But these photographs would still fail to present the "cube itself"; the cube's integration would hinge on a relationship between the images that was not, itself, presented. Even if all the images were juxtaposed in front of the viewer, the cube as such would recede from direct presentation, slipping through the gaps of what was visible as what remained invisible.

In visual representation, the problem of coordinating multiple discrete images reiterates the paradox of sidedness and can even seem to stand in for the challenge of seeing all sides at once. When the spatial extension of an image is mapped as a Cartesian coordinate plane—as all digital images are—correlating spatial relationships between images can seem like a mathematically solvable problem. But algorithmic techniques of computer vision analyze how objects appear across multiple images in terms of purely positive relationships between visible surfaces. This process translates what counts as an object's visibility into a statistical model about how points are positioned in pixel arrays. Because every image shows only the outside of what it depicts, correlating how points relate at the surface of objects across the surfaces of different images only relates "outsides" to one another, in pure externality. This process does not recover or rebind the dimensionality implicit between different views, because things do not cohere as a purely externalized concatenation of surfaces.

So, paradoxically, computer vision's purely positive construct of visibility flips into the register of the invisible. The way the "cube itself" exists for the computer is in the manner of the unseen side, a nonvisible extrapolated from the visible. This extrapolation does not manifest the depth that was missing, enacting a form of relationality analogous to the relational structure of the cube's own sidedness. Instead it does away with depth by reconstructing it as a relationship of mutual externalities, such that there is no "inside" to the cube and likewise no world between seer and seen.[5]

The statistical and predictive model produced by computer vision is even more of an abstraction than the sense of the "cube itself" that escapes the perceiver. When facing a cube, the aspect of that cube that faces away is materially "there," and implicit in the presentation of its visible aspects. In

the computational definition of the cube's visibility, however, the cube coheres through a quantitative extrapolation that is strictly unpresentable, ungraspable in sense experience. Even if we believe that a computer vision system "knows" the visible definition of an object—grasps it in its essence, as whatever core subtends all varying views of it—this would only redefine visibility in terms of an unsituated look that we cannot access or embody. Computer vision's formulation of vision does not deliver the thing itself to perception but, instead, projects the material terms of visibility into the register of mathematical abstraction. Techniques of computer vision rearticulate visibility in ways that undo it.

The large-scale reconstruction of visibility that takes place when algorithms extract visual information from billions of photographic images constitutes an effort to computationally render the world's visibility in exhaustive and explicit terms. It attempts to grasp the complete, interreferential network of spatial relationships that structure the visibility of not only one thing but also any one thing relative to all other things, as a spatially explicit system of mutually defined identifications. Computation can grasp spatiality and relationality, however, only in terms of quantitative relationships that do not allow for the material dimensionality of depth. When we call this vision, ratify it as recognition, and employ this system to "see for us" in ways that authorize decisions and actions, we invest and shore up a depthless model of the world that steals the world away. This model seems to deliver the world to vision more completely, operationalizing something that can count as seeing that seems more objective, freed from the situatedness of seeing. It seems to authorize ways of seeing that are absolved from involvement, but only by positing a world that has no place for us.

There is no way to solve the paradox of the cube. But the working note with which I began points to how Merleau-Ponty rethinks it, by understanding depth as the solution to the problem that depth itself seems to pose. Instead of worrying how the multisidedness of things might make things and the world impossible to grasp, he insists that without depth, "there would not be a world, or Being." He sets aside the impossibility of synthesis by allowing that it cannot happen and does not need to. What others might see as closure, he recasts as "openness." The way the cube assembles its six sides could be understood as its self-enclosure, the way it conceals an "inside" and stops up vision from the outside, demarcating itself as itself, against everything else it is not. Likewise, the way the embodied viewer takes up space can be interpreted not only as what positions them to see from a specific perspective, but also as enclosing an inte-

riority that separates their perceiving consciousness from other subjects and the world of objects they perceive—something I will think more about in chapter 2. But for Merleau-Ponty, the object and the subject, the cube and the perceiver, are open to one another precisely because of the way they are each "sided," mutually structured by depth's spacing.

The sidedness of embodied vision invites us to think about the sidedness of things. "[T]he world certainly appears perspectivally," Merleau-Ponty allows; but "[th]e world has its unity without the mind having succeeded in linking its sides together and in integrating them in the conception of a geometric plan."[6] He argues that "[t]he perception of the thing and of the world can no more be constructed from distinct profiles than binocular vision of an object from two monocular images."[7] This analogy of visual depth perception reappears in the working note on depth: "two incompossible views" can coordinate to produce the impression of three-dimensional space when they are engaged in a way that does not entirely isolate each ("quitting all the rest") or fully fuse them (as if "superposable"). The slightly different views from each eye cohere in depth perception as the apparent dimensionality of the thing perceived. The fact that two different perspectives are slightly "out of phase" with one another is what allows them to "slip into one another," producing an impression of depth that relies on their difference rather than effacing it.

When discrete perspectives suddenly "take" as dimensions of a coherent thing, Merleau-Ponty argues, this is not achieved through an effort by the viewer as much as "in virtue of a field property," a general rule that governs the visible as such. The depth that constitutes the "reality" of things as material objects in the world is a general rule. It characterizes not just the object of perception but also the embodied perceiver, and the world that they both share. The "body is a thing among things; it is one of them. It is caught in the fabric of the world, and its cohesion is that of a thing."[8] Body and world are "in a relation of transgression or overlapping" because "my body is made of the same flesh as the world."[9]

The shared condition of depth that seems to prevent the subject from grasping the world constitutes a "flesh" that relates them. Merleau-Ponty admits that "we are separated from [things] by all the thickness of the look and of the body" but argues that "this distance is not the contrary of this proximity, it is deeply consonant with it, it is synonymous with it"; "the thickness of flesh between the seer and the thing is constitutive for the thing of its visibility as for the seer of his corporeity; it is not an obstacle between them, it is their means of communication."[10] This formulation shifts what might seem like the mutually restrictive limits of embodied

64 / *Entrelacs II*

subjectivity and the world's material extension into the mode of their mutual access and their co-constitution.

Ultimately, the seer and the seen are the "same," in the sense that they articulate related dimensions of Being itself—of all that is.[11] This "sameness" is not a synthesis but a mutual encroachment, envelopment, or overlapping that differentiates what it relates. This is the depth of a binocular view, or the depth that holds back the hidden side of the cube. Depth allows things to cohere not only without synthesis but also precisely by refusing the totalization of synthesis. It is a relational structure in which singularities are spaced without being entirely fused or separated; they cohere as related dimensions or mutually constitutive facets of whatever opens between them. Visibility requires this spacing of mutually incompossible views. The depth and sidedness that seem to block visibility are its very mode of articulation.

2. Surfacing Subjectivity

Portrait Mode and Computational Photography

> Between my background and my foreground I am not sure where I stand.
>
> LATOYA RUBY FRAZIER, *The Notion of Family,* 2016

CAMERAS AND COMPUTERS

Now that most people make most photographs with smartphones, photography has become primarily a computational medium.[1] The fusion of smartphone and camera was led by the iPhone, first released in 2007. Over the next decade, the rapid uptake of smartphones, the adaptation of photography to this platform, and the rise of image-based social media mutually drove one another. Now, billions of photographs are made and shared every day using smartphones. Novel objects, practices, and aesthetic genres have emerged as a result—from selfie sticks to photographic memes. Some of what is most radically new about computational photography, however, is both more obvious and yet harder to see: it follows from materially shrinking cameras to the size of smartphones.

To be the thinnest, lightest device with the largest possible screen means having very tiny camera apertures with very narrow focal lengths. Most camera apertures on smartphones are also fixed, unable to be adjusted.[2] This is one reason most smartphones have multiple cameras, with different focal ranges. No matter how many apertures are added, however, these miniaturized cameras are not capable of optically achieving the focal effects that people have come to expect from photography and that have shaped its visual conventions. The spatial parameters of such a small and thin device dramatically limit how its cameras can collect and bend light, which limits the relationships of depth and focus possible in the images those cameras are used to create. The dimensional aesthetics of traditional photography—governed by the physics of light and geometry of lenses—just do not fit the design demands of a smartphone. So, to adapt depth effects associated with photography for the now dominant platform of smartphone cameras has

FIGURE 2.1. Multiple camera apertures on iPhone 11 Pro Max.

required computational strategies that reinvent how actual space and image space relate.

Computational photography has reinvented the medium of photography, often simulating what it transforms.[3] For example, the camera app on a smart phone simulates using a single-lens camera with a mechanical shutter. Pressing the button to take a picture triggers the sound of a shutter click and a blink of darkness, as if a lens was mechanically opened and closed for a moment of exposure. But there are no shutters for the multiple cameras that the camera app controls, whose apertures are always open. Pressing the shutter button icon brackets a specific range of data that was already being captured and buffered from multiple sensors as soon as the camera app was launched.

The computational nature of smartphone photography begins from the framework of digitization, which displaced analog formats decades ago. It goes far beyond that, however, because smartphones are more than digital cameras: they are mobile computers equipped with many kinds of sensors and powerful microprocessors. What shows up on a smartphone screen after clicking the shutter button, and looks like a single photograph, might combine data gathered from multiple camera apertures on the device, as well as from infrared or LIDAR ("light detecting and ranging") sensors. It could reflect how processes of facial recognition and object recognition have interpreted the content of the image and assigned an aesthetic template: food, selfie, sunset. It may have involved artificial intelligence algorithms that extrapolated and adjusted relationships of lighting, color, and focus to fit rules extracted from example images. All of this could happen in what feels like the point-and-shoot, push-button action of just "taking the picture," before any additional filters or effects are added.[4]

Similar to the way the shutter button icon simulates a technology it actually moves beyond, the menu of "modes" now common in camera apps

acts as a sleight of hand to make complicated computational processes seem simple. Camera modes are increasingly matched to content types—beauty mode, beach mode, moon mode. They offer a set of automated adjustments tailored to the presumed aims and visual norms of a particular kind of picture, "optimizing" images toward preestablished ideals. The first camera mode options that were added to the iPhone were "video" in 2009, "pano" in 2012, "slo-mo" in 2013, and "time-lapse" in 2014. All of these took advantage of the temporal sequence of image frames in digital capture to create variations of spatial and temporal series. Listed as options alongside "photo" mode, these all seemed to suggest ways of making something other than a photograph—unlike more recent modes that specify a particular subject matter for photography.[5]

Portrait mode, popularized on the iPhone in 2017, was the first to move from specifying an image format to specifying a genre or an aesthetic convention—automating a way to relate form and content. Marketed as helping smartphone users "focus on what's most important," Portrait mode makes it easier to take pictures that clearly focus on and foreground the person being portrayed—pushing everything else into a blurred background. Quickly becoming standard across global smartphone brands, its widespread adoption marked a transitional moment in which the computational conditions of the smartphone platform began to more radically restructure both the material techniques and the aesthetic norms that have traditionally defined photography. It opened the door to a proliferation of camera modes driven by artificial intelligence and matched to content types.[6] More recently, as in Samsung's "scene detection" and "scene optimization," automated adjustments are being incorporated into basic camera operations, triggered by recognized objects rather than offered as optional modes a user could select. Portrait mode still tends to be singled out, however, with ongoing refinements such as adjustments in lighting and skin smoothing. Now an established and expected feature of smartphone cameras, it remains one of the best examples of how the dimensional aesthetics of optical photography have been transformed by the computational platform of smartphones.

Portrait mode reinvents an aesthetic convention of portrait photography that would otherwise be impossible for smartphone cameras: shallow depth of field. In a photograph, depth of field describes the distance between the nearest and the farthest things in focus in the image. It is controlled by spatial relationships involved in producing the image: how wide the camera aperture is, how far the camera aperture is from the subject being photographed, and how far the aperture is from the light-sensitive surface where

68 / Chapter 2

FIGURE 2.2. User view of Portrait mode interface on Google Pixel, showing f-stop slider for adjustable depth. Photo: Gergo Lippai, 2018.

the image will be recorded (usually called focal length).[7] These distances modulate the angles at which light moves through the aperture, describing optical geometries worked out over a very long history of experiments in art and science. A smaller aperture, farther away from the subject and closer to the recording surface, will produce an image with deep depth of field—a larger distance between the nearest and farthest things in focus in an image. A larger aperture closer to the subject and farther from the recording surface will produce a shallow depth of field—a narrower band of space in focus in the image. Over the history of photography, deep depth of field has been commonly used to depict landscapes, seeming to open a more objective view onto the world of objects by presenting everything equally clearly from

Surfacing Subjectivity / 69

background to foreground. Shallow depth of field has conventionally been used for portraits, suggesting a more subjective view that narrows the focus of the image to the subject of the portrait. On smartphones, Portrait mode offers an automated aesthetic effect that simulates shallow depth of field.

Because smartphones lack the wide apertures and long focal lengths used to produce shallow depth of field, smartphone photography uses computational techniques to produce what iPhones name a "depth effect." These techniques still involve information about light that has passed through the lenses and apertures of optical cameras. But that information is only one step in a more complex process. Algorithms might triangulate optical measurements captured from multiple camera apertures, each with a different fixed width and focal length. Spatial information might also be collected from infrared and LIDAR sensors that measure spatial relationships in different ways. And sensor data is not just coordinated but also interpolated and adjusted according to learned rules and predictive patterns.

Portrait mode involves the kinds of deep learning and computer vision processes discussed in chapter 1, and demonstrates how smartphone photography operates within a feedback loop of computational imaging: machine learning algorithms extract rules and patterns from large sets of photographs; these rules are incorporated into algorithmic processes used to make new photographs; these new photographs become part of the datasets fed to machine learning algorithms. This loop can make an aesthetic convention self-confirming. Shallow depth of field has shifted from being a formal style often used in photographic portraiture, to defining what characterizes an image as a portrait, to serving as a visual rule for algorithmically recognizing and creating pictures of people.

The way that Portrait mode has standardized shallow depth of field, and has itself become a standard feature of smartphone photography, marks a transformative shift in what seems like the "best" or default way to picture a person—suggesting a broader shift in how people are conceived as already visible and socially produced as visible. From paintings once commissioned for nobility to selfies posted online, the aesthetics of portraiture have always worked to articulate identity within socially defined distinctions of race, class, and privilege. Formal techniques that distinguish a portrait from other modes of picturing people have continually aligned with and legislated the construction of white upper- and middle-class subjectivity. To the extent that visual conventions of portraiture become default norms, they condition what appears as the preferred, and perhaps even the only, way for a person to be seen as such—distinguished from a world of objects to be recognized as a subject by another subject.

70 / *Chapter 2*

Shallow depth of field began to be privileged as a visual strategy of photographic portraiture during the earliest years of photography, in a period when the relationship between portraiture and this new medium was mutually transformative. Portrait studios began to open in major cities within months of Louis Daguerre's process being made public in 1839, and, as John Tagg has traced, within ten years, there were at least two thousand professional daguerreotypists working in the United States alone.[8] As photographic portraits became a "craze," they changed cultural ideas and practices around picturing people. As Alan Trachtenberg has described this shift, "a new regard for visibility, for one's own image as a medium of self-presentation," and "a new form of social identity [began] to emerge, to take shape and body" as people learned, through being photographed, "a new way of seeing themselves in the eyes of others" and "as an image."[9] Trachtenberg's phrasing suggests how the aesthetic form of the photographic image—its materiality as an image—gave "shape and body" to changing modes of identity formation. This was, I will argue, explicitly spatialized: the dimensional relationships staged by photographic representation mediated how subjectivity and identity were thought to be explicit or implicit in the body's own spatialized, visual appearance.

The depth effect of Portrait mode and shallow depth of field in a more traditional photographic portrait are not the same, but they resonate in ways that go beyond visual similarity. The way that Portrait mode's depth effect adapts a photographic convention of portraiture for the platform of smartphone photography echoes how that convention was established, as aesthetics of portraiture were first adapted for the new technology of photography. Over the decade between the iPhone's popularization of smartphone cameras and the standardization of Portrait mode as a new photographic convention, smartphone photography had a transformative impact that might be comparable only to how photography's own introduction and popularization changed norms of picturing people in the nineteenth century.

The shallow depth of field that Portrait mode overtly emulates was just one of several different spatial strategies used for picturing people in early photography. And these different ways of structuring the spatiality of the image related to different ways of staging the subject in the image as visible, and as an image, for a viewer. These distinctions aligned with race and class differentiations, affording white and privileged subjects an implicit interiority that was denied to others. The depth effects involved in picturing people have, in other words, negotiated ways that personhood has been visually conceived—understood as materially embodied and socially recognizable. Shallow depth of field became a convention of photographic

portraiture because it was a cultural technique for conveying and shoring up the privileged visibility of white subjectivity. As smartphone photography has reinvented the photographic mediation of space, and Portrait mode has automated a particular spatial aesthetic for portraits, these developments have not only carried old conventions into new platforms; they have also involved broader reorganizations of what seems like the best way to picture people and why.

PORTRAIT MODE'S DEPTH EFFECT

Portrait mode works slightly differently on different smartphones, but it usually relies on a combination of two techniques: semantic segmentation and depth mapping. Semantic segmentation is the less complicated of the two; it's what is used for blurred and virtual backgrounds in video chat applications like Zoom that need to stream with quick image processing. It uses facial recognition to identity a person and edge detection to trace a boundary around all the pixels identified as part of them. This process creates a mask that can then be isolated from the rest of the image, to keep the person in focus and in the foreground while all the pixels around them become part of a background to blur.

Semantic segmentation parses an image based on what seems to be in it, grouping pixels in ways that reflect how a person would understand and label them. In the pair of images in figure 2.3, for example, both created with an iPhone 12, the image on the right shows the results of using Portrait mode. Edge detection algorithms have done an admirable job tracing around this woman and identifying her hair as part of her—even one stray corkscrew setting out on its own northeast. But there are also some mistakes, because unlike the way a person sees, semantic segmentation is based solely on relationships between pixels in an image plane.

This image pair makes some mistakes in semantic segmentation more obvious than they might otherwise be because the depth effect was pushed to an extreme, exaggerating the differentiation between foreground and background so much that there is a huge shift in focus at the boundary between them and very little transition. Pixels of similar color have sometimes been misassigned across that divide. Because wispier bits of hair on the right side of the woman's head appeared lighter in the image, and less closely associated with the rest of her hair, they have been associated with the light colors of objects behind them and seem to disappear. The metal loop on the left also thins out, because darker rust that discolored its edges was a similar color as darker knots in the wooden beam positioned in close

FIGURE 2.3. Portrait mode comparison photographs taken with iOS app ProCamera on Apple iPhone X, 2018. © Nicolai Bönig.

proximity behind it. These dark-brown pixel clusters were associated not just because they are a similar color, but because they are each similarly darker than the other pixels associated with the chair and the beam. This pixel-swapping between chair and beam was driven and exaggerated by the stark separation between foreground and background. The metal loop of the chair on the left and the wooden beam that was positioned so close to it have been dramatically disassociated from one another in the image, even though both appear equally unrelated to the woman who is the portrait's subject.

Semantic segmentation identifies which group of pixels will be foregrounded as the subject, but other techniques of depth mapping determine how an implicit depth will be articulated to distinguish foreground and background. These techniques glean and model information about the actual space being photographed, producing a depth map that describes how different pixels in the image represent objects at different distances from the device. This depth map can be used to proportionally "blur the background," so that things appear less in focus with increasing distance. These proportional effects simulate the spatial and perceptual relationships associated with photographic optics and embodied vision as distinct from the discrete, spatial relationships of pixels and planes in digital depth mapping. The optical processes of more traditional cameras involve spatialized, physical movements of light between surfaces and through lenses and apertures, in ways primarily delimited by the position and boundaries of a sensitized plate or plane of inscription. Computer vision uses sensor data that is similarly optically recorded, but it intervenes in how that data will be parsed and used to produce the spatial terms of the image. When edge detection and depth mapping algorithms analyze image data to draw boundaries

Almost all smartphones use stereoscopic strategies for triangulating depth, even if they have only one rear-facing camera. The sensor behind a camera aperture can be filtered to produce what are called "dual pixels," which isolate the light that passes through each half of the camera lens to produce a stereoscopic pair of images from a single "take" of sensor data. Recent smartphones have gone further to develop dual pixel sensors with two tiny photodiodes at every pixel location in the sensor array—almost like turning every pixel of the optical sensor into a tiny stereo camera.

Adding a camera aperture offers another, more obvious way to create a stereo pair—and this is one reason that smartphones seem to keep adding more cameras. Image data captured from two separate apertures can be compared to measure the parallax shift between their different points of view. Because the paired image data does not need to be coordinated by a human viewer, the cameras do not have to be spaced like a person's two eyes. They are already much closer than anyone's eyes would be, but they can also be paired vertically or at a diagonal to extrapolate parallax from multiple virtual viewing positions.

Both dual pixel and dual camera strategies of triangulation are limited to relative depth, the amount some pixels shift relative to others that stay stable. To go beyond relative depth, smartphones have also added optical sensors that project lasers onto the physical surfaces of objects facing the device. On the front of most smartphones, there is a group of sensors used for infrared mapping. A dot projector and a flood illuminator project infrared light that an infrared camera then captures as it is refracted off a face. Neural nets running on the phone can then analyze the image to assess how spatial contours of a face have distorted the dot matrix coordinates projected onto it. This depth mapping can be used not only to adjust focal effects but to correct perspectival distortions that are otherwise caused by holding a camera so close to take a selfie.

On the back of a smartphone, where sensors are not competing with the screen, some devices have added LIDAR scanners that can map spatial contours with even more precision. Infrared combines a laser with a camera, but LIDAR is not measuring photons or taking a picture at all. It is a time-of-flight sensor, timing how long it takes for lasers sent from the device to bounce back, measuring how far they traveled before hitting something to bounce back from. This measure yields actual distance, making it possible

74 / *Chapter 2*

to determine not just the relative but the specific dimensions of everything in view.[10]

In Portrait mode, depth mapping attempts to assign the pixels of an image to a distinct spatial plane between the foreground and the background, based on the relative distance between the smartphone and whatever those pixels depict. This allows objects in the image to be proportionally blurred based on their distance from the plane occupied by the subject of the portrait. This proportional blur reshapes how the implicit space of a smartphone photograph will appear; and it can usually be adjusted in different ways after image data has been captured. At the time of this writing, most camera apps have an interface for depth effect or depth control, often with a slider that allows the user to blur the background less or more. Indicating specific f-stop measurements along the slider suggests that the user is controlling the camera's aperture width (see figure 2.2). This interface recodes an abstract, algorithmic process as if it were a manual adjustment of a physical lens, suggesting a direct manipulation that is not at all the case.[11]

The role of artificial intelligence in depth mapping becomes visible when Portrait mode's depth effect misinterprets dimensional relationships between objects depicted in an image and blurs "planes" that do not align with the depth of the pictured scene. In the pair of images in figure 2.4, a curved series of railings at receding distances from the subject has confounded the depth mapping used in Portrait mode on a Google Pixel 3a XL.[12] The stairs in the foreground, where the boy sits, and the railing attached to these are in sharp focus. In contrast, the bricks and railings that surround the boy's figure in the image—as well as the window frame, wooden floor molding, and water fountain to the right of him—have all been blurred as his "background." The problem, however, is that the bricks and chair and railings that are the farthest away from the boy, on the left side of the image, remain in clear focus. They have been mapped as belonging to the same spatial plane as the railings in the foreground. When I look at this image, the parallel spacing of the railing's bars and the repetition of three matching chairs, under matching arches and lamps, at similar bends in the railing, all help articulate the relative dimensions of the depicted space. The algorithms mapping this space, however, have had trouble sorting all this out. Railings at different depths have merged into the same plane or swapped planes, and some appear far too attenuated to be affixed to their wooden base, which remains in clear focus. This image visualizes dimensional relationships that could not correspond to any embodied view or any actual space.

FIGURE 2.4. Demonstration of Portrait mode on Google Pixel 3a XL, 2019. Courtesy of Wasim Ahmad / *Fstoppers*.

76 / Chapter 2

The techniques that smartphones use to measure and model space go beyond the conventional operations of photographic mediation, incorporating a much wider array of operations. These techniques automate assessments about what is "in" a picture, interpreting relationships between pixels to identify and differentiate shapes and colors, people and things. They appear as neutral defaults, technological fixes that computationally adapt photography for the platform of smartphones. They have significantly changed the terms of visual mediation, even if the results are still called photographs. They are not neutral, but neither are the photographic techniques and conventions that they rework. On the one hand, the depth effects of smartphone photography reorganize the dimensional aesthetics of photography—restructuring relationships between the spatiality of what is being recorded by the device, the spatiality of the device itself, and the spatiality of the image. On the other hand, some of these computational strategies reactivate quantitative and stereoscopic approaches that have structured the dimensional aesthetics of photography from its earliest decades— approaches that were not, historically, privileged for portraiture.

PHOTOGRAPHY AND PORTRAITURE

Expectations about how a photograph should portray a person involve how personhood and portraiture are mutually defined. Photography disrupted assumptions about how personhood itself might be visible and representable because, as Oliver Wendell Holmes once put it, "the sun is no respecter of persons or things."[13] By mechanically recording how light bounces off surfaces, photography could seem to simply transcribe the optical visibility of any surface, without regard to what it may be. As William Henry Fox Talbot, one of photography's inventors, understood it, photography shifted the terms of visual representation from the subjective role of an artist to the objectivity of nature itself. He wrote that "the instrument would delineate a chimney-pot or a chimney-sweeper with the same impartiality as it would the Apollo of Belvedere."[14] Much later, Roland Barthes described this indifference as much more threatening, saying the "Photomat always turns you into a criminal type, wanted by the police."[15] In other words, the mechanical nature of this medium might not only fail to register but might even actively undo any visual distinction between person and thing, work of art and functional object, portrait and mug shot. Barthes's suggestion that a lack of aesthetic sophistication—the artless, automated processes of next-day photo kiosks—turns a portrait into a mug shot presumes that good photography would retain and reiterate, through its own aesthetic

Surfacing Subjectivity / 77

qualities, the cultural and social value that might distinguish a Greek sculpture from an ash bin and a European intellectual from a "common criminal." The problem of photographic "impartiality," in other words, is that its failure to render such distinctions threatens to expose that they are not in fact self-evident but rather cultural biases that are naturalized as aesthetic norms and proper ways of seeing or being seen.

From photography's invention through its continual reinvention, concerns about how it could or should or should not picture people have followed a well-worn opposition shaped by biases of race and class. On one side stands the privileged tradition of portraiture, which in photography became associated with what Allan Sekula has called an "honorific" tendency: what Alan Trachtenberg—citing Matthew Brady's *The Gallery of Illustrious Americans*—has identified in early photographs of "illustrious" people; and what Shawn Michelle Smith has explored as nineteenth-century norms of white upper- and middle-class photographic portraits.[16] On the other side stands a way of picturing people that Sekula has called the "repressive" tendency and that is emblematized by the criminal mug shot. The anthropometric system that Alphonse Bertillon devised in the late nineteenth century for what he called the *portrait parlé*—later known as the mug shot—drew on methods of "metric photography" developed in colonial efforts of early ethnographic and anthropological projects to visually classify "types" of people.[17] Before Bertillon, his anthropometric approach—documenting a person's visual appearance in terms of quantifiable features—was used as a form of research and evidence to support, for example, Louis Agassiz's theories of scientific racism and Francis Galton's theories of eugenics.[18] If a photographic portrait might aim to express its subject's individual character, the anthropometric image uses photographic representation toward classificatory systems of identification.

The idea that a photograph might objectively translate anything it pictures into its own objective terms made it well suited to the repressive, ethnographic, anthropometric style of picturing people. This approach uses photography in an attempt to accurately render physical characteristics, treating these as coextensive with an identity that can be visually specified and categorized. Its visual rhetoric follows prephotographic conceits of objectivity developed in scientific illustration, depicting a person much as a botanical specimen might be conveyed.[19] Photographs intended as anthropometric illustrations often pair two images of the same subject—a frontal and a profile view. This juxtaposition of two different "sides" translates the dimensional volume of the body into a relationship between the surface shapes formed by its outline. It also reduces the endless, perspectival

78 / *Chapter 2*

variation possible in an embodied encounter into a discrete, exteriorized relationship between images. This way of depicting a person defined their embodied identity in terms of image relations that could be measured and quantified; and then these image relations could be set in relation to other sets of images in order to define group identities.[20] Theories of scientific racism and eugenics were visually elaborated through the comparison and statistical analysis of photographs whose groupings worked to articulate the "identity" of those gathered into these very groups.[21]

The anthropometric image asserts an equivalence between the overtly visible, material, and measurable qualities of its own surface and the embodied identity of the person it pictures. Measurements that would have been taken from a body began to be taken from the surface of a photograph, twinning body and image. This spatial aesthetic is explicitly codified in nineteenth-century colonial and ethnographic photography that deployed geometrical backdrops. One example is the string grid that English ethnologist John Lamprey introduced in 1869 in order to offer a "common standard" for better "comparison of measurement" in "[c]ollections of photographs illustrative of the races of man." [22] His grid would be stretched behind a subject being photographed, as a stable reference that could later be used to calibrate spatial measurements made at the surface of resulting photographs and also to compare measurements between different photographs that might not have been captured at the same scale.

Lamprey explains his process as a portable means of standardizing how photographers in "foreign stations" could document the human "specimens" found there:

> A stout frame of wood, seven feet by three, is neatly ruled along its inner side into divisions of two inches; small nails are driven into these ruled lines, and fine silk thread is trained over them, dividing the included surface by longitudinal and latitudinal lines into squares of two inches every way. Against this screen the figure is placed [....] By means of such photographs the anatomical structure of a good academy figure or model of six feet can be compared with a Malay of four feet eight in height and the study of all those peculiarities of contour which are so observable in each group, are greatly helped by this system of perpendicular lines [....] [M]y portfolio already contains a collection of specimens of various races. Photographers on foreign stations would greatly assist us if they adopted the same plan.[23]

Likening the vertical and horizontal strings of his grid to a map's lines of latitude and longitude suggests how the bodies of colonized peoples were being collected and surveyed in ways similar to colonized lands—invoking

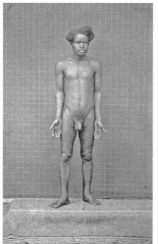
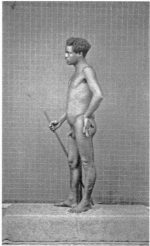

FIGURE 2.5. Jonathan Lamprey, *Antonio, man from Madagascar, aged 19; full face; full length* (left); *Man from Madagascar, aged 23; profile; full length* (right), both ca. 1860. Albumen silver prints, 10 × 17 cm each. © Royal Anthropological Institute (RAI).

uses of photography in colonial land surveying that I discuss in the next chapter. Positing a six-foot "good academy figure" as the standard for comparison suggests an ideal of white masculinity aligned with Western art historical standards of "classical" form, which also idealize white masculinity. Lamprey's way of understanding racial difference—as deviations from the standard "anatomical structure" and "observable" "peculiarities of contour"—aligns with his technique of using photographs to map racial identity as bodily topography.

As a physical object that was positioned in space behind the body being photographed, and then as a visual background for the body depicted in the resulting photograph, Lamprey's grid seemed both to authorize and to be authorized by the abstract grid of a coordinate plane that could be superimposed on the image to measure what it pictured. Because the actual string grid became part of the flat image, sharing the surface of the photograph with the depicted body, its twinning with the abstract grid placed on the photographic surface worked to collapse the volume that the body would take up—as if, like the grid, the body could just as easily be conflated with its photographic depiction and abstraction. Lamprey's grid helped map

80 / Chapter 2

individual, human bodies as quantifiable, comparable, and interchangeable objects within a purportedly neutral system of representation. Whiteness, like the string grid, was both asserted and effaced here as a structural background against which—or as an objective way of seeing within which— "other" racial typologies would be measured and defined. This supported the construction of race as a scientific category and a visible identity, and its implications persist both in ways that contemporary biometric technologies continue to quantify visible identity and in ways that the volumetric grid of coordinate space became the default spatial logic of computing.[24]

The equivalence between body, identity, and image that photography could help produce was exactly what a photographic portrait worked against.[25] The aesthetics of portraiture have always related to how a privileged kind of subjectivity is thought to be visible or can be made visible. Roger Hargreaves, curator at the British National Portrait Gallery, traces the history of portrait painting in Europe from royal patronage in the 1500s, through the representation of the aristocracy in the 1600s, and the wealthy middle class in the 1700s. In the early 1800s, it was possible for a broader social class to obtain a miniature painted portrait—whose handheld format daguerreotype cases would soon emulate—but highly detailed oil paintings were still an expensive luxury. Photography's emergence in the mid-1800s made it possible to achieve a much more detailed image more quickly and inexpensively than ever before, allowing the middle class to participate in a widening cultural economy of self-representation and social hierarchy.[26]

The mechanical reproduction that democratized portraiture threatened the privilege associated with it not only because it made portraiture more accessible but also because the impartiality of its process would not aesthetically demarcate the privileged kind of subjectivity that portraiture was meant to convey. This kind of subjectivity was disidentified with the body, whose brute physicality could be only the mundane and temporary manifestation of a more essential and eternal soul. To be a portrait is to portray a subject—in contrast, for example, to the way a still life is defined by its depiction of objects. But to portray what constitutes a subject as such requires more than simply rendering a person's physical appearance; a portrait must convey the transcendent subjectivity that a body embodies. A portrait's success hinges, then, on the terms of aesthetic mediation: the quality of subjectivity that exceeds the objective externality of the body must be conveyed by an aesthetic quality that exceeds the material facticity of the image.

One way that nineteenth-century discourses attempted to delineate how a photograph could be a portrait was through prescriptions for how the sit-

ter, photographer, and viewer should properly perform their roles. Shawn Michelle Smith and Alan Trachtenberg have shown how a rhetoric of "the fleeting expression" worked to interpolate the mutually authorizing subjectivities of portrait sitter, viewer, and photographer—as well as asserting the aesthetic status of photography.[27] In a successful portrait, the invisible depths of the sitter's character would surface in a momentary arrangement of their face; the sensitive artist would recognize and catch it; the aesthetic nuance of the photograph would convey it; and the sophisticated viewer would discern it in the image. A portrait that fell short of this success would not be a portrait, but merely a "likeness."

As a failed portrait, a likeness offers an interesting boundary case in negotiating early photographic aesthetics for picturing people. A likeness was understood to depict a person—white, middle-class, or otherwise illustrious—who was presumed to possess the special kind of subjectivity that a portrait should portray. The likeness, however, failed to portray the subjectivity of the sitter and only rendered the facts of their outward appearance. This failure was sometimes described in spatial terms, in which the likeness was rejected as merely a topography or topographical map of the face.[28] A likeness, in other words, accidentally renders its subject as an object, treating a face as a landscape. It maps dimensional contours and captures spatial information about facial features, but the arrangement of those features communicates nothing more than so many hills and valleys. The body does not seem to embody anything, but just to assert its own self-evidence. The definition of the likeness as an aesthetic failure defends against the confusion it might otherwise suggest with the anthropometric image. In other words, in order to maintain the presumptive self-evidence of privileged, white subjectivity, any failure of this to be conveyed in a photograph could be only an aesthetic shortcoming of the photograph: the image had simply failed to be a portrait because this subject could not fail to be a subject.

At the same time that rhetoric about the portrait and the likeness was organizing this tension between how interiority could be surfaced or the face could appear as nothing but a contoured surface, another approach to the potential dimensionality of a portrait was offered by the perceptual depth of a stereoscopic view. Stereoscopic daguerreotypes were made in the busiest and most successful early portrait studios, like that of Southworth and Hawes in Boston and Mathew Brady in New York. Southworth and Hawes claimed to have perfected the adaptation of stereoscopy to photography, using their own expertise to fix problems that the stereoscope's inventors had not understood. They built a huge stereo viewer they called the Grand Parlor Stereoscope and sold tickets for visitors to use it in their

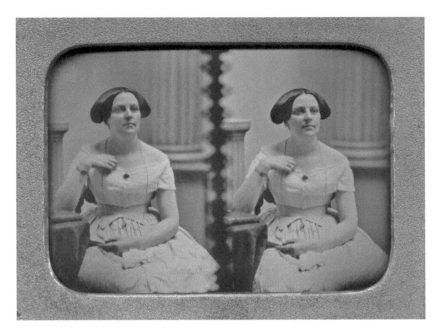

FIGURE 2.6. Southworth and Hawes (Albert Sands Southworth and Josiah Johnson Hawes), *Stereoscopic Portrait of a Woman with Columns*, ca. 1850. Daguerreotype, quarter-plate (3.25 × 4.25 in.). Courtesy Wm. B. Becker Collection/PhotographyMuseum.com.

studio. In an 1855 advertisement, they described it as "one of the most interesting and wonderful novelties of all times" and claimed that "[i]n the Stereoscope, pictures appear like living statues—like nature in solidity and relief."[29] This way of presenting a person—like a living statue, in solidity and relief—does not seem to emphasize any interiorized subjectivity. Its emphasis on visceral volume may align it more with the topography of the likeness than with the flatness of the anthropometric image, but in a way that also threatens to overtly exteriorize and objectify.

The brief heyday of stereoscopic portraiture overlaps with a lucrative business in pornographic stereo daguerreotypes.[30] In Paris, early studio photographers made portraits of nude models that would be sold by street peddlers, despite the fact that the sellers, the photographers, and the models could all be arrested for their involvement. Rather than being viewed in something like Southworth and Hawes' Grand Parlor Stereoscope, these kinds of images were more likely viewed in handheld devices, some of which could be folded up and carried in a pocket. Instead of manifesting an

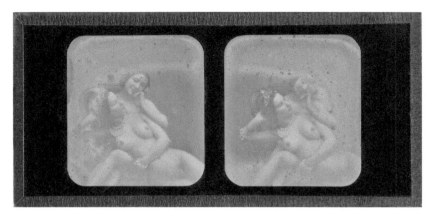

FIGURE 2.7. Artist unknown, [stereographic view of two nude women], French, 1840s. Daguerreotype, 5.6 × 6.5 cm (2 3/16 × 2 9/16 in.) each. © The Metropolitan Museum of Art. Image source: Art Resource, NY.

elusive inner character, the visceral dimensionality of nude stereo views suggests tangible, physical presence. Hand coloring emphasizes this reality effect. If anthropometric objectification flattens the racialized body to its mathematical measurements, this sexualized kind of objectification presents a gendered, voluptuous body and suggests that this body is not just on display but within potential grasp.

In his influential analysis of the stereoscope, Jonathan Crary argues that its "effects of tangibility ... were quickly turned into a mass form of ocular possession"—and he gives special attention to this effect in sexually explicit stereoviews.[31] Crary claims that "it is no coincidence that the stereoscope became increasingly synonymous with erotic and pornographic imagery in the course of the nineteenth century" and suggests that its association with "'indecent' subject matter" helped cause the "demise" of the stereoscopic format around the turn of the twentieth century.[32] Crary does not cite his sources for this view and may be responding to ways that the trade in pornographic stereoviews in Paris influenced French attitudes about stereoscopic photography in the late nineteenth century. Stereoviews remained globally popular through the early twentieth century, however, especially in the United States, where the Keystone View Company was founded in 1892 as a major distributor. What changed was that stereoscopic photography went from being practiced almost interchangeably with other formats—in the same portrait studios and by the same landscape photographers—to becoming a more specific format for certain kinds of commercial and educational photography. It is

84 / *Chapter 2*

significant that stereoscopic portraits in particular were rarely made after the daguerreotype era ended in the late 1850s. By that time, shallow depth of field had become increasingly articulated as the privileged way for organizing the implicit depth of a photographic portrait.[33]

DEPTH OF FIELD

In the earliest portrait studios, shallow depth of field might have been a technical solution for using large-format cameras with imprecise lenses in indoor spaces. A wider aperture, for example, does not just modulate depth of field but also lets in more light. Shallow depth of field is also a way that early photographers attempted to adapt aesthetic norms of painted portraits for the terms of photographic representation, asserting their own choice of focus in the image against what might otherwise appear as a purely mechanical inscription. Over time, however, shallow depth of field developed as a particularly photographic grammar for portraiture.

In contrast to the quantitative flatness of the anthropometric photograph, or the visceral volume of the stereoscopic portrait, shallow depth of field organizes a spatial aesthetics that seemed particularly well suited to the problem of portraying an interiorized subjectivity that was specifically associated with whiteness and class privilege. Formally, it works to differentiate the implicit space of the image into distinct planes, producing a tension between foreground and background, and between what emerges as more clearly visible and what recedes as more difficult to see. In a portrait, this spatialization can seem to stage a tension between interiority and exteriority, subjectivity and objectivity, surface and depth. Instead of isomorphically mapping body space to image space as either equally voluminous and visceral or equally flat and pictorial, it suggests that the dimensional aesthetics of its image might restage how an interiorized subjectivity that is not otherwise explicit can emerge to be seen and recognized by another subject. Instead of objectively rendering the appearance of the body as object, it can seem to render how subjectivity itself appears subjectively visible.

Consider a daguerreotype portrait of Rufus Choate, made in 1853, at the studio of Southworth and Hawes. Choate is roughly centered within a well-appointed room, at a desk where a book lies open. These surroundings help communicate his identity as a successful attorney, using the things around him to express something about who he is—a strategy that is also used in portrait painting. Choate's face is in focus, and behind him the image is increasingly out of focus, with the bust at the back of the studio appearing almost like a painted backdrop, despite the shadow it casts.

FIGURE 2.8. Albert Sands Southworth, *Rufus Choate*, 1853. Daguerreotype, 20.4 × 15.3 cm (8 × 6 in). © The Metropolitan Museum of Art. Image source: Art Resource, NY.

86 / *Chapter 2*

To the extent that shallow depth of field seems to pick out the subject of a portrait as the most important element in the image, this selective focus could translate how a portrait painter would emphasize the subject by placing them in the foreground and depicting them in greater detail. For a painter, making a background appear more distant, and less detailed, offers a spatial logic, within the picture, for the way time and effort were distributed in producing the painting. It makes sense that Southworth, himself a painter and an outspoken advocate for photography as an art form, would emphasize the way that the camera could be subjectively used to produce a selective focus, staging this effect as a signature of aesthetic mediation distinct from simply mechanical or objective recording. Translating the visual emphasis of a painting to the visual focus of a photograph changes how this mediation works, however, and what it might seem to mean.

Choosing to focus on Choate's face renders it with more detail, as a painter might, but because this focal effect is optically produced, organized by the physics of light, aperture, and lens, it structures this choice of attention differently than a painting would. It means Choate not only is centered or foregrounded in the image but organizes how light was optically mediated in this instance to produce a visible image—structuring the photograph's terms of visibility. It is as if the world that Choate looks out from organizes itself around him, and produces itself as visible relative to him, as the space of his appearance. He emerges into focus in a way that suspends this act of appearing. On the other hand, the selective focus also seems to communicate a subjective effect in which the viewer is complicit. It suggests a particularized visual intention and attention, a way of looking that anchors on Choate and reshapes objective space within the dimensions of a subjective view. In other words, the shallow depth of field of the image, the way its implicit space is structured, can seem to align a subjective way of seeing with a way of appearing as a subject. This alignment, in turn, suggests the terms of an intersubjective encounter: subjectivity emerges as visible, with that special quality of visibility that only a subject has, only within the vision of another subject, who sees in the special way that only a subject can. All of this relies on and shores up a mutual recognition reserved for the particularized visibility of white, privileged subjectivity.

In photography's early decades, shallow depth of field proposed a spatial negotiation of how a portrait was expected to surface the subjectivity of white upper- and middle-class subjects. It used the implicit spatiality of the image to stage a tension already presumed to delimit how this kind of subjectivity could and should appear. This technique met a need to conceive of the subject as presenting themselves through the body and through the

image without being entirely identified with the surface visibility of either. It helped distinguish photographic portraiture as a purportedly subjective way of appearing and seeing in contrast to the way that photography's mechanical transcription would presumably convey the objective visibility of things—and the bodily identities of people who were not culturally afforded the privilege of an interiorized subjectivity. On the other hand, shallow depth of field can also complicate and undermine any clear delineation between the person in the image and the things around them, and between what should stand out and what should recede. Its adaptation of portraiture's existing norms and aesthetics also undermined and shifted them.

In the portrait of Choate, for example, the choice to focus somewhat narrowly on his face means that other well-lit things the same distance from the camera are rendered with equal detail. The ornate pattern of embroidery on the side of the chair appears with the same clarity as the wrinkles in the arm of his coat and the creases of his face. The visual effects of focus, in other words, do not entirely fit any analogy that focus might be made to carry between the photographer's intended focus and the anticipated focus of the viewer's attention. The spatial parameters that govern how this aesthetic effect is produced can inflect terms of the image in ways that reassert the kinds of indifference this aesthetic would seem to work against. Instead of being surfaced as a subject, Choate might appear caught up with things that share the space he takes up, and that are surfaced alongside him.

A similar effect emerges in a wet-plate portrait of Martin Van Buren that was made by Mathew Brady just a few years after Southworth and Hawes' portrait of Choate. The strings of the tassel and the brushy texture of the hair and the swirled patterns at the book's edge all stand out in equal detail, and this visual relationship can make them appear related. They resonate in a way that does not seem to work like things in portraits are often meant to, as symbolic ways Van Buren's interior identity is staged by objects around him. Instead they triangulate something that seems to exceed the aim of the portrait, or point from the person to the world, suggesting a reversal of how meaning was meant to emerge here, moving from the outside to the inside, the objective to the subjective.[34] And this reversal could undermine the presumed distinctions that the genre of portraiture would maintain, making subjectivity appear somehow bound up with all the stuff that it is supposedly defined against.

As shallow depth of field became more closely associated with photographic portraiture, it became more explicitly photographic, more distinct from anything painterly. Some images, instead of distinguishing between a subject in the foreground and things around them in the background, can

FIGURE 2.9. Mathew Brady, *President Martin Van Buren*, 1855–58. Salted paper print from glass negative, 48.3 × 39.7 cm (19 × 15 ⅝ in.). © The Metropolitan Museum of Art. Image source: Art Resource, NY.

seem to stage the subject as already dimensional or self-differentiating. For example, consider this 1863 portrait of Abraham Lincoln by Alexander Gardner. By narrowing the depth of field to differentiate only a very small distance between the closest and farthest things in focus, Gardner not only emphasizes details of Lincoln's face but sets them into nuanced relationships. The focus is so sharp in places that the texture of pores can be seen in

Surfacing Subjectivity / 89

his skin as well as individual gray hairs in his beard. But moving out from his eyes and mouth, the focus falls quickly away. His ears, notoriously prominent, recede in a gentle blur. A few tufts of hair also seem to pull away, almost in motion. The dark lines and shadows contouring Lincoln's face contrast with a softness at the outer edges of his figure. There is a dynamic tension here between what is in and out of focus, between what is tightly delimited and what escapes that coordination, but none of it is beyond Lincoln. This close focus exposes Lincoln, a very public figure, with extreme intimacy, bringing him under scrutiny and disclosing a body marked by experience and age. But it also works to suggest that something is held back, that he is not entirely disclosed or fixed by the image because something slips its grasp, exceeds its stabilization, or remains out of focus, like those unruly strands of hair.

If shallow depth of field in the Choate portrait did as much to pick him out as the focus of the image as to entangle him with other things in the same plane, something similar happens with this portrait of Lincoln. The sculptural quality of his face in this image comes close to the kind of explicit dimensionality associated with the likeness rather than the portrait, presenting his face as a landscape or topographical map, rendered with all the solidity and relief that would someday stamp a penny.[35] To the extent that a face takes place as a concrete thing in the world, it is like a landscape whose features have been shaped by time and circumstance. The topography of a face could be read in a way that almost reverses the logic of the fleeting expression. The fleeting expression outwardly performs inner character through a momentary orchestration of the body's surface. The face seen as a landscape would instead allow for how some aspects of subjectivity might be imprinted and incorporated from the outside in.

Even photographic portraits of the most venerated white upper-class men made with the most careful calibration of dimensional complexity cannot entirely defend against the threat of being seen as an object if that threat is understood to precede the photograph, in the very fact of embodiment. Shallow depth of field deployed photographic aesthetics to articulate a paradox already presumed to structure the embodied visibility of subjectivity: it suggested how subjectivity might appear visible through a differentiation between surface and depth, and a tension between what emerges and what recedes. In the case of Rufus Choate, Martin Van Buren, and Abraham Lincoln, the race, gender, class, and social position of these "illustrious Americans" already conditioned how they would be seen and constructed as exemplary kinds of subjects. On the one hand, photographic portraits deployed aesthetic form against the objectifying potential of the

FIGURE 2.10. Alexander Gardner, *Gardner Portrait of Lincoln*, November 15, 1863. Albumen print from glass negative, 24.3 × 19.5 cm. Library of Congress, Rare Book and Special Collections Division, Alfred Whital Stern Collection of Lincolniana.

image. On the other hand, the image helped suggest that a special quality of subjectivity—communicated through aesthetic form and associated with cultural terms of visibility—was self-evident, manifest at the level of embodied appearance and therefore visible to anyone.

BLUR MY BACKGROUND

The automation of shallow depth of field in Portrait mode reworks not only its aesthetic logic but also the cultural ideas it negotiates. It undermines distinctions that shallow depth of field once helped to shore up: for example, between photographs with aesthetic merit and those that only transcribe the surface of things, or between the hidden depths of individual subjectivity and the material metrics of objective identity. Even the name *Portrait mode* seems like an oxymoron: a popular, push-button option that promises to turn any picture of anyone into a portrait redefines what counts as a portrait. In a sense, this popularization and mechanization reiterates the kind of challenge that photography itself constituted to that genre. Broader ideas about how subjectivity is and could be visible inflected how the new medium of photography adapted existing aesthetics and aspirations of portraiture into its own dimensional aesthetics for picturing people. The way Portrait mode has adapted shallow depth of field into its own depth effect communicates ways that the visibility of subjectivity is reconceived in a twenty-first-century context and culture of computation.

The way that Portrait mode has reinvented shallow depth of field retains some of the visual qualities and associations that defined its use in early portrait photography. It focuses on the human subject in opposition to the things around them, suggesting that this subject emerges in the foreground as what should be focused on and foregrounded. By achieving its depth effects through automated, quantitative operations, however, Portrait mode undoes the oppositions that structured how shallow depth of field was used in early photographic portraiture. In nineteenth-century portraiture, shallow depth of field seemed to work against the mechanical objectivity of photographic representation, resisting how a photograph might reduce its subject to the material terms of the image itself—how the contours of the body could be conflated with the surface geometries of the image, as a topography or measurable shape. Portrait mode seems to popularize what was originally exclusive, making what Sekula named the "honorific" aesthetic of portraiture the norm; but it also seems to incorporate the objectifying assumptions and aesthetics of the "repressive" approach, drawing on the spatial strategies of anthropometric and stereoscopic photography to

92 / Chapter 2

produce its depth effect. Rather than presuming or privileging an interiorized subjectivity that would appear visible only to other subjects, Portrait mode's depth effect invests an exteriorized presentation of the subject, as an image that could be externally differentiated from other images.

In order to be in focus and foregrounded in Portrait mode, the subject of the image has to first be identified with, and as, a bounded set of pixels in a specific plane. Facial recognition algorithms begin this process by trying to find a face. This means identifying a geometrical pattern that has been associated with how faces are rendered in pixels—an association made through machine learning algorithms analyzing images already labeled as faces. So, when facial recognition algorithms identify the person that Portrait mode aims to portray, they reinforce a circular logic that has already defined a person in terms of an image, as images are now defined: as numerical descriptions of how pixels appear in a grid. This conflation of a subject with the way they take up space in the plane of an image encodes the racialized, spatial, and statistical techniques that were developed in anthropometric photography as distinct from the aesthetics of photographic portraiture. It sees every subject as a visual object. This is not an undoing of discrimination but, rather, an extension of a mathematical reification of space in which white subjectivity is implicitly aligned with the unmarked vantage point from which—and universal system within which—everything is equally visible and able to be labeled.

When edge recognition algorithms trace around a person to produce a visual boundary, this process translates a distinction between subjects and objects, which earlier photography understood in terms of an invisible interiority and visible exteriority, into a different logic of inside and outside—across a border on the same plane. Subject and object are defined as regions of the same surface, defined by the mutual exteriority of their boundaries as recognizable "things" for computer vision algorithms. Hair becomes a critical border zone, and clothes or objects within the body's outer boundary are literally incorporated, becoming part of the cluster of pixels that will count as the subject. Portrait mode operates as if there is no difference in the way subjects and objects are visible until and unless this difference is produced at the level of the image. The subject must be clearly delimited within the image, and everything else must be pushed away, in order to produce the visibility that would be proper to a subject.

The depth mapping techniques used in Portrait mode probably constitute the first time that stereoscopic strategies have been central to portraiture since the 1850s; but they do not produce depth effects in the same way. To see the depth of a stereoscopic view, the difference between two images

Surfacing Subjectivity / 93

FIGURE 2.11. Demonstration of Portrait mode on Google Pixel 3a XL, 2019. Courtesy of Wasim Ahmad / *Fstoppers*.

needs to be grasped by an embodied viewer looking with two eyes, coordinated as if the parallax between these two perspectives is due to the way the viewer is viscerally situated within the space these images both depict. Dual camera and dual pixel techniques of depth mapping, instead, triangulate parallax shift as a mathematical expression of pixel displacement, using many different pairings of coordinates across images to structure how a single image will be rendered. These techniques treat depth as a quantitative way of relating points across images, leaving human vision out of the loop. LIDAR also quantifies spatial relationships before visualizing them. The way its lasers map actual distances from the camera to condition how pixels will appear in an image almost reverses how measurements have been taken at the surface of photographs to model the actual space they picture.

In a portrait with shallow depth of field, the tension between foreground and background coordinates a dimensional space, a space that coheres through this tension. The subject of the portrait appears within this dynamic, as if their own visibility is equally suspended, and relative to the things around them and the viewer, both emerging and held back. In contrast, the depth effect of Portrait mode opposes foreground and background in a way that dismantles any implicit space between them. Instead of the visible world of the image appearing organized around and by the visibility of the subject, the subject tends to appear isolated from the world around them, like a cardboard cutout. They may be more in focus than the background, but they are just as flat. Foregrounded as a plane, the subject does not have any depth of their own, and the world behind them is not around them; they are in front of it but not within it. There is nowhere to be "in." The person in the picture is a picture, too, in a way that does not situate a

94 / *Chapter 2*

body in a world, or even a person in an image, as much as juxtapose or overlay two equally flat images.[36]

When Portrait mode incorrectly parses pixels, this error can intercut the human subject and objects around them into accidental forms of collage. Parts of a person can seem to detach and dissolve into the background. Or pieces of things can agglomerate as body parts, incorporated into the boundary of what counts as the subject of the image. These confusions reenact the unruliness with which objects would sometimes seem to sneak into the foreground of early photographic portraits made with shallow depth of field, undermining any singular emphasis on the subject. In both cases, an effort to differentiate the subject from their surroundings results in unintended correlations. Rather than undermining the singular visibility of the subject, however, errors in Portrait mode images—by the very way that they show up as errors—support the presumption that clear differentiations could be made and lines properly drawn because what counts as the subject is self-evident. This notion invests the way that Portrait mode unbinds and remodels dimensional relationships to produce the image, even if the image gets things wrong.

For the nineteenth-century portrait photographer, to modulate depth of field required adjusting material, spatial relationships of aperture size and focal length, of distances between the subject, lens, and photographic plate. These interrelated material dimensions involved in producing the image conditioned any effort to single out the human subject. Reorganizing the implicit depth of the image would reorganize how these dimensional relationships were mediated, without undoing them. So, shallow depth of field traded one kind of visual indeterminacy for another: instead of everything equally in focus, a specified focal plane related everything within it. In contrast, Portrait mode constructs the implicit depth of the image based on the two-dimensional relationships of pixels in the image plane. Its depth effects are modulated by determining which pixels belong to the subject while assigning all other pixels to the background. Mistakes are misattributions, confusions about which pixels are parts of what things. Ultimately, misattribution and confusion are fundamental to attempts to read, in the spacing of pixels, how three-dimensional things are arranged in a three-dimensional space. Gleaning mutual edges of things from pixel positions does not account for how things take up voluminous space and are arranged relative to one another in depth. Portrait mode's depth effects can relate mutually exclusive image planes only because they begin from two-dimensional relationships of pixels.

In Portrait mode images, everything identified as "not the subject" is pushed back to become the background. The subject is not really brought

forward as much as the world is pushed away to produce a foreground. It is as if the subject can achieve a privileged visibility only if they are explicitly made to stand out, depriviliging everything around them as their undifferentiated surroundings. This marks an important shift: from the concern in nineteenth-century portrait photography with preserving a privileged interiority and staging how the depths of subjectivity could surface, to a concern with more overtly exteriorizing a subject and rendering that exteriority maximally visible.

This is not to say that Portrait mode is just objectifying, or to invoke all the same claims that were once made about early photographic portraits to dismiss these—too automated, too popular, lacking aesthetic value. Both then and now, changing aesthetics of portraiture relate to changing ways that subjectivity is conceived and produced as visible through both technological and cultural conditions of representation. If the best way to secure a privileged visibility for the subject portrayed is to automate their extractability as an image, this method may fit algorithmic logics governing which images will be prioritized as they move through digital networks and online platforms. The person who might have once performed a fleeting expression to ensure their subtle subjectivity would be recognized might now exaggerate the contours of their features—perhaps sucking in cheeks and pouting out lips in the pose of "Instagram face"—as facial recognition algorithms calculate the shapes and ratios that show up as human.[37]

The way Portrait mode stages the visibility of subjectivity relates to ways people have been learning to see themselves and others, and to produce themselves as visible to others, over the past ten to fifteen years since the first iPhone cameras. The stakes of this shift, as computational photography reinvents photographic aesthetics, are similar to those that surrounded nineteenth-century transformations in how people were pictured. What might look like a matter of changing visual technologies, and the formal techniques that they require or afford, is also an ongoing negotiation of cultural norms. The ways that portraiture is seen to concretize and circulate a privileged form of personal identity corresponds to ways that privilege already shapes how personhood is conceived and visually constituted.

SEEING AND BEING SEEN

Experiments with the dimensional aesthetics of photographic portraiture—relationships of depth and focus, foreground and background, and volume and flatness—engage assumptions not only about how subjectivity appears

96 / Chapter 2

visible in an image, but also about how it is visible at all. Black women photographers have been leading the way in recent experiments that explore how photographic mediation could posit ways of seeing subjectivity not beholden to the exclusionary logics that have shaped portraiture's norms. While they each experiment with very different aesthetic strategies, Lorna Simpson and LaToya Ruby Frazier have both found ways of picturing people in lens-based images that do not conform to the spatial conventions that extend from nineteenth-century portraiture up through Portrait mode. Instead of working to differentiate opposing terms of interiority and exteriority, subject and world, or self and other, Simpson and Frazier explore depth effects that suggest how these convolute. Their artworks attend to the forms of mutual exposure and irreducible relationality through which identities are co-constituted and made visible.

Lorna Simpson's early work seemed to route around or refuse expectations of portraiture. It often depicts Black female figures who refuse the gaze—their faces turned away or their heads not in the frame, or with only hair or wigs serving as synecdoches for gendered and racialized embodied identity.[38] Over the past few decades, Simpson has developed a different strategy in collages that may now be "her most extensively known works."[39] These photocollages feature images of Black women in advertisements that Simpson has cut out from mid-twentieth-century issues of magazines, like *Jet* and *Ebony*, that were directed toward Black, middle-class consumers. In most of these collages, Simpson splices an image of a woman's face with an entirely different image that is positioned where the woman's hair would be. These collages continue Simpson's earlier interest in hair as a site of negotiation between what is personal and what is public, and between the body as living flesh and as external object. Their hand-wrought methods of cutting around hair and juxtaposing a human face with a "background" in two discrete layers both invoke and jar against the visual techniques of Portrait mode.

In *Lyra night sky styled in NYC* (2020), for example, Simpson has laid a black-and-white wig advertisement pulled out from a 1950s issue of *Ebony* magazine over a blue and white astronomical map.[40] The wig has been cut out, leaving only a fringe of hair across the forehead of the Black woman who modeled it; but imperfect cutting has also left behind a few dark slivers that suggest how the wig filled the shape that was removed. In the space where the wig was, the star map shows through, and the labels "LYRA," "DRACO," and "CORONA" indicate constellations near the left, right, and top edges of the opening. Simpson's title mixes text from both of the found images to suggest that the woman has incorporated the stars—as if she is named "Lyra" and the "night sky" of her hair has been "styled in NYC."

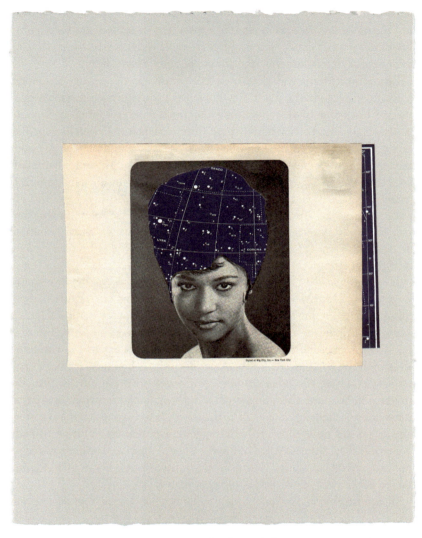

FIGURE 2.12. Lorna Simpson, *Lyra night sky styled in NYC*, 2020. Collage on paper, 45.6 × 34.8 cm / 17 15/16 × 13 11/16 in., 49.2 × 38.4 × 3.8 cm / 19 3/8 × 15 1/8 × 1 1/2 in. (framed). © Lorna Simpson. Courtesy of the artist and Hauser & Wirth. Photo: James Wang.

98 / *Chapter 2*

What *incorporated* might mean here, however, is not straightforward. For one, the night sky appears in place of a wig—whose artificiality would only redouble a way in which hair might already be considered exteriorized, an outer sign styled by others rather than the body's own flesh.

Rhyming with the way that the woman shown in this collage is a model in an advertisement, the night sky shown here is a highly abstracted model. Its grid lines and labels foreground the work of representation, a cartographic translation from actual space to picture plane. Constellations like Lyra are only figures drawn between stars, compositions that star positions only form in the plane of a particularly situated view. This situatedness is both material and cultural: the stars look different from vantage points around the planet, and the same stars that Western astronomers call Lyra make up the Black Tortoise of traditional Chinese astronomy. In this diptych, the visible overlap between two flat sheets of printed paper mounted on another reminds us that we are seeing multiple discrete images overlaid—it is something like a constellation in itself.

It would be a reductive romanticization to interpret the depth effect of *Lyra* as an alternative strategy for meeting the demand portraiture historically posed. If the night sky is seen to surface this woman's inner depth, it would hyperbolically overflow that conceit, refiguring subjective interiority as cosmic expanse. It would be difficult to read this expanse as the soul's transcendence beyond the body's material confines because, in this collage, the wig is where the body's outer limit opens to the outer limit of the universe.[41] The way this collage poses relationships of surface and depth in embodied identity makes it difficult to parse what would count as superficial—as only appearance. It suggests a radical convolution of body and world that colludes with, but overruns, the careful, aesthetic management of embodied subjectivity. It asserts a beauty that is not attributed to hidden depth but is nevertheless unfathomable.

If Simpson's collages are "cut-up portraits," as the title of one review calls them, they are not portraits made from cutouts but rather a cutting up of portraiture's basic conceits. One diptych from the series makes this especially clear, pairing two collages that are themselves image pairs. *Flames* (2019) combines vivid photographs of exploding buildings with vintage advertisements featuring Black women bearing placid expressions. They were made during the COVID-19 global pandemic and first shown in an online exhibition that began in May 2020, a few weeks before the murder of George Floyd sparked nationwide protests about racial violence.[42] An *LA Times* review called the collages in *Flames* "archetypes of the current mood," juxtaposing "social niceties with rampant destruction."[43]

A review in *Hyperallergic* explores how the "ambiguity and tension" between the women's serene expressions in *Flames* and their exploding environments "invites an array of interpretations." The fires could represent "the very real danger of an unjust society" or "the raging wildfires" of "ongoing climate catastrophe" or the "burning of prejudiced assumptions" about Black women or "the external manifestation of internal emotion" that is kept under the surface by the "pressure imposed on Black women to maintain composure, even as they bear the weight of systematic racism."[44] The diptych may invite all these readings, but its images refuse to stabilize as a single analogy or simplify as a symbol. Simpson has said that her collages "play with images," exploring an interest in photography that is not about creating a photographic representation as much as activating multivalent relationships between representations, as representations, at the level of representation.[45] In *Flames* this relationality compounds: each of the four images that Simpson has cut out presents its own scenario; each collage relates two of those images to suggest another scenario; and these scenarios, in turn, relate as sides of the diptych.

In the left-side collage of *Flames*, a self-possessed, well-dressed Black woman is depicted in a black-and-white advertisement. She slightly tilts her head to speak to others with whom she sits sharing coffee. A triangle of three white cups echoes the angled pattern of her dress and the casual bend of her arms, organizing a sense of intimate conversation despite the fact that her interlocutors are out of frame. Their light-skinned, feminine hands suggest where their bodies might extend into the white space of the underlying page. The composition of the image positions the viewer as an implicit fourth at the table. As a woman, the conceit of female friendship invites me in; but, as a white person, I know this solicitation was intended for the magazine's Black readers and not for me. Suspended in midsentence, the woman looks out of frame with an unreturned gaze, at the center of a conversation that she has been left alone to carry. The background around her in the ad has been carefully cut out, along with almost all her hair, leaving her forehead to form a sharp peak. Staggered behind the ad, a color photograph has been positioned so that bright bursts of flames surround her face. In this photograph, fire and smoke spew from vents as a building burns from the inside out. Nothing about the woman in the foreground seems to acknowledge the escalating emergency behind her, even as her own head seems to erupt in flames.

In the right-side collage of *Flames*, a model smiles in the headshot of a color advertisement visibly torn from a magazine. Her face is turned left and her eyes right, her look slightly angled up toward the camera. The black color

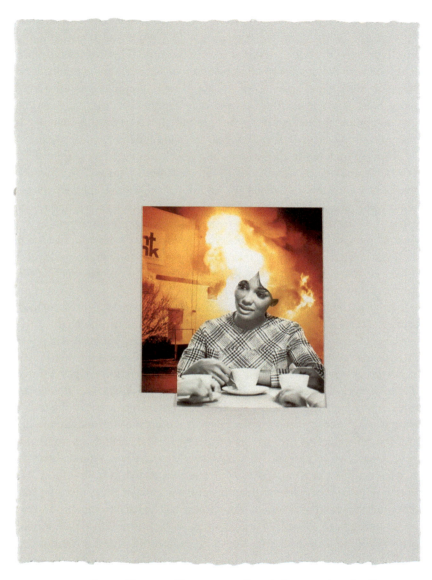

FIGURE 2.13. Lorna Simpson, *Flames,* 2019. Found photograph and collage on paper, two framed collages. Overall installation dimensions variable. *Left framed collage,* 19 × 14 3/16 × 1 ½ in (48.3 × 36 × 3.8 cm); *right framed collage,* 17 5/8 × 16 5/16 × 1 ½ in. (44.8 × 41.4 × 3.8 cm). © Lorna Simpson. Courtesy of the artist and Hauser & Wirth. Photo: James Wang.

Surfacing Subjectivity / 101

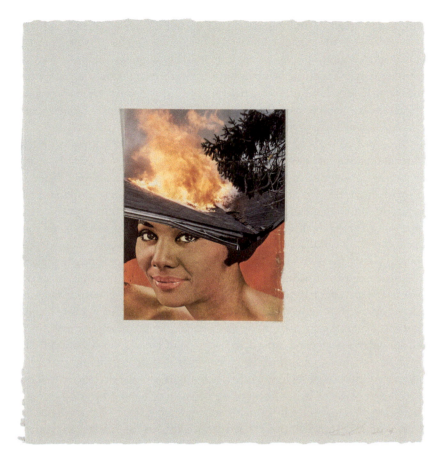

of her hair seems to match the black shingles of a roof in an overlaid image of a house on fire, as if this roof were an elaborately coiffed hairstyle. The model's right arm seems raised behind her, and this gesture shifts from showing off her hair in the ad to holding up the burning roof that is caving in and collapsing downward. Flames rise, like her upturned gaze, and her pupils glint with what could read as a clear-eyed awareness of the catastrophe.

The repetition of similar scenarios between the two collages of the diptych suggests that its two scenarios may figure something much broader—Black women in general, an overarching catastrophe. But *Flames* does not *portray* Black female subjectivity as much as engage how racialized and gendered identity takes place and appears meaningful within material and cultural conditions that are relational, contingent, and unstable. It mixes

102 / Chapter 2

the reality effects of photographs that document actual events with the fictional range of staged, commercial images meant to sell products. It mixes glossy photographs whose temporality suggests the "now" of an unfolding event with halftone images that are recognizably of and from the past. It sets carefully composed images of carefully styled women's appearances—compositions of composure—against glimpses of an uncontrolled, violent force of nature destroying human infrastructures.

Simpson's collages, like *Lyra* and *Flames,* formally echo techniques used in Portrait mode to cut out subjects and set them in a plane apart from the world as another plane. But conceptually, they operate from an entirely different premise, apart from the opposition of subject and world that smartphone photography inherits and automates. These collages explore how expressions of personhood are embodied and enworlded in material realities and social contexts that cannot be dismissed as *only* external or pushed behind us—as history, as elsewhere—with the ease that "blur my background" might suggest.

Lorna Simpson's work deploys conceptual and avant-garde strategies to undermine and critique the representational logics of portraiture, and photography more generally. In contrast, LaToya Ruby Frazier draws on aesthetics of photojournalism, documentary, and vernacular photography to expand interpersonal and cultural frameworks of visual representation.[46] The unusual dimensionality in a pair of portraits that depict the photographer and her mother suggests how subjectivity might appear relationally—not as a surfacing of depth but as a reckoning between self and other. Both images are titled *Momme,* one from 2008 and one from 2018. In each portrait, Frazier stands behind her mother, facing forward; her mother stands closer to the camera, turned in profile. Part of Frazier's face is occluded by her mother's face, with their features overlapping and aligning to almost suggest a single person. These portraits are doubles of one another, and double portraits: they relate as a pair, and each image portrays a relational pairing.

Momme (2008) is from Frazier's photobook *The Notion of Family,* which visually testifies to the impact of sustained environmental, economic, and racial injustice on one family and three generations of Black women.[47] It includes many self-portraits, and portraits of her mother and grandmother in their homes where Frazier grew up in Braddock, Pennsylvania.[48] In one caption, Frazier describes a collaborative practice of portraiture as an ongoing way that she and her mother would play and perform in relationship with one another: "Mom and I found another way to keep making portraits of one another . . . we would quietly rotate, posing for each other and mimicking each other in front of the camera."[49] The image titled *Momme* is captioned: "I found out in 2008 that Grandma Ruby had pancre-

Surfacing Subjectivity / 103

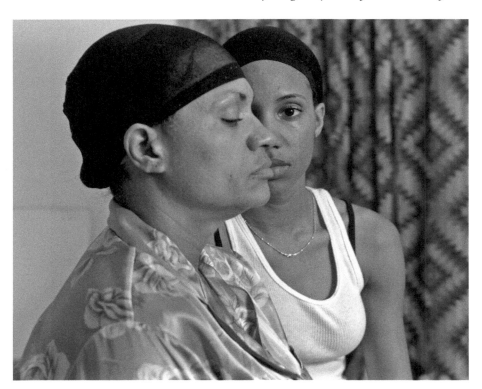

FIGURE 2.14. LaToya Ruby Frazier, *Momme*, 2008, gelatin silver print, 20 × 24 in. © LaToya Ruby Frazier. Used by permission. Courtesy of the artist and Gladstone Gallery.

atic cancer. Mom and I explored a new approach to documenting our illnesses that day. We made a portrait of our bodies overlapping as one; unified in sickness, death, and our struggle to survive."[50] In the portrait, overlapping bodies resonate with the elision of *Mom* and *me* in the title: the two women's lips almost line up to suggest a single pair, with a shared outline and single seam between top and bottom. This alignment also happens, less perfectly, with their noses and eyes and eyebrows. It invites a way of reading the image as a flat figure, made of intersecting rather than overlapping shapes, a photographic surface with no depth.

The visual fusion of faces in this image is possible only because they are similarly in focus, held together in a shared space rather than pulled apart into a foreground and a background. If this photograph had been made using Portrait mode on a smartphone camera, facial recognition and semantic segmentation might have had a difficult time identifying a subject and

104 / Chapter 2

cutting around the body associated with their face. Algorithmic operations might fail to find a person—not locking onto a single set of facial features—or might interpret the two women as one person. Frazier, because she faces forward, might seem to be the subject of the portrait that should be brought forward into the foreground even though she stands behind her mother. Or her mother might be identified as the subject, because she is closer to the camera, causing Frazier to be treated as an object and pushed into the background like the curtain on the wall.

In 2018 Frazier made what she calls "an anniversary self-portrait remake" of *Momme*, with the same title. In each of the two images, Frazier and her mother are positioned in the same way, wearing similar clothes, in what might be the same room. This visual repetition between the two images rhymes with the elision of their faces in each; and the way the two portraits relate across a decade suggests how the connection they depict persists or might be continually re-created as both women change over time. Frazier writes: "*Momme 2018* marks the one-year anniversary of my mother's survival on life support. With our noses, lips, and eyes almost aligned, it signifies how we took courage and remained steadfast in the midst of all the hatred, brutality, injustice, and inequality we've endured as Black working-class women from southwestern Pennsylvania. Our bond and camaraderie are fire-proof."[51] While the visual alignment of their faces is about their relationship as mother and daughter—two bodies having once been one—it is also about their shared identity as Black women who have survived the same brutal circumstances. The bond between them involves a positionality that has been constituted, to some degree, from the outside, "in the midst" of hostility and systemic racism. In these portraits, however, two women stand together in a way that holds a space between them protected from the viewer, an intimacy that serves as a bulwark between the viewer's gaze and the way Frazier meets it.

The unusual composition of these double portraits resonates with, and yet entirely recasts, the way that ethnographic and anthropometric photographs—and still today, mug shots—pair views of the same subject from the front and from the side. In those pairings, the self-relation of depth and sidedness, the dimensionality of a voluminous body, was split across two images to increase exposure; the viewer bridged this gap between views as the volumetric geometry of the body they might extrapolate. Frazier's portraits recast this doubling and sidedness across related bodies within a single image. This moves a hinge that would have been between two images, and between the viewer and the depicted subject in those images, to a space within the image that is not open to the viewer. These images seem to be

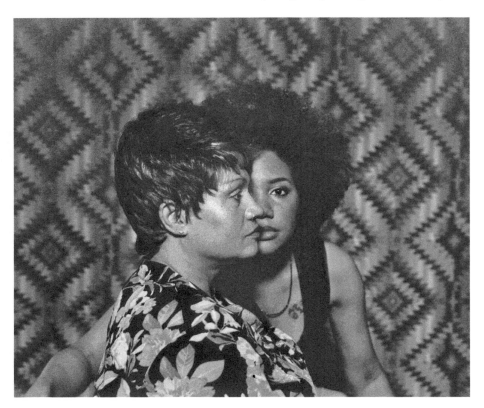

FIGURE 2.15. LaToya Ruby Frazier, *Momme*, 2018, gelatin silver print, 20 × 24 in. © LaToya Ruby Frazier. Used by permission. Courtesy of the artist and Gladstone Gallery.

"about" the relationship between the two women they depict; they seem to depict this relationship. But, in an important way, the photographs position these women such that what stands between them is not presented—it is the constitutive invisibility of this view. This space holds them both together and apart in a way that conditions how they are visible in the image but also articulates something to which the viewer has no access. This inaccessibility, the "hidden depth" at the heart of this image, is not, however, associated with the individual, subjective interiority of each woman portrayed. It is neither interior to them nor strictly externalized; instead, they co-articulate it through and as a relational visibility and embodiment—and even "identity"—that does not oppose inside and outside or self and other. The photograph portrays a relationship between these women that could not be explicitly captured because it remains between them.

106 / Chapter 2

If the visual elision between these two women's faces emphasizes the surface of the image, the divergent gazes of their overlapping faces suggest spatial relationships that exceed the flat plane of the photograph. Frazier looks at the camera but also at and through her mother: her right eye directly faces her mother's left eye, neither of which are visible to the person looking at the photograph. This crossing of bodies and looks, especially given the title and theme of the series, suggests a complex intimacy between mother and daughter—a kind of half rhyme in which they stand together and apart, closely connected and yet separately articulated. The mother is part of the daughter's view and part of how the daughter is visible; she blocks the view from one of the daughter's eyes and blocks half of the daughter's face from being seen. This reading is complicated by the fact that Frazier is the photographer. To the degree that she controls or is aligned with the camera, her gaze is articulated not only as looking out from behind her mother but also as associated with a viewing position outside the image that would have access, along with the viewer of the photograph, to the mother's "other side." Instead of organizing depth of field to single out and focus on one subject, surfacing their hidden depth, these images use a dimensional hinge or sidedness embedded within the image to portray two subjects as mutually constitutive of one another's visibility. Instead of ensuring that one subjectivity is correctly conveyed to another, Frazier's *Momme* images use the aesthetics of portraiture to explore the precarity, and to celebrate the strength, of how identity is always relational, contingent, and co-created.

LaToya Ruby Frazier's *Momme* portraits thematize forms of mutual exposure, in more than one sense. They address the exposure that she and her mother have shared to racism, sexism, and environmental injustice. And the two women's practice of posing and mimicking as they made portraits of each other is another kind of mutual exposure, in which they disclosed aspects of themselves to and for and through the other. In the photographs, there is a fixed form of that encounter, as sides of their bodies that are not visible to the viewer face one another across the unseen space separating their bodies—a gap that is elided to the degree that the viewer might read their features as fused into a single face. Lorna Simpson's collages also explore how portraiture stages a problem of mutual exposure between self and other, but this otherness is not so much another person as it is an outside world, and the way bodily exteriority appears demarcated—through racialized and gendered terms of visibility—as externality, otherness. Depicting this "outside" as also inside the subject or opening out from them dismantles the conceit of a subjective interiority that would transcend body and world while being, somehow, also safely secreted away within them.

The artworks I have discussed by Simpson and Frazier disrupt the conceit of a singular, privileged subjectivity that a portrait is meant to convey. They expand the conception of self that portraiture traditionally aimed to shore up, rejecting an ideal of individual interiority that was always exclusionary and always specified "the subject" by making objects of others. These artworks unsettle aesthetic conventions that differentiated anthropometric images and portraits, redressing racist and sexist presumptions about how particular people could and should be seen. They also decenter the privileged visibility that a portrait was traditionally thought to secure between the photographer, the viewer, and the subject of the portrait, one that rested on a presumption that all three of these roles would be occupied by subjects whose mutual recognizability as subjects was assured, making them somewhat interchangeable. These experiments in portraiture move from that framework of mutual recognizability to instead pose challenges and suggest possibilities of mutual exposure.[52]

SEEING ANOTHER SEER

When the challenge of picturing people seems to center on a problem of proper depiction, a need to protect and secure a privileged kind of visibility, a problem arises with the material conditions of visibility itself. The aesthetics of photographic portraiture aim to modulate those conditions, restaging them to remediate them—as remedy. But, because the visibility of a photographic image is also conditioned by the material and relational dimensions that it stages, the photograph redoubles all the uncertainties that it might have hoped to stabilize. How could one subject see the subjectivity of another if, looking from the outside, they could not see into that subject's interiority or see from their vantage point? How could a subject take place and appear visible—as themselves, to others—if the material, relational conditions of being seen constitute an externalization and exposure that doubles and displaces, positing their visibility outside themselves? These questions shift only if subjectivity and visibility are conceived differently.

The challenge of seeing another subject is not to penetrate the layered obfuscations of body and world, to see into their hidden depth. Instead, it is the demand to recognize them as another seer of a shared world. Embodiment is the basis of this recognition rather than its obstacle. The person who sees and the person who is seen are both visible bodies for one another because visibility itself takes place within a material world they have in common. The visibility of this world exceeds every particular view,

108 / Chapter 2

because each person constitutes an entirely singular vantage point from which a unique dimension of the world's visibility opens.

To see another seer does not take place as a kind of reversal that would allow one person to occupy another's point of view, seeing what they see, but as a realization that there are other, inaccessible views. A subject's hidden depth, then, is not locked up inside them; it is the dimension of their particular articulation of the world, the aspect of the world that they are and that they open as visible—not despite the fact but because of the fact that it could not be fully disclosed to or as the view of another.

This way of thinking about the dimensionality of subjectivity recasts the problems and potentials of picturing people. A photograph of a person renders them as embodied and enworlded by the material visibility of the image itself. If this is a doubling and displacement of their embodied subjectivity, it is also another exposure and opportunity for encounter. It is a further articulation of the visible in which not just the subject but also the world itself seems to double and present itself "in" the image. A photograph is not just an inscription of the body of the other—an othering of that subject and the presentation of an other to the subject looking at the picture; it is also an othering of visibility, and of the visible world that seems to appear "in" the picture. It opens and stages a particular way of looking, and a way of seeing the world arrange itself as visible, one that does not belong to the person pictured or the person looking at the picture. The photograph's technological mediation of visibility can stage another version of the demand to bring a vision other than our own into account. Such a visibility would always hold back as much as it seems to disclose. But the very fact that a photographic image is so limited—a surface that can present only a surface—enables the portrait to reexpose what is unpresentable.

ENTRELACS III

Unfinished Incarnation

"Where is the other in this body that I see?" asks Maurice Merleau-Ponty.[1] I can see another person as a visible thing, but how can I see them as another seer, when I have no access to their seeing or their view? Merleau-Ponty addresses this problem in one of the last working notes for *The Visible and the Invisible*. He titles this note "'The other,'" placed in scare quotes, which he also uses to put the related terms of "'subjectivity'" and "'syntheses'" into question. He suggests that the so-called "'problem of the other'" is not solvable in the way it has been conceived:

"THE OTHER"

November, 1960

What is interesting is not an expedient to solve the "problem of the other"——

It is a transformation of the problem

If one starts from the visible and the vision, the sensible and the sensing, one acquires a wholly new idea of the "subjectivity": there are no longer "syntheses," there is a contact with being through its modulations, or its reliefs——

The other is no longer [...] a rival subject for a subject, but he is caught up in a circuit that connects him to the world, as we ourselves are, and consequently also in a circuit that connects him to us——And this world is *common* to us, is intermundane space——And there is transitivism by way of generality——[...]

the other is a relief as I am, not absolute vertical existence.[2]

If myself and the other are both reliefs—material contours—of the same world, a "wholly new idea" emerges of how subjects are constituted and relate. For Descartes, subjectivity is distinct from the body, as the transcendent, synthetic consciousness of the *cogito*. For Hegel, subjects could

only be rivals because, by definition, a transcendent and synthetic consciousness could not abide another. To conceive of subjects as interconnected modulations of a world in common transforms the problem of the other in the same way that Merleau-Ponty transformed the problem of the cube.[3] In the same way that a cube is a dimensional coordination of different sides, subjectivity takes place through and as the relational structure, or depth, of embodiment.

Merleau-Ponty argues that "[w]e have to reject the age-old assumptions that put the body in the world and the seer in the body."[4] Or at least, we have to change how we understand the "in" of those formulations. The seer is not "in" the body any more than volume is "inside" a cube. Rather, for Merleau-Ponty, the structure of embodied subjectivity is relational in multiple ways, each of which involves a kind of sidedness: binocular vision embodies seeing through a doubling or differentiation that coordinates across a left and a right side; the situated nature of embodied vision orients the viewer toward something and away from something else, as the thickness of the body prevents one from seeing both ahead and behind; and what might be considered the interiority of subjectivity appears as a sidedness that is in principle reversible—as in moments of seeing oneself seeing or touching oneself touching. In each instance, a dimensional cohesion underwrites self-relation.

The sidedness of subjectivity is not a stable architecture but a dynamic relationship that Merleau-Ponty describes as chiasmatic or reversible. Sides relate through a mirroring or turning inside out in which both are sides of the "same" thing, in one sense, but in another sense incompossible—for one side to appear, the other cannot.[5] The body's "inside" and "outside" are held in such a chiasmatic relation, a double inscription of the subject who sees and a body in the world to be seen. This relationship is not a stable architecture but a dynamic articulation, because the site of connection is also a site of differentiation—an active hinge or mobile joint that constitutes the openness of what it might seem to self-enclose.

Merleau-Ponty sees the sidedness that constitutes any one subjectivity as the structural principle for how different subjects also relate. He uses multiple metaphors to express how this paradoxical sidedness works—all of which emphasize life and liveliness. One metaphor he uses in the note above is that of a circuit, in which a current moves between two differently charged poles. If embodiment is a kind of circuit, then consciousness is like a spark leaping across the gap between its sides.[6] This is not a transcendence of the body's material differentiation but a dynamic and provisional synergy that depends on it. If the principle of a subject's self-coordination is a

relational kind of synergy, then its relationship with other subjects and the world "outside" might follow this same principle. Or, to state the "other" side of this reversibility: because he is embodied, the other subject is "caught up in a circuit that connects him to the world, as we ourselves are, and consequently also in a circuit that connects him to us."[7]

Merleau-Ponty transforms the problem of intersubjectivity—the mutual exclusivity of two transcendent consciousnesses—into a question of "intercorporeity," in which differently embodied subjectivities co-constitute what he calls "the flesh of the world."[8] He uses a metaphor of topological contours to describe how this flesh of the world is sided, or structured relationally in the same fashion as the subject's own embodiment: "the other is a relief as I am," another dimension of the world's own self-differing incarnation.[9] This relationship between subjects remodels what Hegel described as a "me-other rivalry" into a "co-functioning."[10] "Just as the parts of my body form a system," argues Merleau-Ponty, "the other's body and my own are a single whole, two sides of a single phenomenon."[11] Our bodies are not fused but form a "single phenomenon" in the same sense as the Necker cube or a binocular view. This "single whole" we form "forms its unity across incompossibilities": "*my* world and the world of the other" remain as distinct as our unique vantage points, and "my visible" is "not superposable on that of the other."[12] Instead of being opposed in our difference, I and the other are "collaborators in perfect reciprocity: our perspectives slip into each other, we coexist through a single world."[13] This "single world" coheres only as the relationship between the worlds it relates; it is an "intermundane space" that is neither *my* world nor the other's but "*common* to us."[14]

The paradoxical assembling of mutual impossibilities that characterizes how the cube, embodied subjectivity, and the world all take place is the ontological structure of depth. Depth does not name just what recedes but also the relational structure of material appearance—how Being incarnates as phenomenal existence. "When we speak of the flesh of the visible," Merleau-Ponty writes, "we mean that carnal being, as a being of depths, of several leaves or several faces, a being in latency, and a presentation of a certain absence, is a prototype of Being, of which our body, the sensible sentient, is a very remarkable variant, but whose constitutive paradox already lies in every visible. For already the cube assembles within itself incompossible *visibilia* [. . .] and indeed it is a paradox of Being, not a paradox of man, that we are dealing with here."[15] Our own embodiment and the "carnal being" of whatever we see are mutually structured by, *and* mutually structure, the "flesh of the visible" such that "the total visible is always behind, or after, or between the aspects we see of it."[16] Our embodied vision could not grasp or

112 / *Entrelacs III*

resolve this "total visible" but "only concentrates the mystery of its scattered visibility."[17]

What Merleau-Ponty calls the scattered structure of the visible might be understood through another of his metaphors: the *dehiscence* of a plant splitting open to release seeds. He argues that "[e]very visual something, as individual as it is, functions also as a dimension, because it is given as the result of a dehiscence of Being. What this ultimately means is that the hallmark of the visible is to have a lining of invisibility in the strict sense, which makes it present as a kind of absence."[18] This structure of dehiscence shifts the self-differing of topographical relief toward a more radical generation of the "other." It recasts the movement of electrical energy through a circuit as the propagation of biological life. The idea that Being dehisces imagines how whatever "is" opens and multiplies, producing new dimensions that were neither already there nor entirely ex nihilo. The dehiscence of carnal being is the ongoing creation of the world within the world.[19]

If no subject exists in the totality of their own self-completion, then self and other would not encounter one another as two "positive subjectivities" who face off in pure externality. Instead, Merleau-Ponty argues, they encounter one another as "two opennesses, two stages where something will take place," both of which "belong to" the "same world" and the "stage of Being."[20] This staging is a provisional enactment and materialization: the body as an ongoing staging of the subject, the world as an ongoing staging of Being. Merleau-Ponty expands from the metaphor of an electrical circuit—in which a current internally circulates—to that of an electrically charged field to think about how the staging of subjectivity may be ecstatic, radiating beyond the body's enclosure. Using ellipses that help rhetorically stage the openness he describes, he writes that the body "offers itself to . . ., opens upon . . . an imminent spectator, is a *charged field*——."[21] This formulation reassigns agency from seer to seen and reframes visual capture as a kind of dehiscence. It imagines how embodiment might not trap a subject as an object within another's look but, rather, might articulate subjectivity within a differentiation that it requires, and that the "flesh of the visible" instantiates. This does not mean that another subject's look provides a completion that the subject otherwise lacks: the other subject remains an "imminent spectator." They are proximate through their own charged field. Their look is a field property inflecting a mutual visibility that remains in flux.

The other's subjectivity, as another seer, is staged by their embodied presence as another visible. But their visibility does not thereby conceal or dissemble some more essential form of subjectivity. Instead, it would be a "hallmark" of their visibility, as it is of any visible, to convey a "certain

absence"—a depth or latency or lining or inner framework. This absence is not an incompleteness caused by inviolable interiority or the transcendence of consciousness but, rather, the structure of "carnal being" as what Merleau-Ponty calls an always "unfinished incarnation":

> The other, not as a "consciousness," but as an inhabitant of a body, and consequently of the world. Where is the other in this body that I see? He is (like the meaning of the sentence) immanent in this body (one cannot detach him from it to pose him apart) and yet, more than the sum of the signs or the significations conveyed by them. He is that of which they are always the partial and non-exhaustive image—and who nonetheless is attested wholly in each of them. Always in process of an unfinished incarnation——Beyond the objective body as the sense of the painting is beyond the canvas.[22]

Like the meaning of a sentence or the sense of painting, the other is "immanent in his body" rather than transcending it or entirely reducible to it. The meaning of the sentence is not equivalent to the words that make it communicable. What the painting expresses is beyond the canvas rather than in the paint, but the medium of painting is the only way that the painting could appear. In the same way that he has rethought the relationship of part and whole to allow for "total parts," Merleau-Ponty suggests that a "partial and non-exhaustive image" may "wholly" attest to that which it depicts. And, in the same way that the meaning or sense of any aesthetic expression exceeds the material articulation of words on a page and brushstrokes on a canvas, who the other "is" exceeds their bodily appearance and yet takes form through their material existence. The Being of the other is "always in process of an unfinished incarnation," because their own embodiment is part of an endless articulation of Being.

The aesthetic metaphors Merleau-Ponty uses in the passage above suggest that images could iterate, participate in, or even concentrate the "mystery" of a visible's "scattered visibility." If an image portrays its subject in a way that is "always partial and non-exhaustive," presenting what could appear only between or behind every presentation, that would not constitute its failure. Instead, the way an image distributes and reorganizes the visibility of subjectivity could be precisely how images serve as another and an "other" articulation of subjectivity's ongoing incarnation.

3. Visible World

Photographic Maps and Computational Photogrammetry

> Google Maps helps over one billion people navigate and explore. And over the past few years, our investments in AI have supercharged the ability to bring you the most helpful information about the real world [...]
>
> Google *Keyword* blog post, May 11, 2022

YOU ARE HERE

The artist Andreas Gursky has said that the idea for his *Ocean* series came to him on a flight from Dubai to Melbourne, as he watched the flight tracker on a little seat-back screen in front of him.[1] His plane appeared as a small icon against a field of ocean-blue pixels. As far offshore as they were, the blue on the screen could have represented anywhere over any water; and the plane's icon, staying centered as the image scrolled, seemed not to move at all. Meant to show passengers where they are, the flight tracker might do more to express how they are temporarily untethered, somewhere in between the places that planes fly to and from. A plane's position is tracked by satellite and mapped to the digital image of the flight tracker through a process that corresponds to the navigational programs and displays guiding the flight under the pilots' watch. When passengers try to locate themselves, however, by way of the tiny plane sliding across the tiny screen, this identification dislocates them from the sense of where they sit still, inside a plane wrapping around them, hovering over an ocean far below outside the window.

True or not, Gursky's story expresses tensions between reality and representation, and between location and dislocation, that are also felt in his *Ocean* series. Each of its six huge images depicts the blue expanse of an ocean, shown from directly overhead and with astounding clarity.[2] Each rectangular image in the series is large enough to make its viewer feel small; *Ocean III* spans almost 120 square feet. On the other hand, these images picture Earth from so far away that the planet shrinks to a miniature scale.

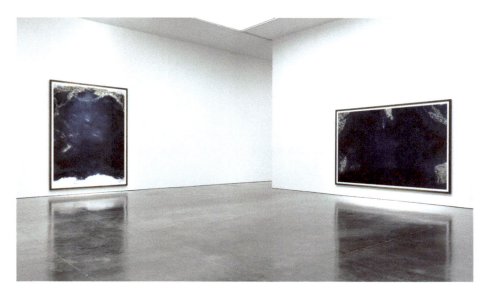

FIGURE 3.1. Andreas Gursky, installation view of *Ocean* series, featuring *Ocean V* and *Ocean I*, exhibited at Gagosian New York, 2011. © Andreas Gursky, Artists Rights Society (ARS), New York / Photo: Robert McKeever / Courtesy Gagosian.

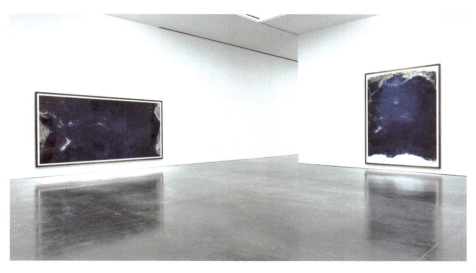

FIGURE 3.2. Andreas Gursky, installation view of *Ocean* series, featuring *Ocean II* and *Ocean V*, exhibited at Gagosian New York, 2011. © Andreas Gursky, Artists Rights Society (ARS), New York / Photo: Robert McKeever / Courtesy Gagosian.

They feel like world maps from which the world we know is missing—the negative space of water without land. Slivers of land edge the water in each image, as if the continents are slipping out of frame. Highly detailed and frosted with white, these shorelines do not register as the recognizable shapes of identifiable places; they almost look like ornate frames setting off the blue swirls of abstract paintings.

Titled *Ocean I–VI*, the six images of this series do not align with the most common enumeration of five oceans; but that only fuels people's desire to name them. When I saw the *Ocean* series installed in a New York City gallery, I watched viewers try to find the right vantage point to make sense of what they were seeing. People stood and rotated slowly in the middle of the gallery's main room, trying to imagine across the gaps between the images; but they also walked closer to and farther from each one, tilting their heads left and right to imagine how each might spin to fit within a map's conventional orientation of north-is-up. Viewers pointed to details and guessed at places, trying to locate where and what these pictures "actually" were in the world. This involved trying to orient themselves in actual space relative to each image, grasping its perspectival organization in terms of their embodied viewing position.[3] I felt a dizzy sense of suspension looking at any one of the images: its darkest blues seemed to pull toward depths that did not recede; the picture plane was so perfectly flat and self-contained that my look could only slide off it.[4]

One reason the *Ocean* images are so disorienting is less about what they depict than about how they depict it. They have the optical verisimilitude of photographs and invoke the aerial point of view of satellite images. But, however distanced, any camera or satellite would capture an image more visibly inflected by Earth's curvature and the geometry of lenses. These images present an impossibly flat and all in-focus space. Without the perspectival conditions that construct an implicit viewing position, the images appear dislocated in a complex, structural way that rhymes with the puzzle of their geographical locations. Each *Ocean* image references an actual place on Earth, positioning the viewer as if looking down on it from far above. Yet each image is also abstracted and disorienting, resisting any way of grasping it from a vantage point that a viewer could actually or even imaginatively embody.

This alienating or hyperreal effect is characteristic of Gursky's work. He is known for producing large-scale images replete with detail that read as single, photographic exposures but are meticulously, digitally crafted from multiple takes in ways that overwrite ordinary rules of perspective.[5] His gallery explains that for the *Ocean* series, he went a step further, to create

118 / Chapter 3

FIGURE 3.3. Screenshot of Google Maps app on an iPhone.

what look like photographs without actually taking any: he "relinquished his position behind the camera to work with satellite images of the world as raw material, resulting in a contemporary *mappe del mondo*."⁶ The *Ocean* images look like maps because they use the same "raw material" as the digital maps that most people use most often. Their picturing of Earth's surface looks like the satellite layer of Google Maps, minus the place labels, search box, and orientation buttons.

Gursky created his *Ocean* images in 2010, when Google Maps was five years old and already the dominant digital mapping platform. With at least a billion users as of 2022—an eighth of the world's population—Google Maps is arguably the contemporary *mappe del mondo*. To make its interactive,

computational maps, Google collects, composites, and edits data that was optically recorded by cameras and satellite sensors in much more than any single capture to produce what can appear to the viewer like a seamless "view" of Earth's surface. Google's Earth is scrubbed of clouds and airplanes and shadows, staged from a perfectly top-down view with no obstructions. This component of making maps from photographs is called "rectification," making right. It "corrects" images by removing details or visual effects that are contingent on the conditions of capture—angle, weather. It abstracts beyond limitations structuring any photographically recorded image to present a computational construct that seems to offer not just a particular view from a particular place and time but an objective presentation of the visible thing itself.

Gursky emulated Google's process at a small scale but also pushed its recomposition further. In the *Ocean* images, the shores of continents are replete with visual detail because satellite imagery has exhaustively documented land, and especially coastlines as borders of economic and military interaction. The "middle" of any ocean is less intensely imaged, however, so Gursky consulted charts of ocean depths and digitally painted different shades of blue—lighter and darker swirls suggesting currents and depths.

Like the Earth of Google Earth, the planet seen in the *Ocean* series is devoid of atmosphere or shadows; but it is also missing any sign of human life. There are no cities or canals, no sense that this planet is inhabited or that its surface has been impacted by people. The viewer feels they are looking at images that optically recorded the visible world of which they are part—where they are and what they see, and in which they would be visible. Yet these images picture a world from which they have been removed, and one that refuses any viewer to the degree that it cannot be oriented in terms of an embodied view.

The *Ocean* images may share the aesthetic of computational mapping apps, but they refuse the promise of access, orientation, and visual mastery that those apps are designed to offer. Usually a map acts as proxy so that a viewer, engaging with its mediation, could grasp an actual coordination of space that would otherwise exceed their immediate perception—and, more than that, negotiate their embodied relationship to that actual space. The *Ocean* images, however, invoke the viewer's idea of the whole world only to suggest that its objective coordination may be constitutively inaccessible to them. This effect frustrates the relationship between image space and lived space that maps are made to navigate. It reverses a map's conventional gesture of "you are here" into a circular gesture of displacement: there is no place for you here.

120 / *Chapter 3*

The *Ocean* series enacts the difficulty of visualizing the world we are part of, when, as part of it, we can embody only a particular point of view within it.[7] Any way of extrapolating the world as a whole, as an explicitly visible thing that coheres beyond the limits of our look, produces an abstraction and a reification that could no longer constitute the context in which our look is embedded. This problem tracks with a tension between maps and the photographs used to create them: a map suggests an objective spatial model, and a photograph conveys a particular perspective. By restaging the Google Maps aesthetic as huge, discrete photographic images on a gallery wall instead of as an interactive model on a digital screen, Gursky reasserts the photographic rather than computational dimensions of that aesthetic. This emphasis exposes differences between maps and photographs that Google Maps makes difficult to see. The alienating effects of Gursky's images also begin to suggest why those differences matter.

GET ORIENTED

From its launch through its most recent innovations, Google Maps has always been "powered," as they put it in one blog post, by techniques for making maps from photographs. These techniques have constantly evolved. Google has relied on images optically recorded by satellites and cameras—images that seem to record and present the world's actual visibility with optical verisimilitude. The ongoing challenge for Google Maps has been how to leverage this imagery into a representation that seems to offer both the objective, spatial coordination of a map and the embedded, perspectival views of a navigable model.

Google Maps began in 2005 as an application for desktop computers, made possible by the public release of high-quality satellite imaging. Wraparound satellite imagery of the globe seemed to render Earth's surface visually indexable and virtually navigable in a way Google Maps made "searchable." Google fused rectified satellite imagery into orthomosaics— apparently seamless composites that had the optical verisimilitude of photographs but the regulated dimensions of a map. This modeling conflated an aerial view with an interactive simulation, so that Earth's actual spatiality and the spatial structure of its representation seemed to coincide and to allow virtual navigation of the world's actual, visible expanse. As smartphones put new emphasis on mobile navigation, Google needed to create a map whose images and mode of interaction suited a user's situated vantage

point "on the ground." A technological problem arose: how to integrate an overview and an embedded view while maintaining both the scalar relationships of a map and the optical verisimilitude of a photograph.

To capture the embedded perspective of someone navigating on the ground, Google introduced Street View in 2007, using images captured from "trekker" camera backpacks worn by pedestrians and cars "equipped with nine cameras that capture high-definition imagery from every vantage point possible."[8] Instead of tracing turn-by-turn directions on a map overview, Street View imagery illustrates a visual experience of moving within the space that the map models. As of 2019 Google claimed that it had collected more than two hundred billion Street View images covering "more than 10 million miles," "a distance that could circle the globe more than 400 times."[9] This encircling sounds so excessive, repeatedly stringing Earth's girth like Christmas tree lights, because the individual perspectives of Street View images can only be endlessly juxtaposed. Their individual vantage points are strung together as serial and successive to create paths that Google Maps users can navigate visually.

To transition between the map overview and the embedded vantage point of Street View, Google offered the avatar of Pegman, a little yellow icon that anthropomorphizes the peg or pin used to mark locations in Google Maps. A Google Maps user can drag and drop Pegman onto the map image to virtually position him as their proxy in a particular location, to see what he would see from there. Echoing the cinematic shift to color in *The Wizard of Oz* (Victor Fleming, 1939), when Dorothy finds herself dropped in a new world by the cyclone, Pegman lands in a world suddenly photorealistic. Also like Dorothy, Pegman has a road he needs to follow. The user can click directional arrows to move him along the panoramic tracks of imagery that Street View cars and trekkers have recorded. As one still image swaps out and another swaps in, the viewer's position shifts in lurching, virtual steps that are not seamless transitions. The map gains virtual volume as a place viewers could be "inside" only to the degree that users virtually flatten themselves to the dimensions of Pegman, identifying their perspective with the limited, photographic scenes of Street View.

The problem of stitching together individual photographs to suggest a seamless, extended space reiterates the problem of seamlessly integrating an embedded perspective and overview. In both cases, a visual model that relies on photographic verisimilitude is limited by the terms of photographic mediation. The fact that each photograph is bounded, framing a

FIGURE 3.4. Image of a user wearing a Google Street View Trekker backpack while walking down a tree-lined street, 2018. Source: Google.

FIGURE 3.5. Detail of a screenshot of Pegman being dragged and dropped into a street map in Google Maps.

fragment of a world that extends left and right and top and bottom beyond its frame, presents one challenge. The more complex challenge, however, is the flatness of the image: cutting a visual plane in the depth of a world that extends beyond that plane produces a distinct, perspectival organization structured by a specific vantage point. Both these challenges are addressed by techniques of photogrammetry, practices for translating between the two-dimensional, perspectival space of photographs and the voluminous dimensionality of the world photographs depict.

In a 2019 blog post about "how imagery powers our maps," Google explains that it has reinvented the "vintage" practice of photogrammetry with new, computational methods:

> Once we've collected photos, we use a technique called photogrammetry to align and stitch together a single set of images. These images show us critically important details about an area—things like roads, lane markings, buildings and rivers, along with the precise distance between each of these objects. All of this information is gathered without ever needing to set foot in the location itself. Photogrammetry is not new. While it originated in the early 1900s, Google's approach is unique in that it utilizes billions of images, similar to putting a giant jigsaw puzzle together that spans the entire globe. By refining our photogrammetry technique over the last 10 years, we're now able to align imagery from multiple sources—Street View, aerial, and satellite imagery, along with authoritative datasets—with accuracy down to the meter.[10]

Google suggests that what is new about its approach to photogrammetry is the scale and range of imagery it involves, and the accuracy or resolution of the model it produces. It is not just the scale that makes its approach unique, however, and the process is not as simple as snapping every pictured meter into its proper slot on a giant jigsaw globe. Images captured from cameras on ground level, from drones or planes, and from satellites are taken at dramatically different elevations, picturing Earth's surface at very different scales. Any image is also recorded from a particular angle, with specific lighting conditions and potential occlusions. And every image is shaped by the perspectival geometry of whatever camera, lens, and aperture may have been used in making it. There is no way to fuse images from many sources into a single, cohesive visualization, like piecing together the image on a puzzle box.

What Google describes as aligning and fusing images is more about extracting and correlating visual information from images. Computational photogrammetry relies on computer vision and AI to identify what Google refers to as "important details" like "roads, lane markings, buildings, and rivers" in images. This process uses methods of object recognition I discussed in chapter 1 to define and identify specific things in images. Algorithms can then use the known GPS location of the camera that captured an image, any additional information available such as LIDAR readings, and a spatialized comparison of features visible across multiple images to build a mathematical model of a geometrical space the images depict. This method uses some of the depth mapping techniques I discussed in chapter 2 and generates a mathematical, spatial model whose visibility is only coherent as a computational abstraction. Visual details from the image data can also be "texture mapped" to the model. This texture mapping allows for optical verisimilitude when the model is used to generate visualizations, to render particular views of the place it models.

One way to think about Google's approach is as if Google hoped to optically scan Earth's surface from as many angles and vantage points as possible, to collect a massive set of images, and then to find a way to coordinate all data from those images into a model that could be virtually traversed at any scale and from any potential viewing position. Google attempted something like this with Google Earth VR, released in 2017. Google Earth VR allows users to explore the visual model of Google Earth as if they were viscerally navigating within its virtual spatiality—floating outside the planet to see from the perspective of a satellite and then drifting down to the ground to see an area from the perspective of a Street View trekker.[11]

FIGURE 3.6. AR overlay of Live View in Google Maps on a Pixel 2. Captured in Manchester, United Kingdom, on July 12, 2019. Photograph by John B. Hewitt.

Google Earth VR, however, is not useful for actual navigation. Like Google Earth, it functions more like the visual model of a globe than like the functional visualization of a map; its immersion is less like the reckoning a map stages between actual and represented space and more like that of a game, in which the user deliberately disregards their actual location to imagine themselves in a virtual world. The challenge for Google Maps was how to correlate a navigable, digital model of Earth's surface with a Google Maps user's embodied, dynamic position in the actual world that the map modeled. Google approached this problem through the augmented reality (AR) feature called Live View, introduced in 2019.

Intended for pedestrians, Live View overlays location-specific information on real-time imagery from a user's smartphone camera. In 2020 it became a top-level option, along with Street View and Satellite View, in the Google Maps mobile interface. If you click a bracketed pin icon marked "LIVE," pop-up instructions urge you to "point your camera at buildings, stores, and signs around you" to "get oriented quickly" by viewing map information "overlaid on your real-world surroundings."[12]

When you move your smartphone to scan around you in Live View, the image on your mobile screen is rendered from live camera data, like a photograph that you keep reframing without taking. AR elements are layered

onto this live camera imagery, so things around you appear annotated with text and graphics. A graphical pin in the otherwise photographic view on your screen may mark a destination you typed in, and arrows may show up on the sidewalk pointing the direction you should walk to get there. Text labels floating in the background or hovering over buildings might indicate the distance to other points of interest nearby and whether a restaurant in view is open. The way that Live View fuses dynamic camera imagery with textual and graphical annotations makes it feel like you are looking at the world through a magic lens that reveals an invisible ink. Information you might have looked for online about your surroundings seems to appear, through the aperture of your screen, "on" those surroundings—as if the world itself serves as a spatial interface for information about it.

This blending of virtual and actual space can feel so intuitive that it causes problems. Google has warned Google Maps users that it is dangerous to look at Live View when you are walking somewhere—as if the only approved interaction is the panoramic spin that visually searches your surroundings while you stand in one place. Orienting yourself through Live View's visualization can overwrite your own embodied perception of where you are. When you navigate toward the world you see through your screen, you can find yourself colliding with actual things, objects more obdurate than images.[13]

The way Live View correlates images from your camera with a three-dimensional map of your location relies on a recent transformation in how Google uses photographic imagery to model the world. This transformation was driven, Google explains, by "advances in computer vision and AI that allow us to fuse together billions of Street View and aerial images to create a rich, digital model of the world." Until recently it was not possible to coordinate images captured on the ground (such as those used in the Street View layer of Google Maps) and aerial images (such as those used in the satellite layer of Google Maps). These were woven into two separate models, different layers of the map, because it is not possible to "fuse" an embedded view and an overview of the same place. These are not just different scales of representation; they are two different structures of spatial visibility. If you "zoom in" from a satellite image to the ground, you still see that ground from a position hovering directly above it rather than as if you were standing on the ground and looking around you. In order to make the world "searchable" from the embedded, dynamic perspective that Live View offers, Google had to invent what it calls a "new technology" of "global localization." This technique relies on computer vision and AI to compare spatial features of live, hyperlocalized camera imagery with the spatial

126 / *Chapter 3*

features Google has already extracted en masse from many billions of images and mapped to specific locations around the globe.[14]

Street View imagery supports Live View—"matching up," as Google describes it, your live camera imagery and its billions of Street View images—through a second-order coordination between the digital model Google has created and dynamic, visual information extracted from your camera's "live view." Google explains how Live View works using the analogy of how a person unsure of their whereabouts might look around for something they recognize. Live View "looks around" when someone uses their smartphone camera to scan their surroundings. It analyzes the dynamic imagery being captured, generating a provisional model of how its spatial features appear arranged. It then attempts to match the pattern of spatial features found in this imagery with patterns of features that have already been "learned" from the billions of images of Earth's surface that Google has collected and analyzed for its maps. To revisit Google's metaphor of a jigsaw puzzle, this technique is almost the opposite of fitting pieces together to match the complete image shown on the box. It is more like trying to match pieces between two puzzles.

Google calls the way that Live View extrapolates location VPS (for visual positioning system), in contrast to GPS, the global positioning system capabilities built into smartphones. Google claims that it invented VPS for Live View because it is more accurate than GPS, and the AR overlays of Live View require "the most precise location possible." These overlays label not only general features like streets but also hyperlocal features like the specific crosswalk a pedestrian should use to cross a street. As a smartphone user moves and repositions their camera, the crosswalk's distinctive pattern of white lines appears in different positions, at different scales, at different angles, and in different orientations in the on-screen image. Despite these deformations of the crosswalk as depicted from different perspectives, the AR arrows marking it in Live View seem to hover over it as if pinned to a position in the actual space "behind" the screen rather than to the labile image. Surprisingly, the way that Live View seems to transcend the image's perspectival variations is only possible because of them. Live View analyzes the changing camera input in order to derive information about the user's position in their surroundings.

The overlaid labeling of a crosswalk in Live View's image is not based on GPS data about the exact location of the crosswalk relative to the exact location of the smartphone. GPS locates the position of a smartphone by pinging a network of satellites that are in orbit around Earth and timing sensor

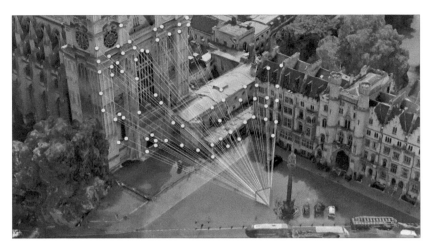

FIGURE 3.7. Illustration of Google's visual positioning system, from Google I/O presentation, 2018.

signals between the satellites and the device to triangulate relative distances. Google Maps can then correlate the smartphone's GPS coordinates with the global, spatial coordinates modeled in its maps. But this process is not precise or fast enough to keep an AR arrow aligned with a crosswalk in Live View. Instead of labeling images of your surroundings based on GPS input about your actual location, VPS analyzes images your smartphone is capturing of your surroundings in order to extrapolate your position within them.

In a 2018 Google I/O presentation, Aparna Chennapragada explains how VPS uses computer vision to identify and spatially relate different points in the images that a smartphone camera is dynamically capturing in Live View.[15] A spatial model of your surroundings is extrapolated by comparing how relationships between these points shift in different two-dimensional images captured from different perspectives. In other words, while GPS bounces timed signals between different material objects in actual space, VPS measures relationships of points depicted in different images. GPS triangulation relies on the way in which different objects are co-present in a shared space whose volume could be traversed by signals. In contrast, VPS extrapolates voluminosity and co-presence from flat and spatiotemporally discrete representations. It produces a model of embedded, situated spatiality by extracting perspectival, dimensional relationships from points in image planes.

128 / *Chapter 3*

Live View may feel like an aperture through which you can see the world itself, rather than a map. But it presents a highly mediated representation rather than offering a "live view." The way it presents the spatialized model of Google Maps with the verisimilitude of live, dynamic camera views invites you to "get oriented" through a profound kind of disorientation. It intervenes in your embodied grasp of the world around you and inflects how you move and feel situated within that world, such that the way of seeing that it offers becomes lived as a view through you. In a sense, the way Live View intervenes in your perception of what surrounds you may literalize or exaggerate how a map always works when it helps someone navigate the place it depicts. Live View alters this function, however, by suggesting that the mapping platform could accomplish a correlation that is usually accomplished through the embodied act of "reading" the map. Live View seems to model not just the terrain but the situated process of orientation, the work of reckoning one's position within that terrain. In other words, it proposes to read your actual surroundings as if they are already the map, and then to show you, by way of your actual view, how your view is situated in the world of—or as—a digital model.

Live View feels closely tethered to the user's embodied, embedded view, but it simulates the perspectival structure of space through a radical deracination of perspective. It reconstructs a perspectival logic that was stripped away in its production. Ostensibly, it offers a perspectival representation of positionality, a dynamic illustration of situated seeing; but this representation is constructed from a model of global space that has been abstracted away from the perspectival limits and situated conditions of any embodied or represented "view." Live View produces a spatialized structure of information that coheres according to computational modes of visibility and spatiality.

By matching aspects of this model with image data from your camera, Live View locates your virtual position within the model and uses it to annotate live imagery that is inflected by perspective and does correlate with your embodied position. As you rotate to take in your surroundings, Live View stages the immediacy of being-here-ness through an embodied, spatialized representation that seems structured in the same way that you experience your actual situation. This development escalates the virtualization worked by the proxy of Pegman, conflating map and territory such that the Google Maps user pointing their smartphone at their surroundings seems to already stand inside a "live" map. Live View extracts and models spatiality in a way that dismantles the dimensionality that coordinates a "place" through and as its interrelated aspects *before* discrete elements are geometrically defined as features and reconstructed as visible objects.

Visible World / 129

With the computing power of Google behind it, and more than 80 percent market share in mobile mapping as of this writing, Google Maps is the dominant platform that other mapping platforms now follow. Its mediation of the volume and interconnectedness of space—the way it stages the terms of being positioned within space and the way that space coheres—structures not only how the world is modeled but also how we conceive of its actual spatiality. This spatial mediation conditions how it seems possible for different places and perspectives to interrelate in an overarching framework of global spatiality, and how we seem positioned within this global space.

It has only recently become possible, with computational photogrammetry, to automate ways of translating between the optical and perspectival spatiality of photographic images and the mathematically modeled spatiality of map imagery. This technological coordination can make it easy to forget how differently the world appears visible through photographs, maps, and the embodied views they mediate—and why those differences matter. As computer vision and artificial intelligence transform photogrammetry, it is worth recalling that photographs were used for making maps long before Google Maps modeled the world using optical data from orbiting satellites and cameras mounted on cars. Photogrammetry stretches back to photography's first decades, when mapmakers struggled to incorporate cameras into land surveying and to make measurements from photographs. The history of photogrammetry demonstrates how fraught it has always been to translate between image space and actual space, maps and photographs, the geometry of perspective and the situated experience of a view.

PHOTOGRAPHIC SURVEYING

The word *photogrammetry* names techniques for measuring (*metr-*) photography's inscriptions (*graph-, gram-*) of light (*photo-*). Google's 2019 blog post is right that photogrammetry is not new, but it emerged even earlier than the 1900s. Its basic idea was proposed at the inception of photography. Announcing Daguerre's invention to the French Academy of Science in 1839, François Arago suggested that this new technology might be used to "measure the highest and most inaccessible buildings and to replace the fieldwork of the topographer."[16] In the 1850s, when wet-plate process married the precision of the daguerreotype with the practical value of paper prints, cameras began to be successfully integrated with existing visual instruments for architectural and topographic surveying. Before the term *photogrammetry* was widely adopted in the early twentieth century, related practices emerged in multiple countries under multiple names,

130 / *Chapter 3*

including *métrophotographie, iconométrie, phototopography,* and *photogeology.*[17]

In the mid-nineteenth century, the primary instruments used in surveying and cartography were already centuries old: compass and telescope, ruler and tape, plumb bob and spirit level, alidade and transit. Techniques for the coordinated use of these instruments evolved into established methods and led to compound tools—such as the theodolite, used in triangulation, which combines a plumb bob, level, and alidade.[18] These surveying instruments did not scale well, however, for the military and economic ambitions of imperialism. Surveying projects in the late eighteenth and early nineteenth centuries expanded to an unprecedented scale and took decades to complete.[19] For example, an effort to triangulate all of Britain, begun around 1790, involved dragging a two-hundred-pound "great theodolite" from one surveying station to the next across the British Empire for more than fifty years. Britain's effort to map the entire Indian subcontinent—the Great Trigonometrical Survey of India—spanned from 1802 to 1871. Purporting to objectively measure and map terrain, these surveys were ways to draw "other" places into dominant, spatialized modes of political control and resource extraction. They were a form of what Katherine McKittrick has called "rational spatial colonialization and domination."[20] Presuming and asserting that any and every place already existed within a continuous global space that could be represented through a single universal system, they ignored and overwrote how places were already ordered by, and ordered, the lives of indigenous peoples, plants, and animals at scales unassimilable to global empire.

As a new optical technology and visual instrument, photography was incorporated into the visual instrumentation of existing surveying techniques.[21] Photography made it easier and faster to survey large areas, and offered particular advantages for mapping more complex topographies and less accessible terrain like mountain ranges. Surveyors could collect and measure *images* of terrain that would have been exceedingly difficult to measure in situ. Rather than understanding a photographic image as a map, surveyors understood the camera as a visual instrument that might be used, alongside others, for expressing perceptible space in terms of graphical notation and mathematical measurement.

When a surveyor used a theodolite for triangulation, for example, they would "sight" points in space to measure the relative angles to two different points from a third position. This process involved physical adjustments and visual alignments, as the surveyor would target a location through a telescopic lens, swiveling the scope up and down and left and right until the

Visible World / 131

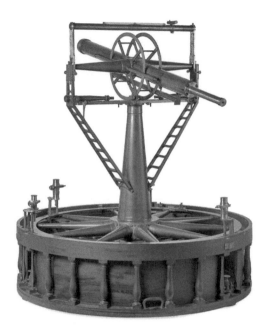

FIGURE 3.8. Three-foot geodetic theodolite, sometimes called the "great theodolite," used for the Principal Triangulation of Great Britain. Created by Jesse Ramsden, 1791, Piccadilly, Westminster, London. © The Board of Trustees of the Science Museum, Science Museum Group.

target point was centered in view. After positioning the scope this way, the surveyor could read off degrees of tilt and rotation from marked circles measuring the scope's position relative to the instrument's base. These angles could then be used to judge the distance and altitude between the physical location of the theodolite and the target location. A surveyor could cover a large terrain by incrementally adding new vertices, tessellating linked triangles and extrapolating the lengths of their sides without having to physically measure the distance between each point.

Plane table surveying codified specific ways of marking locational information on a sheet of paper placed on a flat surface and positioned on a tripod. The three-dimensional orientation of the plane table's surface is established using a compass and level and plumb bob; then relative distances and contours of visible locations around the plane table are calculated and translated to a scaled representation drawn on its surface through direct, material methods. For example, a surveyor might place a "sighting ruler" directly on the plane table and sight a location through two apertures separated on either end of its length. The surveyor could draw a straight line on the paper along the ruler's span to mark the angle at which it must be positioned for the sighted location to line up in the crosshairs of its two

FIGURE 3.9. Illustration of Aimé Laussedat's phototheodolite, as printed in Laussedat's *La Métrophotographie* (Paris: Gauthier-Villars, 1899).

apertures. The surveyor would use visual and manual instruments that mediated their embodied perception of spatial relationships and quantified those relationships, translating them into measurements and geometrical terms that could be graphically represented—mapped to the space of the plane table's paper.

The astronomer and cartographer Aimé Laussedat began using photography in plane table surveying as early as 1852.[22] Laussedat's approach was inspired by concurrent practices of panoramic photography and unfolded in relation to others' efforts to fuse such photographic practices with techniques of plane table surveying.[23] His method involved photographing the same terrain from two or even four different elevated stations, each fixed at a location whose coordinates were known. At each station, he would pivot a camera by regular degrees to capture a panoramic series of views from specific, related angles.[24] The resulting photographs would then depict the same place from not only multiple vantage points but also multiple perspectives at each vantage point. Knowing the spatial relationships between the two camera stations and the angle of rotation for each photograph taken from those stations allowed the images to be analyzed through projective geometry: shapes visible in the images could be interpreted as related, perspectival projections of the same three-dimensional space in different two-dimensional planes. Distances and locations could be triangulated by comparing spatial relationships across different photographs, between points pinned to identifiable features of the objects seen in the images.[25] Laussedat first proved his method in making a map of Paris, producing an overview of the city that was celebrated at the Paris Exposition of 1867.

FIGURE 3.10. Illustration of Aimé Laussedat's method for mapping Paris, as printed in Laussedat's *La Métrophotographie* (Paris: Gauthier-Villars, 1899).

134 / *Chapter 3*

The difficulty and the innovation of Laussedat's method lay in the fact that discrete photographs offered distinct perspectives. Instead of attempting to measure one extended image as a coherent model of the terrain it pictured, Laussedat extrapolated dimensions of the terrain from the discontinuous nature of his images. This method required precision in capturing the images, because the camera's lens and plate needed to be positioned in consistent ways across multiple takes in order to make the spatial terms of different images comparable. To better control the conditions of photographic capture, Laussedat collaborated with scientific instrument makers in Paris to combine a camera and a theodolite into the first phototheodolite, introduced in 1859.[26] This instrument exposed single glass plates with precise readings about the relative angles of every physical and visual element involved. Many other versions of the phototheodolite followed, and photography began to be integrated into surveying projects around the globe in the second half of the nineteenth century. Its integration was inhibited, however, by the complexity of mathematical and photographic techniques that were required.

Canadian surveyor Édouard Deville hoped to help other surveyors incorporate photographic methods with his 1889 manual titled *"Photographic Surveying, including the elements of descriptive geometry and perspective."*[27] Deville is credited as the first to successfully use photography for large-scale surveying, adapting Laussedat's technique to survey the Canadian Rocky Mountains along the route of the Canadian Pacific Railway (CPR). This national railway was promised in 1871—the same year the Dominion Land Survey began to map western Canada—to link colonies newly federated as Canadian national provinces. Completed in 1885, the transcontinental line displaced Indigenous peoples—not only remapping but violently resculpting traditional lands of Indigenous tribes and nations with dynamite-carved cuts and passes. It enabled mass settlement of western territories and helped enable, partly through associated land surveying, systematic forms of resource extraction such as mining for coal and minerals.[28] Deville began photographically surveying in British Columbia as the rail line was being completed, and then continued to map the mountainous "belt" around it. Roughly fourteen thousand square miles of the Canadian Rocky Mountains had been mapped with Deville's methods by 1895, when he republished his book to meet increasing interest.

In an updated preface to *Photographic Surveying*, Deville addresses the reasons why photography was not yet standard in land surveying. He asks, "Can anything more convenient be conceived than a method which enables a topographer to gather rapidly on the ground the material for his maps

FIGURE 3.11. Illustration of Zeiss-Pulfrich field phototheodolite, ca. 1906, as printed in Otto von Gruber's *Photogrammetry: Collected Lectures and Essays* (London: Chapman and Hall, 1942).

and to construct them afterwards at leisure in his office?"[29] He then immediately admits, however, that "the apparent simplicity of photographic surveying is a delusion." Deville argues that "the purely photographic part of the work" is the "most frequent cause of failure," because even the most skilled surveyors have not been trained for it.[30] To ameliorate this, Deville aimed to educate other surveyors about photography—and especially about the spatial parameters of its mediation.

136 / Chapter 3

TOPOGRAPHER and ASSISTANT,
Showing mode of carrying instruments.

FIGURE 3.12. Front plate image and caption from Édouard Deville's *Photographic Surveying: Including the Elements of Descriptive Geometry and Perspective* (Ottawa: Government Printing Bureau, 1889).

Deville devotes at least the first third of his book to the topic of its extended subtitle. He begins with projective geometry because he realized that surveyors may not have studied the specific mathematics needed to "measure by means of perspectives" and extrapolate physical dimensions from flat photographs. He describes how the spatial contours of a three-dimensional object will appear differently in the two-dimensional plane of

81. FROM THE PERSPECTIVE OF A FIGURE IN ANY GIVEN PLANE, TO CONSTRUCT THE HORIZONTAL PROJECTION OF THE FIGURE.—The method of squares can be again employed in this case. Let QOR, Fig. 108, be the traces of the plane of the figure on the ground and picture planes, and $abcd$ one of the squares of the ground plan. The projecting plane of ad intersects the traces of QOR in Q and L : the vertical projection of the intersection of the two planes being Lq'. Through the station draw a parallel to ad, Lq' : the horizontal projection is sv parallel to ad, the vertical projection is PV parallel to Lq' and the vertical trace, V, is the vanishing point of the intersection of QOR with the projecting plane of ad. The perspective of this intersection is VL : the perspective of the intersection of the projecting plane of cb is VK and all the lines required may be drawn in perspective by carrying the distance LK on the trace OR and joining the points of division to V.

Fig. 108

FIGURE 3.13. Diagram illustrating geometrical projection, printed in Édouard Deville's *Photographic Surveying: Including the Elements of Descriptive Geometry and Perspective* (Ottawa: Government Printing Bureau, 1889).

any perspectival projection. After the basics of linear perspective, he considers the geometrical optics of lenses and dimensional relationships between multiple planes involved in making an image—that of the ground, lens, photosensitive plate, and the visible object. Diagrams and formulas illustrate relationships between points and lines and planes in different rotations and intersections. He outlines, in principle, techniques that could be used to measure a terrain's actual dimensions using only photographic views.

The second third of Deville's book explains how to create photographs whose visual dimensions would be useful for the calculations he has explained. This part of *Photographic Surveying* serves as a remarkable primer on photography more broadly: it explains, for example, specific practices for transporting glass plates, offers formulas for mixing emulsion, and describes techniques for avoiding reflections of light inside the camera. Unlike with other contemporaneous explanations of what was still a relatively new technology, Deville's concern with spatial precision causes him to emphasize the dimensional aesthetics of photography.

138 / *Chapter 3*

Deville considers how the material components of photography mediate not only the visibility of spatial relationships but also the spatial relationships structuring visibility. The specific variables of cameras, lenses, photographic plates, chemical emulsions, and printing processes all inflect how spatial relationships that condition visibility will, in turn, condition how spatiality is visible in a photograph. Some of these impacts are straightforward, though difficult to control. For example, when Deville describes how to enlarge a photograph in a new print, he suggests ways to ensure that the wet paper dries perfectly flat and that "expansion or contraction of the paper is equal in all directions," because any distortions of the paper would alter spatial relationships visible in the image printed on it.[31]

Some inflections of this spatial mediation are more complex, however, and more complicated to address. For example, Deville explains that one reason distant details appear blurred in a photograph is that the thickness of the atmosphere diffuses rays of light rebounding across a larger distance to reach the photosensitive plate. In order to register more distant details more clearly, Deville recommends using plates treated with an orthochromatic emulsion insensitive to red light, and adding an orange screen, limiting sensitivity to wavelengths most involved in the atmospheric diffusion that he calls "aerial perspective."[32] This phrase came to mean something very different in the twentieth century, but for him it suggests how the spatial terms of perspective in the image are inflected by the "air," as a way its thickness or taking up of space shows up without being itself visible. Deville's unusual explanation of photography shows how its dimensional aesthetics far exceed whatever mathematical framework might be applied to measure the spatial surface of the image. His account suggests that the problem in photographic surveying is not that a photograph captures only a flat and limited view but, rather, that the photographer has to carefully constrain and delimit the overwhelming complexity of material, dimensional conditions that inscribe the image and that it inscribes.

Only the last third of Deville's book discusses how to use photographs for making maps. His particular technique, later called the Canadian grid method, plots intersections of perspectival angles across different photographs. Deville outlines a painstaking, manual process for annotating and marking photographs using needles strung with threads. Two photographs showing different views of the same place would be affixed to a flat drawing board and aligned within its space like on a plane table. Thin needles would be inserted into the photographs or on the board outside their borders to identify the physical locations of the camera stations. The surveyor would "pick out points" that "best define[d] the surface, such as ridges, ravines,

streams, crests, changes of slope, etc." in the terrain.[33] These points would be marked on each of the photographs, with numbered dots corresponding in each image. Then the surveyor would string a silk thread from a needle marking a station to a point in one image, affixing the other end of the thread to a paper weight with a rubber band, so the thread could be pulled taut. Once this was completed for the same point in both images, the surveyor would mark where the two threads intersected. Having finished this process for each set of points, the surveyor would place strips of paper across the images to create different paths for plotting a second set of intersections, this time using black silk thread. The virtual weave of these threads resulted in crisscrossing lines whose grid was scaled to distances in the terrain.

Unfortunately, there is little archival evidence of Deville's methods because the images that he stuck pins in, as well as his needles and threads, were considered "process" materials and were not saved.[34] As back matter in *Photographic Surveying*, however, Deville includes several photographic plates to illustrate his method. The last plate is a topographic map of Wapta Lake, and it is preceded by four annotated photographs that were used in creating that map.[35] As a demonstration of photographic surveying, this map also demonstrates the interests these surveys served. The topographic project of which it was part, mapping the Canadian Rocky Mountains, uses purportedly objective logics of mathematically translating terrain into maps in ways that overwrote how it was already the space of Indigenous peoples—who had, for example, given Wapta Lake its name. Photographic surveying articulated particular places within abstract spatial systems in ways that helped incorporate land within national ambitions of territorialization, resource extraction, and political control.

Each of the photographic plates that accompany the map was taken from a different station. One, labeled "View No. 2—from C. Hector Station," shows numbered points marked in black and white ink at peaks along the mountain ridge and along bends of a river in the valley. White lines extend from one elevated point, centered in the image, to draw perspectival rays angling down to meet the parallel lines of a grid latticed across the lake's surface area. These rays suggest the paths of strings stretched from a needle pinned to that point. Across the lake, vertical and horizontal lines of a grid are labeled with letters *a* through *m*, hovering at a fixed elevation. In the accompanying map, the lake is depicted from a point of view directly overhead. Numbered points on the map correspond to those marked in the photograph. A horizontal line near the center of the map, labeled " 2 Hector," and an intersecting vector, labeled "View No. 2," indicate the elevated point from which the white lines of perspectival rays fan down in the photograph

FIGURE 3.14. "View No. 2 from C. Hector Station," photographic plate printed in Édouard Deville's *Photographic Surveying: Including the Elements of Descriptive Geometry and Perspective* (Ottawa: Government Printing Bureau, 1889).

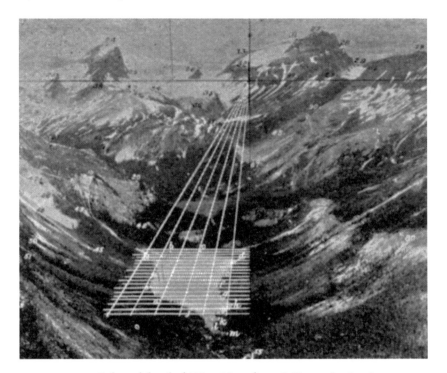

FIGURE 3.15. Enlarged detail of "View No. 2 from C. Hector Station."

labeled "View No. 2 –From C. Hector Station." The lettered grid seen over the lake in the photograph has been rectified in the overhead view of the map so that its lines form regular squares.

The annotated "View No. 2" resonates with the AR overlays of Live View in Google Maps, layering map information on top of a photorealistic "view." This image was only a step toward the goal of the topographic map, however, in which perspectival variations of the photographs would be resolved into the diagram of an overview. That overview gives up the optical verisimilitude of the photographic images that were used to create it. It was not until the much more recent innovations of computational photogrammetry that the verisimilitude and perspectival orientation of the photographic view could be reconciled with the rectified, overarching consistency of the topographical overview.

In some ways, Deville's method constitutes a very different kind of work than traditional topographic surveying. In other ways, it is still a highly embodied technique, with paperweights and threads translating the operations

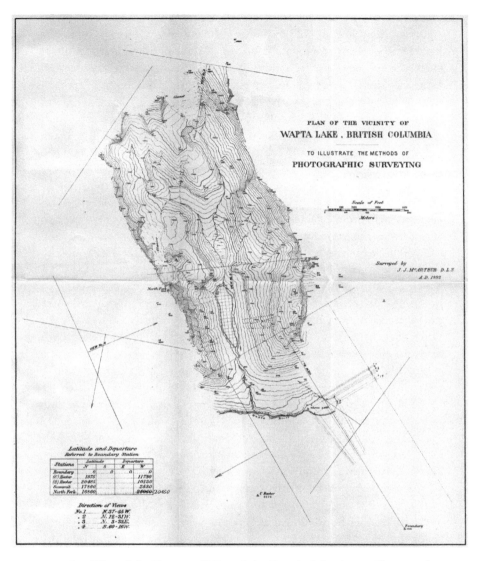

FIGURE 3.16. "Plan of the Vicinity of Wapta Lake, British Columbia, to Illustrate the Methods of Photographic Surveying," printed in Édouard Deville's *Photographic Surveying: Including the Elements of Descriptive Geometry and Perspective* (Ottawa: Government Printing Bureau, 1889).

144 / Chapter 3

that a surveyor would have enacted in the field using tools like a plumb bob and measuring tape. In both techniques, the surveyor uses physical devices that mediate between their perception of spatial relationships and quantifiable expressions of those spatial relationships. Both efforts involve visual and manual tasks of assessment and mark-making. The critical difference, of course, is that the surveyor working with photographs on a drawing board is not "in" the space they survey; its volume and extension are no longer available as the context and data of their embodied perception. Instead, the relational, dimensional expanse of the terrain's contours has to be extrapolated from flat, photographic images.

Deville's method uses the mutually exclusive nature of different views to generate a dimensional model of the terrain that would include and exceed every particular view. The drawing board becomes the context for extrapolating, from the variations between images, whatever coordination could subtend their variations. This process relies on juxtaposing what would otherwise be mutually impossible perspectives within the shared space of the drawing board, making them simultaneous and co-present for the surveyor in this new plane. The terrain is obliquely presented in each image, distorted or deformed by the particular "view" each flat perspective offers. The surveyor uses the plane of the drawing board to mathematically construct the terms of co-presence that would allow for these perspectives to cohere as aspects of the "same" space. With numbered points and strings and bands of paper, the surveyor physically layers an abstract spatiality onto the surface of the images, across the shared surface of the drawing board. Paradoxically, this abstract spatiality is conjured as the "actual" and objective space that the images collectively represent. Anticipating the operations of object and facial recognition that I have described in previous chapters, here the dimensional coordination of a terrain's overall contours appears in a negative register, as a function of the relative deviations in each image.

The surveyor's annotations and calculations coordinate visible points and visual angles by way of what is not explicitly visible. The voluminous space that the images depict is geometrically produced as the relational structure that could subtend the explicit terms of their visibility, without being explicitly presented in any of them. This method conjures a dimensionality that exceeds the flat surface of the photographic image, that is not *in* any photograph, but that seems to structure how each image is articulated relative to the others *as* a perspectival view. The model concretizes what is entirely abstract—the principle of relatedness that binds discrete perspectives as perspectives, with the aim of rendering "objective" dimensions that transcend limits of perspective.

Deville's technique laid the foundations for contemporary photogrammetric practices that also extrapolate between perspectival variations, modeling a virtual spatiality that could objectively coordinate those variations. His practice of identifying specific points in an image that would "best define" the topography of what it depicted, and comparing their perspectival shifts across multiple images, forms the basis for object recognition and feature mapping techniques Google uses to identify "important details" in images like roads and rivers. Even before these developments, his approach provided the framework for the early efforts in facial recognition that I have described in chapters 1 and 2. Woody Bledsoe treated a face as a topographical terrain when he pinned points to the corners of eyes and edges of lips in photographs of the same person seen from different perspectives. Like Deville's surveyors, he extrapolated a mathematical model of the contours that would coordinate these differences. In Bledsoe's effort, this process was meant to allow the "same" person to be identified in any image of them. Both Bledsoe and Google benefited from computational technologies that could automate much of what Deville left to the eyes and hands and mathematical skills of the surveyor.

The abstraction and mathematical complexity of Deville's method was one reason that surveyors were slow to adopt photography, even if they had mastered the "purely photographic part" of taking the pictures. Compared to a process in which distances were measured in the field, photogrammetric methods required preliminary layers of complex calculations to even establish the baseline conditions for making measurements. To determine topography from photographs meant to only laboriously arrive at the terms of voluminous space with which the surveyor in the field would have begun, deriving through calculations what the field surveyor could viscerally intuit. The tipping point for photogrammetry did not come about through efforts to teach surveyors to be better photographers or to make sure they understood projective geometry. Instead, photogrammetry was widely adopted through a different method that seemed to push aside some of this abstraction and recenter the surveyor's embodied perception. New techniques of photogrammetry would return to more perceptual rather than such intensely mathematical approaches to extrapolate the volume missing from flat photographs.

STEREOPHOTOGRAMMETRY

The first phase of photogrammetry was enabled by the invention of the wet-plate photographic process, corresponded with the popularity of

146 / *Chapter 3*

panoramic formats, and was driven by colonial ambitions. The next phase was enabled by the dry-plate process, influenced by stereoscopic techniques, and driven by the development of aerial warfare.[36] Capturing photographs from an airplane instead of by kite or balloon allowed overhead images of terrain to be recorded at controlled elevations in rapid series of consistent spatial intervals. Images made this way could more easily be coordinated to form not just panoramic series but also stereoscopic pairs that could offer a three-dimensional view. As the term and practice of photogrammetry began to be more widely used, its primary methods became those of stereophotogrammetry. Looking at paired photographs through a stereoscopic device, a surveyor could assess a space that seemed more concretely rather than only conceptually voluminous using methods that made sense not just mathematically but also perceptually.

Édouard Deville pointed the way from Laussedat's panoramic methods to the stereoscopic methods that soon followed. Shortly after the 1895 edition of his *Photographic Surveying*, Deville experimented with using pairs of topographical photographs in a device he called a stereo-planigraph.[37] Two images, showing the terrain from related angles, would be placed on vertical panels that faced angled mirrors, in an adaption of a Wheatstone stereoscope. A mapmaker looking into the mirrors, such that each eye saw the reflection of one photograph, could perceptually fuse the reflections into the perception of a three-dimensional image. The mapmaker could mark relative aspects of this perceived image on a screen that could be moved closer or farther from the mirrors. In 1901 Carl Pulfrich used the same principle, but with a Helmholtz reflecting stereoscope, for a device he named the stereocomparator.[38] He termed the stereoscopic view perceived by the mapmaker the "stereomodel," suggesting that it was not simply a view of the terrain but a measurable form whose spatial dimensions modeled those of the terrain. Stereophotogrammetry allowed the operator to trace and measure the perceived, dimensional volume of the stereomodel.

Both the stereo-planigraph and the stereocomparator relied on the principle of the "floating mark," invented by Franz Stolze in 1892, to determine topographical elevation by measuring the parallax of a stereoscopic view.[39] The technique of the floating mark involves the apparent fusion, in the stereomodel, of two "half marks" that are each placed in one of the two images making up the stereo pair: the fused mark seems to "float" in the depth of the three-dimensional image that the viewer perceives. If the half marks are moved closer to or farther from one another in their lateral plane, the floating mark will appear to move between higher and lower elevations in the depth of the stereomodel. If the half marks on the photographs are

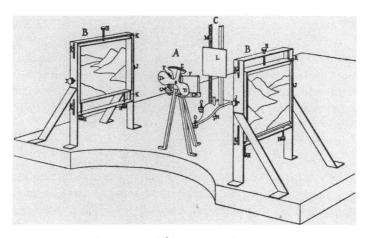

FIGURE 3.17. Illustration of Édouard Deville's stereo-planigraph. Original caption: "Deville's Stereoscopic Apparatus for the preparation of Topographical Maps." Otto von Gruber, *Photogrammetry: Collected Lectures and Essays* (London: Chapman and Hall, 1942), 177.

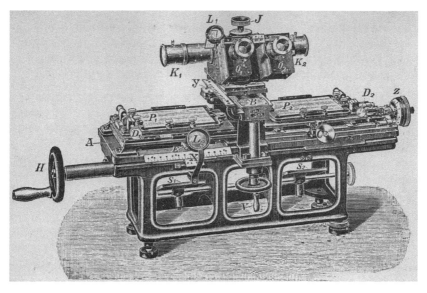

FIGURE 3.18. Illustration of the Zeiss-Pulfrich stereocomparator, ca. 1901. Otto von Gruber, *Photogrammetry: Collected Lectures and Essays* (London: Chapman and Hall, 1942).

148 / *Chapter 3*

moved together, the same distance to the right or left, the floating mark will appear to slide laterally in a single plane of the stereomodel. If the half marks are moved relative to one another, the fused floating mark will appear to slide along an angle that correlates a shifting elevation with shifting horizontal position—as if tracing, for example, along the decline of a mountain's side. With the floating mark, the surveyor could seem to move and measure to some degree "within" the volume of the space they surveyed; this space was virtual but not abstract in the same way as the volume that was mathematically conjured on Deville's drawing board.

The floating mark was also the basis for a different instrumentation that used projected rather than reflected light to create a stereoview that seemed even more materially voluminous. Around 1899 Theodore Scheimpflug developed what he called a "sciopticon," invoking a range of optical devices circulating in late nineteenth-century popular visual culture and perhaps especially the double-projection magic lantern called a "stereopticon."[40] Pulfrich's stereocomparator was designed to achieve a dimensional coordination that doubled magic lanterns had not been used for. It arranged a pair of stereoscopic images, printed on transparent slides, at angles such that lamps behind each image would project beams of light to intersect on a screen in front of them. As with Deville's stereo-planigraph, the screen could be moved closer or farther away, altering what Scheimpflug called the "stereophotogram" that appeared cast onto it.[41] This stereophotogram was like a provisional photograph, a flat image produced by a particular intersection of the light beams by the plane surface of the screen. Scheimpflug's sciopticon pointed to the possibility, however, of viewing not just a stereophotogram but a voluminous stereomodel that would appear rendered in light as a three-dimensional projection.

Following the initial experiments of Deville, Pulfrich, and Scheimpflug, many stereophotogrammetric devices were developed—the stereometer, stereomicrometer, stereoplotter, stereoautograph, autocartograph, stereocartograph, stereoplast, stereogoniometer, and stereotopometer, to list only some. Stereophotogrammetry was how photogrammetry became the standard practice for mapmaking around the globe over the twentieth century. It offered a major advantage over Laussedat's and Deville's earlier method of mathematically calculating perspectival intersections. Instead of mathematically articulating the abstract, geometrical space that could relate different perspectives, the stereoview could make it seem like the contours of the actual terrain manifested through the related images, showing up as a voluminous, perceptible shape. The surveyor using a stereoscopic device was no more "in" the space that they surveyed than the surveyor using Deville's

drawing board would be. But they were able to perceptually grasp and engage with the dimensional relationships of the depicted space in a way that felt more concrete and embodied—more like operations in the field. As with field surveys, they were able to make physical measurements using their own embodied coordination of perceived depth—measuring relationships of volume in which they felt themselves to be positioned and involved.

Stereophotogrammetry anticipates the slippage between image space and object space that supports the immersive model of Live View and Google Earth VR. It also laid the foundations for contemporary forms of photogrammetry in which three-dimensional objects are modeled from images that they do not preexist. From the early to the mid-twentieth century, stereophotogrammetry was used not just to map topographical terrain from images but also to produce spatialized models that translated the contours extrapolated from images back into the plasticity of three-dimensional objects. The history of photographic surveying intersects again here with the histories of object and facial recognition that I have traced in earlier chapters.

Starting in the early twentieth century, some adaptations of stereophotogrammetry took up the aspirations of François Willème's "photosculpture" process, attempting to produce a three-dimensional object from a series of photographic views. In Willy Selke's 1902 patent for a "Photosculpture Apparatus," Selke describes affixing a rod to a stereocomparator, such that an operator moving a floating mark to trace contours of the stereomodel they perceived would, by way of the rod, mark an object in three-dimensional space. Like Willème's process, Selke's used an array of cameras arranged around the subject. His stereophotogrammetric device intervened to replace the pantograph that Willème would have used to manually trace and carve projected profile images. J. H. Smith's 1908 patent for a "Method of Reproducing Objects" also builds on Willème. It describes how to capture images from positions encircling a three-dimensional object and then pair them to assess parallax and produce a topographical model of the object. A mesh of intersecting lines expressing this topography would be projected onto an unshaped sculptural form, such that the sculptor could adjust the three-dimensional contours of the form until the mesh appeared in proper proportion and the shape of the sculpture matched that of the depicted object. This method is a direct precursor to the technique of infrared facial recognition that I discuss in chapter 2, used by iPhone Face ID, which projects an infrared dot matrix on the user's face to assess its contours. In Smith's example, this conflation of portraying a person and mapping a terrain is already emergent in the way he replaces the living subject

150 / Chapter 3

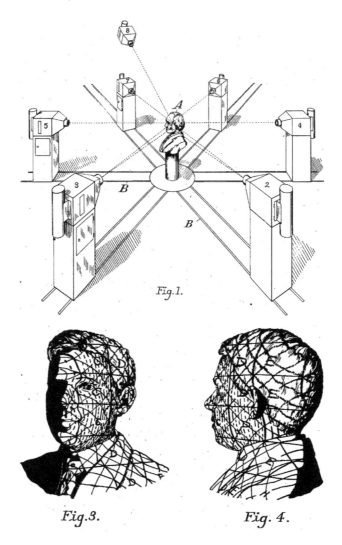

FIGURE 3.19. John Hammond Smith, figure 1 (*top*) and figures 3 and 4 (*bottom*) from US patent #891013A for "Method of Reproducing Objects," 1908.

of Willème's photosculpture with a sculptural bust that he refers to as the "object" to be reproduced.

The sculpting process was further automated with the Zeiss-Bauersfeld stereoplast, patented in 1912.[42] A pair of stereoscopic transparencies were placed on two angled plates, and light was projected through them such that

Visible World / 151

FIGURE 3.20. Prototype of the Zeiss-Bauersfeld stereoplast, ca. 1912. Otto von Gruber, *Photogrammetry: Collected Lectures and Essays* (London: Chapman and Hall, 1942).

the operator could see a floating mark on the "space-image formed from the two plates by means of a visual binocular system attached behind the plates."[43] Similar to the adjustments possible with the stereocomparator, "depth-slides" and "cross slides" were used to manipulate the relative position of the image plates and the floating mark, such that it would "res[t] in contact with the surface" of the space-image (or stereomodel) when the "two images on the plates coincide with images of identical points on the object," and would "remai[n] in contact with the spatial image of the object" when it is moved if the surface of the model "corresponds to that of the object" whose contours it is meant to rearticulate.[44] A sharp "modeling tool" was used to express the position and movements of the floating mark as gestures of carving. Like Willème's use of a pantograph to translate the gesture of tracing an image into the gesture of carving out a clay model, this process translated the operator's gestures of tracing the stereomodel into gestures shaping a physical object. A photograph included in the essay, depicting a prototype of this device, shows it in the process of sculpting a human face, carving it from a solid block of material. Two wheels and a set of binocular lenses suggest the hands and eyes of human operators, but the carving tool is poised in front of an incomplete face that stares blankly in

152 / *Chapter 3*

their absence. This image seems to anticipate how human operators would slowly be pushed out of the loop as later photogrammetric processes would further automate their role and continue to close the circuit between images and objects.

World War I escalated and shifted developments in photogrammetry, and during World War II, stereoplotting from aerial photographs became standard practice in cartography at a global scale.[45] Maps made from aerial perspectives and measuring distances "down to" the ground from aerial positions (rather than, for example, modeling the height of a mountain peak as a topography "of" the ground) supported aerial targeting and the timing of bombs dropped from planes. A multiprojector system called the Multiplex was developed in Germany and in the United States, where Bausch and Lomb began to manufacture a version in 1940. Engineers for the US Geological Survey (USGS) expended considerable resources to invent improved, proprietary versions of this device. The Kelsh stereoplotter, which became standard in the early 1940s, used projected light and optical adjustments to view a stereomodel in anaglyph 3D. Each of a pair of stereo images was projected in either red or blue light, and an operator wore glasses with lenses that filtered either red or blue light for each eye.[46] The operator would align marked points in the images and then use the floating mark method to trace contours in the stereomodel onto a movable transparency. Following the Kelsh stereoplotter, the USGS introduced the ER-55 in 1953. This double, or even quadruple, anaglyph projection system used an oblique projection angle that required first building a precise machine to grind a uniquely oval-shaped lens. To ensure that the ER-55 worked well, the USGS also developed a new machine for printing large-scale photographic transparencies (or diapositives) from negatives.[47] The difficulties faced when using these mid-twentieth-century stereogrammetric systems—with lenses, enlargements, et cetera—extended from the "purely photographic" elements of photogrammetry that Deville had addressed in 1889, still rooted in the optical and physical properties of analog photography.[48]

As with Scheimpflug's earlier sciopticon, midcentury projection stereoplotters intersect without quite aligning with the history of cinematic projection. In the 1950s, Hollywood would use anaglyph 3D for the pop-out effects of popular horror films. These effects could seem to bring voluminous visual elements out from the screen and into the viewer's space. The surveyor using a projection stereoplotter was positioned by the device similarly to the way the viewer of a 3D film was positioned facing the screen, with the film projector behind them. But for the surveyor, the projector was overhead, and they looked down at a flat surface for inscription—like the

Visible World / 153

FIGURE 3.21. Staff working with a Kelsh plotter, a device to make topographic maps, for the Arizona Department of Transportation in Phoenix, 1966. From the collection of the History and Archives Division, Arizona State Library, Archives and Public Records.

sheet of paper placed within reach on a plane table. They saw the projected, dimensional image hovering static in the space below their eyes. Instead of being life-size or larger-than-life, like a monstrous hand reaching out to grab viewers in their movie seat, the image appeared as a smaller-scale model that the surveyor could visually and manually encompass. The surveyor physically traced contours of the image onto the paper below it, moving their hand along virtual shapes they saw in the projection. Adjusting relationships between the two projected images would alter the dimensional structure of the stereomodel, as if its volume had a sculptable plasticity. Instead of a virtual volume that could reach out toward the viewer, the stereomodel seemed to offer a volume that the surveyor could reach into, traverse, and manipulate.

In midcentury projection stereophotogrammetry, the surveyor's embodied perception was integral for the translation they worked from the optical verisimilitude of photographic images to the diagrammatic spatiality of a

154 / Chapter 3

map. The voluminous contours of the terrain that would be rendered on the map were not "in" the photographs or generated by analyzing them through calculations of geometrical projection. Instead, what counted as the "actual" volume of the terrain was produced and perceived through the embodied spatiality of the surveyor. Like anyone using a stereoscope, the surveyor was viscerally interleaved as part of a technical circuit that produced a voluminosity that might *appear* as the very mode of presence asserted by the visual object. Unlike the typical nineteenth-century stereoscope, however, these projection devices enabled a secondary level of image capture or creation, as the surveyor would viscerally trace contours they perceived in the stereomodel to inscribe the material form of the map's image. The map image condensed and abstracted the shape of the terrain it pictured, offering that shape as if extracted from any "view" and presented objectively, in itself. But the contours traced on this map were not drawn from the landscape "itself"; they register a highly contingent and precarious voluminosity, a dimensionality that coordinated multiple perspectives by way of a situated, embodied perceiver.

The role of the embodied surveyor remained central for stereophotogrammetry even as computation came to play a greater role over the second half of the twentieth century. Computational methods in photogrammetry were initially used to mechanize mathematical operations, in ways that followed from the mechanical mediation that instruments like the theodolite offered between physical space and quantitative measurement.[49] The history of photogrammetry is often periodized with a shift from analog to "analytical" methods in the 1960s and 1970s, when computing power made it possible to rework the kind of mathematical strategies that Laussedat and Deville had once used. Their approach relied on traditional surveying methods of resection and intersection but adapted these for photographic images using projective geometry. The surveyor needed meticulous information about the spatial parameters of each photograph in order to mathematically coordinate the perspectival relationships between them—hence Deville's exhaustive discussions of the dimensional aesthetics of photography, explaining how to control and document the relative locations and angles of the aperture, lens, recording surface, ground plane, et cetera. Using computers to solve mathematical problems allowed for a different approach that was more probabilistic than exact. Analytical procedures of photogrammetry relied on the method of least squares—a form of regression analysis used to approximate the best solution without knowing every variable.

The digitization of photographic imaging in the 1990s also made it easier to route photographs through analytic forms of statistical analysis. The fact

FIGURE 3.22. VrTwo Workstation by Cardinal Systems, LLC. Photographed November 15, 2010.

that digitally captured images could be rendered to a digital screen without the intermediary steps of developing negatives, enlarging them, and printing diapositives also eliminated many of what Deville had termed "photographic" problems. Images could be automatically rescaled and redrawn to the screen in ways that solved long-standing restrictions about standardizing scale and focal length in capture and projection. The embodied perception of human surveyors remained central to photogrammetric processes, however, even as computing began to automate more of their tasks. Surveyors using early digital systems may not have been sticking needles into photographic prints or threading strings across them, but they were visually and manually interleaved into a hybrid process that combined the three-dimensional view of stereophotogrammetry with the statistical calculations of analytic photogrammetry. They used updated forms of 3D glasses and custom mouse devices to plot points in images as they interacted with an on-screen stereomodel, and to trace contours of the stereomodel into the topography of a map.[50] Photogrammetric processes at the start of the twenty-first century were in some ways more continuous with the processes of photogrammetry at the start of the twentieth century than they would be with the forms of computational photogrammetry that emerged just decades later.

156 / *Chapter 3*

ALL-NEW IMMERSIVE VIEW

Computational photogrammetry automates operations that had previously relied on how an embodied viewer—either in the field, at the drawing table, or looking through a stereoscopic device—interpreted and coordinated spatial relationships.[51] Computer vision algorithms can select points in images, identify features that correlate points across different images, and test mathematical models that could best account for how a set of multiple, different images might depict the same coherent, dimensional space. Instead of anchoring image relations to a spatial framework that was encoded in the field through fixed stations and careful control of photographic conditions, computational photogrammetry uses artificial intelligence algorithms to generate this framework from the images. Like earlier photogrammetric strategies, this method extrapolates relationships between images. But, because this extrapolation is probabilistic instead of precise, the exact spatial parameters of each image's capture do not need to be known in advance as long as there is a high degree of overlap and repetition. The burden of accuracy no longer rests on the surveyor's ability to control and interpret whatever actual spatial conditions inflect any photographic representation. Instead, accuracy relies on capturing more photographs to compare. Software for computational photogrammetry—like Meshroom, Metashape, and Mapware—aims to offer push-button results from large sets of images. Mapware's website boasts: "Thousands of photos? No problem. [. . .] Just upload your photos, push the process button and your model is ready for you in multiple formats."[52]

In some ways, computational photogrammetry reaches back before stereophotogrammetry to the abstracted operations of Deville's drawing board. But it is almost as if the drawing board itself has been abstracted to relate many more images with many more strings, surfacing intersections between different, overarching spatial models. Deville's photographic surveyor may have put a pin in a mountain's peak in a photograph instead of climbing there, but the manual and visceral tasks performed on the drawing board reactivated some of the spatial interdependencies that field measurements involved. When someone uses a software program for computational photogrammetry, they are relieved not only of any embedded involvement within the space of the field they would survey, but also of their visceral involvement with the spatiality of the images serving as its proxy.

Processes of computational photogrammetry might not route explicitly through embodied human vision until the spatial model is visualized as an image delivered to a viewer. This imaging could take the form of an ortho-

mosaic, a flat tessellation of visual information into what looks like an aerial view but has the "rectified" dimensions of a map. But, because relationships between multiple perspectives are being modeled rather than simply reconciled, computational photogrammetry can also be used to produce a virtual object that molds photographically recorded imagery to a three-dimensional structure matching the contours of what those images depict. And it can be used to produce two-dimensional images whose perspectival structures posit specific vantage points within or relative to the modeled space. These results simulate and reinject what the processes of photogrammetry worked to strip out—the conditions of an embedded perspective that kept photographs from being maps in the first place.

From the first efforts at incorporating photography into mapmaking, the goal was to use measurements from photographs to calculate a mathematical model of space and draw a map. But in computational photogrammetry, the goal has changed or come full circle: maps and topographical models are produced with the optical verisimilitude and perspectival specificity of photographs. This process pushes past the endpoint of the topographical maps Deville drew from his lattice of strings or those that mid-twentieth-century surveyors traced from a stereomodel. It uses the abstract methods of Deville's drawing board as well as the three-dimensional conceits of stereophotogrammetry to produce something like a virtual stereomodel that would seem to contain and reconcile many more than the two perspectives of a stereopair. This model seems to virtually contain the almost infinite perspectives that would have been available to the surveyor "in the field."

The simulation of perspective in computational photogrammetry allows for a form of dimensional modeling that goes beyond the framework of a map or a photograph. It generates what could appear not just as an embodied and embedded view, but also as a recapitulation of *the relational structure of spatiality* in which multiple views could take place. Implied in this operation is that any perspectival view could be derived from the photogrammetrically extrapolated model—as if the model correlates with an objective dimensionality that precedes and includes all possible perspectives. In other words, computational photogrammetry seems not just to map space, making its structure visually graspable, but to make the structure of spatiality visible— in the very way that it self-organizes and manifests *as* visible space. Computational photogrammetry can seem to record and render how the world's dimensional space actually holds together, representing the way every aspect coordinates and making every perspective mutually available.

Google Maps' use of computational photogrammetry suggests that this modeling not only recapitulates the world's space but also makes explicit

158 / *Chapter 3*

how all its aspects coordinate and make sense relative to the user. In May 2022 Google announced "new ways the latest advancements in AI are transforming Google Maps," including "an all-new immersive view of the world" that began rolling out for major cities like London and New York in 2023.[53] Building on the AR features introduced with Live View in 2019, and on the interaction design developed for Google Earth VR in 2016, this "more immersive, intuitive map" allows users to more seamlessly move between what would otherwise constitute discrete layers of the platform.[54] They can "soar" over a neighborhood (as in satellite view) to survey it from above; "glide down to street level" (as in Street View) to see what businesses are open; and virtually "look inside" a restaurant (as in Live View) to "get a feel for the vibe of the place" before making a reservation. Google claims that the newly immersive map lets you "feel like you're right there before you ever step foot inside" where you are headed so you can "make the most informed decisions before you go."[55] The feeling of being "right there" hinges on how an embedded view, with perspectival and optical verisimilitude, is fitted within the conceit of an overarching, dimensional model that seamlessly interrelates different vantage points.

This "whole new way to explore with Maps" uses computational photogrammetry to deliver the world in a more user-friendly way than the world presents itself. The "more immersive" view it offers more explicitly quantifies and simulates the interconnections that would seem to hold the world together and make it visibly cohere. It instrumentalizes the contingency of the viewer's own involvement in that ongoing coordination, simulating immersion in a fully externalized world that would have no "inside." The conceit of immersion remains only to suggest that being "in" a world works in the way the model models.

Like the clickable arrows that mark Pegman's path, the spatial relationships that seem to embed the viewer within the spatiality of the map in this "all-new immersive view" are concretized facets glued together along prescribed routes. The world is posited as a spatialized structure of information that one might navigate through limited frameworks of selection and extraction, choices about consumption and optimization. What counts for Google Maps as "the most helpful information about the real world" is the information most relevant to consumer decisions. The map interrelates features that would help you optimize how you spend time and money, help you plot the fastest route to the highest-rated restaurant.

Google's rearticulation of Earth's actual spatiality into the infinitely explorable model of Google Maps correlates with how Google's broader conceit of "searchability" would index and map every atomizable bit of

information about the world into a quantifiable, spatialized structure of interreference. This paradigm overwrites whatever relational structure may be constituted by the way things materially exist relative to one another—the coordination of coexisting in some shared expanse of time and space that constitutes the world as such, in the most basic sense—with an extracted and simulated version of this coordination. It is a contemporary form of the "rational spatial colonialism and domination" that has used cartography, as Katherine McKittrick reminds us, in service of capitalism's "profitable erasure and objectification."[56] Modeling space through mathematical relationships of spatial coordination—quantifiable relationships of points and positions—suggests that a world *is* the pure externality of how its measurable space coordinates. This notion treats mathematical correlation as the very terms of *relational coexistence* instead of admitting it could only be the representation, through measurements and models, of the material dimensions through which this coexistence takes place.

Computational photogrammetry blends photography and computation in ways that seem to solve a long-standing problem with visually representing space, as if it is finally possible to reconcile the overarching, objective integration of all possible views with the situated, perceptual specificity of each. Within this logic, to concretize how everything interrelates would be to surface what is most important and make the world easier to grasp. But the synthesis being offered is not that of a world or its visibility, because it would unbind the dimensional relationships that hold the world together by spacing it apart.[57] There is no entirely, explicitly visible world. The overarching continuity that Google Maps constructs disarticulates the contingencies that constitute a world as such: the space of the world is nothing but the irreducible, ongoing interrelation of everything and everyone "in" it.

SPACING

If Google Maps promises its user an immersive view of the world's actual space, Andreas Gursky's *Ocean* series does almost the opposite. Seeming to offer accurate and yet impossible views of the planet, it suggests why our world could not be entirely seeable. It stages something not presentable: the spacing and depth that allow a world to coordinate as such, beyond the explicit terms of any visible presentation.

As a series, the six *Ocean* images raise the question of how they might add up. Hung together around the white walls of a gallery, irregular blue shapes tipped with green and white, they seem like pieces of the same puzzle, fragments of a globe wrapped around the viewer. Sharing the title

FIGURE 3.23. Andreas Gursky, *Ocean VI*, 2010. C-print. *Framed,* 134¼ × 98¼ × 2½ in. (340.9 × 249.4 × 6.4 cm). © Andreas Gursky / Courtesy Gagosian / Artists Rights Society (ARS), New York, 2024.

Ocean, they even suggest how Earth's oceans are ultimately interconnected; it is only the places that they space that make oceans appear framed as individual bodies of water. But, looking at these images, there is no easy way for the viewer to identify them individually or fit them together. They invite and frustrate a desire to interpret them as parts of the "whole" world we think we know.

By refusing to make sense either as related panels of a world map or as optically recorded views of the planet, the *Ocean* series reexposes a tension between maps and photographs that photogrammetry has made increasingly easy to forget. It reemphasizes the singularity of any perspectival coordination and the role of the embodied perceiver in structuring what appears as the dimensional coherence of objective space. These were both critical for the development of photogrammetric strategies that now seem to overwrite or virtualize their material conditions. Photogrammetry *relies* on the gaps that space discrete perspectives to produce models that cover over those gaps. A photogrammetric model of space is extrapolated from the perspectival variations of photographs. It is the strict incompatibility between these perspectives that allows for their dimensional interdependence to be deduced, and modeled as a mathematical volume that seems to reconcile all perspectives. The volume that seems to objectively consolidate in the model was not "in" the photographs but coordinated between them; and up until computational photogrammetry, this coordination relied on an embodied, situated perceiver who interpreted the spatiality of the photographic "views" in terms of their own spatialized view. All of this gets forgotten when the photogrammetric model seems to contain not just the potential, mathematical coordination of different perspectival projections but the actual, optical specificity of all possible embedded views.

Computational photogrammetry's spatial modeling reifies relationships between perspectives in a way that denies the mutual contingencies of discrete views—the very limits that allowed the perspectival relationships between different photographs to express, in a negative register, the voluminosity that held them apart. Instead, this modeling suggests that all perspectives coexist as mutually visible in principle, objectively interrelated, equally accessible and available to be made explicit—as if perspectival difference could be constructed from the synthesis of the model, because the model restages the complete, objective self-coordination of space itself. This framework deracinates the dimensional structure of spatiality that allows anything to take place and be visible only *through* its delimited placement and visibility.

The *Oceans* images present as photographic in a way that unsettles how the optical and perspectival verisimilitude of a photographic image might

162 / Chapter 3

seem to translate between the objective space of the visible world and the embodied spatiality of an actual view. Depicting oceans as viewed from directly overhead, the *Ocean* images exaggerate the perspectival confusion that Gursky's work almost always involves. In an image with a more typical perspectival organization, a vanishing point might seem to draw the viewer's gaze toward the center and a distant horizon that seems to open beyond the image, on its other side. But the darkest blues that pool in each *Ocean* image suggest an unfathomable distance to the ocean floor. This is not the depth of a virtual space that a viewer could imaginatively step into, toward a receding horizon. Neither is it the depth of a topographical map, a top-down expression of measurable volume and contours. The swirling blues Gursky has digitally painted at the surface of his oceans communicate depths that remain resolutely at the surface and as a surface for the viewer. Gursky's painstaking rendering of these blues further complicates what they seem to mean. The darkest blues of Gursky's oceans communicate depths that were not optically recorded, simulating a visual realism that compensates for the lack of detail in available satellite imagery.

By centering water instead of land, the *Ocean* series conjures the idea of the whole world by way of the in-betweenness that would hold that whole together. It foregrounds and singles out what might otherwise recede as the shapeless context against which the shapes of places appear. On a world map, all Earth's continents are gathered into the simultaneity of a shared picture plane. Mutually unseeable sides of the planet are made visible together by taking away the volume of the earth that holds them apart. What connects the continents across the abstract space of the map is the blue background they share; it signifies a general spatiality that allows the map's conceit. Instead of gathering the world together by way of its representation, this series looks toward the gaps of how a world spreads out, suggesting this spacing could not be entirely fused or entirely disarticulated. Instead of using visual mediation to produce an objective synthesis of Earth's material surface, these images undermine that concreteness, surfacing a liquidity and an opacity that would escape its framework.

Instead of seeming to show you how the world itself objectively coheres, beyond the limits of your own subjective and embodied view, these images throw you back upon the spatialized and situated terms of visibility as you try to position yourself to make sense of them.[58] By refusing to show you the world you are in, they push you back to the embodied experience of being where you are, already enworlded and looking at the world "from the inside" even if you cannot fully grasp it as an image "from the outside." They leave you with the work of trying to imagine how the whole

world actually appears, extrapolating the coherence these images refuse to present.

The alienating effects of the *Oceans* images suggest how rendering the world entirely visible from within that world is not a technological or an aesthetic problem relating maps and photographs. Instead, the limits of perspective in using photographs for maps disclose a paradox that conditions embodied seeing and aesthetic representation: perspective articulates the situated conditions of seeing the world from within that world. The incompatibility between one point of view and another is what allows a world to open beyond and through each. To fuse visual imagery into an explicitly visible world would be to unravel what allows that world to take place as a spacing of discrete views instead of a spatialized structure of visual information. As the *Ocean* series suggests, fusing maps and photographs might seem to render the visible world as it truly manifests, beyond the limits of our situated perspective, and yet also in terms of embedded views we could make sense of within the framework of our embodied look. But attempting to visually rearticulate how the whole world holds together—so that we might somehow see our own vantage point from our own vantage point, encounter how we are situated—conjures a world whose terms of visibility would exclude us.

ENTRELACS IV

Other Landscapes

World maps present what is otherwise unpresentable: the whole world. To be a world is to coordinate many disparate things as interrelated parts of the same. So, a world is defined by how it constitutes a whole, a closed system, a cosmos. But how could the wholeness of a world ever take place or be graspable—how can it even be said to exist as anything other than an abstraction or a principle—if any way of staging or perceiving it would fail to account for the ongoing contingency of how all its parts interrelate?[1] The question of how the world takes place or appears coordinated as "the world" iterates the paradox that Maurice Merleau-Ponty finds in the way that even any single object—like a cube—appears to cohere. If the coordination of a cube's six faces is not actually presentable or graspable as all-faces-at-once, then how could we presume to see or know the whole world?

The problem of how one object's visibility is spread across mutually exclusive perspectival views expands to the problem of how the whole world would constitute a synthesis of all its possible presentations. In *The Phenomenology of Perception*, Merleau-Ponty asks:

> how could I have the experience of the world as an actually existing individual, since none of the perspectival views I have of it exhaust it, since its horizons are always open, and since, on the other hand, no form of knowledge—not even science—gives us the invariable formula of a *facies totius universi* [face of the whole universe]? How might anything ever be *presented* to us definitively, since the synthesis of it is never completed [. . .]? And yet, there is something rather than nothing.[2]

No one thing can be fully and definitively presented to our perception; and anyone hoping to come face-to-face with the "face of the whole universe" is bound for disappointment. While science offers ways to describe what

166 / *Entrelacs IV*

exists and to extrapolate its principles, that is not the same as rendering all of existence perceptually present. But if we cannot grasp the world completely, then we do not grasp whatever completion and self-enclosure the concept of "world" names. So, it would seem like a paradox that "there is something rather than nothing."

If we have only incomplete access to everything that is, are we forced to accept our partial reckoning as good enough, as close as we can come to any full account? Merleau-Ponty imagines how someone, upon realizing that "we are never in a position to take stock of everything objectively," might complain: "*is that all there is to it?* [. . .] to call 'Being' that which never fully is?"[3] He avers that "this disappointment issues from that spurious fantasy which claims for itself a positivity capable of making up for its own emptiness. It is the regret of not being everything, and a rather groundless regret at that."[4] The world's "horizons are always open"; the perceiver's are as well. In other words, the desire to grasp the world completely and definitively as self-enclosed, to see the face of the universe, is also the perceiver's wish to be self-complete in a way that does not open onto the world, to exist face-to-face with themselves as self-enclosed.

The groundless regret at not "being everything" assumes a groundless subjectivity. A dissatisfaction that demands everything—both a subjectivity and a world that could exist in purely positive terms with no blind spots—would, paradoxically, turn something into nothing. Merleau-Ponty insists that the ability to "take stock of everything" would not deliver the world to us but derealize it and unworld us:

> If the synthesis could be actual, if my experience formed a closed system, if the thing and the world could be defined once and for all, if spatio-temporal horizons could (even ideally) be made explicit and the world could be conceived from nowhere, then nothing would exist. I would survey the world from above, and far from all places and times suddenly becoming real, they would in fact cease to be real because I would not inhabit any of them and I would be nowhere engaged. If I am always and everywhere, then I am never and nowhere.[5]

What would seem to emerge and stabilize concretely and within grasp as the "real" world rather than merely its abstraction would no longer bear the relationship of a world to the one who would grasp it as such. To stretch out the world before us, so that we might have it "once and for all," would be to radically disengage from it and cast it out of reach.[6] If I claim for myself a form of seeing that is not limited by my own embodied instantiation as a seer in the world, then what I take hold of as the world's apparently objective presentation could only be an abstraction that I conjure and

invest as definitive. The viewer who is intent on "installing himself in pure vision, who makes himself a visionary," as Merleau-Ponty puts it, will only be "thrown back to his own opacity as a seer and to the depth of being" because the only "access to the things themselves" is "through opacity and this depth, which never cease: there is no thing fully observable, no inspection of the thing that would be without gaps and that would be total."[7] Visibility is conditioned by relational limits that structure not just seeing but Being.

If Being is structured by depth and opacity, not given in terms of a purely positive presence, then I could not "completely" grasp it except through engaging with its dimensionality. Merleau-Ponty describes this engagement as being "caught up" in rather than soaring over the world we would like to survey. He insists that "[no] more than are the sky or the earth is the horizon a collection of things held together, or a class name, or a logical possibility of conception, or a system of 'potentiality of consciousness': it is a new type of being, a being by porosity, pregnancy, or generality, and he before whom the horizon opens is caught up, included within it. His body and the distances participate in one same corporeity or visibility in general, which reigns between them and it, and even beyond the horizon, beneath his skin, unto the depths of being."[8] Instead of a positive subjectivity whose vision penetrates to "the hard core of being," my embodiment of vision allows for "a zone, a hollow, where what is not inessential, not impossible, assembles" as visible.[9] The porousness of the world and of my own embodiment are consonant and constitute the opening of each onto the other.

To think about how the world appears for the seer who is part of it, rather than the "visionary" who would position themselves outside of it, Merleau-Ponty sometimes uses the metaphor of a landscape.[10] "My" landscape is the world as it appears self-coordinated, but from my vantage point, shaped around me as my context. A landscape is almost the opposite of a map. It does not purport to show the objective topography of terrain. Instead, it names how material elements—hills or trees, a cliff or a valley— seem to organize in a particular arrangement, as a place with its own internal order. A landscape is a way land seems to have been sculpted or shaped, how it seems to assemble related features as aspects of its overall structure. A landscape could be how a particular viewer sees a place but also how that place presents itself organized as or for a particular view. A painter could paint the same place as any number of landscapes—different ways that its apparently objective contours appear interrelated and to afford different perspectives.[11]

168 / *Entrelacs IV*

Because the world extends beyond me and is not just mine, "there are other landscapes besides my own."[12] The world is the common ground for all these landscapes but not something they add up to in any lateral juxtaposition or concatenation, their horizons edge to edge. My landscape and another's landscape are different coordinations of the same world. The "whole world" that could include them both could not produce its wholeness by reconciling them into one larger landscape that is neither mine nor theirs. It would have to hold them together in another way, coordinating mutually exclusive aspects of a spatiality that could not be objectively synthesized.

To map and model the whole world as if its every aspect could be made explicit in relation to all others is to invite a profound alienation. From the photographic techniques developed to map empires to the global reach of Google Maps, techniques used to visually model the world's objective coordination propose ways we might grasp and know and take actions about the "other landscapes" that seem accessible from and continuous with the "here" of our own. But to reify how "here" and "elsewhere" relate would close the horizons that not only keep "elsewhere" at a distance but also constitute the dimensions of "here" and keep them open. Limits of perspective and point of view that structure my "insertion into the world-as-an-individual" are, Merleau-Ponty insists, "much less a limitation on my experience than a way of inserting myself into the world in its entirety"—my means of engaging what exceeds me.[13]

The unseeable aspect that seems to open beyond the limit of the current horizon is not elsewhere in the sense of a lateral extension. But neither is it an emptiness or a blank spot waiting to be filled. The relationship between one landscape and another is a dimensional coordination, relating what would seem mutually exclusive through what Merleau-Ponty calls "a certain *divergence (écart),*" or chiasmatic reversal. Efforts to make maps from photographs encounter this paradox, as images from different vantage points render mutually exclusive perspectival coordinations that cannot be added up to a whole. Using geometrical projection to reconcile discrete perspectives forgets that such irreducible differences are not problems at the level of visual representation but rather structurations of visibility and the world's appearance—what Merleau-Ponty calls quilting points in "the upholstering *(capitonnage)* of the world."[14]

In a working note for *The Visible and the Invisible* titled "World," Merleau-Ponty defines a world as an "organized ensemble" that is "whole" and "*closed*" but specifies, also, that "'[a] world' has dimensions": "*dimensions,* articulation, level, hinges, pivots, configuration."[15] A world's dimen-

sions "are more than singularities of content" but, rather, "have the value of an inner framework." How that framework organizes is mutable, altering the configuration of the world. He uses the example of a shift from two to three dimensions—spatial elements that seem "separated" in a two-dimensional construct might appear "connected" in a three-dimensional formulation. He describes this "passage" into a different dimensional coordination as the "*Urstiftung* [originary foundation] of a meaning, reorganization."[16] It does not add or subtract elements but transforms how elements appear articulated as such, and what whole they seem to co-articulate through their interrelation. It does not create a new world or replace one with another, but instead allows other worlds to coexist as latent within or emergent from the same world. These other worlds appear as objective coordinations, but they are also different ways things organize as sensible and appear to make sense. Like "other landscapes," they seem to signify meaning that is not beyond the world but is, rather, the world's self-expression.

Attempts to map out and make visible the world's inner framework—presenting it through a logic of representation—threaten to overdetermine the radical contingency of its relational hinges and gaps. In order for a world to be an ongoing coordination of everything that makes it up, its elements would have to relate in a way that is not just the pure externality of spatialized parts juxtaposed or fused into a whole. Instead, all the world's aspects would be co-articulated, interrelated, without those relationships being themselves concretized. These relationships serve as quilting points that coordinate the world as such. They are not voids, but neither are they presentable connections, externalized as positive links between co-present elements.

Closing these gaps to make the whole world visible as such—to get at the everything of it, grasping how it holds together and adds up—reduces it to the sense one landscape could be seen to make. It forecloses the other ways of making sense that the world itself could seem to posit, by appearing to cohere otherwise—not as another world, but an other way of seeing and being in this one. The fact that every image can offer only a partial view is not a problem to solve by concatenating images or abstracting their coordination. It is a limit that reasserts itself through every discrete form of aesthetic mediation. It is at that limit, "at the joints where the multiple entries of the world cross," that this world is woven, and other landscapes remain to be seen.[17]

Acknowledgments

Any way to write out acknowledgments seems to narrate them into a timeline, map them into categories, and order them into hierarchies that get gratitude wrong. Every debt is singular. And yet kindnesses redouble and overlap in ways that cannot be singled out. I apologize for only listing names, and for all those I have failed to list. I apologize for the repetition below but also for not repeatedly naming those whom I would thank for almost everything.

Thank you to my family, especially Laura Belisle and Chris Esposito. Thank you to brilliant interlocutors whose ideas and efforts have solicited and supported mine throughout this project, especially Kris Paulsen, Scott Richmond, James J. Hodge, and Kris Cohen. Thank you to Linda Williams and Kaja Silverman, my doctoral advisors, for intellectual and personal generosity over more than a decade. Thank you to Daniel Morgan for the mentoring I needed to finally write the book; and to Todd Barnes and Shane Denson for gracious help and advice in pivotal moments.

Thank you to many colleagues, including some already named, who read parts of this book in progress or heard chapters given as talks and provided valuable feedback, especially Vivian Sobchack, Thy Phu, Kenneth White, Soyoung Yoon, Erica Levin, Greg Zinman, Ariel Rogers, Joshua Neves, Tung-Hui Hu, Patrick Ellis, Daniel Menzo, and Kaya Turan. Thank you to Jeff Schieble and Karen Redrobe for soliciting and editing the chapter "From Stereoscopic Depth to Deep Learning" that I contributed for their volume *Deep Mediations* (University of Minnesota Press, 2021), which grew into chapter 1 of this book. Thank you to the people and institutions who invited me to present work in progress, helping me develop this project, especially Stephanie Dinkins, who brought me as a "plus-one" to the Decolonizing AI project, Massimo Riva and Fulvio Domini at Brown

172 / *Acknowledgments*

University, the Seminar in Media Aesthetics at Northwestern University, the Emerging Global Media Lab at Concordia University, the Art and Objects Seminar at Princeton University, the Seminar on Cinema and Interdisciplinary Interpretation at Columbia University, and the GeoHumanidades Project at Pontificia Universidad Católica de Valparaíso.

Because this book is not a revised dissertation, it was possible only because of postdoctoral fellowships that allowed time away from teaching. I am grateful for the opportunities I received as an American Council of Learned Societies / Getty Foundation Postdoctoral Fellow in Art History, an American Council of Learned Societies New Faculty Fellow, and a National Endowment for the Humanities Postdoctoral Fellow in Visual Culture at the Library Company of Philadelphia. Thank you also to Stony Brook University for a Trustees Faculty Award and FAHSS grant supporting this book.

The research for this project relied on many archives and libraries, including the George Eastman Museum and Archives, Library and Archives Canada, the Library of Congress, the Photography Collection of the New York Public Library, the Library Company of Philadelphia, the Boston Athenaeum, the Kheel Center at Cornell University, the Briscoe Center at the University of Texas at Austin, the Eadweard Muybridge Collection at the University of Pennsylvania, the Bancroft Pictorial Collection at the University of California, Berkeley, and the Metropolitan Museum of Art. I am grateful to all the librarians, archivists, and curators who shared their expertise—especially Erika Piola and Jill Delaney. Thank you to the institutions, artists, galleries, and photographers who allowed their images to be reprinted—especially Benedict Winkler at the Gagosian London for patient assistance and Trevor Paglen for granting permissions with no strings attached. Thank you to D. L. Cui for brilliant editorial work, to Liz Heise-Glass for assistance in obtaining images and permissions, and to Laura Sisti for managing all the fine print, as always. Thank you to Sam Warren, Erica Olsen, and everyone I worked with at the University of California Press but most especially to Raina Polivka for her powerful encouragement and hard work in support of this project.

Thank you to teachers and advisors from my time at Berkeley, Princeton, and NYU, whose scholarship and mentoring continues to inform my work, especially Kristen Whissel, Shannon Jackson, Mark B. N. Hansen, and Douglas Rushkoff. And thank you to mentors I found at Stony Brook, especially Michele Bogart, Meg Schedel, E. K. Tan, Krin Gabbard, and Raiford Guins. I am grateful to Raiford for recruiting me as an editor of the *Journal of Visual Culture* and to Joanne Morra and Marquard Smith for teaching me so much in our work together there. Thank you also to scholars whose

work has inspired mine and who have offered kind encouragement, especially Shawn Michelle Smith, Alison Griffiths, Laura Wexler, and Paula Amad.

I am immensely grateful for intellectual friends and colleagues from whom I continue to learn, whose small gestures of support, huge acts of kindness, and ongoing investments in collaboration have all mattered: especially, in addition to many already named, Izumi Ashizawa, Jennifer Bean, Isak Berbic, Stephanie Boluk, Irene Chien, Robert Crease, David Eng, Kris Fallon, Barbara Frank, Jacob Gaboury, Oliver Gayken, Leon Gurevich, Patrick Jagoda, Patrick Keilty, Homay King, Sohl Lee, Patrick LeMieux, Karen Lloyd, Shannon Mattern, Rahul Mukherjee, Julie Napolin, Gerard Passanante, Zabet Patterson, Paul Roquet, Paul Rubery, Amy Rust, David Smucker, Nicole Starosielski, Benjamin Tausig, Domietta Torlasco, Andrew Uroskie, Andrew Weiner, and Eric Zolov. And thank you, for sustained and sustaining friendship, to Kim Kennemer, Paul Waggoner, and Kasey and Aron Traub.

This book is dedicated to Warren.

Notes

INTRODUCTION

1. My argument about the spatial implications of AI-enabled imaging techniques develops a line of thought pursued by other scholars who, before those recent advances in AI, were already asking how dimensional strategies in computational imaging were reframing the longer history of perspective and spatial mediation in visual representation. See especially William Uricchio, "The Algorithmic Turn: Photosynth, Augmented Reality and the Changing Implications of the Image," *Visual Studies* 26, no. 1 (March 2011): 25–35; Thomas Elsaesser, "The 'Return' of 3-D: On Some of the Logics and Genealogies of the Image in the Twenty-First Century," *Critical Inquiry* 39, no. 2 (Winter 2013): 217–46.

2. My argument about computational imaging, as distinct from digital imaging, picks up from but also intervenes in a discourse about the "postphotographic" that began in response to digitization in the 1990s (see, for example, William J. Mitchell, *The Reconfigured Eye: Visual Truth in a Post-Photographic Era* [Cambridge, MA: MIT Press, 1992]) and was further elaborated in relationship to computation in the early 2000s (see, for example, Mark B.N. Hansen, "Seeing with the Body: The Digital Image in Postphotography," *Diacritics* 31, no. 4 [Winter 2001]: 54–84; Fred Ritchin, *After Photography* [New York: W.W. Norton, 2009]). This discourse asked how—for better or worse—the displacement of analog, chemical photography by electronic, digital imaging platforms "reconfigured" a long-standing, humanist analogy of eye-as-camera, possibly toward "posthuman" imbrications of, as Hansen has phrased it, "bodies in code." I would argue that we are not yet "after" photography—which has always had mutable formats—and that digitization laid the foundation for a more thorough and radical reworking of visual mediation through the computational imaging processes only recently enabled by artificial intelligence. Recent work rethinking photography along these lines has begun to consider how it functions enmeshed within computational platforms, in ways that upend assumptions about medium specificity that have shaped theories of photography both in art history and in media studies. See, for example, Martin Hand,

176 / *Notes*

Ubiquitous Photography (New York: Polity, 2012); Tomáš Dvořák and Jussi Parikka, eds., *Photography off the Scale: Technologies and Theories of the Mass Image* (Edinburgh: Edinburgh University Press, 2021); Adrian MacKenzie and Anna Munster, "Platform Seeing: Image Ensembles and Their Invisualities," *Theory, Culture & Society* 36, no. 5 (2019): 3–22. To some degree, reconceptions of photography in our computational context rediscover capacities that have always been evident to scholars of photography's early history: the way any individual image may function as what Alan Trachtenberg has called "a datum," "no more than a single variable within a set of categorial regularities," or within what Jonathan Crary has called "a combinatorial logic" that undermines "the self-sufficiency of an autonomous image." See Trachtenberg, "Albums of War: On Reading Civil War Photographs," *Representations*, no. 9 (Winter 1985): 5; Crary, *Suspensions of Perception: Attention, Spectacle, and Modern Culture* (Cambridge, MA: MIT Press, 1999), 147.

3. I have written about the relationship between computational aesthetics and nineteenth-century stereoscopic and panoramic formats in previously published essays, especially "Depth Readings: Ken Jacobs' Digital, Stereographic Films," *Cinema Journal* 53, no. 2 (February 2014): 2–26; "Nature at a Glance: Immersive and Interactive Display from Georama to Reality Deck," *Early Popular Visual Culture* 13, no. 4 (Winter 2015): 331–35; "Picturing Networks: Railroads and Photographs," in "Network Archaeology," special issue, *Amodern* 2 (October 2013), https://amodern.net/article/picturing-nineteenth-century-networks/; "The Dimensional Image: Overlaps in Stereoscopic, Cinematic, and Digital Depth," *Film Criticism* 37, no. 3 (Spring/Fall 2013): 117–37; "The Total Archive: Picturing History from the Stereographic Archive to the Digital Database," *Mediascape* (Winter 2013), www.tft.ucla.edu/mediascape /Winter2013_ PicturingHistory.html.

4. Michel Foucault, *The Order of Things: An Archaeology of the Human Sciences* [*Let Mots et les choses*, 1966] (New York: Random House, 1994); Michel Foucault, *The Archaeology of Knowledge* [*L'archéologie du savoir*, 1969], trans. A. M. Sheridan Smith (New York: Random House, 1972); Walter Benjamin, "On the Concept of History," *Selected Writings 4*, ed. Howard Eiland and Michael W. Jennings (Cambridge, MA: Belknap Press of Harvard University Press, 2003), 389–400.

5. Walter Benjamin, N, 1, 8, *The Arcades Project* (Cambridge, MA: Belknap Press of Harvard University Press, 2003), 458, quoting Rudolf Borchardt's *Epilegomena zu Dante*, vol. 1 (Berlin: Rowohlt, 1923), 56–57.

6. I am especially indebted to the pioneering scholarship of Linda Williams, Kaja Silverman, Vivian Sobchack, and Mark B. N. Hansen, which has explicitly drawn on Maurice Merleau-Ponty's phenomenological philosophy to theorize aesthetics of photography, cinema, and digital media. See, in particular, Williams, "Motion and E-motion: Lust and the 'Frenzy' of the Visible," *Journal of Visual Culture* 18, no. 1 (April 2019): 97–129; Silverman, *The Miracle of Analogy: The History of Photography, Part 1* (Stanford, CA: Stanford University Press, 2015), *World Spectators* (Stanford, CA: Stanford University Press, 2000), and

The Threshold of the Visible World (New York: Routledge, 2013); Sobchack, *The Address of the Eye: A Phenomenology of Film Experience* (Princeton, NJ: Princeton University Press, 1991) and *Carnal Thoughts: Embodiment and Moving Image Culture* (Berkeley: University of California Press, 2004); Hansen, *Bodies in Code: Interfaces with Digital Media* (New York: Taylor & Francis, 2006). I share this intellectual lineage with a generation of media scholars who were their students, as our work draws on phenomenology to think about media aesthetics across art history, film studies, and new media. See, especially, Domietta Torlasco, *The Heretical Archive: Digital Memory at the End of Film* (Minneapolis: University of Minnesota Press, 2013); Homay King, *Virtual Memory: Time-Based Art and the Dream of Digitality* (Durham, NC: Duke University Press, 2015); Scott Richmond, *Cinema's Bodily Illusions: Flying, Floating, and Hallucinating* (Minneapolis: University of Minnesota Press, 2016); Kris Paulsen, *Here/There: Telepresence, Touch, and Art at the Interface* (Cambridge, MA: MIT Press, 2017); James J. Hodge, *Sensations of History: Animation and New Media Art* (Minneapolis: University of Minnesota Press, 2019); Shane Denson, *Discorrelated Images* (Durham, NC: Duke University Press, 2021).

ENTRELACS I. DEPTH

1. Maurice Merleau-Ponty, "Eye and Mind," *The Merleau-Ponty Aesthetics Reader*, ed. Galen Johnson, trans. Michael Smith (Evanston, IL: Northwestern University Press, 1993), 121–64, 140. Hereafter abbreviated *EM*.
2. Merleau-Ponty, *EM*, 140.
3. Merleau-Ponty, *EM*, 134–35.
4. Maurice Merleau-Ponty, *The Phenomenology of Perception*, trans. Donald Landes (New York: Routledge, 2014), 254. Hereafter abbreviated *PP*.
5. Merleau-Ponty, *EM*, 140; Maurice Merleau-Ponty, *The Visible and the Invisible*, trans. Alfonso Lingis (Evanston, IL: Northwestern University Press, 1968), 138. Hereafter abbreviated *VI*.
6. Merleau-Ponty, *PP*, 267.
7. Merleau-Ponty, *PP*, 267; Merleau-Ponty, *VI*, 136.
8. Merleau-Ponty, *VI*, 272.
9. Merleau-Ponty, *VI*, 136, 219.
10. The status of perceptual illusions, and examples like the Necker cube, have been important for scholarship that explores the embodied basis of vision and the "virtual" images or special effects conjured through visual media from nineteenth-century optical toys through cinematic 3D and digital virtual reality. For recent discussions of "illusion" that explicitly engage with Merleau-Ponty, see Hodge, *Sensations of History*, 160–67; Richmond, *Cinema's Bodily Illusions*, 88–93. For more context on the role of optical illusions and visual effects in the history and theory of lens-based imaging, see Jonathan Crary, *Techniques of the Observer: On Vision and Modernity in the Nineteenth Century* (Cambridge, MA: MIT Press, 1990); Tom Gunning, "Hand and Eye:

178 / *Notes*

Excavating a New Technology of the Image in the Victorian Era," *Victorian Studies* 54, no. 3 (Spring 2012): 495–516; Kristen Whissel, *Spectacular Digital Effects: CGI and Contemporary Cinema* (Durham, NC: Duke University Press, 2014).

11. Merleau-Ponty, *VI*, 217.

12. My use of the word *place* here resonates with Edward S. Casey's extensive theorization of the concept of place, often in dialogue with Merleau-Ponty. See especially Casey, "'The Element of Voluminousness': Depth and Place Re-examined," in *Merleau-Ponty Vivant*, ed. M. C. Dillon (Albany: SUNY Press, 1991): 1–30. I also want to point out that depth is as much a structure of time as of space in Merleau-Ponty's thinking. By deliberately emphasizing space, I hope to build on and complement the emphasis given to temporality in poststructuralist theory and media theory that extends at least from Husserl's theorization of melody through Heidegger's *Being and Time* to Bernard Stiegler's *Time and Technics*. As Merleau-Ponty, Jacques Derrida, Jean-Luc Nancy, and others make clear, paradoxes of temporal and spatial "thickness"—duration and depth—are related aspects of the "same" ontological dimensionality. By foregrounding spatial dimensionality, I complicate how influential theorizations of photographic, cinematic, and digital temporality have shaped what seems "specific" about each and what would, in turn, appear new about computational imaging.

13. I am not the first to make this claim. See especially Glen Mazis, *Merleau-Ponty and the Face of the World: Silence, Ethics, Imagination, and Poetic Ontology* (Albany: SUNY Press, 2016); Jessica Wiskus, chap. 2, "Depth in the World," *The Rhythm of Thought: Art, Literature, and Music after Merleau-Ponty* (Chicago: University of Chicago Press, 2013); David Morris, *The Sense of Space* (Albany: SUNY Press, 2004); Sue L. Cataldi, *Emotion, Depth, and Flesh: A Study of Sensitive Space—Reflections on Merleau-Ponty's Philosophy of Embodiment* (Albany: SUNY Press, 1993).

14. In his celebrated essay on "différance," for example, Jacques Derrida describes the *"spacing* and *temporalizing"* through which Being presents and articulates itself as such. Similarly, in *Being Singular Plural*, Jean-Luc Nancy uses the idea of "spacing" to describe how Being is always "being-with." Though he insists that his concept of "relation" is not primarily spatial, Édouard Glissant also uses dimensionality to explain how elements "mixing in nonappearance (or depth)" restructure what can be made explicit. See Derrida, "Différance" [1963], trans. Alan Bass, in *Margins of Philosophy* (Chicago: University of Chicago Press, 1982), 3–27; Nancy, *Being Singular Plural*, trans. Robert D. Richardson and Anne E. O'Byrne (Stanford, CA: Stanford University Press, 2000); Glissant, *The Poetics of Relation* (Ann Arbor: University of Michigan Press, 1997), 173.

CHAPTER 1. THE SIDEDNESS OF THINGS

Note: This chapter has been expanded from a shorter essay that was published as "From Stereoscopic Depth to Deep Learning" in *Deep Mediations: Thinking*

Space in Cinema and Digital Cultures, ed. Karen Redrobe and Jeff Scheible (Minneapolis: University of Minnesota Press, 2021), 329–50. I thank Jeff and Karen for feedback that shaped how this chapter developed.

1. Karen Zack has archived what she calls her Chihuahua or muffin meme series on her website at https://www.karenzack.com/work/meme-series. She writes: "a few collages I made on a bus ride home became a viral sensation across the entire globe in a matter of hours, becoming permanently imbedded in internet meme culture and beyond. I later learned a bunch of big companies like Google are still using them to train machines with evolutionary AI intelligence with 'deep-learning.'"

2. *Computer vision* and *machine vision* are sometimes used as interchangeable terms, but for specialists in these fields, there is a distinction. Machine vision refers to ways imaging capabilities are added to automated systems, such as in manufacturing processes. Computer vision, however, specifies computational forms of image analysis that yield higher-order information from imagery. Given that throughout the history of photography and cinema, cameras have often been considered a kind of "machine" seeing, the term *computer vision* also helps to specify the uniquely computational nature of recent systems that incorporate AI-driven processing of visual information from cameras, sensors, or digitized images.

3. For example, Karl Ots, "Dog or Muffin? Training a Custom Computer Vision Classifier to Find Out," LinkedIn, August 10, 2017, https://www.linkedin.com/pulse/dog-muffin-training-custom-computer-vision-classifier-karl-ots; Mariya Yao, "Chihuahua or Muffin? My Search for the Best Computer Vision API," *freeCodeCamp,* October 12, 2017, https://www.freecodecamp.org/news/chihuahua-or-muffin-my-search-for-the-best-computer-vision-api-cbda4d-6b425d/; Affan Kondeth, "Solving the Famous Problem of Puppy vs Muffin by Deep Learning—Web App on Google App Engine/Fastai," *Medium,* June 30, 2020, https://medium.com/@ahffank/solving-the-famous-problem-of-puppy-vs-muffin-using-a-simple-web-application-on-google-app-a3264e2be49c.

4. Among countless computer science textbooks and journal articles devoted to the topics of computer vision and deep learning, some of the early, authoritative texts are Simon Prince, *Computer Vision: Models, Learning, and Inference* (Cambridge: Cambridge University Press, 2012); Ian Goodfellow, Yoshua Bengio, and Aaron Courville, *Deep Learning* (Cambridge, MA: MIT Press, 2016). More recent work on these topics from humanities scholars includes Joanna Zylinska, *AI Art: Machine Visions and Warped Dreams* (London: Open Humanities Press, 2020); Taylor Arnold and Laurel Tilton, "Depth in Deep Learning," in *Deep Mediations: Thinking Space in Cinema and Digital Cultures,* ed. Karen Redrobe and Jeff Scheible (Minneapolis: University of Minnesota Press, 2021), 309–28.

5. Jessica Guynn, "Google Photos Labeled Black People 'Gorillas,'" USA TODAY, July 1, 2015, https://www.usatoday.com/story/tech/2015/07/01/google-apologizes-after-photos-identify-black-people-as-gorillas/29567465/.

180 / *Notes*

6. As Black studies scholars including Saidiya Hartman and Fred Moten have worked to show, even recounting an incident like this, especially as a white woman telling this story, reiterates its violence to some degree. I wrestle with the complexity of this, and hope that bringing this contemporary example forward early in the book helps communicate the continued relevance of the history I go on to recount, and the urgent stakes of its ongoing erasures. See Hartman, *Scenes of Subjection: Terror, Slavery, and Self-Making in Nineteenth-Century America* (New York: Oxford University Press, 1997); Moten's review of Hartman's book in *TDR* 43, no. 4 (1999): 169–75.

7. See "Computer Programs Recognise White Men Better than Black Women: Biased Training Is Probably to Blame," Economist, February 15, 2018, https://www.economist.com/science-and-technology/2018/02/17/computer-programs-recognise-white-men-better-than-black-women; Lauren Rhue, "Racial Influence on Automated Perceptions of Emotions," *SSRN*, November 9, 2018, https://ssrn.com/abstract=3281765; Joy Buolamwini and Timnit Gehru, "Gender Shades: Intersectional Accuracy Disparities in Commercial Gender Classification," Proceedings of Machine Learning Research 81 (January 2018): 1–15; Benjamin Wilson, Judy Hoffman, and Jamie Morgenstern, "Predictive Inequity in Object Detection," arXiv 1902.11097 (February 2019), https://arxiv.org/abs/1902.11097. Researcher Lauren Rhue goes so far as to suggest that "Until facial recognition assesses black and white faces similarly, black people may need to exaggerate their positive facial expressions—essentially smile more—to reduce ambiguity and potentially negative interpretations by the technology." Rhue, "Emotion-Reading Tech Fails the Racial Bias Test," *Conversation*, January 3, 2019, http://theconversation.com/emotion-reading-tech-fails-the-racial-bias-test-108404.

8. See, for example, Cathy O'Neil, *Weapons of Math Destruction: How Big Data Increases Inequality and Threatens Democracy* (New York: Crown, 2016); Safiya Umoja Noble, *Algorithms of Oppression: How Search Engines Reinforce Racism* (New York: NYU Press, 2018); Virginia Eubanks, *Automating Inequality: How High-Tech Tools Profile, Police, and Punish the Poor* (New York: St. Martin's Press, 2018); Simone West, Meredith Whittaker, and Kate Crawford, "Discriminating Systems: Gender, Race, and Power in AI," AI Now Institute, April 2019, https://ainowinstitute.org/discriminatingsystems.html; Kate Crawford, *Atlas of AI: Power, Politics, and the Planetary Costs of Artificial Intelligence* (New Haven, CT: Yale University Press, 2021); Wendy Hui Kyong Chun, *Discriminating Data: Correlation, Neighborhoods, and the New Politics of Recognition* (Cambridge, MA: MIT Press, 2021).

9. Mark Blunden, "Graduates Are Taking £9k Courses to Help Beat AI Interviews for City Jobs," *London Evening Standard*, October 2, 2018, https://www.standard.co.uk/tech/ai-interviews-city-jobs-graduates-a3951296.html.

10. HireVue company website, accessed September 27, 2021, https://www.hirevue.com/platform/online-video-interviewing-software?utm_.

11. I address this further in chapter 2. As Peter Hamilton succinctly argues, the use of photography to compare and categorize people according to "types" began as a colonial project: "The anthropological and geological uses of photog-

raphy to survey and explore unknown peoples and unknown lands were related to colonial interests (which were, in many cases, their pretexts), but seem to have received their greatest impetus from the desire to incorporate 'natives' of all sorts within the wider schemes of human classification." Hamilton, "Policing the Face," in *The Beautiful and the Damned: The Creation of Identity in Nineteenth-Century Photography* (London: Lund Humphries, 2001), 87. Photographic analysis and comparison was used by Louis Agassiz and Francis Galton to visually elaborate eugenic theories and theories of scientific racism and in the "anthropometric" system developed by Alphonse Bertillon for French police. Along with this work to visually identify and classify identity, photography was also used to represent affect as objectively visible and categorizable. Of particular interest in this vein are the photographs that Guillaume-Benjamin-Amand Duchenne du Bologne created for his *Mécanisme de la physionomie humaine, ou analyse électro-physiologique de l'expression des passions* (Paris: Jules Renouard, 1862)—a selection of which were later used by Charles Darwin to illustrate *The Expression of the Emotions in Man and Animals* (London: John Murray, 1872). To create these, Duchenne electrically stimulated facial muscles to produce expressions of various "emotions." Affect was not only categorized but also pathologized in gendered ways in Jean-Martin Charcot's photographs of "hysterical" female patients published in *Iconographie photographique de la Salpêtrière* (1878).

12. One touchstone essay for the art historical theory of medium specificity would be Clement Greenberg, "Towards a New Laocoön," *Partisan Review* (July–August 1940): 296–310.

13. Siegfried Kracauer, "Photography" [1927], *Critical Inquiry* 19, no. 3 (Spring 1993): 433.

14. I have made this argument in previous publications, especially "Depth Readings: Ken Jacobs' Digital, Stereographic Films," *Cinema Journal* 53, no. 2 (February 2014): 2–26; and "The Dimensional Image: Overlaps in Stereoscopic, Cinematic, and Digital Depth," *Film Criticism* 37, no. 3 (Spring/Fall 2013): 117–37.

15. Martha Sandweiss has explained, for example, how panorama painters used photographs as studies, rather than understanding them as rivals for the market in verisimilitude. Sandweiss, Print the Legend: Photography and the American West (New Haven, CT: Yale University Press, 2004).

16. An exemplary discussion of photography's inferiority to painting, due to its slavish recapitulation of detail, can be found in Lady Elizabeth Eastlake, "Photography," *London Quarterly Review*, no. 101 (April 1857): 442–68.

17. This split has been elaborated in film theory, tracing a bifurcation between, on the one hand, the photographic aesthetics of Lumière's "actualities" and the later genre of documentary and, on the other hand, the "trick photography" of Méliès films and 3D cinema as a form of special effect. The most influential formulation of this is Tom Gunning, "The Cinema of Attractions: Early Cinema, Its Spectator, and the Avant-Garde," *Wide Angle* 8, no. 3–4 (1986): 63–70.

182 / Notes

18. Crary, *Techniques of the Observer*.

19. Crary, 2.

20. One reason this has been so easy to forget is that so many early photographers worked with both stereoscopic and single-lens cameras, and one half of a stereoview could be separated as a single image. Many well-known images from *Alexander Gardener's Sketchbook of the Civil War* (1865–66) and from the great surveys of the western United States (1867–79) that have largely circulated and been seen as single prints were captured as one half of a stereo pair. For example, Martha Sandweiss reprints the stereograph of Timothy O'Sullivan's iconic "Ruins in Cañon de Chelle, N.M." from the 1878 Wheeler Survey in her essay "Stereoscopic Views of the American West," *Princeton University Library Chronicle* 67, no. 2 (Winter 2006): 271–89.

21. I use the term *stereoview* to describe a pair of images meant to be viewed in a stereoscope, regardless of format.

22. Oliver Wendell Holmes, "The Stereoscope and the Stereograph," *Atlantic Monthly,* June 1859, https://www.theatlantic.com/magazine/archive/1859/06/the-stereoscope-and-the-stereograph/303361/.

23. Holmes.

24. Holmes.

25. For example, Friedrich Kittler reprints these sentences from "The Stereoscope and the Stereograph" as what he calls an "extremely early passage from 1859, in which (as far as I can see) something like media-technical information appears for the first time." He describes Holmes as "the first real theorist of photography" without clarifying that Holmes is specifically discussing stereoscopic photography. Kittler, *Optical Media* (New York: Polity Press, 2010), 41.

26. Note that sometimes two cameras were used to produce two images that would then be paired for a stereoview, while other times a stereo camera with two lenses could be used to capture a pair of images in one exposure. "The Stereoscope, Pseudoscope and Solid Daguerreotypes," *Illustrated London News,* January 24, 1852, 77–78. The *Illustrated London News* was among the first illustrated newspapers. It doubled its circulation during the Great Exhibition, publishing images of the event using a new collodion process that printed photographs directly on wood blocks for more photorealistic engravings.

27. Robert Silverman, "The Giant Eyes of Science: The Stereoscope and Photographic Depiction in the Nineteenth Century," in *Instruments and the Imagination,* ed. Thomas L. Hankins and Robert J. Silverman (Princeton, NJ: Princeton University Press, 1999), 163–64.

28. See Belisle, "Picturing Networks"; Pauline Stakelon, "Travel through the Stereoscope," *Media History* 16, no. 4 (November 1, 2010): 407–22, https://doi.org/10.1080/13688804.2010.507476; Ellen Strain, "Exotic Bodies, Distant Landscapes: Touristic Viewing and Popularized Anthropology in the Nineteenth Century," *Wide Angle* 18, no. 2 (April 1996): 70–100; Belisle, "Total Archive."

29. On Willème, see Robert A. Sobieszek, "Sculpture as the Sum of Its Profiles: François Willème and Photosculpture in France, 1859–1868," *Art*

Bulletin 62, no. 4 (1980): 617–30; Michele Bogart, "Photosculpture," Art History 4, no. 1 (1981): 54–65; Beaumont Newhall, "Photosculpture," *Image: Journal of Photography and Motion Pictures of the George Eastman House*, no. 61 (May 1958): 103. I owe my discovery of photosculpture to Michele Bogart and Michelle Smiley and thank them for conversations that informed the first version of this chapter, published in the edited collection *Deep Mediations* (Minneapolis: University of Minnesota Press, 2021). I am not the only one to "rediscover" Willème as relevant to more recent media. In 2012 Ian Dawson reconstructed Willème's apparatus with art students and digital imaging technologies, which he documented online: www.iandawsonstudio.com /photosculpture.html. In *Uncomputable: Play and Politics in the Long Digital Age* (London: Verso, 2021), Alex Galloway also positions photosculpture in the lineage of computational imaging, part of the history of how photography "escaped the limitations of the *camera obscura's* single aperture" and "smeared itself across a limitless grid of points" (24).

30. As cited in Bogart, "Photosculpture," 56. Within twenty years of its emergence, however, as tastes and trends changed, photosculpture was all but obsolete. Its method carried forward into the twentieth century less through the vector of fine art than through commercial and research methods for modeling and translating between two- and three-dimensional space.

31. Newhall, "Photosculpture," 103. Michele Bogart explains that this was not done as a linear sequence—rotating, for example, from positions 1 through 24—but, rather, in a process that repeatedly related perspectives at 90 degrees to one another. So, after projecting the image showing position 1 parked on the platform, the operator would then project image 7, then 13 followed by 19, 4 followed by 10, and so forth. Bogart, "Photosculpture," 55–56.

32. I discuss this range of Muybridge's work and what I call his "time studies" in "The Dimensional Image: Overlaps in Stereoscopic, Cinematic, and Digital Depth," *Film Criticism* 37/38, no. 3/1 (2013): 117–37. On the series parsing time instead of motion, see also Eivind Røssaak, "Algorithmic Culture: Beyond the Photo/Film Divide," *Between Stillness and Motion: Film, Photography, Algorithms* (Amsterdam: Amsterdam University Press, 2011); Marta Braun, *Eadweard Muybridge* (London: Reaktion, 2010).

33. Muybridge, *Animal Locomotion*, 16. Thank you to librarians at the University of Pennsylvania's Eadweard Muybridge Collection, who helped me access and understand archival materials that provided crucial context for the spare notes on these spatial variations in the published studies.

34. Much of the Gilbreths' work is attributed solely to Frank, but I am choosing to credit them both because they are known to have collaborated in their time and motion research and are both named as authors of the major publication that came out of it: Frank and Lillian Gilbreth, *Applied Motion Study: A Collection of Papers on the Efficient Method to Industrial Preparedness* (New York: Sturgis & Walton, 1917).

35. Photographs from the Gilbreths' time and motion studies are held in archives at the Smithsonian Institute's National Museum of American History,

184 / *Notes*

https://sova.si.edu/record/NMAH.AC.0803, and the Kheel Center for Labor-Management Documentation and Archives at Cornell University, https://rmc .library.cornell.edu/EAD/htmldocs/KCL06126p.html. The Cummings Center for the History of Psychology at the University of Akron has digitized its collection of the Gilbreths' stereographs; see http://rave.ohiolink.edu/archives /ead/OhAkAHA0570.

36. Cyclegraphs followed a photographic strategy similar to what Italian futurist photographer Anton Bragaglia called "photodynamism," capturing uninterrupted motion in an uninterrupted exposure. A related technique that the Gilbreths called "chronocyclegraphs" followed a method more similar to Etienne Jules Marey's "chronophotography," using an intermittent shutter to capture periodic phases of motion such that the path traced by lights appeared as dots and dashes whose span indicated the distance moved over each interval of time. For more on the cinematic methods of the Gilbreths, see Scott Curtis, "Images of Efficiency," in *Films That Work: Industrial Film and the Productivity of Media,* ed. Patrick Vonderou and Vinzenz Hediger (Amsterdam: Amsterdam University Press, 2019), 85–100.

37. Gilbreth, *Applied Motion Study,* 67–68; see also 83–84.

38. Gilbreth, 85. On screens, see also Gilbreth, 69.

39. Gilbreth, 124.

40. Gilbreth, 127–28. On motion models, see also Gilbreth, 89.

41. Here my argument aligns with an argument Alexander Galloway makes in *Uncomputable* (London: Verso, 2021) that "the photographic multiple" is part of the history of how computational aesthetics works to "multiply" and "distribute" points of view to produce an aesthetic mode that "has no point of view (because it has all of them)" (57–58). I would argue, instead, that such constructs of a universal visibility—or ways to seemingly extract the visible out from the limits of perspective—are not new to computing or achieved by it but, rather, are recurring assertions of a very particularized, privileged perspective as unmarked and all-encompassing.

42. Woodrow Wilson Bledsoe, "The Model Method in Facial Recognition," Technical Report PRI 15 (Stanford, CA: Panoramic Research, August 12, 1964), 2.

43. Woodrow Wilson Bledsoe, "Facial Recognition Project, a report," March 6, 1964, 1, box 96–349/7, Bledsoe Papers, Briscoe Center for American History, University of Texas at Austin.

44. Bledsoe, "Model Method," 10.

45. Bledsoe, "Facial Recognition," appendix 4, p. 2.

46. Bledsoe, "Facial Recognition," appendix 4, p. 13.

47. Bledsoe, "Facial Recognition," appendix 4, p. 9.

48. Bledsoe, "Facial Recognition," appendix 4, p. 11.

49. Bledsoe, "Facial Recognition," appendix 4, p. 13.

50. Bledsoe, "Model Method," 13, 11.

51. Bledsoe, "Model Method," 11.

52. Bledsoe, "Model Method," 11.

53. Bledsoe, "Model Method," 9.

54. Bledsoe, "Model Method," 16. Sarah Kember explains more recent, related practices of "normalizing" images in computational modes of facial recognition in "Face Recognition and the Emergence of Smart Photography," *Journal of Visual Culture* 13, no. 2 (2014): 182–99.

55. Bledsoe, "Facial Recognition," 4

56. Bledsoe, "Model Method," 9.

57. COIL stands for Columbia Object Image Library, and 100 refers to the number of objects in the set. COIL-20 names a related set of images, made at Columbia in a similar way, picturing 20 objects in grayscale. See S.A. Nene, S.K. Nayar, and H. Murase, "Columbia Object Image Library (COIL-100)," Technical Report CUCS-006–966, Columbia University Department of Computer Science, 1996.

58. Cited from online documentation of NORB archived at https://cs.nyu .edu/~yann/research/norb/. NORB stands for NYU Object Recognition Benchmark. It was developed at New York University by Fu Jie Huang and Yann Lecun and first published in July 2004. The initial dataset is now known as the "small" version, or V1.0.

59. As described at https://cs.nyu.edu/~ylclab/data/norb-v1.0/.

60. Yann Lecun, Fu Jie Huang, and Leon Bottou, "Learning Methods for Generic Object Recognition with Invariance to Pose and Lighting," Courant Institute, New York University, 2004. See also Hugo Penedones, Ronan Collobert, François Fleuret, and David Grangier, "Improving Object Classification using Pose Information," IDIAP Research Report, September 2012.

61. See https://image-net.org/about.php.

62. John Markoff, "For Web Images, Creating New Technology to Seek and Find," *New York Times*, November 19, 2012, https://www.nytimes .com/2012/11/20/science/for-web-images-creating-new-technology-to-seek-and-find.html.

63. Fei-Fei Li, as quoted in Dave Gershgorn, "The Data That Transformed AI Research—and Possibly the World," *Quartz*, July 26, 2017, https://qz .com/1034972/the-data-that-changed-the-direction-of-ai-research-and-possi-bly-the-world/.

64. Holmes, "Stereoscope and Stereograph."

65. Other scholars, such as Allan Sekula, have noted this: "The dominant value in Holmes' discussion is that of bourgeois political economy; just as use value is eclipsed by exchange value, the photographic sign comes to eclipse its referent. For Holmes, quite explicitly, the photograph is akin to money [. . .] photographs stand as the 'universal equivalent,' capable of denoting the quantitative exchangeability of all sights. Just as money is the universal gauge of exchange value, uniting all the world's goods in a single system of transactions, so photographs are imagined to reduce all sights to relations of formal equivalence." Sekula, "The Traffic in Photographs," *Art Journal* 41, no. 1 (Spring 1981): 22–23.

66. Brendan Cole, "Chinese University Tests Facial Recognition System to Monitor Attendance and Students' Attention to Lectures," *Newsweek*,

September 2, 2019, https://www.newsweek.com/33anjing-china-facial-recognition-1457193.

67. Vidushi Meel, "83 Most Popular Computer Vision Applications in 2022," March 9, 2021, https://viso.ai/applications/computer-vision-applications/.

68. Walter Benjamin and many others make this claim about Muybridge's motion studies, but there is an important difference I want to draw out between the way his images present phases of motion that would not have been visible otherwise—like that horse with all its hooves in the air—and the way that the Gilbreths used photography to render motion itself as objectively visible or as a visible thing.

69. I have examined Paglen's work in previous publications: Brooke Belisle, "I See the Moon, The Moon Sees Me: Trevor Paglen's Satellite Views," in "Art & Infrastructures: Hardware," special issue, *Media-N* 10, no. 1 (Spring 2014), https://median.newmediacaucus.org/art-infrastructures-hardware/i-see-the-moon-the-moon-sees-me-trevor-paglens-satellite-images/; Brooke Belisle, "Artifacts: Trevor Paglen's Frontier Photography," in *Making the Geologic Now: Responses to Material Conditions of Contemporary Life,* ed. Jamie Kruse and Elizabeth Ellsworth (New York: Punctum Books, 2012).

70. Paglen tends to privilege the phrase *machine vision* rather than *computer vision,* but I am shifting his phrasing toward my own because the examples he considers are almost always better suited to the general definition of *computer vision* than that of *machine vision.*

71. Trevor Paglen, "Invisible Images (Your Pictures Are Looking at You)," *New Inquiry,* December 8, 2016, https://thenewinquiry.com/invisible-images-your-pictures-are-looking-at-you/. "The fact that digital images are fundamentally machine-readable regardless of a human subject has enormous implications. It allows for the automation of vision on an enormous scale.... In aggregate, AI systems have appropriated human visual culture and transformed it into a massive, flexible training set . . . If we want to understand the invisible world of machine-machine visual culture, we need to unlearn how to see like humans. We need to learn how to see a parallel universe composed of activations, keypoints, eigenfaces, feature transforms, classifiers, training sets, and the like."

72. This followed an earlier collaboration with Hito Steyerl that explored computer vision and facial recognition, *Machine Readable Hito* (2017). See Kate Albers's discussion of this in *The Night Albums: Visibility and the Ephemeral Photograph* (Oakland: University of California Press, 2022), 74–77.

73. For example, see this thread on Twitter where users are posting their *ImageNet Roulette* results: https://mobile.twitter.com/i/events/1105075874095869954.

74. "An Update to the ImageNet Website and Dataset," March 11, 2021, https://image-net.org/update-mar-11–2021.php. "The dataset was created to benchmark object recognition—at a time when it barely worked. The problem then was how to collect labeled images at a sufficiently large scale to be able to

train complex models in laboratories. Today, computer vision is in real-world systems impacting people's Internet experience and daily lives. An emerging problem now is how to make sure computer vision is fair and preserves people's privacy. We are continually evolving imagenet [*sic*] to address these emerging needs. In a FAT* 2020 paper, we filtered 2,702 synsets in the 'person' subtree that may cause problematic behaviors of the model. We have updated the full imagenet data on the website to remove these synsets." See the paper referenced: Kaiyu Yang, Klint Qinami, Li Fei-Fei, Jia Deng, and Olga Russakovsky, "Towards Fairer Datasets: Filtering and Balancing the Distribution of the People Subtree in the imagenet Hierarchy," Conference on Fairness, Accountability, and Transparency, 2020.

75. Trevor Paglen and Kate Crawford, "Excavating AI: The Politics of Images in Machine Learning Training Sets," https://excavating.ai/.

76. Tim Clark, "From Apple to Anomaly," *British Journal of Photography* #7888, September 2019, reprinted at 1854, https://www.1854.photography/2019/10/trevor-paglen-barbican/; Tom McKim, "Trevor Paglen Trains His Sight on the Rise of Machine Vision," *Apollo Magazine*, October 17, 2019, https://www.apollo-magazine.com/trevor-paglen-machine-vision/.

77. Holly Herndon is an important artist in her own right, innovating the use of AI in music. See Emily McDermott, "Holly Herndon on Her AI Baby, Reanimating Tupac, and Extracting Voices," *Art in America*, January 7, 2020, https://www.artnews.com/art-in-america/interviews/holly-herndon-emily-mcdermott-spawn-ai-1202674301/.

78. For example, see Dziga Vertov's elaboration of "Kino-Eye" and Walter Benjamin's theorization of shock and innervation in essays including "The Work of Art in the Age of Mechanical Reproducibility." Vertov, *Kino-Eye: The Writings of Dziga Vertov*, ed. Annette Michelson, trans. Kevin O'Brien (Los Angeles: University of California Press, 1984); Brigid Doherty, Michael W. Jennings, and Thomas Y. Levin, eds., *Walter Benjamin: The Work of Art in the Age of Its Technological Reproducibility and Other Writings on Media* (Cambridge, MA: Harvard University Press, 2008).

ENTRELACS II. HOW A CUBE COHERES

1. Merleau-Ponty, *VI*, 219.

2. Merleau-Ponty follows Edmund Husserl, who follows Kant, and so on, and in some cases, the cube is a die or a house. For example, see Husserl's extended discussion in *Thing and Space* of how we can perceive a house when we can see only one side of it at a time. *Thing and Space: Lectures of 1907*, trans. Richard Rojcewitcz (Berlin: Kluwer, 1997).

3. Merleau-Ponty, *VI*, 202.

4. Merleau-Ponty, *PP*, 242.

5. In object recognition systems, this is apparent when any learned term is visually rendered, as Trevor Paglen demonstrated in presenting ImageNet's "goldfish" as an abstract blob of orange surrounded by blue. It is demonstrated

188 / *Notes*

in computer graphics, as Jacob Gaboury explains, by the way that the problem of the cube's hidden side becomes how to hide it—how to render a cube that seems to have a "back side" that is held back and not presented. Gaboury, "Hidden Surface Problems: On the Digital Image as Material Object," *Journal of Visual Culture* 14, no. 1 (April 2015): 40–60.

6. Merleau-Ponty, *PP,* 342.

7. Merleau-Ponty, *PP,* 344.

8. Merleau-Ponty, *EM,* 126.

9. Merleau-Ponty, *VI,* 248.

10. Merleau-Ponty, *VI,* 135.

11. Merleau-Ponty, *VI,* 261. See also Merleau-Ponty, *VI,* 202: "I, my *view,* are caught up in the same carnal world with it [the cube]; i.e.: my view and my body themselves emerge from the *same* being which is, among other things, a *cube."*

CHAPTER 2. SURFACING SUBJECTIVITY

1. Estimates in 2023 suggest almost seven billion people own smartphones, which make up 90 percent of mobile phones worldwide. Globally, smartphones are the dominant device for taking photographs; 90 percent of around 1.4 trillion photographs made during 2021 were made on smartphones. For statistics, see https:// www.pewresearch.org/internet/fact-sheet/mobile/; https://explodingtopics.com /blog/smartphone-stats; https://www.statista.com/statistics/330695/number-of-smartphone-users-worldwide/; https://riseaboveresearch.com/rar-reports/2021-worldwide-image-capture-forecast-2020–2025/.

2. An exception is the Sony Experia 1 IV, announced in May 2022, which uses a zoom lens that physically moves. See the review by Wasim Ahmad, "Sony Stuffs an Actual Zoom Lens onto a Smartphone," *Fstoppers,* May 27, 2022, https://fstoppers.com/gear/sony-stuffs-actual-zoom-lens-smartphone-606018.

3. For a general introduction to computational photography, see Brian Hayes, "Computational Photography," *American Scientist* 96, no. 2 (March–April 2008): 94–98. For a technical overview, see Mauricio Debracho, Damien Kelly, Michael Brown, and Peyman Milanfar, "Mobile Computational Photography: A Tour," Google Research and York University EECS Department, March 10, 2021. For humanistic, critical analyses, see Sarah Kember, "Face Recognition and the Emergence of Smart Photography," *Journal of Visual Culture* 13, no. 2 (2014): 182–99; Sy Taffel, "Google's Lens: Computational Photography and Platform Capitalism," *Media, Culture, and Society* 43, no. 2 (2021): 237–55.

4. Smartphone photography's automated modes can be seen to inherit and update conceits of ease and convenience that can be traced back to the popularization, miniaturization, and "deskilling" of photography associated with Eastman Kodak's first snapshot cameras, which were marketed with the slogan "You press the button, we do the rest." A collection of late nineteenth- and early twentieth-century Kodak print advertisements can be seen at "Early

Eastman Kodak Ads," pbs.org, https://www.pbs.org/wgbh/americanexperience/features/early-eastman-kodak-ads/.

5. The panorama of Pano mode may not seem temporal since it presents a static, horizontally extended image, but it is stitched from a series of successive frames, captured while the user moves the phone across a spatially proscribed path.

6. Beauty modes in general, and Huawei's Moon mode in particular, have prompted debate as some argue that AI assistance does not optimize as much as "fake" photographs. While these "controversies" seem to reassert the rules about how reality and representation are meant to relate in photography, they point to more profound ways that computational photography challenges the assumptions subtending those rules. See, for example, C. Scott Brown, "Huawei P30 Pro 'Moon Mode' Stirs Controversy," *Android Authority*, April 24, 2019, https://www.androidauthority.com/huawei-p30-pro-moon-mode-controversy-978486/.

7. Today aperture width is usually referred to as the f-stop, and the distance between aperture and recording surface is usually understood as focal length. In some nineteenth-century cameras, the width of the camera itself could also be changed to alter the distance between aperture and photographic plate, opened or compressed along accordion folds.

8. On the correlation of photography's rise as a new medium and the popularity of photographic portraiture, see Alan Trachtenberg, "Illustrious Americans," *Reading American Photographs: Images as History—Mathew Brady to Walker Evans* (Hill and Wang, 1990), 21–70; John Tagg, "A Democracy of the Image: Photographic Portraiture and Commodity Production," *The Burden of Representation: Essays on Photographies and Histories* (Minneapolis: University of Minnesota Press, 1993); Roger Hargreaves and Peter Hamilton, *The Beautiful and the Damned: The Creation of Identity in Nineteenth-Century Photography* (London: Lund Humphries, 2001). An announcement in the *New York Sun*, in March 1840, may mark the opening of the first portrait studio in the United States, in New York City. John Tagg claims: "It is estimated that more than ninety percent of all daguerreotypes ever taken were portraits. In a 'daguerreotypemania,' the middling people flocked to have photographs made [. . .] Within a decade, there were already two thousand daguerreotypists in the country, and Americans were spending between eight and twelve million dollars a year on portraits, which made up ninety-five percent of photographic production. By 1853, three million daguerreotypes were being made annually and there were eighty-six portrait galleries in New York City alone." Tagg, *Burden of Representation*, 43.

9. Trachtenberg, *Reading American Photographs*, 29, 9.

10. Because it is not measuring photons, LIDAR is especially useful for modulating the focus in images made at night, when there is less light for cameras to record. LIDAR can specify not just that one tree is closer than another, but also that this tree is ten feet away from the device and eight feet tall.

190 / Notes

11. This interface also maps the spatial terms of the user's gesture—how far they drag their finger—to the spatial terms of the image's dimensional reformulation. In some interfaces, the user can also touch to reorganize the focal effect around a specific point in the image, suggesting a plasticity of not only focus but of all the implicit dimensional relationships internally organizing the image.

12. I thank Wasim Ahmad for graciously allowing me to use images he created, discussed in an article he wrote about Portrait mode; see Wasim Ahmad, "Are Smartphone Portrait Modes for Photographers?," *Fstoppers*, August 23, 2019, https://fstoppers.com/originals/are-smartphone-portrait-modes-photographers-400461. Ahmad teaches in the Communications Program at Quinnipiac University; he shares my interests in AI and photography and is currently completing a doctoral dissertation on the topic.

13. Holmes, "Stereoscope and Stereograph."

14. See the caption for plate II, "The Boulevards of Paris," in William Henry Fox Talbot, *The Pencil of Nature* (London: Longman, 1844).

15. Roland Barthes, *Camera Lucida: Reflections on Photography* (New York: Hill and Wang, 1982). Barthes's reference to the Photomat suggests a now-defunct brand of photo developing business that was popular from the 1960s to the early 1980s. The American company Fotomat, for example, offered low-cost, overnight film processing at drive-through kiosks that were often located in parking lots or strip malls.

16. See Allan Sekula, "The Body and the Archive," *October* 39 (Winter 1986): 3–64; Trachtenberg, *Reading American Photographs;* Mathew Brady, *The Gallery of Illustrious Americans* (New York: D'Avignon, 1850). For more on the "honorific" tendency, see Beaumont Newhall, *The Daguerreotype in America* (New York: Dover Publications, 1976); Barbara McCandless, "The Portrait Studio and the Celebrity: Promoting the Art," in *Photography in Nineteenth-Century America*, ed. Martha Sandweiss (New York: Harry N. Abrams, 1991), 48–75; Shawn Michelle Smith, "Baby's Picture Is Always Treasured: Eugenics and the Reproduction of Whiteness in the Family Photograph," *American Archives: Gender, Race, and Class in Visual Culture* (Princeton, NJ: Princeton University Press, 1999), 113-35.

17. In the 1840s, just as the new medium of photography arrived, academic disciplines of ethnology and anthropology were organizing: for example, the American Ethnological Society of New York was founded in 1842, and the Ethnological Society of London was founded in 1843. These disciplines quickly incorporated photography into efforts to visually study "the human." See Elizabeth Edwards, *Anthropology and Photography 1860–1920* (New Haven, CT: Yale University Press, 1994); Zahid Chaudhary, *Afterimage of Empire: Photography in Nineteenth-Century India* (Minneapolis: University of Minnesota Press, 2012). Anthropometry was a system of biometric measurements correlated with front and profile view portrait photographs, first developed in French policing by Alphonse Bertillon. I use the term *anthropometric* instead of *biometric* to retain the sense in which these measuring techniques aimed to

specify the human, and to point back to their historical imbrication with photography. See Bertillon, *La Photographie judiciaire* (Paris: Gauthier-Villars, 1890); Josh Ellenbogen, *Reasoned and Unreasoned Images: The Photography of Bertillon, Galton, and Marey* (University Park: Pennsylvania State University Press, 2012); Shawn Michelle Smith, "The Scene of the Crime," *Photographic Returns: Racial Justice and the Time of Photography* (Durham, NC: Duke University Press, 2020), 61–92.

18. On Agassiz, see Molly Rogers, *Delia's Tears: Race, Science, and Photography in Nineteenth-Century America* (New Haven, CT: Yale University Press, 2021); on Galton, see Ellenbogen, *Reasoned and Unreasoned Images.*

19. See Lorraine Daston and Peter Galison, *Objectivity* (New York: Zone Books, 2010).

20. The dimensional pairing of front and side views was codified through the work of Francis Galton and Alphonse Bertillon. Galton also used a different spatial strategy for relating discrete photographs in order to visually extrapolate larger types or identity groups; he superimposed exposures of different faces to produce what he called "composite portraits." His approach to layering visual features correlated with eugenicist ideas about how genetic lineage was similarly "inlaid" and physically manifest.

21. For example, Louis Agassiz commissioned daguerreotypes of enslaved African Americans to compare with anthropometric studies of Europeans and Africans. Francis Galton elaborated his theories of eugenics—a word he coined—through his "composite portraiture," which compared the facial features of people who were, for example, related within the same family or who shared the same occupation or suffered from the same illness. And, around the world in the nineteenth century, photographs of Indigenous people in colonized lands were gathered and compared both to classify racialized identities within a universal hierarchy of "the human" and to organize colonial governance by providing a visual guide to the "local types." For example, in the late 1860s, the India Office of Great Britain published an eight-volume guide, *The People of India: A Series of Photographic Illustrations, with Descriptive Letterpress, of the Races and Tribes of Hindustan* (London: India Museum, 1868–75).

22. Lamprey published an explanation of his grid system in the first volume of the journal of the Ethnological Society of London, for which he served as secretary—alongside the noted proponent of scientific racism John Huxley, who was president. See J.H. Lamprey, "On a Method of Measuring the Human for the Use of Students in Ethnology," *Journal of the Ethnological Society of London* 1 (April 1869): 84–85. Lamprey begins his entry: "Collections of photographs illustrative of the races of man, have experienced the greatest difficulty in questions of comparison of measurement of individuals by some common standard" (84). See also Edward B. Taylor, "Ethnological Photographic Gallery of the Various Races of Man," *Nature* 13 (January 1876): 184–85.

23. Lamprey, "On a Method of Measuring the Human."

24. On the relationship between what Kris Cohen calls "computational personhood" and the graphical space of computation, see Cohen, "Superimposed,

192 / *Notes*

Still," *JCMS* 61, no. 4 (Summer 2022): 163–68; Cohen, "The Irresolutions of Charles Gaines," in *Nervous Systems,* ed. Johanna Gosse and Timothy Stott (Durham, NC: Duke University Press, 2021), 105–24.

25. See Grahame Clarke, ed., *The Portrait in Photography* (New York: Reaktion Books, 1992); Alan Trachtenberg, "Lincoln's Smile: Ambiguities of the Face in Photography," *Social Research* 67, no. 1 (Spring 2000): 1–2. Trachtenberg points out that initially photography seemed ill-suited to portraiture and was adapted for it through technological and aesthetic efforts to modulate lenses, lighting, and the like until "Before long [. . .] the photograph overwhelmed all other graphic modes of picturing faces" (10).

26. Roger Hargreaves, "Putting Faces to the Names, Social and Celebrity Portrait Photography" in *Beautiful and the Damned,* 20. John Tagg explains that "The portrait [was] therefore a sign whose purpose [was] both the description of an individual and the inscription of social identity. But at the same time, it [was] also a commodity, a luxury, an adornment, ownership of which itself confers status"; "To 'have one's portrait done' was one of the symbolic acts by which individuals from the rising social classes made their ascent visible to themselves and others and classed themselves as among those who enjoyed social status." Tagg, "A Democracy of the Image," *Burden of Representation,* 37.

27. Smith, "Superficial Depths," *American Archives.* In "Lincoln's Smile," Alan Trachtenberg complicates this rhetoric, arguing that even at the time, "working photographers would have understood that expressions are not emanations but performances," with the making of the portrait "a dialogic situation with the expression directed toward the open-ended situation of being viewed, with ambiguity that will be resolved in multiple ways through provisional narratives the viewer brings to the image" (14). See also Trachtenberg, "Likeness as Identity: Reflections on the Daguerrean Mystique," in Clarke, *Portrait in Photography,* 173–92.

28. Eastlake, "Photography"; Marcus Aurelius Root, *The Camera and the Pencil or the Heliographic Art* (Philadelphia: Lippincott, 1864).

29. Advertisement appearing in George Adams, "Advertising Department," in *The Maine Register for the Year 1855: Embracing the State and County Officers and an Abstract of the Laws and Resolves; Together with a Complete Business Directory of the State, and a Variety of Useful Information* (Portland: Blake & Carter, 1855), 67. Item P8550001 in the daguerreotype archive of Gary Ewer, www.daguerreotypearchive.org.

30. Dennis Pellerin, *History of Nudes in Stereo Daguerreotypes* (Nevada City, CA: Carl Muntz, 2020).

31. "Some have speculated that the very close association of the stereoscope with pornography was in part responsible for its social demise as a model of visual consumption. Around the turn of the century sales of the device supposedly dwindled because it became linked with 'indecent' subject matter." Crary, *Techniques of the Observer,* 127.

32. Crary, 127.

Notes / 193

33. See John Plunkett, "'Feeling Seeing': Touch, Vision and the Stereoscope," *History of Photography* 37, no. 4 (2013): 395; David Ogawa, "Arresting Nudes in Second Empire Paris," *History of Photography* 31, no. 4 (2007): 330–47; Miriam Ross, "From the Material to the Virtual: The Pornographic Body in Stereoscopic Photography," *Screen* 60, no. 4 (Winter 2019): 548–66.

34. This might draw connections with Barthes's punctum, but I do not mean it that way at all—his punctum is about what touches or pricks the viewer, suggesting an emotional impact or a subjective kind of meaning, while this, on the other hand, presents as something neither for the viewer nor about meaning at all, but rather as a way that formal qualities of the image communicate the "thingly" aspects of things.

35. Using a photograph of Lincoln opens onto broader questions about his historical and cultural significance and how it has been constructed and mediated through his representation. He was not the first president of the United States to be photographed, but the circulation of his photograph has often been credited as garnering the popular support that won him the presidency. In "Lincoln's Smile," Alan Trachtenberg explains that Lincoln's face was considered especially problematic for portraiture, yet was one of the most photographed or widely seen in photographic representation in the 1860s. Trachtenberg also engages something similar to the problematic that I invoke with this image, suggesting that Lincoln's smile is paradigmatic of what he calls the "ambiguity of the face."

36. This could invoke what Christopher Pinney has called a play of and at the surface that characterizes some postcolonial styles of photographic portraiture. It is not like his examples, which emphasize what he calls the sensual and textural qualities of the surface, but it could be related to a kind of imagined mobility he sees in those practices, "concerned with the body as a surface that is completely mutable and mobile, capable of being situated in any time and space." Pinney, "Notes from the Surface of the Image: Photography, Postcolonialism, and Vernacular Modernism," in *Photography's Other Histories*, ed. Christopher Pinney (Durham, NC: Duke University Press, 2013), 211.

37. In *Digital Lethargy* (Cambridge, MA: MIT Press, 2022), Tung-Hui Hu echoes the connection I make here between the "fleeting expression" and "Instagram face" (106–7), in dialogue with a talk I gave from this chapter at Northwestern University for the summer 2021 Media Aesthetics seminar. Thank you to Jim Hodge for inviting me to share this work there, and to fellow presenters Joshua Neves and Alenda Chang and other participants for feedback that helped develop it.

38. On this "refusal" and its broader theorization, see Huey Copeland, "Bye, Bye Black Girl: Lorna Simpson's Figurative Retreat," *Art Journal* 64, no. 2 (June 2005): 62–77; Brooke Belisle, "Felt Surface, Visible Image: Lorna Simpson and the Embodiment of Appearance," *Photography and Culture* 4, no. 2 (July 2011): 157–78; "Lorna Simpson with Osman Can Yerebakan," *Brooklyn Rail*, June 2019, https://brooklynrail.org/2019/06/art/LORNA-SIMPSON-

194 / *Notes*

with-Osman-Can-Yerebakan; Leigh Raiford, "Burning All Illusion: Abstraction, Black Life, and the Unmaking of White Supremacy," *Art Journal* 79, no. 4 (January 14, 2021), https://artjournal.collegeart.org/?p = 15113. More recently, Shawn Michelle Smith has used the term "displaced portraits" to think about Simpson's 1995 work *9 Props*, which suggests an evocative shift from the notion of "anti-portrait" that has often been applied to Simpson's earlier work. Smith, *Photographic Returns*, 101.

39. Yerebakan, "Lorna Simpson."

40. This artwork can be seen on Simpson's studio website at https://lsimpson-studio.com/collages/collages-2019–2020. Simpson identifies the source for this image in an interview: Hailey Maitland, "Artist Lorna Simpson Is Turning '50s Ebony Magazine Portraits into Heavenly Collages under Lockdown," *British Vogue*, May 4, 2020, https://www.vogue.co.uk/arts-and-lifestyle/article/lorna-simpson-interview.

41. Simpson has made other collages similar to this one that replace hair with other kinds of celestial imagery or awe-inspiring geological formations. These images can be read as expressions of Black female beauty and glamour, as if seeking empowering associations between body and world that could act against the way those were bound in negative stereotypes. A paradigmatic example is a series of collages Simpson made using images of Rihanna for the January–February 2021 issue of *Essence* (https://www.essence.com /feature/rihanna-artist-lorna-simpson-collab-january-february-cover-exclu-sive/). In the cover image for that issue, Rihanna's face appears surrounded by a huge formation of crystals that look like the diamonds in a necklace she wears.

42. Hauser and Worth hosted Simpson's online exhibition *Give Me Some Moments*, which launched in 2020. As of January 2023, the exhibition was still online, and *Flames* could be viewed at https://www.vip-hauserwirth.com /online-exhibitions/lorna-simpson-give-me-some-moments/.

43. Shana Nys Dambrot, "Lorna Simpson Picks Up the Pieces," *LA Weekly*, May 14, 2020, https://www.laweekly.com/lorna-simpson-picks-up-the-pieces/.

44. Kate Silzer, "Lorna Simpson's Cut-Up Portraits Evoke the Complexity of Identity," *Hyperallergic*, June 27, 2020, https://hyperallergic.com/573498 /lorna-simpsons-cut-up-portraits-hauser-wirth/.

45. Yerebakan, "Lorna Simpson."

46. Laura Wexler traces some of these lineages in her catalogue essay "A Notion of Photography," in *The Notion of Family* (New York: Aperture, 2016).

47. Laura Malone, "LaToya Ruby Frazier's 12-Year Project," *WIRED*, October 12, 2015, https://www.wired.com/2015/10/interview-photographer-latoya-ruby-frazier/; Maurice Berger, "LaToya Ruby Frazier's Notion of Family," *New York Times*, October 14, 2014, https://lens.blogs.nytimes.com/2014/10/14 /latoya-ruby-fraziers-notion-of-family/.

48. Others have also drawn attention to the role of these images in *The Notion of Family*; for example, Walter Ben Michaels discusses "Mom Making an Image of Me" in his essay "Anti-Capitalism and the Camera," in *Capitalism*

and the Camera: Essays on Photography and Extraction, ed. Kevin Coleman and Daniel James (London: Verso, 2021), 101–19.

49. LaToya Ruby Frazier, *The Notion of Family* (New York: Aperture, 2016), 90.

50. Frazier, *Notion of Family,* 92.

51. Michael Beckert, Stephanie Eckardt, and Maridelis Morales Rosado, "27 Photographers' Portraits of Their Moms, from Loving to Unapologetic," *W Magazine,* May 11, 2019, https://www.wmagazine.com/gallery/photographers-portraits-of-their-own-mothers.

52. The way these photographers complicate portraiture demonstrates a resistance to how a "politics of recognition" has also constrained how Black art has been understood and has shaped the demands made of it. Instead of aiming to make Black subjectivity visible through the terms of portraiture that had attempted to negate it, these artists explore how the aesthetics of picturing people could hold other potentials for staging possibilities of personhood unlike the mode of subjectivity those terms had privileged. Black studies scholars have been elaborating how a rethinking of representation and the aesthetics of non-representation inform not just Black art but a Black aesthetics: see, for example, Alexander G. Weheliye, "Introduction: Black Studies and Black Life," *Black Scholar* 44, no. 2 (Summer 2014): 5–10; Fred Moten, *Black and Blur* (Durham, NC: Duke University Press, 2017). Thank you to Kris Cohen for helping me think about these artworks in relation to this broader discourse.

ENTRELACS III. UNFINISHED INCARNATION

1. Merleau-Ponty, *VI,* 209.

2. Merleau-Ponty, *VI,* 269.

3. The Hegelian dialectic, in which thesis and antithesis resolve through synthesis, cannot illuminate a dimensional relationship such as that between a cube's six sides. "What do I bring to the problem of the same and the other?" Merleau-Ponty asks, and answers, "that the same be the other than the other, and identity difference of difference——this 1) does not realize a surpassing, a dialectic in the Hegelian sense; 2) is realized on the spot, by encroachment, thickness, *spatiality.*" Spatiality allows Merleau-Ponty to recast Hegel's idea of negation as "position, negation, negation of negation: this side, the other, the other than the other." Merleau-Ponty, *VI,* 264.

4. Merleau-Ponty, *VI,* 138.

5. Chiasmus is a structural heuristic for depth in Merleau-Ponty's thought, in keeping with his overall analogy between ontological depth and binocular vision: the chiasmatic structure of the optic nerves crossing from each eye provides a figure for this form of reversal and differentiation that is at the same time a form of coordination or cohesion. Kris Paulsen discusses Merleau-Ponty's concept of chiasmus as a way that visual mediation can figure self-other relation in the "Inhabiting Interface" chapter of *Here/There: Telepresence, Touch, and Art at the Interface* (Cambridge, MA: MIT Press, 2017), 115–17.

196 / *Notes*

6. For more on this "circuit," see Merleau-Ponty, *VI*, 202, 269.

7. Merleau-Ponty, *VI*, 269.

8. Merleau-Ponty, *VI*, 142. For more on intercorporeity, see Scott Marratto, *The Intercorporeal Self: Merleau-Ponty on Subjectivity* (Albany: SUNY Press, 2012).

9. Merleau-Ponty, *VI*, 269.

10. Merleau-Ponty, *VI*, 116.

11. Merleau-Ponty, *PP*, 370.

12. Merleau-Ponty, *VI*, 216.

13. Merleau-Ponty, *PP*, 370. For a later, more complex elaboration of this chiasmatic intercorporeity, see Merleau-Ponty, *VI*, 141–42. The concepts of *intercorporeity* and *flesh* might conjure images of bodies adding up to a larger body, agglomerating like so many hands and eyes operating under one monstrous consciousness. But Merleau-Ponty uses the word *transitivism* to describe how the relationality that constitutes one embodied subject would also relate subjects with one another (*VI*, 269). A transitive property is a relationship of relationships: it is what must obtain between A and C, if it is found to relate A and B in the same way that it also relates B and C. Transitivism is another chiasmatic formulation (*VI*, 264). If "my body is made of the same flesh as the world" and "this flesh of my body is shared by the world" in a way that also pertains to the other—their body is also made of the same flesh of the world, and their flesh is "shared" by the world—then there is a way in which my body and the body of the other are the same or shared as the flesh of the world (*VI*, 248).

14. Merleau-Ponty, *VI*, 269.

15. Merleau-Ponty, *VI*, 136.

16. Merleau-Ponty, *VI*, 136.

17. Merleau-Ponty, *VI*, 136.

18. Merleau-Ponty, *EM*, 147.

19. Here my language and thinking are influenced by that of Jean-Luc Nancy in *The Creation of the World, or Globalization* (Albany: SUNY Press, 2017).

20. Merleau-Ponty, *VI*, 263.

21. Merleau-Ponty, *VI*, 264.

22. Merleau-Ponty, *VI*, 209.

CHAPTER 3. VISIBLE WORLD

1. The press release for the Gagosian exhibition in New York in 2011 is archived at https://gagosian.com/exhibitions/2011/andreas-gursky/. The *Ocean* series can be viewed online by clicking through all six images, beginning with *Ocean I*, at https://www.andreasgursky.com/en/works/2010/ocean /ocean-1.

2. The most common enumeration of Earth's five oceans is the Pacific, Atlantic, Indian, Southern, and Arctic. A seventh image is usually included with the series despite having its own title and breaking their compositional rule:

often hung in a room separate from the other images, *Antarctica* depicts the continent of Antarctica as a white landmass centered within the frame and surrounded by dark-blue water. The Gagosian gallery describes it as a "coda" to the *Ocean* series and interprets it as "raising an apocalyptic finger" about the danger of global warming. See https://gagosian.com/exhibitions/2011/andreas-gursky/.

3. In the 2011 installation in the Gagosian gallery, most of the *Ocean* series could be seen within the same continuous space even though this space was not as simple as a single room with four walls.

4. The ambiguous and dizzying qualities of these images are typical of the "aerial view," as Patrick Ellis describes it in *Aeroscopics*. Gursky's images compound these qualities, however, both through the perspectival complications of mixing photographic and digital techniques—which I will say more about—and in the interrelationship of images as a series. Ellis, *Aeroscopics: Media of the Bird's-Eye View* (Oakland: University of California Press, 2022).

5. Writing before the explicitly planetary images of the *Ocean* series, Peter Galassi argues that Gursky's images are always projects of world-making, but they present worlds from which the viewer is "resolutely" excluded. He explains that Gursky's images exclude us because they "obliterate the contingencies of perspective, so that the subject appears to present itself without the agency or interference of an observer." Galassi, "Gursky's World," in *Andreas Gursky* (New York: Museum of Modern Art, 2001), 30, 41. Michael Fried argues that Gursky achieves a "severing" of perspective that disrupts how a viewer might be "led to 'identify'" with a photograph as restaging an "originary perceptual experience." Fried, *Why Photography Matters as Art as Never Before* (New Haven, CT: Yale University Press, 2008), 164. Johanna Zylinska positions Gursky's deformations of perspective within a recent trend of photography in the era of the Anthropocene: the apparent objectivity of the camera can seem to stage a "nonhuman" view that invokes "ruination and extinction as a particular art historical mode of re/presentation and aestheticization." Zylinska, *Nonhuman Photography* (Cambridge, MA: MIT Press, 2017), 89. Writing particularly about the *Ocean* series, Donald Kuspit describes it as "implicitly apocalyptic," picturing a "ruined earth" with which we can no longer "feel any bond," by giving us the world as visually mediated by "death-dealing" remote-sensing technologies that are tools of resource extraction, warfare, and geopolitical control. Kuspit, "Andreas Gursky's Oceanic Feeling," *Artnet*, November 23, 2011, https://www.artnet.com/magazineus/features/kuspit/andreas-gursky-gagosian-11-23-11.asp?print=1. Though I will not venture an overall reading of Gursky's work, I will offer a reading of the *Ocean* series that disagrees with Kuspit's and pulls away from the general argument that Gursky's digital manipulation of photographic perspective is more complicit with than critical of the alienating logics it seems to thematize.

6. See https://gagosian.com/exhibitions/2011/andreas-gursky/. In a catalogue essay on the *Ocean* series, Norman Bryson discusses it in relation to the European history of world maps, which he describes as "a whole category of

198 / *Notes*

image-making dedicated to the totality idea, encompassing all of terrestrial space" (14). Bryson, "Gursky's Mappa Mundo," in *Andreas Gursky* (New York: Gagosian, 2010), 13–19.

7. Edward Casey has explored how this question inflects a range of aesthetic practices, asking how art may function as a form of mapping, in *Earth-Mapping: Artists Reshaping Landscape* (Minneapolis: University of Minnesota Press, 2005).

8. Thomas Escobar, "Google Maps 101: How Imagery Powers Our Map," *Keyword,* December 13, 2019, https://www.blog.google/products/maps/google-maps-101-how-imagery-powers-our-map/.

9. Escobar.

10. Escobar. Google's methods of photogrammetry also integrate more recent technologies, such as GPS triangulation and LIDAR sensor readings, that allow additional information about location and position to be recorded along with photographs.

11. I have analyzed Google Earth VR in a previously published essay. See Brooke Belisle, "Whole World within Reach: Google Earth VR," *Journal of Visual Culture* 19, no. 1 (April 2020): 112–36.

12. The interface for Live View on the iPhone iOS as of January 2022 includes this text on the initial pop-up: "Easily know where to go[.] Get oriented quickly with directions overlaid on your real-world surroundings. To start, step outside in a well lit area and hold up your phone." The next pop-up continues: "Point your camera at buildings, stories, and signs around you." It is important to note that, given how quickly visual technologies and mobile platforms develop, this description as well as others addressing "contemporary" media in this book are historically specific to the time of its writing and may have already changed by the time of its publication.

13. This problem with AR gained attention when people using Pokémon GO on mobile devices—walking and driving while looking at their surroundings through the AR overlay on their device—began experiencing both silly mishaps and serious accidents. See, for example, Ron Dengler, "Pokémon Go Caused Accidents and Deaths," *Science,* November 27, 2017, https://www.science.org/content/article/pok-mon-go-caused-accidents-and-deaths.

14. Aparna Chennapragada introduced VPS at Google I/O on May 18, 2018.

15. A video of the keynote presentation from the 2018 Google I/O conference can be viewed at https://www.youtube.com/watch?v = 0gfYd705cRs. The illustration of VPS that I have reproduced as a figure appears in this presentation at 1:27:14.

16. Dominique François Arago, "Report," in *Classic Essays on Photography,* ed. Alan Trachtenberg (New Haven, CT: Leete's Island Books, 1980).

17. Albrecht Meydenbauer is usually credited with coining the term *photogrammetry,* at least as early as an 1867 essay, "Ueber die Anwedung der Photographie zur Architektur- und Terain-Aufnahme," *Zeitschrift für Bauwesen* 17 (1867): 61–70. On the history of photogrammetry, see J.A. Flemer, *An Elementary Treatise on Phototopographic Methods and Instruments: Including a*

Concise Review of Executed Phototopographic Surveys and of Publications on This Subject (New York: Wiley & Sons, 1906); Otto von Gruber, ed., *Photogrammetry: Collected Lectures and Essays* (Boston: American Photographic Publishing Co., 1942); Richard Finsterwalder, *Photogrammetrie* (Berlin: De Gruyter & Co., 1952); Heinz Gruner, "Photogrammetry: 1776–1976," *Photogrammetric Engineering and Remote Sensing* 43, no. 5 (May 1977): 569–74.

18. Jesse Ramsden produced a series of "great theodolites" used in surveys between 1784 and 1853. See the collection of the Science Museum Group, https://collection.sciencemuseumgroup.org.uk/objects/co53377/theodolite-used-for-the-principal-triangulation-of-great-britain-geodetic-theodolite.

19. Surveys of this scale included the Cassini map of France, begun in the 1740s and published in 1815; the Principal Triangulation of Great Britain, begun in the 1780s and published in 1853; the Great Trigonometrical Survey of India, begun in 1802 and published in 1871; and the US Coast and Geodetic Survey, authorized in 1807 and published in 1836. On the history of cartography, see Peter Whitfield, *The Image of the World: 20 Centuries of World Maps* (London: British Library, 2010) and the ongoing, multivolume project *The History of Cartography* (Chicago: University of Chicago Press, 1987–).

20. Katherine McKittrick, *Demonic Grounds: Black Women and the Cartographies of Struggle* (Minneapolis: University of Minnesota Press, 2006).

21. At the Great Exhibition in 1851, photography was exhibited in Class X, for "Philosophical Instruments and Processes depending on their use." According to the jury report on this class, it included "instruments relating to Astronomy, Optics, Light, Heat, Electricity, Magnetism, Acoustics, Meteorology, &c; in fact all relating to Physical Sciences." *Reports by the Juries on the Subjects in the Thirty Classes into Which the Exhibition Was Divided* (London: Spicer Brothers and W. Clowes and Sons, 1852), 243.

22. There is some disagreement about the precise date when Laussedat began using photography in his surveying, partially caused by the fact that this was preceded by his use of the camera lucida—which is an optical but not a photographic instrument, despite some misapprehensions to the contrary. On Laussedat, see A. Laussedat, "Rapport, sur un mémoire intitulé : Mémoire sur l'emploi de la photographie dans le levé des plans et spécialement dans les reconnaissances militaires" (Mallet-Bachelier, Institut impérial de France, Académie des sciences, 1860); A. Laussedat, *La Métrophotographie* (Paris: Gauthier-Villars, 1899); "Laussedat Bicentenary: Origins of Photogrammetry," *Photogrammetric Record* 34, no. 166 (June 2019): 128–47; L. Polidori, "On Laussedat's Contribution to the Emergence of Photogrammetry," *International Archives of the Photogrammetry, Remote Sensing and Spatial Information Sciences* 43-B2 (2020): 893–99; Louis Ragey, "The Work of Laussedat and Education in Photogrammetry at the National School of Arts and Crafts Paris," trans. Dr. L. Skitsky, paper delivered to the VI International Congress of Photogrammetry, The Hague, 1948.

23. In 1858 the Italian geodesist and optical engineer Paulo Porro incorporated a sighting telescope, compass, and level with a panoramic camera that was

200 / *Notes*

designed to swivel at regular intervals to expose sensitized paper mounted on a cylinder. The same year, Auguste Chevallier introduced what he called "La Planchette Photographique," the photographic plane table. It positioned a circular photographic plate where the paper would have been placed in plane table surveying, parallel rather than perpendicular to the ground, and captured an anamorphic view similar to those used in printed guides for painted panoramas. When the US Geological Survey first began using photogrammetry, it was with panoramic cameras designed by brothers C.W. and F.E. Wright (who are not the Wright brothers of aviation). Like Porro's and Chevallier's inventions, this camera swiveled to expose an extended horizon on one extended plate. See C. Tronquoy, *Note sur la planchette photographique de M. Auguste Chevallier* (Paris: Martinet, 1862); "The Photographic Plane Table of M. Auguste Chevallier," *Photographic News,* February 7, 1862, 63–64; Capt. R.H. Stotherd, "Description of an Application of Photography to Surveying Purposes, called 'La Planchette Photographique,'" Paper 6, *Professional Papers of the Corps of Royal Engineers,* New Series, 17 (1869): 128–30; Rupert B. Southhard, "Highlights of US Geological Survey Activities in Photogrammetry and Remote Sensing," *Photogrammetric Engineering and Remote Sensing* 50, no. 9 (September 1984): 1323–31. On the relationship between panoramic photography and surveying, see Thomas Luhrman, "A Historical Review on Panorama Photogrammetry," University of Applied Sciences, Institute for Applied Photogrammetry and Geoinformatics, Oldenburg, Germany, 2004.

24. Sometimes he captured full, wraparound panoramas from each surveying station, such that the images could be aligned horizontally to depict what Robert Barker, in his patent of panoramic format, specified as a complete and continuous view. Other surveyors and photographers at the time were also experimenting at the intersection of panoramic aesthetics and topographic techniques, but they all captured a spatially continuous view instead of multiple, discrete perspectives.

25. This is closely related to techniques I described in chapter 1 for extrapolating three-dimensional shapes from multiple two-dimensional perspectives— in particular, Woody Bledsoe's "rotation equation" and image sets used for training object recognition (like COIL-100) that picture objects from a series of rotated perspectives.

26. Paulo Porro designed a phototheodolite in 1865, and Italian engineer Pio Paganini designed one in 1884, for mapping the Alps. See, for example, P. Paganini, *La Fototopographia in Italia* (Rivista di Topografia e Catasto, 1889).

27. Édouard Deville, *Photographic Surveying: Including the Elements of Descriptive Geometry and Perspective* (Ottawa: Government Printing Bureau, 1889; rev. ed., 1895).

28. This project also helped inspire the global use of "standard time," the system of twenty-four time zones proposed by the chief engineer of the Canadian Pacific Railway, Sandford Fleming, which was adopted the same year the transcontinental line was completed and is still used around the world today. On the fascinating history of the Canadian Pacific Railway, see Harold A.

Innis, *A History of the Canadian Pacific Railway* (Toronto: University of Toronto Press, 1999); Matthew Sparke, "Mapped Bodies and Disembodied Maps: Displacing Cartographic Struggle in Colonial Canada," in *Places through the Body*, ed. Steve Pile and Heidi Nast (New York: Routledge, 1998), 305–36; Sandford Fleming, "Report in Reference to the Canadian Pacific Railway" (Ottawa: Roger Maclean, 1879); Doug Owram, *Promise of Eden: The Canadian Expansionist Movement and the Idea of the West, 1856–1900* (Toronto: University of Toronto Press, 1992); Joe Bongiorno, "Uncovered Tracks: The Bloody Legacy of Canada's Railways," *Canada's National Observer*, December 21, 2020, https://www.nationalobserver.com/2020/12/21/opinion/bloody-legacy-canadas-railways-indigenous-peoples.

29. Deville, *Photographic Surveying*, 5.

30. Deville, vi.

31. Deville, 201.

32. Deville, 181–82.

33. Deville, 211.

34. Library and Archives Canada (LAC) does, however, own many photographic "views" taken by Deville and his team along the railway. See, for example, two albums of albumen prints titled "Views on the C.P. Railway" (R214-3006-0-E, RG45, box 2102; R214-3007-2-E, RG45, box 2103) and another labeled "Deville Album" from 1886 (R1461-6-4-E, MG30-A33, box 2). These photographs offer a powerful encounter with what was stripped away in making the topographical maps, each image reasserting not only the spatial and temporal specificity but also the formal specificity and aesthetic force of photographic mediation. Some of these have been digitized and can be viewed online on the LAC website, such as a selection here: https://recherche-collection-search.bac-lac.gc.ca/eng/Home/Search?DataSource=Archives|FonAndCol&SearchIn_1=PartOfEn&SearchInText_1=157651. I am indebted to Dr. Jill Delaney at LAC for her research expertise and assistance on Deville.

35. In some instances of *Photographic Surveying*, these plates are missing titles and the topographic map is omitted, but I base my account on a comparison of printed and digitized versions held by the University of California, Berkeley; Columbia University; the University of Wisconsin; and the Getty Research Institute.

36. Andrew Birrell emphasizes the hindrance posed by the wet-plate format, which required surveyors to carry not only heavy glass plates but also working darkrooms into the sites they would survey. Birrell, "Survey Photography in British Columbia 1858–1900," *BC Studies*, no. 52 (Winter 1981/82): 39–60. On the history of aerial photography, see Paula Amad, "From God's-Eye to Camera-Eye: Aerial Photography's Post-humanist and Neo- humanist Visions of the World," *History of Photography* 36, no. 1 (Spring 2012): 66–86; Jason Weems, *Barnstorming the Prairies: Aerial Vision and Modernity in Rural America* (Minneapolis: University of Minnesota Press, 2015).

37. See von Gruber, *Photogrammetry*, 176–78; C.H. Birdseye, "Stereoscopic Phototopographic Mapping," *Annals of the Association of American*

202 / Notes

Geographers 30, no. 1 (1940): 1–24; Édouard Deville, "On the use of Wheatstone Stereoscope in Photographic Surveying," *Proceedings and Transactions of the Royal Society of Canada*, Second Series, 8 (1902): 63–69.

38. See *The Century Dictionary Supplement*, ed. B.E. Smith (New York: Century Co., 1914), s.v. "Stereocomparator"; F. Vivian Thompson, "Stereophoto Surveying," *Geographical Journal* 31, no. 5 (May 1908): 534–49.

39. H.G. Fourcade, "A Stereoscopic Method of Photographic Surveying," *Nature* 66, no. 1701 (June 1902): 139–41.

40. He first wrote about this in 1897. The stereopticon magic lantern did not project a three-dimensional image—despite some contemporary confusion that suggests otherwise. It was a compound magic lantern that had two separate lenses for projection, such that the operator could transition between slides by covering one lens and uncovering another. Scheimpflug also published what became known as the "Scheimpflug rule," explaining how the plane of focus in an image is contingent on related angles between three planes: that of the photosensitive surface (image plane), the lens (lens plane), and whatever aspect of the subject being photographed would appear in the plane of the image (subject plane).

41. Von Gruber, *Photogrammetry*, 159–60.

42. Only one prototype may have been made, but W. Sander offers an extended description in an essay included in von Gruber's *Photogrammetry*, 178–81.

43. Von Gruber, 180.

44. Von Gruber, 180–81.

45. For example, in his 1962 history of Multiplex mapping, H. Gruner claims, "Multiplex mapping operations assumed enormous proportions, due to acceleration by military necessities on world-wide theaters of operation and to the tremendous civil pressure for mapping in the post-war period." Gruner, "The History of the Multiplex," presented at the 28th Annual Meeting of the American Society of Photogrammetry, Washington, DC, March 14–17, 1962, and published in *Photogrammetric Engineering* 28, no. 3 (July 1963): 480–84. On stereographic aerial surveillance photography, also see Paul St. Amour, "Modernist Reconnaissance," *Modernism/Modernity* 10, no. 2 (April 2003): 349–80.

46. C.L. Filmore, "Application of High Order Stereoscopic Plotting Instruments to Photogeologic Studies," *USGS Bulletin* 1043-B (Washington, DC, 1957), 23-34; Rupert B. Southard, "Highlights of U.S. Geological Survey Activities in Photogrammetry and Remote Sensing," *Photogrammetric Engineering and Remote Sensing* 50, no. 9 (September 1984): 1323–31.

47. Russell Bean, "The Development of the ER-55 Projector," presentation to American Society of Photogrammetry, Washington, DC, January 14, 1953; published in *Photogrammetric Engineering* 19, no. 1 (March 1953): 71–84.

48. Russell Bean, "ER-55 Projector for Aerial Mapping," *Science* 118, no. 3069 (October 23, 1953): 484–86.

49. The history of computation itself overlaps with that of photogrammetry, reaching back to the large-scale triangulation surveys that spanned from the late eighteenth to mid-nineteenth century: the trigonometric tables that

were needed for those surveys influenced Babbage's conception of the difference engine. In the 1940s, as the US government was funding the development of projection stereoplotters, motivated by aerial warfare, the US military was also using the first electronic, programmable computers to calculate ballistics trajectories made more complicated by aerial bombing. Thank you to Scott Richmond for pointing this out.

50. Kent Brown, "Photogrammetry Methods at the Utah Geological Survey: From Field Mapping to Published Map," Digital Mapping Techniques '04 Workshop Proceedings, US Geological Survey Open-File Report 2004–1451, https://pubs.usgs.gov/of/2004/1451/brown/index.html.

51. See, for example, steps of the "Photogrammetry Pipeline" as explained on the website for Meshroom, which includes the following steps: "Natural Feature Extraction," "Image Matching, "Features Matching," "Depth Maps Estimation," "Meshing," "Texturing," and "Localization"; see https://alicevision.org/#photogrammetry.

52. See Mapware.com, accessed May 12, 2023, https://mapware.com/how-it-works/.

53. See https://blog.google/products/maps/three-maps-updates-io-2022/.

54. See Belisle, "Whole World within Reach."

55. Daniel, "Immersive View Coming Soon."

56. Katherine McKittrick connects the history of "land grabbing" with contemporary practices of data mining and automated, computational methods for extracting information and producing knowledge. She argues: "Land grabbing is a self-replicating system that provides the avaricious conditions for the data grab. They are not the same, but they are both tied to colonialism and capitalism and they are both entwined with the production of space. The task of data grabbing is to remake our sense of place, heartlessly." McKittrick, *Dear Science and Other Stories* (Durham, NC: Duke University Press, 2021), 109.

57. Although I do not overtly engage with Jean-Luc Nancy's philosophy in this chapter, my thinking is thoroughly inspired by his concepts of spacing and being-singular-plural, and his way of theorizing what a world is—all of which I see as inflected by and sharing the lineage of Merleau-Ponty's thought. See especially Nancy, *The Creation of the World, or Globalization* (Stanford, CA: Stanford University Press, 2002); *Being Singular Plural* (Stanford, CA: Stanford University Press, 2000); and *The Sense of the World* (Minneapolis: University of Minnesota Press, 1997).

58. My reading of how embodied spectators experience the *Ocean* images resonates with the reading James J. Hodge proposes of Peter Bo Rappmund's films as a form of "earth-specific art." While his essay is thinking about moving rather than still images, and Edmund Husserl's rather than Merleau-Ponty's phenomenology, both of us are asking how aesthetic mediations of "Earth" as a subject of representation might open onto its unrepresentable nature as the grounds of perception. Hodge, "Earth-Specific Art: Phenomenology and the Digital Cinema of Peter Bo Rappmund," *ASAP* 2, no. 3 (September 2017): 579–601. Edward Casey suggests that this recursivity in representations of Earth is

204 / *Notes*

not only an accomplishment of particular artworks (such as "earthworks") but also shows up, in all maps, as Earth's "resistance" to mapping. Casey, *Earth-Mapping*, 59.

ENTRELACS IV. OTHER LANDSCAPES

1. Martin Heidegger offers one influential response to this question in "The Age of the World Picture"—which I have discussed elsewhere in relationship to the photographic and computational mapping of Google Earth VR. Here I deliberately set Heidegger aside so that his essay does not center, as it so often has, any way of thinking about the relationship between "world" and "picturing." See Brooke Belisle, "Whole World within Reach: Google Earth VR," *Journal of Visual Culture* 19, no. 1 (April 2020): 112–36; Heidegger, "The Age of the World Picture," *The Question Concerning Technology and Other Essays*, trans. William Lovitt (New York: Harper and Row, 1977), 115–54.

2. Merleau-Ponty, *PP*, 345; Merleau-Ponty is quoting Spinoza here.

3. Merleau-Ponty, *EM*, 149.

4. Merleau-Ponty, *EM*, 149.

5. Merleau-Ponty, *PP*, 347.

6. Merleau-Ponty restates this in *The Visible and the Invisible*, where he argues that to achieve a "positive vision that would definitively give me the essentiality of the essence," I would have to "soar over my field" in a way that would "deprive me of that very cohesion in depth of the world and of Being without which the essence is subjective folly and arrogance." *VI*, 112.

7. Merleau-Ponty, *VI*, 78.

8. Merleau-Ponty, *VI*, 149.

9. Merleau-Ponty, *VI*, 112.

10. Merleau-Ponty, *PP*, 345, 349; *VI*, 140–42.

11. Paul Cézanne—whose work Merleau-Ponty saw as resonant with his own—does this, of course, with his many paintings of Mount Saint-Victoire. See Merleau-Ponty, "Cézanne's Doubt," in *Sense and Non-Sense*, trans. Hubert and Patricia Dreyfus (Evanston, IL: Northwestern University Press, 1992), 9–25.

12. Merleau-Ponty, *VI*, 141.

13. Merleau-Ponty, *PP*, 366, 345. Merleau-Ponty also expresses this paradox in terms of the way a horizon line both limits perspective and marks how it opens onto what exceeds it: when "I gaze upon the horizon," he claims, "all of the landscapes are already there in the concordant series and open infinity of their perspectives"—neither abstractly nor explicitly but immanent in the horizon that articulates his landscape for him. *PP*, 345. He also argues that the "World" is this whole where each "part," when one takes it for itself, suddenly opens unlimited dimensions—becomes a *total part*.

14. Merleau-Ponty, *VI*, 272, 260. See also Merleau-Ponty, *VI*, 223, 261.

15. Merleau-Ponty, *VI*, 224.

16. Merleau-Ponty, *VI*, 224.

17. Merleau-Ponty, *VI*, 260.

Bibliography

Adams, George. *The Maine Register for the Year 1855: Embracing the State and County Officers and an Abstract of the Laws and Resolves; Together with a Complete Business Directory of the State, and a Variety of Useful Information.* Portland: Blake & Carter, 1855.

Ahmad, Wasim. "Are Smartphone Portrait Modes for Photographers?" *Fstoppers*, August 23, 2019. https://fstoppers.com/originals/are-smart-phone-portrait-modes-photographers-400461.

———. "Sony Stuffs an Actual Zoom Lens onto a Smartphone." *Fstoppers*, May 27, 2022. https://fstoppers.com/gear/sony-stuffs-actual-zoom-lens-smartphone-606018.

Albers, Kate Palmer. *The Night Albums: Visibility and the Ephemeral Photograph.* Oakland: University of California Press, 2022.

Amad, Paula. "From God's-Eye to Camera-Eye: Aerial Photography's Post-humanist and Neo- humanist Visions of the World." *History of Photography* 36, no. 1 (Spring 2012): 66–86.

Arago, Dominique François. "Report." In *Classic Essays on Photography*, edited by Alan Trachtenberg. New Haven: Leete's Island Books, 1980.

Arnold, Taylor, and Laurel Tilton. "Depth in Deep Learning." In *Deep Mediations: Thinking Space in Cinema and Digital Cultures*, edited by Karen Redrobe and Jeff Scheible, 309–28. Minneapolis: University of Minnesota Press, 2021.

Barthes, Roland. *Camera Lucida: Reflections on Photography.* New York: Hill and Wang, 1982.

Bean, Russell. "The Development of the ER-55 Projector." Presentation to American Society of Photogrammetry, Washington, DC: US Geological Survey, January 14, 1953. Published in *Photogrammetric Engineering* 19, no. 1 (March 1953): 71–84.

———. "ER-55 Projector for Aerial Mapping." *Science* 118, no. 3069 (October 23, 1953): 484–86.

206 / *Bibliography*

Beckert, Michael, Stephanie Eckardt, and Maridelis Morales Rosado. "27 Photographers' Portraits of Their Moms, From Loving to Unapologetic." *W Magazine*, May 11, 2019. https://www.wmagazine.com/gallery /photographers-portraits-of-their-own-mothers.

Belisle, Brooke. "Artifacts: Trevor Paglen's Frontier Photography." In *Making the Geologic Now: Responses to Material Conditions of Contemporary Life,* edited by Jamie Kruse and Elizabeth Ellsworth. New York: Punctum Books, 2012.

———. "Depth Readings: Ken Jacobs' Digital, Stereographic Films." *Cinema Journal* 53, no. 2 (February 2014): 2–26.

———. "The Dimensional Image: Overlaps in Stereoscopic, Cinematic, and Digital Depth." *Film Criticism* 37, no. 3 (Spring/Fall 2013): 117–37.

———. "Felt Surface, Visible Image: Lorna Simpson and the Embodiment of Appearance." *Photography and Culture* 4, no. 2 (July 2011): 157–78.

———. "From Stereoscopic Depth to Deep Learning." *Deep Mediations: Thinking Space in Cinema and Digital Cultures,* edited by Karen Redrobe and Jeff Scheible, 329–50. Minneapolis: University of Minnesota Press, 2021.

———. "I See the Moon, The Moon Sees Me: Trevor Paglen's Satellite Views." In "Art & Infrastructures: Hardware," special issue, *Media-N* 10, no. 1 (Spring 2014). https://median.newmediacaucus.org/art-infrastructures-hardware/i-see-the-moon-the-moon-sees-me-trevor-paglens-satellite-images/.

———. "Nature at a Glance: Immersive and Interactive Display from Georama to Reality Deck." *Early Popular Visual Culture* 13, no. 4 (Winter 2015): 331–35.

———. "Picturing Networks: Railroads and Photographs." In "Network Archaeology," special issue, *Amodern* 2 (October 2013), n.p. https://amodern.net/article/picturing-nineteenth-century-networks/.

———. "The Total Archive: Picturing History from the Stereographic Library to the Digital Database." *Mediascape* (Winter 2013). http://www.tft.ucla.edu/mediascape/Winter2013_ PicturingHistory.html.

———. "Whole World within Reach: Google Earth VR." *Journal of Visual Culture* 19, no. 1 (April 2020): 112–36.

Benjamin, Walter. *The Arcades Project.* Cambridge, MA: Belknap Press of Harvard University Press, 2003.

———. "On the Concept of History." *Selected Writings 4.* Edited by Howard Eiland and Michael W. Jennings, 389–400. Cambridge, MA: Belknap Press of Harvard University Press, 2003.

Berger, Maurice. "LaToya Ruby Frazier's Notion of Family." *New York Times,* October 14, 2014. https://lens.blogs.nytimes.com/2014/10/14/latoya-ruby-fraziers-notion-of-family/.

Bertillon, Alphonse. *La Photographie judiciaire.* Paris: Gauthier-Villars, 1890.

Birdseye, C.H. "Stereoscopic Phototopographic Mapping." *Annals of the Association of American Geographers* 30, no. 1 (1940): 1–24.

Birrell, Andrew. "Survey Photography in British Columbia 1858–1900." *BC Studies,* no. 52 (Winter 1981/82): 39–60.

Bledsoe, Woodrow Wilson. "Facial Recognition Project, a Report." March 6, 1964. Box 96-349/7. Bledsoe Papers, Briscoe Center for American History, University of Texas at Austin.

———. "The Model Method in Facial Recognition." Technical Report PRI 15. Stanford: Panoramic Research, August 12, 1964. Box 96-349/12. Bledsoe Papers, Briscoe Center for American History, University of Texas at Austin.

Blunden, Mark. "Graduates Are Taking £9k Courses to Help Beat AI Interviews for City Jobs." *London Evening Standard,* October 2, 2018. https://www.standard.co.uk/tech/ai-interviews-city-jobs-graduates-a3951296.html.

Bogart, Michele. "Photosculpture." Art History 4, no. 1 (1981): 54–65.

Bongiorno, Joe. "Uncovered Tracks: The Bloody Legacy of Canada's Railways." *Canada's National Observer,* December 21, 2020. https://www.nationalobserver.com/2020/12/21/opinion/bloody-legacy-canadas-railways-indigenous-peoples.

Brady, Mathew. *The Gallery of Illustrious Americans.* New York: D'Avignon and Company, 1850.

Braun, Marta. *Eadweard Muybridge.* London: Reaktion, 2010.

Brown, C. Scott. "Huawei P30 Pro 'Moon Mode' Stirs Controversy." *Android Authority,* April 24, 2019. https://www.androidauthority.com/huawei-p30-pro-moon-mode-controversy-978486/.

Brown, Kent. "Photogrammetry Methods at the Utah Geological Survey: From Field Mapping to Published Map." Digital Mapping Techniques '04 Workshop Proceedings. US Geological Survey Open-File Report 2004–1451. https://pubs.usgs.gov/of/2004/1451/brown/index.html.

Bryson, Norman. "Gursky's Mappa Mundo." In *Andreas Gursky,* 13–19. New York: Gagosian, 2010.

Buolamwini, Joy, and Timnit Gehru. "Gender Shades: Intersectional Accuracy Disparities in Commercial Gender Classification." Proceedings of Machine Learning Research 81 (January 2018): 1–15.

Casey, Edward S. *Earth-Mapping: Artists Reshaping Landscape.* Minneapolis: University of Minnesota Press, 2005.

———. "'The Element of Voluminousness': Depth and Place Re-examined." *Merleau-Ponty Vivant,* edited by M.C. Dillon, 1–30. Albany: State University of New York Press, 1991.

Cataldi, Sue L. *Emotion, Depth, and Flesh: A Study of Sensitive Space— Reflections on Merleau-Ponty's Philosophy of Embodiment.* Albany: SUNY Press, 1993.

The Century Dictionary Supplement, ed. B.E. Smith, s.v. "Stereocomparator." New York: Century Co., 1914.

Chaudhary, Zahid. *Afterimage of Empire: Photography in Nineteenth-Century India.* Minneapolis: University of Minnesota Press, 2012.

Chun, Wendy Hui Kyong. *Discriminating Data: Correlation, Neighborhoods, and the New Politics of Recognition.* Cambridge, MA: MIT Press, 2021.

208 / Bibliography

Clark, Tim. "From Apple to Anomaly." *British Journal of Photography*, no. 7888 (September 2019). https://www.1854.photography/2019/10/trevor-paglen-barbican/.

Clarke, Grahame, ed. *The Portrait in Photography*. New York: Reaktion Books, 1992.

Cohen, Kris. "The Irresolutions of Charles Gaines." *Nervous Systems*, edited by Johanna Gosse and Timothy Stott, 105–24. Durham, NC: Duke University Press, 2021.

———. "Superimposed, Still." *JCMS* 61, no. 4 (Summer 2022): 163–68.

Cole, Brendan. "Chinese University Tests Facial Recognition System to Monitor Attendance and Students' Attention to Lectures." *Newsweek*, September 2, 2019. https://www.newsweek.com/"anjing-china-facial-recognition-1457193.

Coleman, Kevin, and Daniel James, ed. *Capitalism and the Camera: Essays on Photography and Extraction*. London: Verso, 2021.

"Computer Programs Recognise White Men Better than Black Women: Biased Training Is Probably to Blame." *Economist*, February 15, 2018. https://www.economist.com/science-and-technology/2018/02/17/computer-programs-recognise-white-men-better-than-black-women.

Copeland, Huey. "Bye, Bye Black Girl: Lorna Simpson's Figurative Retreat." *Art Journal* 64, no. 2 (June 2005): 62–77.

Crary, Jonathan. *Suspensions of Perception: Attention, Spectacle, and Modern Culture*. Cambridge, MA: MIT Press, 1999.

———. *Techniques of the Observer: On Vision and Modernity in the Nineteenth Century*. Cambridge, MA: MIT Press, 1990.

Crawford, Kate. *Atlas of AI: Power, Politics, and the Planetary Costs of Artificial Intelligence*. New Haven, CT: Yale University Press, 2021.

Dambrot, Shana Nys. "Lorna Simpson Picks Up the Pieces." *LA Weekly*, May 14, 2020. https://www.laweekly.com/lorna-simpson-picks-up-the-pieces/.

Daniel, Miriam. "Immersive View Coming Soon to Maps—Plus More Updates." *Keyword*, May 11, 2022. https://blog.google/products/maps/three-maps-updates-io-2022/.

Darwin, Charles. *The Expression of the Emotions in Man and Animals*. London: John Murray, 1872.

Daston, Lorraine, and Peter Galison. *Objectivity*. New York: Zone Books, 2010.

Debracho, Mauricio, Damien Kelly, Michael Brown, and Peyman Milanfar. "Mobile Computational Photography: A Tour." Google Research and York University EECS Department, March 10, 2021.

Dengler, Ron. "Pokémon Go Caused Accidents and Deaths." *Science*, November 27, 2017. https://www.science.org/content/article/pok-mon-go-caused-accidents-and-deaths.

Denson, Shane. *Discorrelated Images*. Durham, NC: Duke University Press, 2021.

Derrida, Jacques. "Différance" [1963]. *Margins of Philosophy*, translated by Alan Bass, 3–27. Chicago: University of Chicago Press, 1982.

Deville, Édouard. "On the Use of Wheatstone Stereoscope in Photographic Surveying." *Proceedings and Transactions of the Royal Society of Canada.* Second Series, vol. 8, 63–69. Ottawa: Royal Society of Canada, 1902.

———. *Photographic Surveying: Including the Elements of Descriptive Geometry and Perspective.* 1889. Rev. ed. Ottawa: Government Printing Bureau, 1895.

Doherty, Brigid, Michael W. Jennings, and Thomas Y. Levin, eds. *Walter Benjamin: The Work of Art in the Age of Its Technological Reproducibility and Other Writings on Media.* Cambridge, MA: Harvard University Press, 2008.

Dvořák, Tomáš, and Jussi Parikka, eds. *Photography off the Scale: Technologies and Theories of the Mass Image.* Edinburgh: Edinburgh University Press, 2021.

Duchenne, Guillaume-Benjamin-Amand. *Mécanisme de la physionomie humaine, ou analyse électro-physiologique de l'expression des passions.* Paris: Jules Renouard, 1862.

Eastlake, Lady Elizabeth. "Photograph." *London Quarterly Review,* no. 101 (April 1857): 442–68.

Edwards, Elizabeth. *Anthropology and Photography 1860–1920.* New Haven, CT: Yale University Press, 1994.

Ellenbogen, Josh. *Reasoned and Unreasoned Images: The Photography of Bertillon, Galton, and Marey.* University Park: Pennsylvania State University Press, 2012.

Ellis, Patrick. *Aeroscopics: Media of the Bird's-Eye View.* Oakland: University of California Press, 2022.

Elsaesser, Thomas. "The 'Return' of 3-D: On Some of the Logics and Genealogies of the Image in the Twenty-First Century." *Critical Inquiry* 39, no. 2 (Winter 2013): 217–46.

Escobar, Thomas. "Google Maps 101: How Imagery Powers Our Map." *Keyword,* December 13, 2019. https://www.blog.google/products/maps /google-maps-101-how-imagery-powers-our-map/.

Eubanks, Virginia. *Automating Inequality: How High-Tech Tools Profile, Police, and Punish the Poor.* New York: St Martin's Press, 2018.

Filmore, C.L. "Application of High Order Stereoscopic Plotting Instruments to Photogeologic Studies." *USGS Bulletin* 1043-B, 23–34. Washington, DC, 1957.

Finsterwalder, Richard. *Photogrammetrie.* Berlin: De Gruyter & Co., 1952.

Flemer, J.A. *An Elementary Treatise on Phototopographic Methods and Instruments: Including a Concise Review of Executed Phototopographic Surveys and of Publications on This Subject.* New York: Wiley & Sons, 1906.

Fleming, Sandford. "Report in Reference to the Canadian Pacific Railway." Ottawa: Roger Maclean, 1879.

Foucault, Michel. *The Archaeology of Knowledge* [*L'archéologie du savoir,* 1969]. Translated by A.M. Sheridan Smith. New York: Random House, 1972.

———. *The Order of Things: An Archaeology of the Human Sciences* [*Let Mots et les choses,* 1966]. New York: Random House, 1994.

Fourcade, H.G. "A Stereoscopic Method of Photographic Surveying." *Nature* 66, no. 1701 (June 1902): 139–41.

210 / *Bibliography*

Frazier, LaToya Ruby. *The Notion of Family.* New York: Aperture, 2016.

Fried, Michael. *Why Photography Matters as Art as Never Before.* New Haven, CT: Yale University Press, 2008.

Gaboury, Jacob. "Hidden Surface Problems: On the Digital Image as Material Object." *Journal of Visual Culture* 14, no. 1 (April 2015): 40–60.

Galassi, Peter. "Gursky's World." In *Andreas Gursky,* 9–45. New York: Museum of Modern Art, 2001.

Galloway, Alex. *Uncomputable: Play and Politics in the Long Digital Age.* London: Verso, 2021.

Gershgorn, Dave. "The Data That Transformed AI Research—and Possibly the World." *Quartz,* July 26, 2017. https://qz.com/1034972/the-data-that-changed-the-direction-of-ai-research-and-possibly-the-world/.

Gilbreth, Frank, and Lillian Moleth Gilbreth. *Applied Motion Study: A Collection of Papers on the Efficient Method to Industrial Preparedness.* New York: Sturgis & Walton, 1917.

Glissant, Édouard. *The Poetics of Relation.* Ann Arbor: University of Michigan Press, 1997.

Goodfellow, Ian, Yoshua Bengio, and Aaron Courville. *Deep Learning.* Cambridge, MA: MIT Press, 2016.

Greenberg, Clement. "Towards a New Laocoön." *Partisan Review* 7, no. 4 (July–August 1940): 296–310.

Gruner, Heinz. "The History of the Multiplex." *Photogrammetric Engineering* 28, no. 3 (July 1963): 480–84. Presented at the 28th Annual Meeting of the American Society of Photogrammetry, Washington, DC, March 14–17, 1962.

———. "Photogrammetry: 1776–1976." *Photogrammetric Engineering and Remote Sensing* 43, no. 5 (May 1977): 569–74.

Gunning, Tom. "The Cinema of Attractions: Early Cinema, Its Spectator, and the Avant-Garde." *Wide Angle* 8, no. 3–4 (1986): 63–70.

———. "Hand and Eye: Excavating a New Technology of the Image in the Victorian Era." *Victorian Studies* 54, no. 3 (Spring 2012): 495–516.

Guynn, Jessica. "Google Photos Labeled Black People 'Gorillas.'" USA TODAY, July 1, 2015. https://www.usatoday.com/story/tech/2015/07/01/google-apologizes-after-photos-identify-black-people-as-gorillas/29567465/.

Hamilton, Peter, and Roger Hargreaves. *The Beautiful and the Damned: The Creation of Identity in Nineteenth-Century Photography.* London: Lund Humphries, 2001.

Hand, Martin. *Ubiquitous Photography.* New York: Polity, 2012.

Hankins, Thomas L., and Robert J. Silverman, eds. *Instruments and the Imagination.* Princeton, NJ: Princeton University Press, 1999.

Hansen, Mark B.N. *Bodies in Code: Interfaces with Digital Media.* New York: Taylor & Francis, 2006.

———. "Seeing with the Body: The Digital Image in Postphotography." *Diacritics* 31, no. 4 (Winter 2001): 54–84.

Hartman, Saidiya V. *Scenes of Subjection: Terror, Slavery, and Self-Making in Nineteenth-Century America.* New York: Oxford University Press, 1997.

Hayes, Brian. "Computational Photography." *American Scientist* 96, no. 2 (March–April 2008): 94–98.

Heidegger, Martin. *The Question Concerning Technology and Other Essays.* Translated by William Lovitt. New York: Harper and Row, 1977.

Henisch, Heinz, and Bridget Ann Henisch. *The Photographic Experience 1839–1914: Images and Attitudes.* University Park: Pennsylvania State University Press, 1994.

Hodge, James J. "Earth-Specific Art: Phenomenology and the Digital Cinema of Peter Bo Rappmund." *ASAP* 2, no. 3 (September 2017): 579–601.

———. *Sensations of History: Animation and New Media Art.* Minneapolis: University of Minnesota Press, 2019.

Holmes, Oliver Wendell. "The Stereoscope and the Stereograph." *Atlantic Monthly,* June 1859. https://www.theatlantic.com/magazine/archive/1859/06/the-stereoscope-and-the-stereograph/303361/.

Hu, Tung-Hui. *Digital Lethargy: Dispatches from an Age of Disconnection.* Cambridge, MA: MIT Press, 2022.

Husserl, Edmund. *Thing and Space: Lectures of 1907.* Translated by Richard Rojcewitcz. Berlin: Kluwer, 1997.

Innis, Harold A. *A History of the Canadian Pacific Railway.* Toronto: University of Toronto Press, 1999.

Kember, Sarah. "Face Recognition and the Emergence of Smart Photography." *Journal of Visual Culture* 13, no. 2 (2014): 182–99.

King, Homay. *Virtual Memory: Time-Based Art and the Dream of Digitality.* Durham, NC: Duke University Press, 2015.

Kittler, Friedrich. *Optical Media.* New York: Polity Press, 2010.

Kondeth, Affan. "Solving the Famous Problem of Puppy vs Muffin by Deep Learning—Web App on Google App Engine/Fastai." *Medium,* June 30, 2020. https://medium.com/@ahffank/solving-the-famous-problem-of-puppy-vs-muffin-using-a-simple-web-application-on-google-app-a3264e2be49c.

Kracauer, Siegfried. "Photography" [1927]. *Critical Inquiry* 19, no. 3 (Spring 1993): 421–36.

Kuspit, Donald. "Andreas Gursky's Oceanic Feeling." *Artnet,* November 23, 2011. https://www.artnet.com/magazineus/features/kuspit/andreas-gursky-gagosian-11-23-11.asp?print=1.

Lamprey, J.H. "On a Method of Measuring the Human Form for the Use of Students in Ethnology." *Journal of the Ethnological Society of London* 1 (April 1869): 84–85.

Laussedat, A. *La Métrophotographie.* Paris: Gauthier-Villars, 1899.

———. *Rapport, sur un mémoire intitulé : Mémoire sur l'emploi de la photographie dans le levé des plans et spécialement dans les reconnaissances militaires.* Mallet-Bachelier, Institut impérial de France, Académie des sciences, 1860.

"Laussedat Bicentenary: Origins of Photogrammetry." *Photogrammetric Record* 34, no. 166 (June 2019): 128–47.

212 / Bibliography

Lecun, Yann, Fu Jie Huang, and Leon Bottou. "Learning Methods for Generic Object Recognition with Invariance to Pose and Lighting." Courant Institute, New York University, 2004.

Luhrman, Thomas. "A Historical Review on Panorama Photogrammetry." Oldenburg, Germany: University of Applied Sciences, Institute for Applied Photogrammetry and Geoinformatics, 2004.

MacKenzie, Adrian, and Anna Munster. "Platform Seeing: Image Ensembles and Their Invisualities." *Theory, Culture & Society* 36, no. 5 (2019): 3–22.

Maitland, Hailey. "Artist Lorna Simpson Is Turning '50s Ebony Magazine Portraits into Heavenly Collages under Lockdown." *British Vogue,* May 4, 2020. https://www.vogue.co.uk/arts-and-lifestyle/article/lorna-simpson-interview.

Malone, Laura. "LaToya Ruby Frazier's 12-Year Project." *WIRED,* October 12, 2015. https://www.wired.com/2015/10/interview-photographer-latoya-ruby-frazier/.

Markoff, John. "For Web Images, Creating New Technology to Seek and Find." *New York Times,* November 19, 2012. https://www.nytimes.com/2012/11/20/science/for-web-images-creating-new-technology-to-seek-and-find.html.

Marratto, Scott. *The Intercorporeal Self: Merleau-Ponty on Subjectivity.* Albany: SUNY Press, 2012.

Mazis, Glen. *Merleau-Ponty and the Face of the World: Silence, Ethics, Imagination, and Poetic Ontology.* Albany: SUNY Press, 2016.

McDermott, Emily. "Holly Herndon on Her AI Baby, Reanimating Tupac, and Extracting Voices." *Art in America,* January 7, 2020. https://www.artnews.com/art-in-america/interviews/holly-herndon-emily-mcdermott-spawn-ai-1202674301/.

McKim, Tom. "Trevor Paglen Trains His Sight on the Rise of Machine Vision." *Apollo Magazine,* October 17, 2019. https://www.apollo-magazine.com/trevor-paglen-machine-vision/.

McKittrick, Katherine. *Dear Science and Other Stories.* Durham, NC: Duke University Press, 2021.

———. *Demonic Grounds: Black Women and the Cartographies of Struggle.* Minneapolis: University of Minnesota Press, 2006.

Meel, Vidushi. "83 Most Popular Computer Vision Applications in 2022." March 9, 2021. https://viso.ai/applications/computer-vision-applications/.

Merleau-Ponty, Maurice. "Eye and Mind." In *The Merleau-Ponty Aesthetics Reader,* edited by Galen Johnson, translated by Michael Smith, 121–64. Evanston, IL: Northwestern University Press, 1993.

———. *The Phenomenology of Perception.* Translated by Donald Landes. New York: Routledge, 2014.

———. *Sense and Non-Sense.* Translated by Hubert and Patricia Dreyfus. Evanston, IL: Northwestern University Press, 1992.

———. *The Visible and the Invisible.* Translated by Alfonso Lingis. Evanston, IL: Northwestern University Press, 1968.

Meydenbauer, Albrecht. "Ueber die Anwedung der Photographie zur Architektur- und Terain-Aufnahme." *Zeitschrift für Bauwesen* 17 (1867): 61–70.

Mitchell, William J. *The Reconfigured Eye: Visual Truth in a Post-Photographic Era.* Cambridge, MA: MIT Press, 1992.

Morris, David. *The Sense of Space.* Albany: SUNY Press, 2004.

Moten, Fred. *Black and Blur.* Durham, NC: Duke University Press, 2017.

———. Review of *Soul: Black Power, Politics, and Pleasure,* ed. Monique Guillory and Richard C. Green, and *Scenes of Subjection: Terror, Slavery, and Self-Making in Nineteenth-Century America,* by Saidiya V. Hartman. *TDR: The Drama Review* 43, no. 4 (1999): 169–75. muse.jhu.edu/article /32971.

Muybridge, Eadweard. *Animal Locomotion: An Electro-photographic Investigation of Consecutive Phases of Animal Movements.* Vol. 2, *Men (Nude).* Philadelphia: University of Pennsylvania Press, 1887.

Nancy, Jean-Luc. *Being Singular Plural.* Translated by Robert D. Richardson and Anne E. O'Byrne. Stanford, CA: Stanford University Press, 2000.

———. *The Creation of the World, or Globalization.* Translated by François Raffoul and David Pettigrew. Albany: SUNY Press, 2017.

———. *The Sense of the World.* Translated by Jeffery S. Librett. Minneapolis: University of Minnesota Press, 1997.

Nene, S.A., S.K. Nayar, and H. Murase. "Columbia Object Image Library (COIL-100)." Technical Report CUCS-006–966. Columbia University Department of Computer Science, 1996.

Newhall, Beaumont. *The Daguerreotype in America.* New York: Dover Publications, 1976.

———. "Photosculpture." *Image: Journal of Photography and Motion Pictures of the George Eastman House,* no. 61 (May 1958): 100–105.

Noble, Safiya Umoja. *Algorithms of Oppression: How Search Engines Reinforce Racism.* New York: NYU Press, 2018.

Ogawa, David. "Arresting Nudes in Second Empire Paris." *History of Photography* 31, no. 4 (2007): 330–47.

O'Neil, Cathy. *Weapons of Math Destruction: How Big Data Increases Inequality and Threatens Democracy.* New York: Crown Publishers, 2016.

Ots, Karl. "Dog or Muffin? Training a Custom Computer Vision Classifier to Find Out." LinkedIn, August 10, 2017. https://www.linkedin.com/pulse /dog-muffin-training-custom-computer-vision-classifier-karl-ots.

Owram, Doug. *Promise of Eden: The Canadian Expansionist Movement and the Idea of the West, 1856–1900.* Toronto: University of Toronto Press, 1992.

Paganini, P. *La Fototopographia in Italia.* Rivista di Topografia e Catasto, 1889.

Paglen, Trevor. "Invisible Images (Your Pictures Are Looking at You)." *New Inquiry,* December 8, 2016. https://thenewinquiry.com/invisible-images-your-pictures-are-looking-at-you/.

———, and Kate Crawford. "Excavating AI: The Politics of Images in Machine Learning Training Sets." Accessed January 16, 2023. https://excavating.ai/.

214 / Bibliography

Paulsen, Kris. *Here/There: Telepresence, Touch, and Art at the Interface.* Cambridge, MA: MIT Press, 2017.

Pellerin, Dennis. *History of Nudes in Stereo Daguerreotypes.* Nevada City, CA: Carl Muntz, 2020.

Penedones, Hugo, Ronan Collobert, François Fleuret, and David Grangier. "Improving Object Classification using Pose Information." IDIAP Research Report, September 2012.

"The Photographic Plane Table of M. Auguste Chevallier." *Photographic News,* February 7, 1862, 63–64.

Pinney, Christopher, ed. *Photography's Other Histories.* Durham, NC: Duke University Press, 2013.

Plunkett, John. "'Feeling Seeing': Touch, Vision and the Stereoscope." *History of Photography* 37, no. 4 (2013): 389–96.

Polidori, L. "On Laussedat's Contribution to the Emergence of Photogrammetry." *International Archives of the Photogrammetry, Remote Sensing and Spatial Information Sciences* 43-B2 (2020): 893–99.

Prince, Simon. *Computer Vision: Models, Learning, and Inference.* Cambridge: Cambridge University Press, 2012.

Pulfrich, C. "Über neuere Anwendungen der Stereoskopie und über einen hierfür bestimmtem Stereo-Komparator." *Zeitschrift für Instrumentenkunde* 22, 1902.

Ragey, Louis. "The Work of Laussedat and Education in Photogrammetry at the National School of Arts and Crafts Paris." Translated by Dr. L. Skitsky. VI International Congress of Photogrammetry, The Hague, 1948.

Raiford, Leigh. "Burning All Illusion: Abstraction, Black Life, and the Unmaking of White Supremacy." *Art Journal* 79, no. 4 (January 14, 2021). https://artjournal.collegeart.org/?p = 15113.

Reports by the Juries on the Subjects in the Thirty Classes into Which the Exhibition Was Divided. London: Spicer Brothers and W. Clowes and Sons, 1852.

Rhue, Lauren. "Emotion-Reading Tech Fails the Racial Bias Test." *Conversation,* January 3, 2019. http://theconversation.com/emotion-reading-tech-fails-the-racial-bias-test-108404.

———. "Racial Influence on Automated Perceptions of Emotions." *Social Science Research Network,* November 9, 2018. https://ssrn.com/abstract = 3281765.

Richmond, Scott. *Cinema's Bodily Illusions: Flying, Floating, and Hallucinating.* Minneapolis: University of Minnesota Press, 2016.

Ritchen, Fred. *After Photography.* New York: W.W. Norton, 2009.

Rogers, Molly. *Delia's Tears: Race, Science, and Photography in Nineteenth-Century America.* New Haven, CT: Yale University Press, 2021.

Root, Marcus Aurelius. *The Camera and the Pencil, or the Heliographic Art.* Philadelphia: Lippincott, 1864.

Ross, Miriam. "From the Material to the Virtual: The Pornographic Body in Stereoscopic Photography." *Screen* 60, no. 4 (Winter 2019): 548–66.

Røssaak, Eivind, ed. *Between Stillness and Motion: Film, Photography, Algorithms*. Amsterdam: Amsterdam University Press, 2011.

Ryan, James. *Picturing Empire: Photography and the Visualization of the British Empire*. London: Reaktion Books, 2013.

Sandweiss, Martha, ed. *Photography in Nineteenth-Century America*. New York: Harry N. Abrams, 1991.

———. *Print the Legend: Photography and the American West*. New Haven, CT: Yale University Press, 2004.

———. "Stereoscopic Views of the American West." *Princeton University Library Chronicle* 67, no. 2 (Winter 2006): 271–89.

Sekula, Allan. "The Body and the Archive." *October* 39 (Winter 1986): 3–64.

———. "The Traffic in Photographs." *Art Journal* 41, no. 1 (Spring 1981): 15–25.

Silverman, Kaja. *The Miracle of Analogy: The History of Photography, Part 1*. Stanford, CA: Stanford University Press, 2015.

———. *The Threshold of the Visible World*. New York: Routledge, 2013.

———. *World Spectators*. Stanford, CA: Stanford University Press, 2000.

Silzer, Kate. "Lorna Simpson's Cut-Up Portraits Evoke the Complexity of Identity." *Hyperallergic*, June 27, 2020. https://hyperallergic.com/573498 /lorna-simpsons-cut-up-portraits-hauser-wirth/.

Smith, Shawn Michelle. *American Archives: Gender, Race, and Class in Visual Culture*. Princeton, NJ: Princeton University Press, 1999.

———. *Photographic Returns: Racial Justice and the Time of Photography*. Durham, NC: Duke University Press, 2020.

Sobchack, Vivian. *The Address of the Eye: A Phenomenology of Film Experience*. Princeton, NJ: Princeton University Press, 1991.

———. *Carnal Thoughts: Embodiment and Moving Image Culture*. Berkeley: University of California Press, 2004.

Sobieszek, Robert A. "Sculpture as the Sum of Its Profiles: François Willème and Photosculpture in France, 1859–1868." *Art Bulletin* 62, no. 4 (1980): 617–30.

Southhard, Rupert B. "Highlights of US Geological Survey Activities in Photogrammetry and Remote Sensing." *Photogrammetric Engineering and Remote Sensing* 50, no. 9 (September 1984): 1323–31.

Sparke, Matthew. "Mapped Bodies and Disembodied Maps: (Dis)placing Cartographic Struggle in Colonial Canada." *Places through the Body*, edited by Steve Pile and Heidi Nast, 305–36. New York: Routledge, 1998.

Stakelon, Pauline. "Travel through the Stereoscope." *Media History* 16, no. 4 (November 1, 2010): 407–22.

St. Amour, Paul. "Modernist Reconnaissance." *Modernism/Modernity* 10, no. 2 (April 2003): 349–80.

"The Stereoscope, Pseudoscope and Solid Daguerreotypes." *Illustrated London News*, January 24, 1852, 77–78.

Stotherd, Capt. R.H. "Description of an Application of Photography to Surveying Purposes, called 'La Planchette Photographique.'" Paper 6,

Professional Papers of the Corps of Royal Engineers, New Series 17 (1869): 128–30.

Strain, Ellen. "Exotic Bodies, Distant Landscapes: Touristic Viewing and Popularized Anthropology in the Nineteenth Century." *Wide Angle* 18, no. 2 (April 1996): 70–100.

Talbot, William Henry Fox. *The Pencil of Nature.* London: Longman and Co., 1844.

Taffel, Sy. "Google's Lens: Computational Photography and Platform Capitalism." *Media, Culture, and Society* 43, no. 2 (2021): 237–55.

Tagg, John. *The Burden of Representation: Essays on Photographies and Histories.* Minneapolis: University of Minnesota Press, 1993.

Taylor, Edward B. "Ethnological Photographic Gallery of the Various Races of Man." *Nature* 13 (January 1876): 184–85.

Thompson, F. Vivian. "Stereo-photo Surveying." *Geographical Journal* 31, no. 5 (May 1908): 534–49.

Torlasco, Domietta. *The Heretical Archive: Digital Memory at the End of Film.* Minneapolis: University of Minnesota Press, 2013.

Trachtenberg, Alan. "Albums of War: On Reading Civil War Photographs." *Representations,* no. 9 (Winter 1985): 1–32.

———. "Illustrious Americans." *Reading American Photographs: Images as History—Mathew Brady to Walker Evans,* 21–70. New York: Hill and Wang, 1990.

———. "Lincoln's Smile: Ambiguities of the Face in Photography." *Social Research* 67, no. 1 (Spring 2000): 1–23.

Tronquoy, C. Note sur la planchette photographique de M. Auguste Chevallier. Paris: Martinet, 1862.

"An Update to the ImageNet Website and Dataset." March 11, 2021. https://image-net.org/update-mar-11-2021.php.

Uricchio, William. "The Algorithmic Turn: Photosynth, Augmented Reality and the Changing Implications of the Image." *Visual Studies* 26, no. 1 (March 2011): 25–35.

Vertov, Dziga. *Kino-Eye: The Writings of Dziga Vertov.* Edited by Annette Michelson. Translated by Kevin O'Brien. Los Angeles: University of California Press, 1984.

Von Gruber, Otto, ed. *Photogrammetry: Collected Lectures and Essays.* Boston: American Photographic Publishing Co., 1942.

Vonderou, Patrick, and Vinzenz Hediger, eds. *Films that Work: Industrial Film and the Productivity of Media.* Amsterdam: Amsterdam University Press, 2019.

Watson, J. Forbes, John William Kaye, Meadows Taylor, and Great Britain India Office. *The People of India: A Series of Photographic Illustrations, with Descriptive Letterpress, of the Races and Tribes of Hindustan.* London: India Museum, 1868–75.

Weems, Jason. *Barnstorming the Prairies: Aerial Vision and Modernity in Rural America.* Minneapolis: University of Minnesota Press, 2015.

Weheliye, Alexander G. "Introduction: Black Studies and Black Life." *Black Scholar* 44, no. 2 (Summer 2014): 5–10.

Welling, William. *Photography in America: The Formative Years, 1839–1900.* Albuquerque: University of New Mexico Press, 1987.

West, Simone, Meredith Whittaker, and Kate Crawford. "Discriminating Systems: Gender, Race, and Power in AI." AI Now Institute, April 2019. https://ainowinstitute.org/discriminatingsystems.html.

Wexler, Laura. "A Notion of Photography." In *The Notion of Family.* New York: Aperture, 2016.

Whissel, Kristen. *Spectacular Digital Effects: CGI and Contemporary Cinema.* Durham, NC: Duke University Press, 2014.

Whitfield, Peter. *The Image of the World: 20 Centuries of World Maps.* London: British Library, 2010.

Williams, Linda. "Motion and E-motion: Lust and the 'Frenzy' of the Visible." *Journal of Visual Culture* 18, no. 1 (April 2019): 97–129.

Wilson, Benjamin, Judy Hoffman, and Jamie Morgenstern. "Predictive Inequity in Object Detection." arXiv 1902.11097 (February 2019). https://arxiv.org/abs/1902.11097.

Wiskus, Jessica. *The Rhythm of Thought: Art, Literature, and Music after Merleau-Ponty.* Chicago: University of Chicago Press, 2013.

Yang, Kaiyu, Klint Qinami, Fei-Fei Li, Jia Deng, and Olga Russakovsky. "Towards Fairer Datasets: Filtering and Balancing the Distribution of the People Subtree in the ImageNet Hierarchy." Conference on Fairness, Accountability, and Transparency, 2020.

Yao, Mariya. "Chihuahua or Muffin? My Search for the Best Computer Vision API." *freeCodeCamp,* October 12, 2017. https://www.freecodecamp.org/news/chihuahua-or-muffin-my-search-for-the-best-computer-vision-api-cbda4d6b425d/.

Yerebakan, Osama Can. "Lorna Simpson with Osman Can Yerebakan." *Brooklyn Rail,* June 2019. https://brooklynrail.org/2019/06/art/LORNA-SIMPSON-with-Osman-Can-Yerebakan.

Zack, Karen. "Meme Series." Accessed January 14, 2023. https://www.karenzack.com/work/meme-series.

Zylinska, Joanna. *AI Art: Machine Visions and Warped Dreams.* London: Open Humanities Press, 2020.

———. *Nonhuman Photography.* Cambridge, MA: MIT Press, 2017.

Index

Page references in *italics* refer to illustrations

aesthetic mediation, 5–6; camera's, 86; discrete forms of, 169; of "Earth," 203n58; for portraits, 80; techniques of, 4

aesthetics: of materiality, 1; of nonrepresentation, 195n52; phenomenological implications of, 6; of photographic mediation, 201n34. *See also* computational aesthetics; dimensional aesthetics

Agassiz, Louis: enslaved persons daguerreotypes, 191n21; scientific racism of, 77, 181n11

Ahmad, Wasim, 190n12

Alciné, Jacky, 18

algorithms: bias in, 19–21; colonialist assumptions in, 20; of computer vision, 2, 16–23, 54, 156; dehumanization through, 18, 180n6; dimensional coordinations of, 2; of edge detection, 92; extraction of visible information, 62; of facial recognition, 20, 104; Google's, 18–19, 123; misrecognition by, 16, 17, 18–19, 21, 51; probabilistic extrapolation and interpolation by, 2, 44; relational structures of, 48; of smartphone photography, 5, 66, 69; spatial operations of, 4

Alps, mapping of, 200n26

Amazon, Mechanical Turk platform, 43

American Ethnological Society, 190n17

anthropometry, photographic, 4, 21; abstraction in, 79; early, 77–80, 181n11; front and profile views, 77, 190n17; grid system, 78–80, *79*, 191n22; "metric," 77; objectification in, 83, 91; spatiality of, 78, 91–92; volume in, 79. *See also* ethnography, photographic

Arago, François, 129

archives, visual: management of, 43–44; privilege in, 21

art, contemporary: depth effects of, 13–14; dimensional aesthetics of, 3; object recognition in, 50; racial biases in, 48; sense experience of, 13; using *ImageNet*, 48–49, *49, 50*

artificial intelligence (AI): appropriation of visual culture, 47, 186n71; colonialist assumptions in, 20; in computational photography, 66; deep learning processes of, 39, 44; in depth mapping, 74; in Google Maps, 124–26, 158; imaging techniques of, 175n1; for object recognition, 17, 39; in photogrammetry, 123; processing camera information, 179n2;

219

220 / Index

artificial intelligence (AI) *(continued)*
psychological assessments by,
19–20; video analysis, 19–20; visual
representation through, 2

Babbage, Charles: difference engine of,
203n49
Barker, Robert: panorama patent of,
200n24
Barthes, Roland, 193n34; on Photomat
images, 76, 190n15
Bausch and Lomb, multiprojector system of, 152
Behold These Glorious Times! (video
installation, 2019), 51–56, *52, 55;*
aesthetics of, 56; categorizing effect
of, 53, 54–55; computer vision training in, 52–53; facial expression in,
54; forms of relationality in, 56;
invocation of montage, 56; object
recognition in, 53–54; perceptual
training in, 53; score of, 53
Being: dehiscence, 112; depth as structure of, 12, 167; dimensionality in,
167; Merleau-Ponty on, 165; of the
other, 113; phenomenal existence of,
111; seer and seen in, 64
Benjamin, Walter: *Arcades Project,* 3;
on dimensionality, 3; historical materialism of, 3; on Muybridge, 186n68;
theorization of shock, 187n78
Bertillon, Alphonse, 191n20; anthropometry of, 77, 181n11
Birrell, Andrew, 201n6
Black people, computer mistagging of,
18, 48, 180nn6–7
Black studies, on representation, 195n52
Black women: photographic portraits
of, 96, *97,* 98–99, *100–101,* 101–7,
103, 105; refusal of gaze, 96, 193n38
Bledsoe, Woodrow Wilson: archives of,
36; "best guesses," 46; computer
vision work, 35–41; facial recognition work, 35–39, *37,* 41, 48, 145;
rotation equation of, 200n25;
"standard head" of, 50; use of stereoscopic views, 36–38

Bloom (art installation, 2020), sculpture of head, 50, *51*
bodies: inside/outside of, 110; photographic objectification of, 20; serial
images of, 30–33; two-dimensional
spatiality of, 39. *See also* photosculpture
bodies, colonized, 78–80, *79;* defined
against whiteness, 80. *See also*
anthropometry, photographic;
colonialism
Bogart, Michele, 183n31
Brady, Mathew: *The Gallery of Illustrious Americans,* 77; stereoscopic
daguerreotypes of, 81
—*President Martin Van Buren,*
87–88, *88*
Bragaglia, Anton, 184n36
British Empire, surveying of, 130,
199n19
Bryson, Norman, 197n6

cameras: aesthetic mediation by, 86;
analogy with eyes, 27, 175n2; apertures, 189n6; as machine seeing,
179n2; movement of light in,
72; snapshot, 188n4. *See also*
photography; portraiture,
photographic
cameras, smartphone: depth interface,
75, 190n11; dual pixel sensors, 73;
Google Pixel, *68,* 74, *75, 93;* infrared
mapping by, 73; iPhone, 65, 67,
71–72, *72;* multiple apertures, 65–66,
66, 67–69, 73; neural nets in, 73;
Samsung, 67; sensors of, 66; standards across brands, 67; time-of-flight
sensors, 73–74. *See also* Google
Maps; photography, smartphone
Canadian Pacific Railway (CPR): displacement of Indigenous peoples,
134; role in standard time, 200n28;
surveying along, 134–35
capitalism: exchangeability in, 5; mapping in, 159; and production of
space, 203n56; support by photographic representation, 26–27

Cardinal Systems, LLC, VrTwo Workstation, 155

Casey, Edward S., 178n12, 198n7, 203n58

Central Intelligence Agency, funding of facial recognition, 36

Cézanne, Paul: interrogation of depth, 14; Mount Saint-Victoire landscapes, 204n11

Charcot, Jean-Martin, 181n11

Chennapragada, Aparna, 127, 198n14

Chevallier, Auguste: photographic plane table of, 200n23

chiasmus, 168, 195n5

Choate, Rufus: daguerreotype portrait of, 84, *85*, 86–87, 89

chronocyclegraphs, 184n36

chronophotography, 184n36

cinema: temporal coordination in, 24; 3D, 152; visual/temporal grammars of, 56

circuit, 109; embodiment as, 110; propagation of life, 112

Claudet, Antoine, 28

coexistence, mathematical modeling of, 159

Cohen, Kris, 191n24

COIL-100 dataset (computer vision), 39–41, 54, 185n57; objects photographed for, *40*, 40–41; process used for, *41*; wraparound views, 41

colonialism: in algorithmic assumptions, 20; assumptions in computer vision, 20; human classification in, 181n11; photogrammetry and, 146; in photographic typing, 180n11; presumptions concerning visibility, 5; and production of space, 203n56; rational spatial, 159; surveying in, 130

colonized peoples: ethnographic photography of, 78–80, *79*. *See also* anthropometry, photographic

computational aesthetics: multiplication of viewpoints, 184n41; panoramic format and, 176n3; stereoscopic format and, 176n3. *See also* aesthetics

computational imaging: Cartesian space in, 13; depth mapping in, 2, 74; versus digital imaging, 175n2; dimensional aesthetics of, 1–2, 3, 67; Google's use of, 145; in mainstream visual culture, 3; object recognition in, 2, 15–18; in photogrammetry, 4; referential values in, 2; reorganization of visual representation, 14; representational values in, 2; use of photographic strategies, 5. *See also* imaging

computational photography: aesthetics of, 95; artificial intelligence in, 66; depth mapping in, 2; imaging in, 1, 2, 5, 65; reinvention of medium, 66; in smartphones, 65

computer vision: algorithms of, 2, 16–23, 54, 156; applications for, 45–46; assessing ergonomics, *46*; assumptions of early photography in, 23; biases in, 19–21; Bledsoe's work with, 35–41; COIL-100 data set for, 39–41, 54, 185n57; colonialist assumptions in, 20; construct of visibility, 23, 61; in data parsing, 72; depth algorithms of, 54; emulation of human vision, 15; errors in, 18–19; in Google Maps, 125, 127; image analysis in, 16–23, 179n2; impacting daily lives, 19, 187n74; improved training of, 21; inclusiveness for, 57; increasing accuracy in, 56–57; invisible images of, 47, 56; machine vision and, 179n2; Muybridge's techniques and, 39–40; NORB dataset for, 41–43, 47, 185n58; numerical nature of, 56; object recognition in, 15–23, *40*, 40–46, *42*, 50–51; in photogrammetry, 123; pixel patterns in, 16; portrait mode, 69; relational structure of, 22; scholarship on, 179n4; spatial relationships in, 23, 72; statistical models of, 61; for surveillance, 46; training sets for, 39–43; Willème's techniques and, 39–40. *See also* vision

222 / Index

consciousness: Merleau-Ponty on, 111, 113, 196n13; potentiality of, 167; synthetic, 109–10

Crary, Jonathan, 176n2; on the stereoscope, 25, 83

Crawford, Kate, 14; "Excavating AI: The Politics of Images in Machine Learning Training Sets," 47–48; *Training Humans*, 47–48, 51–52

cubes: coordination of faces, 165; depth of, 60–61; dimensionality of, 60; Merleau-Ponty on, 62, 63, 110, 165, 187n2, 188n11; mutual impossibilities of, 111; paradox of, 62; sidedness of, 61; *totum simul*, 60; unseen side of, 60, 61–62, 64, 188n5; visual representation of, 61, 62. *See also* Necker cube

cyclegraphs, 33, *34*; photographic strategy of, 184n36

Daguerre, Louis, 129

daguerreotypes, 25; of enslaved persons, 191n21; popularity of, 189n8

daguerreotypes, stereoscopic: pornographic, 82–83, *83*, 192n31; portraits, 81–82, *82*, 189n8. *See also* photography, early; stereoscopic views

Darwin, Charles: *The Expression of the Emotions in Man and Animals*, 181n11

data mining, 203n56

datasets: diversification of, 21; expansion of, 43; internal structure of, 43; management of, 43–44; for object recognition, 39–44. *See also* ImageNet; NORB

dehiscence, Merleau-Ponty on, 112

deep learning: in AI, 39, 44; dimensionality in, 45; in portrait mode, 65; 3D, 45

depth: absence in, 13; algorithms of, 54; in artworks, 13–14; co-constitutive elements of, 11; coherence through, 64; in conceptualization of difference, 12; constitution of reality, 63; of cubes, 60–61; Descartes and, 10,

12–13; embodied experience of, 9; existential dimension of, 10; gaps as, 11; in geometry, 9; in Gursky's *Ocean* series, 162; mapping techniques, 92; in measurement of volume, 9; Merleau-Ponty on, 6–7, 9–14, 59–60, 167, 178n12; ontology of, 6, 10, 13, 111; openness of, 59; paradoxes of, 11, 12, 14; in perspective, 10; in photographic realism, 24; properties of, 9; quilting points of, 11; reciprocity of, 10; as refusal of synthesis, 60; relationality of, 10, 13; Renaissance solutions of, 10; scholarship on, 1; sidedness and, 60; the simultaneous in, 59; singularities within, 64; in smartphone portrait mode, 71–76; spacing function of, 6, 10–11; stereoscopic, 3, 23–35, 92–93; structure of Being, 12, 167; structure of time, 178n12; subjectivity/intersubjectivity of, 11–12; visibility and, 4–5, 6, 12, 13, 24

depth of field, 67–71, 84–91; computerized alteration of, 2; in portrait mode, 67–69

depth of field, shallow, 4, 69; in early photography, 84–91; in photographic portraiture, 84, *85*, 86–87, *88*, 89, 91, 94; in smartphone portrait mode, 70, 91–95; visual strategy of, 70

depth perception, 27, 60; stereoscope's embodiment of, 27; visual, 63. *See also* perception

Derrida, Jacques, 178n12; on *différance*, 178n14

Descartes, René: and depth, 10, 12–13; on subjectivity, 109

Deville, Édouard: contribution to photogrammetry, 145, 152, 156, 157; on dimensional aesthetics, 154; mathematical strategies of, 154; on "photographic" problems, 155; stereoplanigraph of, 146, *147*, 148

—*Photographic Surveying*, 134–39, *136*, 142, 144–45; atmosphere in, 138; back matter of, 139; Canadian

grid method in, 138–39, 142; embodiment in, 142, 144; geometrical projection in, *137*; orthochromatic emulsion in, 138; "Plan of the Vicinity of Wapta Lake, British Columbia," 139, *143*; projective geometry in, 136–37, *137*; spatial mediation in, 138, 144; variant published states of, 201n35; "View No. 2—from C. Hector Station," 139, *140–41*, *142*; working materials for, 139, 201n34

differentiation: coordination through, 5; surface/depth, 89

digitization: in computational imaging, 2; of photographic imaging, 154–55; replacement of analog formats, 66; visual mediation of, 175n2

dimensional aesthetics, 1–7; abstract approaches to, 7; of computational imaging, 1–2, 3, 67; concrete approaches to, 7; of contemporary art, 3; critical framework for, 4; of materiality, 1; photographic, 14, 22–23, 65, 76, 154; of photographic portraiture, 84, 95–96; of photographic surveying, 137–38; relational contingencies of, 5; in visual culture, 7. *See also* aesthetics

dimensionality: abstraction in, 50–51; aesthetic mediation of, 4, 6, 13; in Being, 167; of cubes, 60; in deep learning, 45; extraction from photographs, 50–51; facial, 38–39; instantiation of synthesis, 60; mathematical forms of, 13; measurability in, 1; Merleau-Ponty on, 6; multiplying, 1; in object recognition, 41; and pixel relationships, 23; producing, 1; quantifiable, 39; and medium specificity, 178n14; spatial, 1, 12, 57, 161, 178n12; of stereoscopic views, 3; of subjectivity, 108; of world, 168–79; of world's depth, 57

Dominion Land Survey, of western Canada, 134

Duchenne du Bologne, Guillaume-Benjamin-Amand: *Mécanisme de la physionomie humaine,* 181n11

Earth: five oceans of, 117, 196n2; Google Earth views, 118–19, 123; interconnectivity of oceans, 161; "resistance" to mapping, 204n58; spatial representation of, 120; virtual navigation of, 120. *See also* Gursky, Andreas: *Ocean* series; world

Eastman Kodak, snapshot camera of, 188n4

Ellis, Patrick, 197n4

embodiment: of circuits, 110; of depth, 9, 27; in photographic surveying, 142, 144; in relationship to space, 119; in stereographic views, 32. *See also* vision, embodied

ethnography, photographic, 21, 77, 78–80, *79*; geometrical backdrops of, 78; spatial aesthetic of, 78. *See also* anthropometry, photographic

Ethnological Society of London, 190n17

eugenics, 191nn20–21; use of photographic analysis, 77, 181n11

exchangeability, capitalist logics of, 5

existentialism, French, 12

experience: aesthetic mediation of, 5–6; relational terms of, 6

eye, as camera, 175n2

Face ID, 149

facial recognition: across photographic representations, 39; algorithms of, 20, 104; Bledsoe's work with, 35–39, *37*, *41*, *48*; Deville's contributions to, 145; dimensionality in, 38–39; factors affecting, 38; from flat photographs, 36–39, *37*; hierarchical interpretation in, 36; infrared, 73, 149; mathematical relationships in, 38; perspective in, 36; photographic surveying and, 145, 149; probability in, 38; in smartphone portrait mode, 71–72, *72*, 92; steps in, 36; Willème's interest in, 36

224 / *Index*

flight trackers, viewers' dislocation in, 115

"floating mark," 151; in photographic surveying, 146, 148

Fotomat (film processing company), 190n15

Foucault, Michel: and media archaeology, 3

France, Cassini map of, 199n19

Frazier, LaToya Ruby, 4; collaborative portraiture of, 102; complication of portraiture, 195n52; identity in works of, 96; portraits of Black women, 96, 102–6

—*Momme* portraits, 102–6, *103*; dimensionality of, 104; flat figure of, 103; illness in, 103, 104; inaccessibility of, 105; mutual exposure in, 96, 106; relational visibility of, 105; sidedness in, 104, 106; 2018 version, 104, *105*

—*The Notion of Family*, 102, 194nn47–48

Fried, Michael, 197n5

From "Apple" to "Anomaly" (art installation, London, 2019), 48–49, *49, 50*; material space of, 49; object recognition in, 49

Gaboury, Jacob, 188n5

Galassi, Peter, 197n5

Galloway, Alexander, 184n41

Galton, Francis, 77, 181n11, 191nn20–21

Gardner, Alexander: *Sketchbook of the Civil War*, 182n20

—*Portrait of Lincoln, 90*; dynamic tension in, 89; focus in, 88–89

geometry: depth in, 9; perspectival, 123; in photographic ethnology, 78; projective, 136–37, *137*, 168

Gilbreth, Frank B. and Lillian: cinematic methods of, 184n36; time and motion studies of, 33–35, 54, 183nn34–35, 47, 186n68

Gilbreth, Frank B.: *Efficient Work Operations, 34*

Give Me Some Moments (online exhibition, 2020), 194n42

Glissant, Édouard: on dimensionality, 178n14

global positioning systems (GPS), 198n10; in smartphones, 126–27; timed signals of, 127

Google Earth, 119; Google Earth VR, 123–24, 149, 158, 198n11, 204n1

Google Maps, 120–29, 145, 168; AI elements of, 125, 158; augmented reality (AR) features, 124, *124*, 126, 127, 142, 158; computational imaging in, 145; computational photogrammetry in, 122–23, 129, 157–58, 198n10; computer vision in, 125, 127; destinations in, 125; disorientation in, 128; domination of market, 129; embedded spatiality of, 127–28; embodied perspective in, 124, 125, 128; geometrical space models in, 123; "global localization" in, 125–26; hyperlocalized imagery, 125–26; image space and object space in, 149; imagined planes of, 127; immersive features, 158, *159*; interactive features, 118–21, *122*, 124–28; on iPhone, *118*; LIDAR use in, 123, 198n10; Live View, *124*, 124–28, 142, 149, 158, 198nn11–12; object recognition in, 123; origin of, 120; orthomosaics in, 120; pedestrian use of, 124–26; Pegman figure, 121, *122*, 128, 158; perspectives of, 121–23; photogrammetry in, 122–23, 129, 198n10; photographic verisimilitude in, 121–22; real-time imagery in, 124; rearticulation of Earth's spatiality, 158–59; satellite imagery of, 118, 120, 125; shared space/time in, 159; spatialized information structure of, 128–29; Street View imagery, 121, 123–25; Street View Trekker, *122*; users' embodiment in, 124; vantage points in, 120–21, 123; virtual/actual space in, 125; visual positioning system (VPS), 126–28, *127*, 198n14

Google Photos: category errors in, 18–19, 48; visual algorithms of, 18–19
Google Pixel, portrait mode of, *68*, 74, *75, 93*
Grant, Ulysses S.: photographic portrait of, 28
Great Exhibition (London, 1851), photography at, 199n21
Great Trigonometrical Survey of India, 130, 199n19
Gruner, H., 202n45
Gunning, Tom, 181n17
Gursky, Andreas, 4; alienating effects of, 117; perspective in works of, 197n5; world-making projects of, 197n5
—*Ocean* series, 115–20, 159, 161–63; abstract space in, 162; alienating effects of, 120, 163; as apocalyptic, 197n5; depth in, 162; disorientation at, 117, 162; Earth in, 115; embodied viewers of, 162, 203n58; European world maps and, 197n6; exhibition of, 196n1; human absence from, 119; inspiration for, 115; maps/photographs tension in, 161; *Ocean I, 116*; *Ocean III*, 115, *116*; *Ocean V, 116*; *Ocean VI, 160*; optical verisimilitude of, 117; perspectival confusion in, 162; photographic/digital techniques in, 115, 117, 118, 197n4; simulation of realism, 162; use of satellite images, 117; vantage points for, 117, 120; visual detail of, 119

hair, personal/public negotiation of, 96
Hamilton, Peter, 180n11
Hansen, Mark B. N., 175n2, 176n5
Hargreaves, Roger, 80
Hegel, Georg Wilhelm Friedrich: on self and other, 111; on subjectivity, 109–10; thesis and antithesis in, 195n3
Heidegger, Martin: "The Age of the World Picture," 204n1; *Being and Time*, 178n12
height: measurement of, 9; shifts in perception of, 10

Herndon, Holly, 52, 187n77
HireVue (video analysis platform), 19–20
Hodge, James J., 203n58
Hollywood, anaglyph 3D use, 152
Holmes, Oliver Wendell, 76, 182n25; stereoscope library of, 26–27, 28, 33–34, 43–44, 185n65
Hu, Tung-Hui, 193n37
Huawei, Moon mode of, 189n6
Husserl, Edmund, 203n58; on melody, 178n12; *Thing and Space*, 187n1
hysteria, female: photographic categorization of, 181n11

identity: bodily topography of, 79, 82, 91; in portraiture, 69–70, 192n26; quantification of, 78; racial, 79; in visual appearance, 70
illusions, perceptual, 177n10
Illustrated London News: photographic process of, 182n26; on the stereoscope, 27
ImageNet (computer vision dataset), 43, 44, 186n74; art installations using, 48–49, *49*, 187n5; Large Scale Visual Recognition Challenge (ILSVRC), 44
ImageNet Roulette (art installation), 48
images: computer vision algorithms for, 156; of cubes, *11*, 61; in dimensional space, 156; exteriorized relationships between, 78; externality of, 61; Google Maps', 122–27; machine-mediated, 23; mediation between viewer and object, 21; partial views of, 169; planes of focus in, 202n42; postphotographic, 175n2; precinematic, 24; as quantitative information, 2; referents and, 2; relationship with models, 38; self-sufficient, 176n2; spatiality of, *1*, 35, 49, 61, 86; subjects defined by, 92; systems of relations, 56; three-dimensional spatiality of, 35; in "world of objects," 44, 56

226 / Index

images, digital: Cartesian coordinate planes of, 61; computer analysis of, 16–23; displacing of analog, 66; management of, 43; numerical expression of, 45; object recognition of, 2, 15–18; quantitative patterns in, 20; recognizability of, 21; searchable, 17–18

images, photographic: authority of, 21; bounded spatiality of, 20; digitization of, 154–55; extrapolation of patterns in, 21; frameworks for, 35; geometrical figures in, 20; material/relational dimensions of, 107; objectification of bodies, 20; serial strategies for, 22; spatial relationships in, 3, 20, 22, 35, 39. *See also* photographs

imaging: in computational photogrammetry, 4, 142, 152, 156–57; in computational photography, 1, 2, 5, 65; feedback loops in, 69; quantitative logics of, 2. *See also* computational imaging

imaging, lens-based, 2; versus computational imaging, 24; displacement by computational techniques, 23

imperialism, control by proxy, 5. *See also* colonialism

India Office of Great Britain, *The People of India*, 191n21

information: computational extraction of, 203n56; visible, 62. *See also* artificial intelligence

Instagram Face, 95

intercorporeity, 196n8; Merleau-Ponty on, 111, 196n13

intersubjectivity, Merleau-Ponty on, 111

iPhone: camera of, 65, 67; Face ID, 149; Google Live View on, 198n12; Google Maps on, *118*; portrait mode of, 71–72, *72*

Kelsh stereoplotter, 152, *153*
Keystone View Company, 83
Kittler, Friedrich, 182n25
Krakauer, Siegfried, 23
Kuspit, Donald, 197n5

labor, industrialized: cyclegraphs of, 33, *34*, 54; quantification of, 33

Lamprey, John: anthropometry of, 78, 191n22; *Antonio, man from Madagascar*, 79

landscapes: dimensional coordination of, 168; horizons of, 168, 204n13; versus maps, 167; Merleau-Ponty's metaphor of, 167–69; varying perspectives on, 167

Laussedat, Aimé: map of Paris, 132, *133*; mathematical strategies of, 154; phototheodolite surveying method, 132, *132*, 134, 199n22; use of panorama, 200n24

learning, deep, 4; AI methods of, 39, 44; based in object recognition, 44–45; feature vectors in, 45; layers in, 45; mathematical dimensionality in, 45; meme training in, 179n1; neural networks of, 2, 17; perception of profundity in, 46–47; in portrait mode, 69; processual analysis in, 54; relational processes of, 22; scholarship on, 179n4; three-dimensional space in, 45

Li, Fei-Fei, 43

LIDAR (light detecting and ranging) sensors, 66; Google Earth's use of, 123, 198n10; modulation of focus, 189n10; on smartphones, 73; spatial relationships in, 93; time-of-flight, 73–74

likeness (portraiture), as aesthetic failure, 81

Lincoln, Abraham: facial ambiguity of, 193n35; Gardner portrait of, 88–89, *90*

Live View, 124–8, 198n12

London Stereoscopic Company, 26

Lumière, Auguste and Louis: "actualities" of, 181n17

machine vision: computer vision and, 179n2; Paglen on, 186n71. *See also* computer vision; vision

Index / 227

mapping: art as function of, 198n7; in capitalism, 159; mediation for viewers, 119; Multiplex, 152, 202n45; in postwar era, 202n45; "you are here" in, 119. *See also* surveying

mapping, digital, 118; optical verisimilitude for, 121; from photographs, 119, 120; rectification process, 119; scalar relationships in, 121. *See also* Google Maps

mapping, mobile: computational photogrammetry in, 2; Google's market share in, 129; in smartphone use, 120. *See also* Google Maps

maps, world, 7; coordination of the disparate, 165; inviting alienation, 168; versus landscapes, 167; negative space in, 117; shared plane of, 162. *See also* Gursky, Andreas: *Ocean* series

Mapware (photogrammetry software), 156

Marey, Etienne Jules: chronophotography of, 184n36

masculinity, white: in Western art, 79. *See also* whiteness

Mazis, Glen, 178n13

McKittrick, Katherine, 130, 159; on "land grabbing," 203n56

media, digital: postcinematic, 24; transformative effects of, 25

media, lens-based: spectacular versus evidentiary, 24

media aesthetics, phenomenology of, 177n6

media archaeology, 3

media theory, 6

medium specificity: art historical theory of, 181n12; photographic, 3, 22, 175

Méliès, Georges, 181n17

memes, object-recognition, 15–18, *16*; for AI training, 179n1

Merleau-Ponty, Maurice: on Being, 165; on *capitonnage*, 168; on Cartesian space, 10; on chiasmus, 168, 195n5; concept of "flesh," 6–7, 12, 63; concept of place, 178n12; on consciousness, 111, 113, 196n13; on the cube,

62, 63, 110, 165, 187n2, 188n11; death of, 13; on dehiscence, 112; on depth, 6–7, 9–14, 59–60, 178n12; on dimensionality, 6; on divergence, 168; on incarnation, 113; on intercorporeity, 111, 196n13; on intersubjectivity, 111; landscape metaphor, 167–69; on originary foundation, 169; on the other, 109; phenomenology of, 9, 12, 176n5, 203n58; on pure vision, 167; on self and other, 112; on sidedness, 110; on synthesis, 165; on transitivism, 196n13; on unity of world, 63. Works: "Eye and Mind," 9–10; *The Phenomenology of Perception*, 9, 165; *The Visible and the Invisible*, 9, 59–60, 109, 168, 204n6

Meshroom (photogrammetry software), 156

Metashape (photogrammetry software), 156

Meydenbauer, Albrecht, 198n17

Michaels, Walter Ben, 194n48

modernity, technological: perceptual training for, 53

movement: quantifiable, 35; shape of, 34–45. *See also* time and motion studies

mug shots, 77

Multiplex mapping, 152, 202n45

Muybridge, Eadweard: *Animal Locomotion*, 31, *32*; cameras used by, 31; computer vision and, 39–40; motion studies of, 30–33, 34, 186n68; spatiotemporal views of, 31; time studies of, 183n32. *See also* serial views

Nancy, Jean-Luc, 178n12, 196n19, 203n57; *Being Singular Plural*, 178n14

nature, photographic objectivity for, 76

Necker cube, *11*, 11–12, 111, 177n10; three-dimensionality of, 11

neural networks, artificial, 2, 17, 20, 22; breaking down of images, 54; convoluted (CNNs), 44–45; images moving through, 45; layers of, 45

228 / *Index*

Newhall, Beaumont, 29
NORB dataset (computer vision),
85n58; for object recognition, 41–43;
objects photographed for, *42*, 43–44;
stereoscopic images of, 41, *42*, 43

objectivity, prephotographic conceits
of, 77
object recognition, 4; accuracy in, 43,
44; AI for, 17, 39; algorithms for,
16–23, 51; categorical shapes in,
44–45; COIL-100 data set for, 39–41;
computational approach to, 35; in
computer vision, 15–23, *40*, 40–46,
42, 50–51; datasets for, 30–44; deep-
learning based, 44–45; dimensional-
ity in, 41; in Google Maps, 123;
interpretive processes for, 21;
learned terms in, 187n5; memes of,
15–18, *16*; NORB dataset for, 41–43,
185n58; perspective in, 41; photo-
graph sets for, *40*, 40–43, *42*; rela-
tional processes of, 22; relation of
discrete images, 21–22; role in aerial
surveillance, 43; of social media
images, 17–18; subjective, 49; three-
dimensionality in, 41; training sets
for, 39–43
objects: abstract ideas and, 7; instantia-
tion of categories, 22; paradox of
coherence, 165, 204n13; sidedness of,
62–63
O'Sullivan, Timothy: "Ruins in Cañon
de Chelle, N.M.," 182n20
the other: Being of, 113; Merleau-
Ponty on, 109; self and, 109–12
Ots, Karl: "Dog or Muffin," 179n3

Paganini, Pio, 200n26
Paglen, Trevor, 4, 186n69, 187n5; on
invisible images, 47, 186n71; on
machine vision, 186n70; on object
recognition, 50. Works: *Behold
These Glorious Times!*, 51–56, *52*,
55; *Bloom*, 50, *51*; "Excavating AI:
The Politics of Images in Machine
Learning Training Sets", 47–48;

From "Apple" to "Anomaly," 48–49,
49, 50; *Training Humans*, 47–48,
51–52
painting, panoramic, 181n15. *See also*
panoramic views
panoramas, 3, 176n3; Barker's patent
for, 200n24; computational aesthet-
ics and, 176n3; in painting, 181n15;
popularity of, 145–46; smartphones',
189n6; spatialized integration in,
23–24, 28; in surveying, 132,
200nn23–24
Paris, Laussedat's map of, 132, *133*
Paulsen, Kris, 195n5
perception: depthless, 62; illusions of,
177n10; versus machine legibility,
47; organizing of visual experience,
24. *See also* depth perception
personhood: "computational," 191n24;
effect of photography on, 76; privi-
leged shaping of, 95; subjective, 3;
visual conception of, 70–71, 76
perspective: aerial, 138; articulation of
seeing world, 163; contingencies of,
56; depth in, 10; as dimensions of
object, 63; of embodied viewers, 62;
in facial recognition, 36; geometrical
projection of, 168; in Google Maps,
121–23, 125; limits of, 184n41; lin-
ear, 137; mathematical coordination
of, 161; measurement by means of,
136; mutually exclusive views, 165;
in object recognition, 41; in photo-
graphic surveying, 136–37, 142,
144–45; in photosculpture, 30; rec-
onciliation of, 168; three-point, 1;
variations in photographs, 161
phenomenology: German, 12; Mer-
leau-Ponty's, 9, 12, 176n5, 203n58
photogrammetry, computational, 129–
30; "analytical" methods in, 154;
colonial ambitions in, 146; Deville's
contributions to, 145, 152, 156, 157;
dimensional relationships in, 157,
159; dry-plate process of, 146;
embodied perceivers of, 161; in
Google Maps, 122–23, 129, 157–58,

198n10; and history of computation, 202n49; imaging in, 4, 142, 152, 156–57; immersive views in, 156–59; in mobile mapping, 2; origin of term, 198n17; perspectival relationships in, 157, 161; production of virtual objects, 157; relational structure of spatiality in, 157; relationship between images in, 156; replacement of embodied viewer, 156; software for, 156; spatial modeling of, 161; use of AI, 156; US Geological Survey's use of, 200n23; viewer involvement in, 158; in visual representation of space, 159; during World Wars, 152. *See also* stereophotogrammetry

photographs: absence of volume in, 145; abstraction into data, 36; digital mapping from, 119, 120; dimensionality in, 4, 23; extrapolation of three-dimensional shapes from, 23, 28–29, 30, 33, 200n25; facial recognition from, 36–39, *37*; formal equivalence systems of, 185n65; indexicality of, 3; as isomorphic imprints, 2; object recognition of, *40*, 40–43, *42*; optical scanning of, 36; perspectival variations in, 161; as proxies for things pictured, 27, 36; spatial relationships in, 20, 39; spatiotemporality of, 3. *See also* images, photographic

photography: in Anthropocene era, 197n5; body-as-image in, 20; colonialist typing in, 180n11; depth of field in, 67–71; dimensional aesthetics of, 14, 22–23, 65, 76, 137–38, 154; effect on cultural bias, 77; effect on personhood, 76; extraction of dimensionality from, 50–51; f-stops, 189n6; as inferior to painting, 181n16; mediation of visible world, 23; monocular logic of, 25; numerical information in, 35; paradox of depth in, 14; person/thing distinctions in, 76; portraiture and, 76–84;

quantitative data in, 14; race/class in, 70, 77; reality in, 189n6; reiteration of social/cultural values, 76–77; as system of exchange, 26–27, 185n65. *See also* panoramic views; stereoscopic views

photography, aerial: object recognition in, 43; perspective in, 152; stereoscopic views from, 146; during World War II, 152

photography, computational, 65, 188n3; AI in, 66; dimensional aesthetics of, 67; imaging in, 1, 2, 5, 65; platforms for, 175n2; reconception of traditional photography, 175n2; simulation of subjects, 66; statistical analysis in, 154–55. *See also* photography, smartphone

photography, early: collodion process, 182n26; coordination of multiple images, 22; dimensional aesthetics of, 22–23; embodied vision in, 23; from glass plates, 25; at Great Exhibition of 1851, 199n21; influence on computer vision, 23; perceptually coherent view of, 39; *portrait parlé* of, 77; promises of, 5; race/class in, 70; realism in, 24; shallow depth of field in, 84–91; spatial relationships in, 3, 22, 35, 39, 70; transformation of visual culture, 23; trick, 181n17. *See also* anthropometry, photographic; ethnography, photographic; portraiture, photographic; serial views; stereoscopic views

photography, smartphone, 65–71; algorithms of, 5, 66, 69; automatic adjustments, 67; circulation of, 17; computational processes of, 4, 65; dimensional reformation, 190n11; focal effects of, 65–66, 68; modeling of space, 76; modes of, 66–67, 188n4; neural defaults of, 76; "pano," 67; reinvention of early photography, 5; restructuring of aesthetic norms, 67; simulation of sound, 66; "slo-mo," 67; stereoscopic strategies, 73;

230 / *Index*

photography, smartphone *(continued)*
subject/world opposition in, 102;
"time-lapse," 67; transformative
impact of, 70–71; triangulation of
depth, 73; visual mediation by, 76.
See also portrait mode
Photomat images, 76, 190n15
photosculpture: material work in, 32;
perspective in, 30; rematerialization
of subjects, 30; Selke's patent for,
149; use of pantograph, 29, 149, 151;
Willème's, 28–30, *30*, 32, 150,
183nn30–31; Zeiss-Bauersfeld stere-
oplast, 150–51, *151*
phototheodolites: " great," 130, *131*,
199n18; in photographic surveying,
132, *132*, 134; Porro's design,
200n26; Zeiss-Pulfrich field, *135*
Pinney, Christopher, 193n36
Pokémon GO, AR in, 198n13
Porro, Paulo: phototheodolite of,
200n26; surveying method of,
199n23
portrait mode, 4, 67–71, 89, 91; blurred
backgrounds in, 71; border zones, 92;
in computer vision, 69; deep learn-
ing in, 69; depth effect of, 71–76;
depth mapping in, 71, 74, 92; depth
of field in, 67–70, 91–95; dimen-
sional relationships in, 74, *75*; draw-
ing of boundaries, 71–73; edge
detection in, 71, 72, 92; errors in,
71–72, 74, *75*, 94; exteriorized sub-
ject of, 92, 95; facial recognition in,
71–72, *72*, 92; flat image of, 94; fore-
ground/background tension in, 93;
of Google Pixel, *68*, 74, *75*, *93*; nego-
tiation of cultural norms, 95; objecti-
fication in, 95; photographic aesthet-
ics of, 95; pixel technique of, 93–94;
planes of, 102; popularization of, 89,
91; quantitative operations of, 91;
semantic segmentation in, 71–72,
72; shallow depth of field of, 70,
91–95; spatial relationships in,
67–68, 73, 74; visibility of subject,
95; visible exteriority of, 92; white

subjectivity in, 92. *See also* cameras,
smartphone; photography, computa-
tional; portraiture, photographic
portraiture, painted: aesthetics of, 69;
of the aristocracy, 80; depth of field
in, 84–91; miniatures, 80; selective
focus in, 86
portraiture, photographic, 28; aesthetic
mediation in, 80–81, 86, 107; of Black
women, 96, *97*, 98–99, *100–101*, 101–
7, *103*, *105*; changing aesthetics of,
95; conception of self in, 107;
daguerreotype, 84, *85*, 86–87, 89;
democratized, 80; dimensional aes-
thetics of, 84, 95–96; dimensional
relationships of, 94; dimensional sub-
jects of, 88; effect of smartphone on,
70; embodied subject of, 108; facial
typography in, 89; failed, 81; fleeting
expression in, 81, 192n27, 193n37;
impartiality of, 80; interiority of, 81,
95; and mapping of terrain, 149–50;
of middle class, 80; mutual exposure
in, 96, 106, 107; mutual recognizabil-
ity in, 107; objects in, 94–95; photog-
raphy and, 76–84; politics of recogni-
tion in, 195n52; popularity of, 189n8;
postcolonial styles of, 193n36; pres-
entation of subject, 87; privileged vis-
ibility in, 107; representational logics
of, 102; selected focus in, 86; self and
other in, 106; self-presentation
through, 70; shallow depth of field in,
84, *85*, 86–87, *88*, 89, 91, 94; social
hierarchy in, 80, 89; social identity in,
69–70, 192n26; stereoscopic, 81–82,
82; subjectivity in, 80–81, 86, 87, 107;
surface geometries of, 91; undermin-
ing of painting norms, 87; white sub-
jectivity in, 69, 71, 77, 81. *See also*
photography, early; photography,
smartphone
postcolonialism, 12
poststructuralism, 12; temporality in,
178n12
Principle Triangulation of Great Brit-
ain, 199n19

Proust, Marcel: interrogation of depth, 14
psychological assessments, AI, 19–20
Pulfrich, Carl: Helmholtz reflecting stereoscope of, 146; stereocomparator of, *147*, 148
puns, visual: memes of, 15–16, *16*, 17

quilting points, 168, *169*; depth of, 11

racism, scientific: use of photography for, 181n11
Ramsden, Jesse, 199n18
Rappmund, Peter B., 203n58
realism, photographic, 24
reality, augmented (AR): in Google Maps, 124, *124*, 126, 127, 142, 158; in in Pokémon Go, 198n13
reality, representation and, 115
Rhue, Lauren, 180n7
Rihanna, in collages, 194n41

Sander, W., 202n42
Sandweiss, Martha, 181n15, 182n20
Scheimpflug, Theodore: sciopticon of, 148, 152, 202n40
Sekula, Allan, 77, 185n65; on "honorific" and "repressive" functions of portraiture, 91
self, and other, 109–12
self-representation, cultural economy of, 80
Selke, Willy: "Photosculpture Apparatus" of, 149
serial views: abstraction in, 33; duration in, 31; numbered sets, 28; perspectival differences in, 32; spatiality of, 23–24, 28, 31; volume in, 31
shapes: abstract dimensionalities of, 35; objective, 5; political/ideological operation of, 5; rearticulation of, 35; recognition of, 35
sidedness: blocking of visibility, 64; of cubes, 61; depth and, 60; of embodied vision, 56–57, 63; of objects, 63; of subjectivity, 110
Silverman, Kaja, 176n5

Simpson, Lorna, 4; celestial imagery, 194n41; collages, 96, *97*, 98–99, *100–101*, 101–2, 106; critique of portraiture, 102, 195n52; identity in works of, 96; and photographic representation, 99; mutual exposure, 96; Rihanna images, 194n41
—*Flames*, 98–99, *100–101*, 101–2; composure/disorder in, 102; online exhibition of, 98; racialized/gendered identity in, 101; white viewers of, 99
—*Give Me Some Moments* (exhibition), 194n42
—*Lyra night sky styled in NYC*, 96, *97*, 194n40; depth effect of, 98; grid lines of, 98
smartphones: Google Live View use on, 124–28, 142; Google Pixel, *68*, 74, *75*, *93*; GPS in, 126–27; Huawei, 189n6; iPhone, 65, 67, 71–72, *118*, 198n12; LIDAR scanners on, 73; mobile navigation with, 120; modes of, 189n6; number of users, 188n1; panoramic mode, 189n6; Samsung, 67; Sony Experia 1 IV, 199n2. *See also* cameras, smartphone; photography, smartphone
Smith, John Hammond: "Method of Reproducing Objects," 149, *150*
Smith, Shawn Michelle, 77; on displaced portraits, 194n38; on the fleeting expression, 81
social media, 15–18, 95
Sony Experia 1 IV, zoom lens of, 199n2
Southworth, Albert Sands: on photographic art, 86
Southworth and Hawes (firm): stereoscopic daguerreotypes of, 81–82; *Stereoscopic Portrait of a Woman with Columns*, 82
—*Rufus Choate*, 84, *85*, 86–87; subject and objects in, 87; selective focus in, 86, 87; shallow depth of field, 89

232 / Index

space: dimensional coherence of, 161; of embodied viewers, 62; gaps in, 13; mathematical expression of, 20–21, 92; photogrammetric model of, 161; positivity of, 11; quantification of, 35, 49; self-coordination of, 161; smartphone modeling of, 76

space, Cartesian, 10, 13; in CNNs, 45; of cubes, 61

spatiality: algorithmic mediation of, 5; in anthropometry, 78, 91–92; in computational photogrammetry, 157; depth and, 4–5, 6, 10–11, 24; dimensional, 1, 12, 161, 178n12; of images, 1, 20, 35, 49, 61, 86; immanent relationships of, 1; interreferential networks of, 62; of multiple images, 24; mutually exclusive aspects of, 168; objective relationships of, 1; production by computer vision, 72; quantitative model of, 13; of serial views, 23–24, 28, 31; structuring vision, 138; three-dimensional, 35; two-dimensional, 169; visible, 4, 157; of visual information, 163

standard time, global use of, 200n28

stereocomparators: "floating mark" of, 146, 148; Zeiss-Pulfrich, *147*

stereocyclegraphs, 33–34, *34*

stereographs: embodied perception in, 32; in geological surveys, 35; invention of, 28; mass production of, 26; numbered sets, 28; paired images of, 27; perceptual coordination for, 27; popularity of, 25–26, 28; provisional nature of, 33; as system of exchange, 26–27, 185n65; and verisimilitude 27

stereopanoramas, 31

stereophotogram, Scheimpflug's, 148

stereophotogrammetry, 145–55; embodied surveyor's role in, 154; geometrical projection in, 154; image space and object space in, 149; measurement of volume, 146; in photographic surveying, 146, 148–49, 152–55; Selke's device for, 149;

three-dimensional, 157; use of non-preexisting images, 149. *See also* photogrammetry

stereo-planigraph, *147*, 148; topographical photographs from, 146

stereoplotters, 148; in aerial warfare, 152, 203n49; Kelsh, 152, *153*; of mid-twentieth-century, 152–53

stereoplotting, 148; during World War II, 148

stereopticons (magic lanterns), 148, 202n40

stereoscopes, *26*; Grand Parlor, 81–82; Helmholtz, 146; Wheatstone, 146

stereoscopic views, 3; aerial, 146; Bledsoe's use of, 36–38; commercial, 83; computational aesthetics and, 176n3; daguerreotype portraits, 81–82, *82*; decline of, 83; depth effect of, 3, 23–35, 92–93; dialectical structure of, 3; educational, 83; and historical perspective, 3; as illusion, 24; in NORB dataset, 41–43; object recognition in, 4; perspectival difference in, 25; in photographic surveying, 146; popularity of, 25–26, 83; pornographic, 82–83, *83*, 192n31; relating of multiple images, 22; sciopticon in, 148; separation into single images, 182n20; smartphones, 73; spatial strategies of, 23–24, 91–92; from two cameras, 182n26. *See also* daguerreotypes; photography, early

stereoviews, 182n21

Steyerl, Hito, 186n72

Stiegler, Bernard: *Time and Technics*, 178n12

Stolze, Franz: "floating mark" of, 146, 148

A Study of Invisible Images (art installation, 2017), 52

subjectivity: Black, 195n52; Cartesian, 109; dimensionality of, 108; ecstatic staging of, 112; embodied, 110–13; Hegel's, 109–10; incarnation of, 113; interiorized, 84, 87; objectifying potential of, 89, 91; in portraiture,

80–81, 86; as relational, 102, 105, 111; restrictive limits of, 63–64; sidedness of, 110; surface/depth differentiation in, 89; visibility of, 86, 89, 95–96, 107, 113; in visual appearance, 70

subjectivity, white: interiorized, 84; in portraiture, 69, 71, 77, 81, 86; privilege in, 86. *See also* whiteness

subjects: articulation of world, 107; conflation with space consumed, 92; defined by images, 92; self-completion of, 110; self-coordination of, 110–11: world-in-common of, 110–11

surveillance, computer vision for, 46

surveillance, aerial: object recognition in, 43

surveying, photographic, 129–45; abstract spatial systems, 139; atmospheric elements in, 138; of Canada, 134–35, 138–39; Canadian grid method, 138–39; Deville's method of, 134–39, *136, 140–41, 142, 142, 143*, 144–45; discontinuous images in, 134; embodiment in, 142, 144; facial recognition and, 145, 149; "floating mark" in, 146, 148; grids in, 138–39, 142; manual tasks in, 156; mathematic spatial models in, 157; orthochromatic emulsion in, 138; panoramic photography and, 132, 200nn23–24; perceptible space in, 130; perspective in, 136–37, 142, 144–45; phototheodolite in, 132, *132, 134, 135*; principles of relatedness in, 144; projective geometry in, 136–37, *137*; spatial parameters of, 135; stereophotogrammetry in, 146, 148–49, 152–55; stereoscopic views in, 146; terms of visibility in, 144; use of mirrors, 146; visceral involvement in, 156. *See also* mapping

surveying, land: of British Empire, 130; instruments for, 130–31; plane table, 131–32; theodolites in, 130–31, *131*, 134; trigonometric tables for, 202n49

synthesis, dimensionality in, 60

Tagg, John, 189n8

Talbot, William Henry Fox, 76

temporality, in poststructuralism, 178n12

theodolites, 154; Great Theodolites, 130, *131*

therbligs (motion units), 35

thickness, temporal/spatial, 178n12

3D, 35; cinematic, 177n10; in deep learning, 45; extrapolation from photographs, 23, 28–29, 30, 33, 200n25; of Necker cube, 11; in object recognition, 41

time, and depth, 178n12

time and motion studies, 33–35

topography: of bodily identity, 79, 82, 91; derived from photographs, 145; facial, 81, 89; intersecting lines expressing, 149; photographic surveying of, 129

toys, optical, 25, 177n10

Trachtenberg, Alan, 176n2; on the fleeting expression, 81, 192n27; on Lincoln photographs, 193n35; on photographic portraiture, 70, 77, 192n25

Training Humans (art exhibition, 2019), 47–48; computer vision in, 51–52

training sets (data): archaeology of, 47–48; for computer vision, 39–43; inclusiveness for, 21; for object recognition, 39–43

transitivism, 196n13

universe, whole face of, 165

US Geological Survey (USGS): aerial mapping by, 152; ER-55 stereoplotter, 152

Van Buren, Martin: Brady's portrait of, 87–88, *88*

vantage points: computerized altera-
tion of, 2; in Google Earth, 120–21;
of Google Maps, 123; for *Ocean*
series, 117, 120; of visibility, 56, 111
Vertov, Dziga: on "Kino-Eye," 187n78
virtual reality (VR), 1, 123–4, 149
visibility: absence in, 112–13; across
perspectival views, 165; algorithmic
reshaping of, 47; of Black subjectiv-
ity, 195n52; body's participation in,
167; colonial presumptions concern-
ing, 5; computational transforma-
tion of, 47; computer vision's con-
struct of, 23, 61; cultural terms of,
91; depth and, 4–6, 12–15, 24; Mer-
leau-Ponty on, 109, 111–12; other-
ing of, 108; perspectiveless, 56; pho-
tographic mediation of, 108; pixel
arrays of, 61; as quantifiable, 23,
56–57; racialized/gendered terms of,
106; reconstruction of, 62; scattered,
112–13; seer and seen in, 13, 56, 64;
spacing of views in, 64; spatialized
terms of, 4, 138, 162; of subjectivity,
86, 89, 95–96, 107, 113; universal,
184n41; vantage points of, 56, 111;
between viewer and subject, 107; of
white privilege, 86; of world, 163,
169
vision: automation of, 47; computa-
tional model of, 13; coordination
of multiple images, 27; machine-
mediated, 23; monocular, 25; pure,
167; quantified construction of, 23;
as recognition, 62; seer and seen in,
112. *See also* computer vision
vision, embodied, 167; ontological
dimensionality of, 57; digital enrich-
ment of, 18; equivalence with com-
puter vision, 36; of Google Maps,
128; of Gursky's *Ocean* series, 162,
203n58; incommensurability with
object recognition, 51; machine-
mediated images and, 23; recogni-
tion in, 107; sidedness of, 56–57, 63;
situated nature of, 57, 110; space of,
62; total visibility and, 111–12

visual culture: AI appropriation of, 47,
186n71; computational, 13; displace-
ment by machine culture, 47; media
forms of, 28; nineteenth-century,
148
visual representation: automated proc-
esses of, 2; comprehensive system
of, 56; of cubes, 61; definition of the
visible in, 44; monetary currency
and, 44; perspective in, 175n1; spa-
tialized, 2, 175n1; through AI, 2
volume: absence from photographs,
145; of cubes, 60; measurement of, 9;
in serial views, 31

warfare, aerial, 154, 203n49; stereo-
plotters in, 152, 203n49; stereoscopic
views from, 146
The West, U.S.: stereoscopic views of,
182n20
wet-plate processes in, 145–46, 201n26
Wexler, Laura: "A Notion of Photogra-
phy," 194n46
whiteness: masculine, 79; overrepre-
sentation in recognition algorithms,
19; in portrait mode, 92. *See also*
subjectivity, white
width: measurement of, 9; shifts in
perception of, 10
wigs, 96–98
Willème, François: and computer
vision, 39–40; facial representation,
36; photosculptures of, 28–30, *30*,
32, 150, 183nn30–31; studio of, *29*;
use of pantograph, 29, 149, 151
Williams, Linda, 176n5
Wizard of Oz (film, 1939), color shift
in, 121
world: as abstraction, 165–66; chias-
matic reversal of, 168; dimensional-
ity of, 168–69; disengagement of,
165; embodied experience of, 162–
63; expansive dimensions of, 3–4;
inner framework of, 169; logic of
presentation, 169; coordination of,
22, 168–9; perspectival appearance
of, 63, 165; "picturing" and, 204n1;

quilting points of, 168–169; self-enclosure of, 165; singularity or plurality of, 169; visibility of, 163, 169; wholeness of, 165. *See also* Earth

World War I, photogrammetry during, 152

World War II, stereoplotting during, 152

Wright, C.W. and F.E., 200n23

Zack, Karen, "chihuahua or muffin?" meme, 15–16, *16*, 17–18, 21, 179n1

Zeiss-Bauersfeld stereoplast, *151;* sculpting process of, 150–52

Zeiss-Pulfrich field phototheodolite, *135*

Zeiss-Pulfrich stereocomparator, *147*

Zylinska, Johanna, 197n5

Founded in 1893,
UNIVERSITY OF CALIFORNIA PRESS
publishes bold, progressive books and journals
on topics in the arts, humanities, social sciences,
and natural sciences—with a focus on social
justice issues—that inspire thought and action
among readers worldwide.

The UC PRESS FOUNDATION
raises funds to uphold the press's vital role
as an independent, nonprofit publisher, and
receives philanthropic support from a wide
range of individuals and institutions—and from
committed readers like you. To learn more, visit
ucpress.edu/supportus.